PRAISE FOR *OUT OF SIGHT*

"In *Out of Sight*, William Hackman deftly charts the genealogy of the city's art scene to reveal a complex network of practitioners, gallerists, and patrons, all intent on celebrating the challenging of assumptions surrounding celebrity, civil rights, site, commerce, and institutional acceptance. This book is a most welcome disruption to a body of art historical texts that privilege tried-and-true cultural meccas such as Paris and New York City."
— ADAM SONDERBERG, SEMINARY CO-OP BOOKSTORES (CHICAGO, IL)

"William Hackman's writing on Los Angeles in the 1960s is as full of lucidity and subtly cosmic interrogation as the art of Bengston, Ruscha, Celmins, and others that he takes as his subjects. His explanations are careful and passionate, his tone piercing and happy to challenge accepted wisdom on the artists and the city around them."
— JONATHAN WOOLLEN, POLITICS & PROSE (WASHINGTON, DC)

"Few books bring together soon-to-be established postwar artists like Edward Ruscha, Vija Celmins, Billy Bengston, Ed Kienholz, and Judy Chicago with the art schools, collectors, curators, and agents who shaped the culture quite as well as *Out of Sight* does. William Hackman's history examines the Los Angeles art scene as it transforms from a place of cultural irrelevance to one with a distinctive identity. As a former art student, I greatly appreciated Hackman's engaging approach to this fascinating period in L.A. history."
— RICHARD FOX, ROSCOE BOOKS (CHICAGO, IL)

OUT OF SIGHT

ALSO BY WILLIAM HACKMAN

Inside the Getty

OUT OF SIGHT

THE LOS ANGELES ART SCENE OF THE SIXTIES

William Hackman

 OTHER PRESS / NEW YORK

Copyright © 2015 William Hackman
Production editor: Yvonne E. Cárdenas
Text designer: Julie Fry
This book was set in Futura and Caslon.

10 9 8 7 6 5 4 3 2 1

Library of Congress Cataloging-in-Publication Data

Hackman, William R.
 Out of sight : the Los Angeles art scene of the sixties /
William Hackman.
 pages cm
 Includes index.
 ISBN 978-1-59051-411-5 (hardback)
 ISBN 978-1-59051-412-2 (e-book)
1. Art, American—California—Los Angeles—20th cen-
tury. 2. Art and society—California—Los Angeles—
History—20th century. 3. Los Angeles (Calif.)—Civili-
zation—20th century. I. Title.
 N6535.L6H28 2015
 709.794'9409046—dc23
 2014036633

FOR MARILYN

HAMM: And the horizon? Nothing on the horizon?
CLOV (*lowering the telescope, turning toward Hamm, exasperated*):
 What in God's name could there be on the horizon?

—Samuel Beckett, *Endgame*

CONTENTS

The living room in Louise and Walter
Arensberg's Hollywood home.

"It was very possible to entertain the future here"

WALTER HOPPS WAS AN UNLIKELY HERO for a cultural revolution. A fifth-generation Californian, Hopps grew up in Eagle Rock, a leafy and unhurried precinct of oak-lined streets, Craftsman-style bungalows, and middle-class virtues on the northeast edge of Los Angeles facing the San Gabriel Mountains. He was, by his own account, a "math-science nerd" who expected to follow in the footsteps of his parents and grandparents by pursuing a career in medicine. The adolescent Hopps had only a passing familiarity with the arts, some of it attained in a high-school class designed to turn college-bound science prodigies into more "well-rounded" students. The class readings and lectures were supplemented by field trips to local landmarks, such as the Los Angeles County Museum, known primarily for its natural history displays, and the Huntington Library, the former estate of the railway and land baron Henry E. Huntington, notable for its collections of rare books and eighteenth-century British paintings. Nothing prepared the seventeen-year-old Hopps for the strange and wonderful works he encountered one Saturday afternoon in the spring of 1949, when the class visited the Hollywood home of the collectors Walter and Louise Arensberg.

Under a canopy of tall pines and alders on a quiet hillside street, the Arensberg residence was, from the outside, an unassuming two-story affair with white stucco walls and a red-tile roof. Inside was another world. The couple had assembled one of the country's

most coveted collections of early twentieth-century European and American avant-garde art (nothing else in Southern California even came close). They had started collecting in 1913 in the wake of the International Exhibition of Modern Art in New York, better known as the Armory Show, and continued long after they settled in Los Angeles in 1927. By the time of Hopps's visit, they owned some eight hundred works of modern art and pre-Columbian artifacts, which they also began collecting in the twenties. Objects filled their house: With pictures hung from floor to ceiling and sculptures covering every conceivable surface, its rooms resembled a crowded Paris salon exhibition more than a modern collector's fashionable home. Art covered "every available inch," Jules Langsner reported in *ARTnews* around the time of Hopps's visit. With more than two dozen first-rate works by all the major figures of the Cubist movement, the Arensbergs boasted a more comprehensive collection of the movement than most museums. Surrealism, too, was well represented, as was nonobjective art. Tables and cabinets were topped with pre-Columbian figures and bowls; larger pieces rested on the floor. "The whole house," noted *Vogue* magazine in a 1945 photo spread, "is an exciting assault on the eyes."

Room after room, masterpiece after masterpiece, an astonished Hopps navigated his way as the history of early twentieth-century modernism unfolded before his eyes. In his own tour of the Arensberg home, Langsner found it "necessary sometimes to stoop and peer into a darkened corner, or stretch and twist against a reflecting light to see a fragile [Paul] Klee or attempt to perceive at two feet a huge [Jacques] Villon." In sheer numbers, two artists towered above the rest: the Romanian-born sculptor Constantin Brancusi, represented by nineteen of his exquisite forms in bronze and marble, and Marcel Duchamp, whose 1912 painting *Nude Descending a Staircase (No. 2)* had been a cause célèbre at the Armory Show. The Arensbergs owned not only the painting that had so scandalized the public but a somewhat smaller, earlier version as well as studies for it. In all they possessed nearly forty works by Duchamp, "one

of the two or three greatest innovators of this century," in Walter Arensberg's view. Duchamp was also the couple's good friend and principal adviser.

"I was blown away," Hopps recalled of that first day at the Arensbergs'. "So I asked Mr. Arensberg if I could come back." He could. And he did, again and again. "I thought of myself as a rational positivist. And I couldn't figure out why this seemingly nice, intelligent man had devoted his life to this collection." It was the start of a unique, and enviable, education in the history of art. Walter Arensberg spent generous amounts of time with the young man, discussing individual works and artists. Hopps soaked it all in, questioning Arensberg at length and poring over books and periodicals in the Arensbergs' library. Deep in his studies one day, Hopps was startled by the appearance in the doorway of a vaguely familiar-looking older gentleman, who introduced himself as Marcel Duchamp.

HOPPS'S VISIT TO THE ARENSBERG RESIDENCE would prove to be a turning point—for Hopps, for Los Angeles, and for American art in the second half of the twentieth century. Although the young man headed north to study pre-med at Stanford University as planned, he soon abandoned the terra firma of a career in medicine. By 1952 he was back in L.A. and plunged headlong into the murky depths of modern art.

Modern art had barely existed in Los Angeles before World War II. Beyond the Arensbergs, there were few serious collectors and no galleries or museums that showed the kinds of art that had become familiar to viewers in Europe and the eastern United States. A handful of artists worked in relative isolation; those who were young and ambitious, such as Philip Guston (born Goldstein) and Jackson Pollock, students together at L.A.'s Manual Arts High School, packed up and headed to the East Coast. During the decades following the war, however, the Los Angeles art scene witnessed a burst of creative energy and invention unmatched in American history since

New York had emerged as a crucible of modernism and the nation's cultural capital at the start of the twentieth century. The artists, and the work, that galvanized Los Angeles from the mid-fifties through the early seventies are at the heart of this book.

By the early 1960s, "the whole scene in America had changed," recalled John Coplans, a founding editor of *Artforum*. In contrast to the city's prewar population, postwar L.A.'s newly affluent middle class included cosmopolitan urbanites who were both willing and able to support the sorts of cultural institutions typically associated with a major metropolis. In tandem with this educated and ambitious middle class was a new generation of the truly rich, men and women whose fortunes and personal loyalties were unconnected to the "old money" families that had long dominated the cultural life of the city. Up and down a half-mile stretch of La Cienega Boulevard, some two dozen galleries set up shop, representing both established figures from Europe and New York and emerging talents from both coasts. Newly instituted Monday-night art walks became a powerful magnet for the public; with as many as two thousand visitors a night, one dealer fretted that serious buyers could barely see the art through the crowd. The national press took notice. *Time* magazine declared in 1963: "Monday night on La Cienega is quite possibly not only the best free show in town but also one of the most popular institutions in Los Angeles."

L.A. artists were suddenly at center stage. "San Francisco may be a pleasanter place to live," the *New York Times*'s usually skeptical art critic Hilton Kramer opined, ticking off the relative virtues of American cities. "But Los Angeles is where the artists are—especially young artists." *Artforum* editor Philip Leider went further still, contending that, "taken as a group, the Los Angeles avant-garde may be producing the most interesting and significant art...in America today." Part of a scene that advanced in fits and starts, these men and women pursued a distinct artistic sensibility in a city experiencing the full-throttle social and economic transformations of the postwar boom. For much of the fifties, this emerging generation

of L.A.–based artists worked in relative obscurity, absorbing the lessons of the major twentieth-century movements and tentatively setting out new ideas of their own, experimenting with unorthodox materials and techniques.

But a community of artists, however talented or ambitious, is not enough to sustain a thriving art scene. Artists need exposure, in the form of galleries and reviews, and the financial support of committed dealers and collectors. Museums are crucial to the formula as well: They expose artists and their audiences alike to what has come before and what is happening elsewhere; and, ideally, they cultivate patrons and develop networks of like-minded members. Those elements, absent for so long in Southern California, came together in the mid-sixties. The reasons for this sudden transformation are complex, and one of the goals of this book is to examine the convergence of historical forces that made such changes possible. But abstract forces do not make an art scene; people do. And among the people who shaped the L.A. art scene of the fifites and sixties, none was more important than Walter Hopps. Part agent provocateur, part impresario of the avant-garde, Hopps seemed to be everywhere in those years. "Some of us thought he was in the CIA," joked the architect Frank Gehry. Hopps became the driving force behind the most important exhibitions and spaces for new art in 1950s Los Angeles, including Ferus Gallery, where many of the artists featured in this book first showed. The tutor of a generation of collectors who would sustain L.A.'s nascent art scene in the fifties and sixties, Hopps was, as filmmaker and actor Dennis Hopper, both an artist and a collector himself, once said, "the intellectual godfather" of the L.A. art scene.

In 1962 Hopps signed on as the head curator at the Pasadena Art Museum; within eighteen months he was its director. During Hopps's time there, the museum became one of the country's most adventuresome, alternating between shows of contemporary artists and historic exhibitions of the early twentieth-century avant-garde, and between the East and West Coast. But by the end of the

decade, Hopps and the museum had parted company, and by the mid-1970s the Pasadena Art Museum had ceased to exist. Indeed, the Los Angeles art scene of the sixties had faded from view: museums floundered, galleries closed, publishers pulled out, artists left town.

Those setbacks knocked the wind out of the Los Angeles art scene just as it was reaching its stride. The immediate causes included institutional politics, inflated egos, and timidity in the face of challenging new art and an uncertain market. But underlying all of these was a larger, more intractable problem: the enduring provincialism of Southern California life, particularly among the region's social and cultural elites. Not all of the obstacles confronting L.A. artists and their advocates were local, however. Hopps and his fellow travelers also needed to overcome the parochialism of the mid-century New York art world.

HISTORY IS WRITTEN BY THE VICTORS. That's as true for painting as it is for politics. But compared to politics, identifying winners and losers in the history of art can be a fuzzy business. Critics and historians don't just record and interpret facts; they judge which developments are important and which are dead ends, which artists are "major" and which are "minor." In cultural history, in other words, the victors are in no small part determined by *who writes* the history. (How different might our view of the Renaissance be if Vasari had lived in Venice?)

The history of modern art is typically told as a tale of two cities. It begins in Paris and ends in New York. While there is the occasional European detour—a day trip, say, to Berlin or Vienna or Moscow—there are no such diversions on this side of the Atlantic. From the 1913 Armory Show forward, modern art in America was nearly synonymous with New York. The city's preeminence was only reinforced in the years just before and the two decades after World War II. The term "American art" came to mean whatever

was made by artists living in New York. Outside of New York, American art amounted to little more than "regionalism" and could be safely ignored. Los Angeles, in this telling, was out of sight and out of mind.

What Los Angeles so sorely lacked—museums, galleries, collectors, critics—New York had in abundance. Almost as influential as the art itself was the writing about it. New York was the seat of publishing in the United States. *ARTnews, Arts,* and *Art in America,* the most widely read magazines in their field, were all located there. So were the news weeklies, literary weeklies and monthlies, and the small periodicals associated with the left and liberal intelligentsia. All of these publications regularly carried art criticism by some of the most important critics of the day. No conspiracy theory is needed to explain the dominance of New York in postwar art. Its inhabitants had little incentive to look outside the city to comprehend postwar American art. Be that as it may, it must also be said that the priestly caste of critics and curators greeted the art of Los Angeles with all the enthusiasm and bonhomie of the sixteenth-century church confronted with a heliocentric universe. The hostility was often so pronounced that one cannot help but wonder what all the fury was really about. Was the problem really the art? Or was it something else?

"That there is such a thing as 'California art' is…undeniable," Peter Schjeldahl opined in the pages of *The New York Times* in 1972. But, he added, he found it "hard not to feel a bit patronizing when using the term. For California art, in the last decade or so, has generally comprised flashy, high-style (or flamboyantly *low-*style, amounting to the same thing) variations on ideas current in New York—variations with singularly slight staying power." With a flourish that is a testament to his own flashy high style, Schjeldahl further explained that "New York's gravitational field is so strong that any American working in a mainstream (New York) mode will, should he become influential, more or less automatically be a 'New York artist.' (Ron Davis and Bruce Nauman, in the sixties, were two

such 'adopted' Californians.)" Schjeldahl wasn't alone in this view, but few stated it so plainly: A serious artist was necessarily a New York artist; a "Los Angeles artist" was, almost by definition, unserious and irrelevant.

A guiding premise of this book is the conviction that the all but exclusive focus on New York has presented an incomplete, and thus distorted, picture of postwar American art. Even a cursory glance at the work produced by artists based in Los Angeles during the fifties, sixties, and early seventies suggests that this work is only partially related to developments in New York. A closer inspection suggests not simply a body of work unduly neglected by most accounts but a strikingly different view of what American postwar art was all about.

Put simply, I think the art of Los Angeles tells us more about the sort of country America was at mid-century, and the sort of place it was rapidly becoming, than does the self-conscious and sophisticated art of New York at the time. It's not that I think art needs or even benefits from a social or political "message," but I also don't think it is unreasonable to search a work of art for some insight into the context of its making. Consider, by way of comparison, the early twentieth-century European avant-gardes. A century later, we can still sense in the earliest rumblings of modernism the innumerable shocks of turn-of-the-century Europe: the ravages of war evident in German Expressionism; the proto-fascist revolutionary fervor that animated Italian Futurism; the utopian yearnings of the Russian avant-garde; the transmutability of space and time in Cubism.

The upheavals that roiled U.S. society in the period that interests me here—roughly the mid-fifties to the early seventies—were less cataclysmic than those of Europe half a century earlier, but they were considerable nonetheless. It was an age of extremes, for good and for ill. In its broadest outlines, the story is well known: the giddy optimism of middle-class contentment and endless prosperity competed with growing anxieties about social and cultural changes at home and the threat of nuclear annihilation from enemies abroad.

In its thematic emphases, its emotional range, and its stylistic diversity, the art discussed in this book represented realities of American life at the time in ways that much of the work coming out of New York simply did not: the ugly facts of racial inequality and conflicts over sexual morality; the ubiquitous youth culture of hot rods and surfing and the introduction of new synthetics borrowed from the aerospace and automotive industries; the emerging high-tech society and the American landscape in the age of suburban sprawl; and the violence and paranoia of the 1960s' tumultuous final years.

THE INTELLECTUALLY AND ARTISTICALLY CHARGED CLIMATE of postwar New York endowed artists there with a sophistication enjoyed by few others. The New York art world of the 1960s was, consequently, animated in part by a dynamic akin to what, in a different context, the literary critic Harold Bloom called the "anxiety of influence," a sort of artistic life-and-death Oedipal struggle between generations. To labor in the shadow of masters can be invigorating, challenging the young artist with standards of greatness. But it can also be unforgiving; tradition can be stifling. For the generation of artists in New York still grappling with the legacies of Jackson Pollock, Mark Rothko, and their brethren, the anxiety of influence could be a debilitating affliction.

Artists in Los Angeles faced the opposite problem. They had no masters and little sense of history. Their knowledge of modernism and its milestones was largely secondhand, gleaned from reproductions in books and magazines. Robert Irwin, a pioneering figure in the Light and Space movement and one of the most influential artists to come out of Los Angeles in the sixties, taught himself the history of art in the UCLA library one summer, studying reproductions he arranged chronologically on large tables, dozens of images every day. "People in New York," Irwin once said, "assume everything there is to know is either known or eminently available.

Growing up on the West Coast, you start out with the assumption that everything there is to know is to be found out."

What Los Angeles–based artists lacked in sophistication, they made up for in brio, independence, and resourcefulness. Far from the competitive pressures of the New York scene — its self-conscious wrestling with modernist theory and the legacy of Abstract Expressionism — artists in Los Angeles felt freer than their New York counterparts to explore issues not preordained by the critical priesthood. "The beauty of growing up in California at this moment in time," Irwin insisted, was "that you [had] very little dead weight…All the things that New Yorkers would say to me was wrong with California — the lack of culture, place, sense of the city and all that — is exactly why I was here. It was very possible to entertain the future here." That sense of freedom was contagious among artists in Los Angeles. Unencumbered by prescriptive regimes, the most important artists to emerge in sixties L.A. saw little need to defend or justify their work according to genre or style.

Writing in *The Nation* in 1964, Max Kozloff identified two basic tendencies in Southern California art, the "Sterilized" and the "Sweaty." These different strains, he added, were "more physiological than stylistic." Compared to what most New York critics were saying at that point, Kozloff's appraisal nearly qualified as a rave. Over the years, other writers have made more or less the same point, though in somewhat more flattering terms: "clean" and "dirty"; "sunshine" and "noir." All are to some extent variations, I think, on "Classicism" and "Romanticism." But whatever you want to call it, the dualist approach made sense. Los Angeles artists in the 1960s did seem to fall into two camps: one that feverishly explored the "dark underside" of modern society, and another that unreservedly embraced the region's natural beauty as well as the city's upbeat, sometimes delirious consumer culture. But that insight has by now hardened into a cliché. In truth, the distinctions between the two camps were never so clear-cut. Robert Irwin and Edward Kienholz, no doubt the artists Kozloff most had in mind when he coined his

terms, were almost certainly the two most influential artists in 1960s Los Angeles: Irwin was an exemplar of the "sterilized," keeping with Kozloff's nomenclature, as Kienholz was of the "sweaty." Yet both influenced artists on either side of that alleged divide.

More than any person, however, this book's central character is Los Angeles itself. Indeed, it is a book about the city as much as it is about the art, an attempt to read the one through the other. And if we want to understand how postwar Los Angeles and its art scene shaped each other, we need to start by asking what it was that had made the climate of early twentieth-century Los Angeles so inhospitable to modern art in the first place. To put it simply: What took so long?

Work in Progress

"FAMOUS ART COLLECTION AND GALLERIES FOR HOLLYWOODLAND," announced the headline in the *Los Angeles Examiner* of January 5, 1924. The article—little more than a press release, really, from self-styled "community builder" S. H. Woodruff, the promoter of the new Hollywoodland housing development—announced that the estimable downtown dealer J. F. Kanst, "for more than twenty-five years a foremost art collector and connoisseur," had purchased a prime lot on Mulholland Drive. His planned home would include "an art gallery which will prove to be a beautiful setting for the masterpieces which he owns and for the collections that will be exhibited in his galleries." Above all, the Kanst home and galleries would be "the nucleus of a most interesting colony of artists, musicians, and writers." The most celebrated product of Woodruff's overheated imagination was that singular monument, the Hollywood sign. But neither his rhetoric nor his grandiose scheme were unique in 1920s Los Angeles. As with so much else concerning the history of Los Angeles, speculation in land and real estate development was the engine that propelled its art world.

Los Angeles experienced little of the cultural ferment that stirred New York during the first decades of the twentieth century. Indeed, L.A. was hardly a city at all by East Coast standards. Home to a mere 1,600 souls when California joined the United States in 1850, the city experienced its first boom in the 1880s. As late as the

second decade of the next century, it was still an agricultural center and had more in common with a small Midwestern town than with the cosmopolitan throng of New York. That should come as no surprise: Midwesterners—many of them pensioners looking to live out their days in balmier climes—constituted the majority of those who settled in Los Angeles before 1920.

Civic boosters devised a variety of schemes to lure newcomers, updating the ancient myth of El Dorado and promoting the region as a haven for healthful living; one of the first periodicals devoted to life in Southern California was titled *Land of Sunshine*. The boosters recognized that prospective immigrants were driven west not by poverty but by wealth; newcomers hoped to translate their material well-being into spiritual fulfillment. And unlike the newly arrived Jews and Italians, among others, who took up residence in New York's Lower East Side, L.A.'s recent transplants settled in sparsely populated areas where they could avoid the unfamiliar rhythms of city life. "They wanted homes, not tenements," wrote Carey McWilliams, the dean of California historians. "And homes meant villages." Villages were what they got.

A central business district had, by the turn of the twentieth century, begun to take shape near the original pueblo of Los Angeles, some twenty miles inland from the Pacific shoreline. But the real business of the burgeoning city was its own regional growth. Huge tracts of land were controlled by a small number of businessmen. Bit by bit, these speculators sold off parcels to develop new suburban communities; decentralization was the order of the day. Los Angeles, declared the city's director of planning in 1923, "shall be, not one great whole, but a co-ordination of many units." The result was an amalgam of towns and unincorporated areas spread across the vast coastal plain that reaches from the San Gabriel Mountains, in the northeast, to the Pacific Ocean, some forty miles to the southwest. Neighborhoods sprung up not in the usual pattern for cities, with an ever-widening ring around the city center, but scattered far and wide, often many miles away from both the downtown

area and one another. By the 1910s, these districts combined residential neighborhoods with retail and other businesses, establishing a pattern that continues to this day. Pasadena and the other towns of the San Gabriel Valley appeared some ten miles to the northeast of downtown; Beverly Hills and environs, at a similar distance to the west; Van Nuys, farther away in the San Fernando Valley, to the northwest; and San Pedro, in the harbor area, about fifteen miles to the south. The resulting patchwork was, in the words of one historian, a "fragmented metropolis."

Even with its rapidly growing population, Los Angeles in the twenties had one-tenth as many people per square mile as New York, and nine out of ten L.A. families lived in single-family homes. Little surprise then that the city should, in the words of the muckraking journalist Morrow Mayo, have "the manners, culture and general outlook of a huge country village." The citizenry regarded traditional cities as "congested, impoverished, filthy, immoral, transient, uncertain, and heterogeneous"—in short, "the receptacle for all European evils and the source of all American sins." Early twentieth-century Los Angeles, McWilliams concluded, was "the most priggish community in America. A glacial dullness engulfed the region."

If artistic innovators of the modern era have cultivated a self-image as courageous independents who dare conventions and risk ridicule and scorn, it is nonetheless true that they have from the outset depended on the sympathies of a sophisticated urban elite that is not only prepared to indulge these heroic fantasies but eager to live vicariously through them. Artists in Los Angeles who set out to pursue a modernist agenda would have found plenty to reject but next to nothing in the way of support in the decades before World War II. The painter Lorser Feitelson, who after years in New York and Paris arrived in L.A. the same year as the Arensbergs, put it plainly: "There wasn't any modern art around here." It was very nearly true. Feitelson may have exaggerated slightly when he remarked that L.A.'s middle class "just didn't give a goddam about

art!" But it was certainly fair to say, as a local art critic did in 1924, that "in Los Angeles, we treat modern art as an intruder, a stranger, unwelcome at the gates." The few successful galleries were located in hotels; nearly three out of every four pictures sold were purchased by tourists. The Los Angeles County Museum, the region's first, opened in 1913 as part of festivities marking the completion of the 223-mile-long aqueduct that would slake the city's growing thirst with water siphoned off from the verdant Owens Valley. With divisions devoted to history, science, and art, the museum was a sort of Cabinet of Wonders, with, as Richard Brown, the director who would reform it in the fifties, sharply observed, "everything but a unicorn's head and an ostrich egg." The galleries devoted to art, however, remained dark for three years because there was no work to exhibit.

Los Angeles may have lacked an art museum, but it wasn't without something resembling an art establishment, a well-organized network that included patrons and city boosters. As early as the 1920s the Commercial Board of Los Angeles—an ad hoc group whose membership included the head of the chamber of commerce, the lead editorial writer for the *Los Angeles Times*, and the president of the California Art Club—had congregated to reflect on "What Art Means to the Commercial Life of Los Angeles." They recommended that "out of the monies voted for construction of public buildings, a minimum of $50,000 be used as prizes to California artists for such bronzes, statuary and paintings descriptive of the history and beauty of the Southland as may be determined in cooperation with the City Art Commission and the Board of Public Works."

Like most of the region's clubs, the California Art Club boasted a membership largely comprising plein air painters, landscape artists working in a neo-Impressionist vein. The artists shared their patrons' enthusiasm for growth. "Has anybody noticed in the daily papers a few words to the effect that Los Angeles is growing?" asked an announcement in the California Art Club's newsletter:

We see new hotels, great business blocks, schools, churches and the like springing up over night all around us—and this means increase in population.

To an artist, given to dreaming, statistics are dull—and should be. But let's take a look at our side of the question. This all means that our market is growing! We have decided that we will step along with progress.

Another of the clubs, Artland, went so far as to propose its own ambitious plans for an artists' colony to be developed on fifteen acres fronting Venice Boulevard, not far from the ocean, and featuring "a clubhouse in Italian Renaissance style" that would include studios, dining rooms, bedrooms, galleries, swimming pools, tennis courts, bowling greens, shops, cottages, a gymnasium, and three theaters, one of which would be "a Patio Theater within a lovely colonnade where members may listen to programs in the open air while dining."*

ARTISTS NOT AFFILIATED WITH THE CLUBS amounted to little more than a handful of independent souls working in relative isolation—from one another as well as from the larger world of art. Their work was rarely seen by more than an equally small number of friends and supporters. In February 1923, the Group of Independent Artists, a loose-knit association of modern painters and sculptors, mounted an exhibition of their recent work. Stanton

*Questions about Artland's intentions were apparently raised from the start. The second issue of the club's newsletter included a rebuttal to unnamed critics: "Oven [sic] Artland does not escape the cry of 'commercialism' often thrown at any great civic or cultural movement by uninformed cynics—native iconoclasts—who say the world is dominated by the dollar, yet whose perception is dulled and dominated by the same token in thought. The Board of Governors of Artland refute this charge by reiterating that 'realty promotion' has no place whatever in Artland's plans." (Perret research materials, Archives of American Art)

Macdonald-Wright, who had returned to his hometown of Santa Monica after achieving a modicum of fame as a painter in Europe and New York, provided a manifesto-like essay for the exhibition catalog. More striking than the familiar rhetoric about the responsibility of the modern artist to "express his own age" is the sense that Macdonald-Wright and his compatriots felt overwhelmed by their circumstances. Instead of the swaggering self-confidence of cultural insurgents intent on scandalizing the bourgeoisie, Macdonald-Wright's essay strikes the reader as an earnest plea by a beleaguered group of artists who sought nothing more than "fairness" and open-mindedness. "Let our work affect you as it will," Macdonald-Wright wrote, "but at least let your final opinion not be the result of a preconceived antagonism."

Such attempts to break out of that social and cultural isolation, rare as they were, were more often than not met with indifference or even hostility. For modernism wasn't simply ignored by the clubs. Their membership took to the pages of their monthly newsletters to inveigh against it: "Such feeble flutterings," editorialized one, "puzzle the mind of the public and poison the sincere beginner in art." In the politically charged climate of the thirties and forties, antimodernism merged with anticommunism. City councilmen joined forces with club members and the Sanity in Art Society to blast "degenerate" and "un-American" works of "communist-inspired 'abstract-modern' art." A letter to the county board of supervisors, co-signed by art club members and "civic leaders" and reprinted in the local papers, warned that America's youth were being subjected to "a morbid mental epidemic disease (mass psychosis) which has been and is even now dangerously affecting the art world." The needed remedy was clear: "We raise our lances to defend the sacredness of art."

In such an environment, "the few artists that were serious," Feitelson explained, "had no audience, no patronage, and if they liked it out here, they'd better paint for their own satisfaction." Predictably, the Arensbergs found their early years in Los Angeles painful.

The potter Beatrice Wood, who knew the couple on both coasts, described them as "isolated" and "lonely" on the West Coast. The situation did improve over the years, and the Arensberg home became, in the thirties and forties, a favored venue for a small contingent of modern artists and their supporters in Southern California. The photographer Edward Weston was a frequent guest, as was the Danish-born Knud Merrild, whose "flux" paintings anticipated the poured works of Jackson Pollock by a decade, and Galka Scheyer, a German émigré who was the U.S. agent for a group of painters she dubbed the Blue Four: Lyonel Feininger, Alexei Jawlensky, Wassily Kandinsky, and Paul Klee. It was also at the Arensberg residence that a seventeen-year-old painter named Philip Goldstein (later Guston) discovered the works of Giorgio di Chirico, an influence he would return to in the 1970s, after decades as one of the foremost proponents of the so-called New York School of Abstract Expressionist painters.

The Arensbergs bore their self-imposed exile with bemused stoicism, though the depth of their disaffection occasionally showed through. In a 1939 article noting the fact that the Los Angeles County Museum had hired its first curator of art since the start of the Depression, *Time* magazine reported that Walter Arensberg regarded Southern California as "the most perfect vacuum America can produce." That judgment no doubt reflected the dismay the Arensbergs felt over the fate of their collection. As early as 1936, the couple broached the idea of building a museum of modern art in Los Angeles, using their collection and Scheyer's Blue Four holdings as the linchpin. They offered to fund an addition to the Los Angeles County Museum, but its board of governors proved indifferent to the proposal. "The county museum was ultraconservative," explained the actor and collector Vincent Price, echoing Feitelson. "It was run by people, the old families of Los Angeles, who really didn't give a damn about modern art."

A decade later, Scheyer and the Arensbergs approached UCLA but encountered a new set of obstacles there (including resistance

to Walter Arensberg's demands concerning a proposed chaired professorship in Bacon studies—Francis Bacon, and his alleged authorship of Shakespeare's plays, being an abiding passion of Arensberg's). Disappointed, the Arensbergs began to entertain offers from museums in the East and Midwest. Price, "determined to try and get the collection to stay on the West Coast," tried to rectify the situation. "I wanted to start a much-needed museum of contemporary art in Los Angeles," said Price, who had studied art history as a Yale undergraduate and done graduate work in the field at London's prestigious Courtauld Institute.

What little support did exist locally for modernism came mostly from individuals in the movie business. If cosmopolitanism existed anywhere in Southern California, it was in Hollywood, an intellectual and cultural oasis occupied by, among others, recently transplanted New Yorkers and European immigrants, many in flight from fascism. With few exceptions, the German and other European writers, musicians, and artists who came to L.A. in the forties, did so because of Hollywood, where they wrote scripts and musical scores, directed, acted, designed and painted sets, and worked in animation. In Europe, where it was still viewed more as an art form than as a business, film played an important role in shaping modernist aesthetics, so it was only natural that some of the European filmmakers who arrived in Los Angeles would have important collections of modernist art. The German-born directors Ernst Lubistch and Billy Wilder had notable collections, as did, not surprisingly, their French colleague Jean Renoir. Josef von Sternberg, who had come to Hollywood in the twenties, owned one of the city's most formidable collections of modern art, especially sculpture.

It wasn't just the Europeans. In 1948 Price was joined by half a dozen or so other Hollywood collectors to found the Modern Institute of Art in Beverly Hills. "Mr. Arensberg was excited and backed me with the hope that if I could succeed, the Arensberg Collection would stay in California," Price said. But despite the well-attended

shows, the project was underfunded and closed the following year. The Arensberg collection wound up at the Philadelphia Museum of Art.

BLAME FOR THE FAILURE OF MODERN ART to find an audience in pre–World War II Los Angeles can't be laid solely at the feet of the reactionary resistance it met, potent though that antimodernist sentiment was. The region's self-styled modernists were often part of the problem as well. Throughout the first half of the century, those artists, primarily painters, dutifully assimilated the lessons of Europe's modern "masters," producing work that was inevitably derivative and, more important, stripped of its raison d'être when transplanted from a Europe ravaged by war and revolution to a Southern California wrapped up in dreams of material well-being and individual fulfillment. The exhibition by the Group of Independent Artists was a case in point. Stylistically, it offered a tidy survey course on major currents in modern art. Works variously testified to influences ranging from Cubism to Expressionism, Surrealism, and every other movement of the European avant-garde. There were touches of Picasso and Kandinsky, Léger and Kokoschka. A painting titled *Dying Vienna*, depicting a female nude strapped to a cello played by a human skeleton, seemed to mimic the doom-laden eroticism of the great Viennese artist Egon Schiele at his most lugubrious. Taken as a whole, the art on display looked as if it could have come from any number of European capitals, but nothing about it suggested it had been made in Los Angeles.

Much the same was true of Feitelson. Following his arrival in Los Angeles in 1927, he became a fixture within the small community of painters and sculptors who were attuned to developments in Europe and the eastern cities of the United States. Full of ideas and enthusiasms picked up from his own years in New York and Paris, Feitelson was a one-man dynamo, devoted to bringing modern art to Los Angeles and Los Angeles art to the rest of the world. In the thirties

and forties, he promoted something he called post-Surrealism. But post-Surrealism was purely an exercise in style, an attempt to dress up in the fancy robes of Surrealism while disregarding the political and psychosocial revolutionary ideology woven into its fabric. Indeed, Feitelson dismissed artists he labeled "futuristic expressionists" and objected when Philip Guston and two friends traveled to Mexico to study with the Mexican muralist David Siqueiros, whose left-wing politics were well known. A similar failing plagued the work of another influential artist of the forties and early fifties, Rico Lebrun, an Italian-born painter who attempted to fuse elements of Picasso and Surrealism to quattrocento scenes of the Virgin or the Crucifixion in a horrific post-nuclear landscape. Lebrun's concern for the fate of humanity may well have been genuine, but the work amounted to little more than bombast and pastiche.

There were exceptions to the rule—notably, Merrild and the Russian-born Peter Krasnow, both of whom made highly original work in a variety of media—but for the most part, Southern California artists who were interested in modern work before mid-century generally made the same mistake, tinkering with inherited styles that lacked the force of historical necessity when removed from their original context. Modernism was never about formal invention for its own sake; the compulsive swirl of radical new styles bore witness to the experience of displacement and disequilibrium that were hallmarks of modern life. Modernism was forged in the crucible of industrialization and urbanization. Los Angeles, despite the encroachments of both phenomena, remained in thrall to its own mythology as a new Garden of Eden.

In this sense, we might say that, in early twentieth-century Los Angeles, modernism's enemies grasped its true nature more fully than its defenders. Modern art not only offended the plein air painters' sensibility, it threatened their livelihood, casting suspicion on the carefully constructed image of Southern California they worked hard to maintain. They cheered the city's growth even as they continued to depict the region as an unsullied Arcadia. They

were in the business of timeless beauty. An art that suggested otherwise was to be feared.

The war and its aftermath would change that balance of power. The California dream would not die, but the dreamers could no longer escape the encroachment of urban reality. Los Angeles had become a modern city.

CHAPTER TWO

The Coast of Bohemia

"Who digs Los Angeles IS Los Angeles!"
—Allen Ginsberg, "Footnote to *Howl*"

SOUTHERN CALIFORNIA, *Life* magazine assured its readers in the fall of 1945, enjoyed "at least some of the elements of Utopia." Sunny and warm year-round, this "modern paradise" was blessed with snow-peaked mountains, fertile valleys, and a sense of possibility as limitless as the horizon. The result was "the most glowing example of the modern good life" in the country. *Look*, the other leading glossy of the day, was no less effusive, hailing a forward-looking society that offered "unprecedented opportunities for personal pleasure and fulfillment." The California "good life" trumpeted by these and other popular publications of the day was not so different from the one touted in the promotional campaigns of the late nineteenth and early twentieth centuries, updated to catch the triumphant mood of the postwar moment.

Yet while Southern California in the fifties may still have been the "land of sunshine," shadows cast by the postwar boom had begun to loom large. Some of these were inevitable consequences of rapid growth. Orchards full of citrus were still a familiar sight in parts of Southern California in the years after World War II, but manufacturing quickly overtook agriculture as the region's economic engine, accounting for a quarter of all jobs in greater Los Angeles. The burgeoning defense-related industries of aerospace and electronics offered plentiful, high-paying positions for blue-collar workers, engineers and scientists, and middle managers.

Newcomers established themselves in the prosperous suburbs that sprang up from the San Fernando Valley to Orange County. The San Fernando Valley's population quintupled between 1945 and 1960, while Orange blossomed into the fastest-growing county in the nation. In Lakewood, near the Douglas Aircraft factory, home sales were in the hundreds per day—more than one hundred an *hour* at one point! Streets grew congested, and the sky grew dark with smog; sewer lines were overtaxed, classrooms overcrowded.

Other shadows were less predictable, perhaps, but no less ominous. For the upbeat outlook of America in the fifties masked a growing sense of discontent. Critics lamented a vacuous "affluent society" that, they charged, had produced a mind-numbing mass culture, conformity, personal alienation, and an absence of community—a "terrible shapelessness," as one critic put it—in American life. And Los Angeles became a symbol of this spreading ennui. "The essence of the new postwar Super-America is found nowhere so perfectly as in Los Angeles' ubiquitous acres," Norman Mailer wrote in 1960.

Against this shifting backdrop, a strange, unexpected character arrived on stage in mid-century Los Angeles: the unbound antihero of the Beat generation's bohemia. Writing of the aspiring young artists and intellectuals who flocked to Manhattan's Lower East Side at the outset of the twentieth century, the historian Thomas Bender notes that, amid the heady talk of socialism and modernism, they discovered "a moral intensity that implied a richer, deeper sense of culture than traditional culture seemed to offer." This deeper sense of culture likewise animated the postwar bohemia that materialized in Los Angeles. Exploring new forms of art and poetry, embracing bebop music and experimental film, rejecting the region's deeply entrenched social and political conservatism, L.A.'s emergent bohemia sought an alternative to the material dreams that had come to define Southern California in the 1950s.

The idea of bohemia as some moral duty-free zone within modern society emerged in Paris in the 1830s. The term itself is an

allusion to Gypsies, who, it was erroneously believed, hailed from the territory of Bohemia in what is now the Czech Republic. But bohemia was never solely a matter of starving artists and romantic youth. Its denizens have typically run the gamut from petty criminals to fervent radicals and plotting revolutionaries. Gypsies themselves, it should be recalled, were, in the eyes of the respectable bourgeois, morally suspect. Bohemia is thus a term of opprobrium, one tinged with racial overtones.

Bohemia, the historian Jerrold Seigel has written, took root where "the borders of bourgeois existence were murky and uncertain," producing a space where "social margins and frontiers were probed and tested." Bohemia, one might say, is the domain of the "daemonic" in the modern world. By that I mean something analogous to what I think Freud had in mind when he described the unconscious as daemonic—the specter of Otherness within oneself, a churning cauldron of ideas and impulses hidden from the waking self but nourishing that self in unsuspected ways—or akin to what Romantic poets such as William Blake intended when they judged Satan to be the hero of *Paradise Lost*, the Gnostic spark refusing to be extinguished by an unremitting Reason.

Seigel calls bohemia a "dramatization of [its inhabitants'] ambivalence." That seems right. One might add that a similar ambivalence seems to fuel modernism itself. That's not to suggest that bohemia and modernism are one and the same, but neither are they unrelated. Bohemia marks a turning point in the rise of modernism as well as a rent in the fabric of urban life. "The borders of bourgeois existence" in prewar Los Angeles were, if not quite impermeable, sufficiently sturdy and well marked. But the growing urbanization and industrialization spurred by the war, and the disaffections they spawned, left an unexpected opening for the daemons of bohemia. In postwar Los Angeles, as in mid-nineteenth-century Paris and early twentieth-century New York, bohemia provided a petri dish in which the culture of modernism could grow.

——

LIKE EVERYTHING IN LOS ANGELES, its bohemia was diffuse. The Beat era, with its poetry readings and coffeehouses, is commonly identified with neighborhoods such as New York's Greenwich Village and San Francisco's North Beach. In Los Angeles, the sheer size of the city, and its unusual urban topography, imposed a different social geography. Artists, writers, and musicians, as well as their friends and lovers, were dispersed throughout an archipelago of more or less distant enclaves, each constituting a distinct environment: the beach towns, above all, Venice; the outskirts of Hollywood; and the canyons that snake through the Santa Monica Mountains all but undetected by the outside world. Wherever you were, the artist George Herms observed, "you were still forty-five minutes from everyone" else. L.A.'s bohemia was thus a movable feast, an informal circuit of artists' studios, bars, jazz clubs, and other spots where members of the city's itinerant avant-garde would cross paths—and where Walter Hopps would encounter many of the artists he would show at one or another of the venues he devised from 1955 through 1957. The result, Hopps explained, was "a loose group that included artists and poets" from the far-flung bohemian enclaves in and around Los Angeles. Together, they formed the heart and soul of L.A.'s artistic underground. And from their ranks would emerge some of the defining characters of the Los Angeles art scene as it would develop over the next decade.

The world to which Hopps and his friends were drawn existed largely "in the shadows," as he put it, far from the land of sunshine and "out of sight to the public world." By steering a course through the different neighborhoods, however—strolling the broad boulevards of Hollywood and the labyrinthine cul-de-sacs of Venice, making the acquaintance of important artists and their friends—we can trace Hopps's steps and begin to limn the general contours of L.A.'s mid-century bohemia and glimpse at least the rudiments of the artistic achievements that grew from its fertile soil.

The best known of L.A.'s bohemian quarters was Venice. Founded in 1904 by the ambitious, high-minded developer Abbot

Kinney, Venice, with its central lagoon and network of canals carved out of three square miles of marshland south of Santa Monica, resembled not so much the city of Titian and seat of empire as the later, languorous, slightly down-at-the-heels destination of the Victorian upper classes making their way on the Grand Tour. And whatever glory Kinney might have bestowed on Venice, California, the place had begun to fade even before his death in 1920. Where he had imagined art galleries and concert halls, there were instead roller coasters, bingo parlors, carnival barkers, and body builders. Its double-vaulted archways and simulacrum Saint Mark's notwithstanding, Kinney's creation ended up more Coney Island than Doge's Palace. By the time of the Depression, the neighborhood had largely gone to seed, and so it remained for decades to come.

Decrepitude became Venice's saving grace. By the fifties it was an ideal location for artists in search of large studios and low rents, and a haven for unappreciated poets, slumming Hollywood types, self-styled geniuses, drug-addled visionaries, and pretty much anyone on the make. In *The Holy Barbarians*, his curious hybrid social study and roman à clef, published in 1959, Lawrence Lipton described the neighborhood as a beacon to "the lost, the seekers, the beat, the disaffiliated…in quest of a new vision." Venice, he rhapsodized, was where you could find "the silent ones who come to sit and listen, to 'dig' the talk and the jazz."*

One artist within Hopps's circle, the painter Arthur Richer, had the dubious distinction of briefly being the face of the Venice bohemia to the outside world. In the fall of 1959, *Life* magazine published a seven-page photo-essay headlined "Squaresville U.S.A. vs. Beatsville." Contrasting "a happy home in Kansas" and "a hip family's cool pad," *Life* invited readers into Richer's Venice

*Lipton's book, built on half-truths and exposé, was regarded by the locals as a self-serving exercise in hype; a better title, said one, would have been *Holy Horseshit*. For background about Lipton, in particular reaction to his book, see John Arthur Maynard, *Venice West* (New Brunswick, NJ: Rutgers University Press, 1991), III.

bungalow. One spread featured a large photograph of this hip family's living room, the Richers joined on this occasion by a skinny, bearded figure flopped on a mattress on the floor. The unlikely caption set the scene: "Richer and his wife discuss art philosophy with sprawling cohort, George Herms." Doubtful as that seems, the editors confidently continued in much the same vein, sober and self-assured ethnographers sagely elucidating for the reader the exotic beatnik ways:

> Family life in Venice centers on a pad, as the Beats call their domicile, where the emphasis is all on "creativity" with no interest in physical surroundings. The pad of Beat artist Arthur Richer, 32, is a ramshackle $75-a-month house, nearly walled in with huge abstract canvases. Crowded into these quarters are Richer's wife Bette and their four children. Here, Richer lives happily…"I am called to the frontier of so-called civilization, bizarre as it is. I must find chaos. My expression drives me."

Eliding the fact that Richer was a navy vet and an academically trained artist, *Life* depicted him as the quintessential beatnik, unkempt and of undetermined talent, a lightly mocked symbol of squalor. It may have been a caricature, but it made for great copy. What it ignored was Richer's strengths as a painter. His paintings, like those of many ambitious young artists of the period, showed the heavy influence of Abstract Expressionists such as Franz Kline and Jackson Pollock. He shared with the pre-splatter Pollock an imagery dense with mythic symbols, an emphatic stroke, and thickly applied pigment. But in one sense, *Life* got it right: Richer typified the bohemian spirit that animated many within L.A.'s bohemia, determined to follow his instincts rather than social conventions and to let his art take him where it would, beyond the borders of respectability. Richer stayed tragically true to type in another way, drinking and drugging himself into an early grave.

———

From "Squaresville U.S.A. vs. Beatsville,"
a 1959 photo-essay in *Life*, featuring
Arthur Richer and George Herms.

AMERICAN ART IN THE 1950S meant, first and foremost, Abstract Expressionism, and Abstract Expressionism meant painting. That was true not only in New York but also in San Francisco, which emerged as a West Coast center of postwar painting. In Los Angeles, however, despite the talents of promising young painters such as Richer, the decade's most important developments lay elsewhere, in ceramic sculpture and assemblage, constructions of found objects that could be likened to three-dimensional collages. The most important artists in these movements, those who would figure prominently in Hopps's world, circulated through the jurisdictional patchwork of neighborhoods held together under the convenient heading of "Hollywood."

Like Bohemia, Hollywood is as much an idea as a geographical reality. Unlike Bohemia, the idea of Hollywood is more or less contiguous with the place itself. Geography aside, talk of Hollywood suggests a world of artifice, where actors speak other people's words and move in carefully choreographed ways through a landscape that is very like a painted backdrop. Bohemia, by contrast, was intended as a place for authenticity and spontaneity. To be spontaneous was to be alive. Performance wasn't about following a script; it was about letting go, allowing yourself be swept up and carried away by some greater power in art. Artists sought to re-create the ecstatic, personally liberating experience of jazz in their art. Herms, for one, loved to "get bombed and listen to people create right in front of me," he said. "I wanted to be able to do that while making a sculpture or a painting."

Yet Hollywood and bohemia weren't so much opposites as they were different but overlapping outlines traced on a palimpsest. It was possible to inhabit both at once: Actors such as James Dean and Dennis Hopper did. But even those who lived in bohemia full time regularly crisscrossed the streets of Hollywood—the ones you can see on a map—visiting art studios, attending poetry readings, and passing hours in bookstores, jazz clubs, little theaters, and other popular hangouts. At the Coronet Theatre, on La Cienega, L.A.'s underground assembled weekly to be entranced by

Expressionist- and Surrealist-inspired European films. Across the street was Books 55, an arty avant-garde bookstore that was another scheduled stop for the bohemian crowd. Its shelves were lined with volumes of poetry from small presses and titles dealing with mysticism, the occult, and non-Western philosophy. Hollywood was dotted with jazz clubs such as Billy Berg's, near Sunset and Vine, where the initiated would hole up until the wee hours listening to bebop. It was in the dim light of a Hollywood jazz club that Hopps first spied Wallace Berman, who would become one of the most influential figures of L.A.'s artistic underground and an artist of startling originality.

Deep within Hollywood proper, just blocks from several of the most important movie studios, the artists and poets of L.A.'s bohemia would crowd onto the wooden bleachers in the small room with a tiny proscenium stage that housed the Instant Theatre. The aesthetic precepts of the Instant Theatre—the use of found objects, an emphasis on spontaneity and process, its debt to Surrealism—were those that animated bohemian Los Angeles in general. Improvisation reigned, from dialogue to movement to lights, sets, and sound. It wasn't unusual for one actor to step off the stage and work the lights while those on the boards kept pace with the unanticipated changes of character and story. Costumes were pieced together from scraps. Performers appropriated found objects—not as props but as integral elements in the mise-en-scène. "It was really alive," recalled Berman's wife, Shirley. "It was just this big beautiful assemblage."

The possibility of stripping away layers of self-deception and social pretense had particular resonance in a town where one was constantly reminded of the artifice and ironies of a life lived on an elaborate movie set. And beginning in the mid-fifties, hallucinogenic drugs offered a new key for opening the floodgates to a deeper self. The interest within L.A.'s bohemia was triggered by two virtually simultaneous local events. The first was Aldous Huxley's 1954 account of a mescaline trip in *The Doors of Perception*. It was after reading Huxley that many in the bohemian circles around Berman

first tried peyote. "We were [searching] for an interior vision," the poet Michael McClure recalled of his and Berman's use of peyote. "For alchemical, hermetic understanding of ourselves or of the universe." Huxley's book was "very widely passed around," recalled Berman's friend Robert Alexander. "If you were any kind of artist, you would wonder if maybe this chemical would give you space in your own body that would give you room to work, because you know you're locked in there and can't get out." The other important development was the research conducted by the psychiatrist Oscar Janiger into LSD and its effects on creativity. "Word of the Beverly Hills shrink who had a creativity pill swept through the local bohemian art scene like a Malibu brush fire," as one historian has written. "Within days Janiger was besieged by painters and sculptors, all begging for an opportunity to expose their artistry to LSD." Among them was the painter Gil Henderson, a particular favorite of Hopps. Henderson also persuaded the writer Anaïs Nin to participate in Janiger's project, though it didn't take much convincing; she had been nudging her friend Huxley to turn her on for months. Eventually, said Alexander, "we all tried acid."

HOPPS, HAVING DECIDED HE WANTED TO OPEN AN ART GALLERY, figured that the surest way to underwrite it would be to earn a living as a jazz promoter. So with two friends—Jim Newman, whom he had met during his year at Stanford, and Craig Kauffman, a rising young painter Hopps had known since childhood—he formed Concert Hall Workshops in 1952. The venture quickly failed. Looking back on the notion some thirty years later, Hopps could only laugh at their youthful naïveté. "We had the illusion that booking great jazz musicians, primarily black, on college campuses would help support the gallery," he explained. "It turned out that art [makes] all the money and the jazz musicians don't." But it's easy to see how Hopps and company could have gotten it wrong. After all, jazz was thriving in Los Angeles in the decade after the war, while there

was little evidence to suggest that a contemporary art gallery could break even, much less turn a profit. "New art," he observed, "was not shown, was not sold, was not written about, was not taught." He was determined to change all of that.

Hopps and Kauffman found a funky building constructed of old pier pilings and telephone poles covered with tar. "If you poked the paint," Kauffman said, "this tar would sort of leak out." The place was about a block from the Veterans Hospital in West Los Angeles. Today the neighborhood is part of a commercial district serving the Brentwood area, one of the most exclusive in Los Angeles. But in the fifties it was a no-man's-land of seedy bars frequented by disabled and down-on-their-luck vets. With a couple of poet friends, Hopps and Kauffman rented the space for $65 a month and named it Syndell Studio. The name, Hopps claimed, was an homage to Maurice Syndell, a Nebraska farmer who mysteriously, and shockingly, took his life by throwing himself in front of Newman's car as he was driving cross-country.

Syndell Studio wasn't an art gallery so much as a latter-day Cabaret Voltaire, the Zurich club where the Dada movement was born. The point was simply for artists to show their work, if only to one another. "We clamored for space," Kauffman said. They invited artists they had gotten to know around town to participate in their ragtag atelier. Nobody expected to make money at Syndell, and their non-expectations were borne out.

The immediate precedent for Syndell was the King Ubu Gallery in San Francisco and its successor, the Six Gallery, where Allen Ginsberg gave his first public reading of *Howl* in the fall of 1955. The artistic undergrounds of Los Angeles and San Francisco were virtually indistinguishable during the mid-fifties; many of the principals were one and the same. "There was no Mason-Dixon line," explained Herms. Hopps and Kauffman would visit San Francisco during their student years at UCLA. "We were kind of nervy kids and just kind of went up there and went to [artists'] studios," Kauffman told an interviewer in the 1970s. "Walter was as smooth then as

he is now and just walked in." Indeed, Hopps was barely out of his teens when he first approached San Francisco artists about showing their work in L.A. "He just sort of appeared," said the painter Jay DeFeo. "He was all wide-eyed and enthusiastic," she recalled. "My attitude toward Walter always was, 'Well, good luck.'" DeFeo assumed not much would come of it. "Little did I know," she mused. "He had an excellent eye for picking out the best of the stuff that I did. He would just very quietly take it away." DeFeo became one of the dozen or so Bay Area artists who, along with Southern Californians like Berman, Kauffman, and Richer, would form Hopps's West Coast network in the middle to late fifties.

In early 1955, Hopps and Kauffman set out to organize a large exhibition of the artists they had come to know and admire—some forty in all—which they hoped would be the first in a series of annual salons. Hopps wanted to make art matter to mid-twentieth-century Californians in the way it had to nineteenth-century Parisians. "We wanted to get art back into life," Hopps said. Toward that end, they searched for a space where the show might capture the imaginations of those not predisposed to wandering into galleries or museums. Their first choice was the former Schwab's, the Sunset Strip drugstore where Lana Turner had allegedly been discovered. But, said Hopps, they "couldn't get the [building's owners] to rent to anyone as young as us." They likewise came up short at a handful of other locations before they succeeded in booking the merry-go-round on the Santa Monica pier. Officially dubbed *ACTION*, the exhibition, which opened in May 1955, would be memorialized as the Merry-go-round Show. And though it was received with indifference by the local press, Hopps was energized by what he considered the show's popular success.

With his boundless energy and single-minded focus, Hopps was just getting started. Syndell Studio and the Merry-go-round Show provided the template for his even more ambitious ventures in 1956 and 1957, as the young man attempted to build a spiritual home for the artists of L.A.'s young bohemia.

A Feral Gallery

WHEN HE SHOWED UP AT THE NOW GALLERY IN THE WINTER OF 1956, Walter Hopps was a man on a mission. He had heard talk of this new showplace occupying space at the Turnabout Theatre—a puppet theater on La Cienega with stages front and back, and seats that turned 180 degrees so you could watch the show, first on one stage and then the other—and of the gallery's proprietor, a relative newcomer to Los Angeles who was showing work by some interesting young artists Hopps hadn't already corralled himself. The Merry-go-round Show behind him, Hopps was contemplating his next move. With that in mind, he headed over to this quirky new gallery and introduced himself to Edward Kienholz.

Kienholz was the sort of bigger-than-life character memorialized in tall tales and legends of the American West; you half expected a giant blue ox to be trailing behind him wherever he went. Physically imposing to begin with—strapping as a young man, substantially beefier as the years passed; cagey, flashing eyes crowned by extravagant woolly-bear eyebrows; a hipster's goatee anchoring the chin—Kienholz's stature seemed to grow still larger when you heard him speak. His exploits were fabled, and even his most outlandish stories usually turned out to be true. (He once took an ax to an airline employee's desk when the company refused to reimburse him for a Tiffany lamp that had been shattered while in its care.)

Born to a Presbyterian mother he characterized as "religious and in a way fanatic" and "an angry disciplinarian" father who worked his son hard, Kienholz was in his teens when he set out from the family farm, the site of a former Indian trading post in rural Washington State, near the Idaho border. Though lacking formal training in art, and having next to no experience of galleries or museums—the cultural offerings in eastern Washington were limited at best: radio and occasional day trips to Spokane to see a movie—Kienholz taught himself to paint with watercolors on paper and, throughout his teens and early twenties, grew enamored of the idea of being an artist. Given the carpentry skills he had acquired on the farm, he designed and built sets for plays while in high school and briefly contemplated architecture as a career. Beyond that, the prospect of earning a living through his art seemed a distant dream.

Kienholz's first sale of a work of art—actually a trade for dental work—came on his first day in L.A., in 1953. Elated, he quickly set himself up in a small studio on Ventura Boulevard in the San Fernando Valley. A few doors down was the Contemporary Bazaar, a shop owned by Robert Alexander. It was a sort of bohemian general store offering obscure literary journals, jewelry, miscellaneous objets d'art, and whatever else Alexander felt like stocking. Alexander was on his way to the store when he spotted the newcomer to the block. Entering the studio, he saw the proprietor sitting on a plywood worktable, fashioning chess pieces out of old tin cans. "What do you do?" he asked his new neighbor. "I'm an artist," came the reply. Alexander looked around and noted a painting of a bird. "The strangest looking bird that I ever did see," he later said. Alexander offered to show some of Kienholz's things at his bazaar. He also offered to introduce his new acquaintance to his bohemian crowd of friends and to the Los Angeles gallery scene as it existed in the mid-fifties. With Alexander as his guide, Kienholz entered an art gallery for the first time.

The city's most noteworthy modern art galleries were in Beverly Hills. Frank Perls, a "ruddy-faced, round-faced man, who looked

rather like Peter Ustinov" and was the scion of one of Berlin's most prominent purveyors of modern art, dealt largely in leading figures from the School of Paris. Perls's first gallery was on Sunset Strip, when it still shone with Hollywood glamour. When the Strip declined, Perls moved closer to his clientele — mainly movie people such as Billy Wilder and Edward G. Robinson — setting up shop on Camden Drive in the heart of the Beverly Hills business district. The gallery became the destination for the small number of members in good standing of the monied classes who were in the market for a Picasso or a Matisse.

The proximity to such giants redounded to the benefit of the few local painters Perls elected to show, a group revolving around Rico Lebrun. But for Perls, "abstract paintings used to be a big joke," according to the dealer Paul Kantor, whose gallery was next door. Kantor's gallery was the primary West Coast venue for abstract painting, showing such New York School artists as Robert Motherwell, William Baziotes, and Willem de Kooning in their prime. It was there as well that the California painter Richard Diebenkorn had his first show. Craig Kauffman "thought that was going to be the in [place]" and showed Kantor some of his work in the mid-fifties. But "he just sort of treated me like some young kid." Kantor also turned away Hopps when the young man tried to purchase a drawing — only serious collectors need apply.

For Kienholz's initiation into the world of commercial galleries, Alexander brought him to the Felix Landau Gallery on La Cienega Boulevard. The street had few galleries of note in those days. From Santa Monica Boulevard to Melrose Avenue, it was lined with small businesses devoted mainly to interior design and furnishings — decorators, antique dealers, rug merchants, furniture makers and refinishers. The first important sign of change on the street had come when the rare-book seller Jake Zeitlin took over the big red barn that stood out so unexpectedly just a block above Melrose, an architectural anomaly the locals relied on to navigate the neighborhood. Zeitlin, for decades a mainstay in downtown L.A.

and a fixture in the small world of artists, collectors, and writers in early twentieth-century Los Angeles, had shown prints and drawings in a shop his friend Lloyd Wright designed for him at Sixth and Grand. He became the city's first important dealer in photography when he exhibited the work of another close friend, Edward Weston, whose prints he sold for as little as two dollars apiece. Zeitlin's shop was a frequent destination for many of the same people who at other times could be found at the Arensbergs' residence. When Zeitlin moved his operation into the barn in 1948, it became a magnet for serious collectors and aficionados of all kinds. Over the next few years, Esther Robles and Felix Landau opened galleries up the street. Even as late as the mid-fifties, however, "you couldn't exist by selling art alone," Kantor explained. "Most of the places," he said of the early galleries on La Cienega, "existed by also making frames and selling frames." Robles sustained her gallery that way, and Kauffman recalled that even Landau, who was more successful than most, put expensive frames on the pictures and charged the artists for the privilege: "Felix would say, 'Well, that's the reason it sold, because it had this great frame on it.'"

Kienholz, having had no idea that such places existed, was astonished by his visit to Landau. It wasn't so much the art; later on, he could barely recall what had been on the walls. What had made a lasting impression was the space itself, a space devoted to showing art. He wanted one of his own. Within months he had struck a deal with the owner of the Turnabout Theatre: Kienholz would remodel the theater in return for free use of the greenroom and other backstage areas as studio space and gallery. Soon after, he also took over the lobby of his landlord's nearby Coronet Theatre, the movie house that was so much a part of bohemian L.A. There, on the outskirts of Hollywood, Kienholz accumulated a group of friends, including several struggling young artists he would show at the Now Gallery and in the Coronet Theatre lobby.

Shortly before Hopps's visit to the Now Gallery, Kenneth Ross, the head of the Municipal Art Commission, had entrusted Kien-

holz with the All-City Art Festival, to be staged at Barnsdall Park, a hilly piece of land in the middle of Hollywood. Shows of this sort—large annuals sponsored by a city or county agency—had a long history in Southern California. Indeed, until mid-century, the county museum, with little art of its own to display, not only sponsored annuals; it offered its galleries to local art clubs as well. The amateur-only All-City festival, begun just a few years earlier, had little popular or political support and was poorly funded. Ross had been sorely tempted to drop it, but Kienholz got him to change his mind. Hopps would now join Kienholz in the effort. "Walter's gang sort of met Kienholz's gang," Kauffman said. "It was kind of like two gangs coming together." The marriage of Hopps's knowledge of the art world and Kienholz's matchless skills as a hustler was ideal. And by opening the festival to all the commercial galleries in town, they were able to include their own, bringing greater exposure to the artists they had been promoting.

SOUTHERN CALIFORNIA IN THE FIFTIES was a hotbed of right-wing activism. Blacklists destroyed careers in the entertainment industry and drove back to Europe many of those artists and intellectuals who had once found in Hollywood a refuge from fascism. The John Birch Society was the best known, but by no means the only, group driven by such causes as opposition to the United Nations, the Warren Court, integration, the federal income tax, and fluoridation of the drinking water.

Art made an all but irresistible target for L.A.'s right-wing crusaders. "Communist symbols" seemed to show up everywhere the city fathers looked in the 1950s. The city council passed a resolution condemning modern art as a "tool of the Kremlin." Objecting to a slightly abstract landscape painting, one city councilman fumed that "any damn fool knows the moon is round." A painter of innocuous seascapes was accused of displaying a hammer and sickle in one of his sailing scenes, though the image in question turned

out to be a racing insignia. When a curator at the county museum managed to persuade a donor to part with a Picasso portrait, he was stymied by the political appointees in charge, for whom the artist's left-wing politics were a deal-breaker and who demanded the picture be barred from the galleries and hidden away in storage. More sinister still, James Elliott, who befriended many local artists when he took over as the curator of the county museum in the mid-fifties, was targeted by the Birch Society after one of the museum's Junior League volunteer docents decided that his facial hair, unorthodox dress, and living arrangements made him suspect. The absurdity of such episodes made them no less threatening to those who were targeted.

Such was the climate for art when Kienholz persuaded Ross that he could deliver an All-City Art Festival everyone would be happy with. Teaming up with Hopps would further smooth the way. Hopps and Kienholz were on their best behavior in dealing with the authorities. It helped that Hopps "looked straight and professional," as the photographer Charles Brittin pointed out. He also spoke with quiet authority. "He was very, very sharp and he certainly knew how to handle people," Alexander said. "It's just a knack that Walter had." City officials complained of work they found offensive: a large homoerotic sculpture and a "great big, free-form cut-out piece of plywood" that was, in Hopps's words, "all tits-and-ass curves" with a sprinkling of wood shavings arranged to suggest pubic hair and painted blue. The latter construction—the handiwork of various artist friends of Hopps and Kienholz—was facetiously attributed to the late Maurice Syndell. Nonetheless, when the powers that be demanded that the work be removed, Hopps and Kienholz complied without hesitation. By the time the festival opened in late July 1956, they were already looking ahead. It was a relief not to have lost money producing the show; they even made a couple of hundred bucks. More important, they had caught the attention of the small number of modern art dealers and collectors in Los Angeles. On a paper hot-dog holder, Kienholz and Hopps penned a contract

that would transform the Los Angeles art scene. Signed by both of them, it read: "We will be partners in art for five years."

Ferus was literally a product of the All-City Art Festival: Strapped for cash, Kienholz and Hopps had quietly hauled away the construction materials they had used in building the exhibition booths for the festival, and they employed the same inner circle of artists they had recently overpaid from the city's coffers. Kienholz's deviousness seemed to know no bounds. He went so far as to persuade the city to demolish a dilapidated building near Ferus and boosted from a lumber yard whatever he hadn't scavenged from the city festival. As recompense, he gave all his future business to that same lumber yard, but he never did come clean. "We keep our own books in our own ways," Kienholz told Hopps. Ferus opened in March 1957, just a few doors up La Cienega from Landau, Robles, and the former site of the Now Gallery. Hopps and Kienholz launched the gallery with a survey of West Coast painters—boldly titled *Objects on the New Landscape Demanding of the Eye*—that included most of the artists Hopps and Kienholz had collected during the previous couple of years and shown at one venue or another.

The night before the opening, as Kienholz and others prepped and painted the gallery, Hopps established a precedent that would become a signature gesture over the next four decades: He disappeared. The phantom of the art world, Hopps would materialize without warning—typically at some artist's studio around two or three in the morning—and just as suddenly vanish, leaving no trace. "He [was] always lurking somewhere," Kauffman said. Nearly everyone who was part of the L.A. art scene in the fifties and sixties had been awakened by a ringing telephone and heard Hopps's authoritative baritone reassuring them from the other end: He was on his way, had encountered some slight delays, there were a few details to attend to, but he'd be there soon. (Years later, a popular item on both coasts would be a button that read: "Walter Hopps will be here in 20 minutes.") But to bug out on the night before the opening of his own art gallery seemed extreme even for Hopps.

Kienholz was furious—until his missing partner turned up with a painting by the famously elusive Clyfford Still. "It made the show," Kienholz said later. "Nobody remembered the paint job, but everybody remembered the Still."

"YOU GUYS ARE *IT?*" asked a tall, dark, handsome stranger who approached Hopps and Kienholz in the gallery not long after it opened. "I guess so," Kienholz replied. "Who are you?" His name was John Altoon, he said, and he was a painter. "And that was sort of it," Kienholz said later. "He became part of the gallery."

Altoon had returned to his native city in 1956, after four years in New York and Europe, primarily Spain, where he and the poet Robert Creeley became close friends. A particularly able draftsman, Altoon had spent his time in New York as a commercial illustrator and would sometimes support himself in Los Angeles by drawing album covers for jazz labels. But he was torn between the easy financial rewards to be had from commercial work and his desire to be a serious artist. The latter impulse prevailed. "His habitat was the studio," Kienholz said of Altoon. "The floors were covered in old canvases used as rugs." Hans Burkhardt, an Abstract Expressionist painter who had moved to L.A. after studying in New York, considered Altoon a genius. Of all the young artists climbing the ranks in mid-century L.A., Burkhardt insisted, Altoon "had the most guts, the most originality," an opinion echoed by many. "If you could take one artist who was a swashbuckler of that period," Ed Ruscha said, "it was John Altoon, without a doubt." It was not by chance that the publishers chose a photograph of Altoon for the dust jacket of *The Holy Barbarians*: He was an outsize figure with outsize appetites. The son of Armenian immigrants, he had, Kienholz said, "the features of an Indian chief and the hands and feet of a van Gogh peasant." Irving Blum, who in 1958 would replace Kienholz as Hopps's partner in Ferus, recalled Altoon as "probably the most charismatic person that I've ever met."

For Blum, Altoon personified the spirit of Ferus: "dearly loved, defiant, romantic, highly ambitious—and slightly mad." On that last point, Blum was speaking literally; Altoon was indeed "slightly mad." His return from Spain had been precipitated by a psychotic episode that included a suicide attempt. These events became more frequent. Milton Wexler, who would become Altoon's psychiatrist and friend, reported that he first treated the painter when a group of fellow artists all but dragged him to Wexler's office. Altoon informed Wexler that the voice of God had instructed him to destroy all the art he could get his hands on. "He was passionate, exposed, vulnerable," Wexler said. For all those reasons, and because Altoon was so loved by almost all who knew him, Wexler added, "people generally forgave him the excesses which in others they would find offensive." Blum, for instance, forgave Altoon for the time he burst into Ferus and held a knife to Blum's throat. The enraged artist demanded access to the storeroom, which held several paintings he had recently completed—"probably, the most remarkable things he'd ever done," according to Blum. "I knew he was hell-bent on destroying the pictures," said Blum, who, terrified that in such a state Altoon might even be capable of killing him, yielded to his friend. "And sure enough, he wiped out six or seven of these monumentally beautiful pictures." Then, like Dr. Jekyll returning to sanity after a murderous rampage in the guise of Mr. Hyde, Altoon regained his composure almost immediately. Seeing the destruction he had wrought, the artist "burst into tears, and left."

Surprisingly, perhaps, Altoon's paintings don't immediately suggest a tormented soul. On the contrary, they have frequently been labeled "lyrical abstraction." Altoon was, among other things, a brilliant colorist who could seduce with his deep crimsons and decidedly out-of-fashion but irresistible blue-greens. But to consider Altoon's paintings solely in such terms is largely to miss their magic. More telling, perhaps, is his friend Creeley's suggestion that painting was probably "too slow" for Altoon's purposes. "At times in

Mallorca," recalled the poet, "he was mixing pigment as he worked, finally just dumping turpentine on piles of dry pigment, not even looking so intent was he on the canvas." Altoon's real métier was drawing. He was seldom without a pencil, scribbling on the closest available surface—napkins, envelopes, whatever was at hand—as well as on the pads he carried with him constantly, and turning out "between twenty and thirty a day," by one fellow artist's estimation. In the studio, according to Susan Benay, one of his regular models, he would draw "page after page after page." Often erotic, not to say obscene, the drawings were populated not only by provocative nudes but also by a recurring cast of cartoonlike characters that included satyrs, horny rabbits, and walking phalluses. The compulsive, overflowing eroticism of the drawings is more contained in Altoon's abstract prints and paintings, but just barely. And it was not just the work that was suffused with erotic power. Benay testified to Altoon's sexual magnetism. Sitting for him, she said, she felt "transfixed." It was "like he was inside of me, like the throb of my sensuality...almost like I was his phallus and he was the blood rising up in it."

Sexual obsession was hardly unique to Altoon as an artist, of course. But the erotic dimension of his work bears brief comment here, if only because it is emblematic of a more general truth about bohemia, masculinity, and sexuality in 1950s America—and, by extension, the changing sexual regime in which Ferus and its artists operated. The postwar era bristled with contradictions about sexuality and the nature of manhood. The Kinsey reports on the sexual behavior of Americans revealed a chasm between public norms and private lives, between the accepted facts and what actually went on in the nation's bedrooms. Also appearing in these years was *Playboy*. With its carefully orchestrated mix of tastefully posed nudes, fashions, and high-priced commodities, the magazine helped define a new moral code, a vision of the good life very much in tune with postwar consumer culture. Yet at this selfsame moment, sociological studies such as *White Collar* and *The*

Organization Man and novels such as *The Man in the Gray Flannel Suit* proffered the idea of American manhood under siege. Rugged individualism had given way to offices full of yes-men. And the culprit seemed to be the very culture that *Playboy* so zealously promoted. The American ideal of the self-made man had been repackaged and sold as a fantasy of leisure to men whose own lives were in reality circumscribed by their dual roles as employees and consumers.

To be sure, the life of an artist is by definition more independent and creative than that of a middle manager. Bohemia, moreover, always a haven for nonconformists, offered alternative routes to manhood: the dandy, the delinquent, the revolutionary, the homosexual, and the hipster, among others. To choose such a life was, at least implicitly, to resist the onslaught of postwar consumer culture and the ignoble fate of the white-collar "company man." But not even the artist can completely escape the stresses and strains of his or her historical moment, and the postwar culture's conflicting signals about sexuality and selfhood found their way into much of the art coming out of bohemian Los Angeles.

The ritual humiliation of American manhood, for instance, was a recurring theme in Kienholz's work, announced as early as 1957 in a relief painting titled *George Warshington in Drag*, with the father of our country reduced to a travesty. And it returned with a vengeance two years later in *John Doe*, one of the artist's first freestanding assemblages. The figure's head and torso have been separated from his lower body, and the two halves are joined by a hollow pipe that runs from his chest through his hips and extends a foot or so beyond the crotch, a direct line between heart and phallus. Or more to the point, perhaps, the pipe replaces those organs, draining Kienholz's everyman of the capacity for love, in any sense of the word. Thus eviscerated, the remaining shell has been placed in a baby stroller, completing the infantilization of the American man. Likewise *Boy, Son of John Doe* has already learned to compartmentalize his emotions, most especially his developing sexual desire: He furtively

carries a condom and a well-thumbed paperback titled *The Impotent Fear Through the Erogenous Zones.*

Against this backdrop of anxiety about the fate of American manhood, an air of machismo enveloped the Ferus crowd. The title of one exhibition, *The Studs*, fairly encapsulates the self-image of many of its artists. As playful and ironic as this macho attitude often was, it nonetheless fostered a boys' club atmosphere that just about any aspiring woman artist would have found intimidating, a situation that helped spur the rise of the feminist art movement in the 1970s.

"OUT OF THE NON-OBJECTIVE ASHES of two advance guard art galleries," wrote Gerald Nordland, the art critic for *Frontier* magazine, "there has arisen a new and potentially significant showplace for the West's experimental artists." Reviewing the opening show in the magazine's May 1957 issue, Nordland added that "the Fergus Gallery [*sic*] seems likely to provide an excitement and a leaven to the orthodoxy of much of the local exhibition scene."

Ferus provided the home for West Coast artists that Hopps had been trying to create since the days of Syndell Studio. As a commercial venture, however, it was only slightly more successful than Syndell. Sales of Altoon's paintings and drawings helped pay the rent, but there was little else that could be counted on. "We were all naïve," Kienholz said. "Nobody knew what the fuck they were doing." That would have to change, Hopps knew, if the gallery hoped to survive. The arrival of Blum in mid-1958 helped. His knowledge of business was by no means vast, but it dwarfed that of Kienholz or Hopps; at the very least, he understood sales. Even so, you can't sell something until you have someone to sell it *to*. So, having brought together an eclectic group of artists, Hopps now set to work creating an audience for them.

Hopps started with talks and slide shows in the gallery on Friday nights. Then, beginning in 1959, with help from his wife, Shirley,

and her fellow UCLA art history grad student Henry Hopkins, Hopps designed and taught a series of classes through the university's continuing education program. Most of those who signed up for the UCLA course had done so after first wandering into Ferus and hearing the enthusiastic Hopps explain the art on the walls and how it fit into a larger history. "For me, the Ferus gallery was the entrée," said Donald Factor, who had been looking at a show at Felix Landau's when he happened to notice the new gallery nearby. "I was a total neophyte," he explained. "And I got sort of enthralled" by the work at Ferus. The collector Betty Asher had a harder time of it at first; she and her husband "walked in and walked out" of their initial visit to Ferus. "I just didn't understand it," she explained. But over time she became a tireless champion of the gallery and its artists.

In the beginning, Factor recalled, "Walter couldn't get enough students to do it through UCLA, so we just paid him personally." Hopps, moreover, was still officially an undergraduate at the university, whereas most instructors were either professors or doctoral candidates. But the ranks quickly swelled to the point where the school would give its blessing, and Hopps, after all, had two grad students helping out. Strapped for classroom space, UCLA's extension program enticed would-be students with free enrollment if they would open their homes for courses. Hopps would arrive at his students' elegant Westside homes—most often that of Fred and Marcia Weisman—armed with a slide projector that he would set up in the living room. "A small group of us met each week," recalled Betty Factor, who, with her husband, Monte (no relation to Donald), was among the first serious collectors of Kienholz's work. "We really learned at Walter's knee." Indeed, "that whole first generation of California collectors of contemporary art," said Blum, "came out of classes that Walter and Shirley...held at various collectors' houses."

Beyond the slide lectures, Hopps would lead the group on outings to local galleries and artists' studios. The studio visits were

crucial, as Hopps's protégés got to know the Ferus artists and gained a sense of what made them tick. Meanwhile, this circle of budding collectors morphed from a class of students into a close-knit social clique; collecting ceased to be a hobby and became instead, in the words of Donald Factor, "a way of life."

Obscure Objects of Desire

SOMEBODY CALLED THE COPS. Exactly *who* is anybody's guess: an anonymous complaint, they said. And so, on this otherwise fine mid-week afternoon in June 1957, two plainclothesmen from the local vice squad appeared in the doorway of the newly renovated, barnlike building at 736A La Cienega Boulevard—an odd, unfamiliar place set back behind an antique shop along the unincorporated commercial strip between Santa Monica Boulevard and Melrose Avenue. They had come on the lookout for something recognizably obscene; what they found inside the Ferus Gallery wasn't recognizably, well, *anything*. In the entryway were a dozen stained, antique-looking parchments bearing Hebrew lettering. Standing apart from one another in the main gallery were a hooded figure inside a tumbledown construction about the size and shape of a phone booth; an indeterminate piece of furniture covered with photographs and foreign phrases; and a cross large enough to hang behind the altar of a village church. All appeared culled from the junk heap. The cops had never seen anything like it. "What's this, an art show?" one of them demanded. "Where's the art?"

Wallace Berman's exhibition at Ferus, his first and last in a Los Angeles gallery, lasted less than a week and landed him in jail. Seen by few other than the opening-night revelers, it has enjoyed an afterlife of some renown in the half century since. If not for his friendship with Edward Kienholz and Walter Hopps and his

enthusiasm for Ferus—Berman hand-printed the preopening announcements—it is doubtful that Berman would have bothered with the exhibition. "He didn't care if he ever showed," said his wife, Shirley. The art market was anathema to him, as was art-world hype. Besides, not many dealers would have been eager to represent an artist who regularly gave away his work to friends and admirers. He was content with his job as a furniture finisher and with making art for the few he thought would appreciate it. "Why interview me?" Berman asked when a *New York Times* reporter approached him at his 1967 exhibition at the Jewish Museum. "I really don't make this scene." Yet Berman's influence was widespread, and not only within the assemblage movement with which he was most identified. Many of L.A.'s pop and conceptual artists of the sixties and seventies also acknowledged their debt to him.

Berman's talents were evident in early adolescence: Expelled from Fairfax High School for gambling, he enrolled in art school in the mid-forties. But the academic environment provided too plodding a pace. "He went through figure and life drawing in about twenty minutes and had painted himself into a white canvas," recalled Robert Alexander, alluding to a white-on-white painting Berman had executed near the end of his art-school days. "I loved it," Alexander said of the work, "but he felt that was the end of his painting. He'd sort of done it all. He had tried everything and nothing grabbed him." A protean artist, Berman moved comfortably through a range of media, from drawing and painting to collage, photography, and film. And though bored with painting, he continued to draw, producing portraits of musicians and other scenes from the world he had become a part of. His drawings graced the covers of jazz albums; lithographs of his works were sold through record stores and magazines.

Street-smart and possessed of a disarming wit, Berman developed a reputation in the late forties and early fifties as a hipster, a habitué of the city's jazz clubs by night and by day of the pool halls where he supported himself hustling eight ball. ("Give me a

hustler over an intellectual any day," Kienholz said, referring to Berman.) The first time Hopps saw Berman, in a darkened nightclub, he was spellbound by "a stunning presence." Hopps recalled Berman's "young, hawk-face intensity, straight ahead stare, super cool, zoot suit type attire topped by brush cut hair straight up." "Who was that?" Hopps asked of no one in particular. "That's Wally Berman," spoke a voice from a nearby table, as if there were nothing more to say.

By the time Hopps and Berman actually met a few years later, the erstwhile hipster and hustler was already at the center of a widening circle of friends, acquaintances, and correspondents that included artists, poets, actors, musicians, and other kindred spirits. "Wallace opened a very different sort of future from any I'd imagined in 1953," Hopps said. Friends would show up, in ones or twos, at the Bermans' tottering, two-room habitat on Crater Lane in Beverly Glen, a rustic canyon carved into the hills west of Hollywood. It was little more than "a shack on stilts in buckets of cement," said Shirley Berman. The rickety, wood-frame structure was eventually washed away in a diluvial downpour, but for a period, recalled a bemused Shirley Berman, "we had an absolutely open house, the 'Hotel Berman.' People were sleeping on the floor, people that we didn't know showing up at our door [asking] 'Can I come in?'" The Berman residence was "a place where art and poetry and music were celebrated as daily ritual," recalled assemblage artist George Herms. "Wallace had his hand press in the front room, the *View* magazines with the Cornell [reproductions] in them, *The Dada Painters and Poets* book [by Robert Motherwell]. Whatever he was interested in was yours." Another regular was the photographer Charles Brittin, who helped Berman master the art of photography with a camera given to the artist by actor Dean Stockwell. "You'd listen to some music and you'd smoke some pot and talk and look at things," Brittin explained. "There were books, pictures, art books, clippings from newspapers." He and others would "bring little collages, drawings, odds and ends, and leave them." It was, Brittin said, "almost like a

token, an offering." Alexander summed it up best: "That little house on Crater Lane was just heaven for a lot of us."

Berman's community, and its gift economy, reached well beyond the confines of the house on Crater Lane. He would mail photographs, drawings, and collages to those who weren't in the immediate vicinity (and even to those who were). And in 1955, he produced his first edition of *Semina*, a publication that was in itself a work of assemblage: a combination of verbal and visual elements culled from diverse sources and disseminated to an expanding universe of friends and fellow artists. (Early editions comprised about a hundred and fifty copies; later the number would increase to as many as three hundred and fifty.) And though he contributed his own poems, drawings, photographs, and collages, and personally printed the text on a hand press, it is fair to say that Berman's most important role in producing *Semina* was in forging a collective voice. "From the first," the poet Robert Duncan observed, "the intent of *Semina* was not a choice of poems and art works to exercise the editor's discrimination and aesthetic judgment, but the fashioning of a context." It was a collective work of art, through which a community spoke to itself. And within that community, the creative self came into being through its relationship to others. Comparing this community's collective vision to that of Romanticism, Duncan explained that "we began to see ourselves fashioning unnamed contexts, contexts of a new way of life in the making, a secret mission."

THE FREESTANDING OBJECTS IN THE FERUS SHOW reflected Berman's skills as a furniture finisher—he used wood scraps and other nearby materials to make small, playful sculptures—as well as his personal motto: "Art Is Love Is God." There was, first of all, the *Cross*, a towering cruciform of wooden beams or railroad ties that had been burned and cut in various places, standing some seven feet high and mounted on a crate. Hanging by a chain from the right side of the horizontal beam was a small box frame containing a photograph—a

Wallace Berman installation at Ferus Gallery, June 1957.

tightly cropped shot of male and female genitalia interlocked in sexual congress—and the Latin phrase *Factum Fidei* ("act of faith") was painted on the frame's glass. The decrepit shrine or sanctuary containing the robed and hooded figure was titled *Temple*. It was composed of wooden slats and boards on all but one side, which was open to the viewer. The life-size, monk-like figure stood with his back to the viewer, a large key hanging from his neck. Scattered at his feet were poems, photographs, and drawings—pages from the handmade first issue of *Semina*. The final piece, *Panel*, was an amalgam of elements that Berman had accumulated and slowly pieced together over several years: little wooden knobs, drawings, fragments of Hebrew writing, and, front and center, a photograph of Shirley Berman.

Astonishingly, in making their confused sweep of the gallery, the cops somehow managed to miss the image that triggered the original complaint: the pornographic photograph hanging from the cross, which could not have been more explicit. Overlooking that photograph, but apparently eager to make a bust, they sifted through the pages from *Semina* on the floor of the *Temple* and selected a drawing. Executed in a spindly pen-and-ink that seems two parts Aubrey Beardsley and one part Flash Gordon, the drawing in question was, though less explicit than the photograph on the *Cross*, nonetheless emphatic in its eroticism. Again a couple appear sexually entangled: the male figure kneels behind the female, who crouches catlike on her hands and knees, her head raised, as if in ecstasy; a serpent's tongue hisses from her mouth. Her companion's flesh seems to have been peeled away, revealing a sinuous ribbon of blood vessels and muscle tissue (not unlike the clear plastic "invisible man" figures popular in the postwar decades as educational toys). He is faceless, except for a spidery starburst, a black hole of consciousness.

Compounding their error, the police not only seized the wrong image; they had the wrong artist. Berman hadn't made this strange drawing. That distinction belonged to his friend Marjorie Cameron,

Marjorie Cameron, untitled (*Peyote Vision*),
1955 (ink, paint on paper, 17½ x 22¾ in.).
This drawing was seized by police during
their raid of Berman's Ferus exhibition.

and the image was a souvenir from a peyote trip. There was, nonetheless, something oddly appropriate about the detectives' choice. Berman himself had been so mesmerized by the drawing the first time he saw it, hanging in Books 55, that he simply removed it from where it hung and took it home. Oddly enough, the police now seemed to have more or less the same reaction. When they seized Cameron's drawing, they revealed more than they knew about Berman's work, his methods, and his curious installation at Ferus.

A striking beauty with, by all accounts, a magnetic personality, Cameron influenced a number of local artists, including Berman, thanks to her knowledge of the occult. Like her friend the filmmaker Kenneth Anger, she was an acolyte of Aleister Crowley, the celebrated libertine, author of *Diary of a Drug Fiend*, and self-proclaimed Antichrist. Anger cast Cameron to play several characters in his 1954 Crowley-inspired extravaganza, *Inauguration of the Pleasure Dome.** The film is essentially an occult communion; its climax, an orgy conjured by a magical elixir, completes the transformation from corporeal to spiritual being. "The magician becomes...intoxicated with God," Anger quoted from Crowley, "his mortal frame shedding its earthly elements." The passage is as much a key to Cameron's drawing as it is to Anger's film. For Cameron, the peyote button doubled as a communion wafer, her equivalent of the magic elixir.

Something similar seems to have been at work in Berman's Ferus installation. Allusions to magic and mysticism abound. The antiquated look of the Hebrew lettering recalled that of the recently published Dead Sea Scrolls, which had already spurred both scholarly interest and the popular imagination since their discovery a decade prior. The additional bits of Latin and Hebrew inscribed on the *Panel* similarly hint at sacred, liturgical texts within. And

*In her diary Anaïs Nin, who co-starred, noted that Anger and his circle "talked of Cameron as capable of witchcraft." Nin herself was less enchanted, noting in her diary that she detected "an aura of evil" around Cameron.

Berman knew that Kabbalistic tradition held that Hebrew letters themselves were emblems of divinity. It was in this light that he adopted as his personal mark the aleph, the beginning of all language and expression. Art and poetry, Berman implied, could be as intoxicating as a drug, as revelatory as a magic potion.

Berman was no mystic, despite the image that has sometimes been painted of him. He was, rather, as much a scavenger of ideas as he was of objects and images. Religions, philosophical systems, and simple habits of mind were all raw material, ways of thinking and seeing that he sometimes found useful and other times not. His unifying subject was insemination and regeneration. That is the point of the photograph on the *Cross*, the traditional Christian symbol of resurrection and regeneration. But whereas one line of Christianity holds that the body of Christ falls away, freeing him from sin and worldly pain, Berman's *Cross* embraces the heretical view associated with some early sects that spiritual knowledge is experienced through the body—that sex is a sacrament: *"Factum Fidei!"* Insemination begets transfiguration. Hence *Semina*.

ALERTED TO THE COMPLAINT AND IMPENDING POLICE VISIT, Berman and the Ferus crew awaited the cops' arrival. Kienholz and Hopps were young and brash and no doubt understood the P.R. value of martyrdom (from the beginning there have been whispers, unproven, that it was Kienholz himself who had made the call). The three principals were joined by Alexander, Arthur Richer, and Brittin, who photographically documented the event from start to finish. But no one had thought far enough ahead to imagine a scenario that ended with Berman behind bars. They "were really kids," Brittin said. "There was a lack of knowledge about how the real world works." Learning that her husband was being taken downtown for booking, Shirley quickly called Stockwell, and together they rushed to the courthouse to make the $150 bail before nightfall. A judge rendered the verdict: guilty. Wallace Berman, artist, was now, at

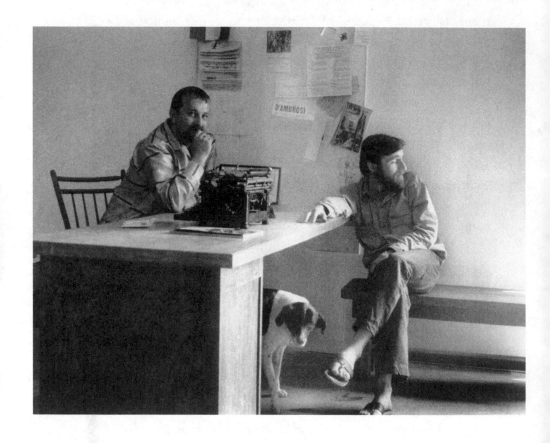

Ed Kienholz and Wallace Berman
at Ferus Gallery, June 1957.

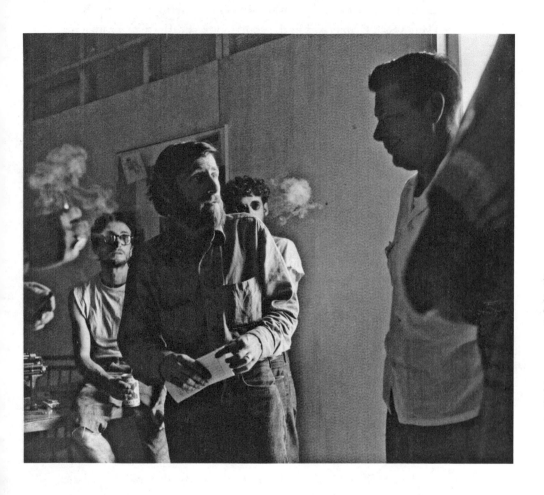

Wallace Berman talks to a vice squad detective as Arthur Richer and Robert Alexander look on.

least in the eyes of the law, officially Wallace Berman, pornographer. There was a chalkboard in the courtroom, and Berman approached it and wrote, "There is no justice; there is just revenge."

Embittered by his arrest and its aftermath, and stunned that he could be jailed for making art, Berman abandoned his hometown at the end of 1957, declaring Los Angeles a "city of desolate angels," and moved to San Francisco. In 1960 he and his family decamped to Larkspur, a small town along an estuary of the San Francisco Bay, some twenty minutes north of the city, where they lived on a houseboat. Berman converted a second houseboat into the Semina Gallery, where he showed work by friends, and a studio of his own from which he continued to produce the publication for which the gallery was named. He returned to Los Angeles with his family in 1961.

SEMINA HAD OPENED A DOOR for Berman to redefine his role as an artist, away from that of the work's originator and toward that of redactor. He published the final edition of *Semina* three years after returning to L.A. and turned his attention to a process that would take his self-effacing aesthetic further still. In a trade with a neighbor, Berman acquired a secondhand Verifax machine. Like so much else in his art, the machine itself was a cast-off of late-industrial culture; Verifax photocopy technology had enjoyed a brief success before it was eclipsed by xerography. By altering the balance of chemicals used in the Verifax process, Berman managed to create images that appeared more photographic than an ordinary copy, yet had less definition than an ordinary photograph. The resulting image was eerily anachronistic and otherworldly—up to date, yet out of date—and the source of his most compelling work.

The Verifax machine gave Berman unprecedented control over the images he used—newspapers and magazines, tarot cards, religious symbols, movie stills, mechanical diagrams, and, once again, Hebrew calligraphy—freeing him to try out endless combinations and different effects. Especially striking was a photograph of a hand

holding a transistor radio, which served as a framing device for other, superimposed images. It was as though the transistor picked up not just radio waves but also a galaxy of signs and symbols, secret codes from another world.* But the converse was also true: Berman implied that the Delphic mysteries could be tuned in like the latest hits from the underworld. He flipped the quotidian and the cosmic, an impression compounded by his printing some of the Verifax copies as negatives, others as positives.

His next move was to arrange this panoply of images in a grid, divided into equal numbers of rows and columns. Each box in the grid contained a Verifax collage, each with a different image in the handheld radio. The repetition was hypnotic, an effect that set Berman's work apart from the serialized imagery of such contemporaries as Andy Warhol and Jasper Johns. The images themselves, especially when printed in negative, had a ghostly mien; each became the visual equivalent of a word that, repeated enough times, is eventually drained of meaning. The grid was the great leveler: The rational and the nonrational—a diagram of a crankshaft, say, and a numerological chart—receive equal billing. Expecting the artist to guide us through an orderly universe of symbols, we have instead been set adrift in a chaos of signs. All that holds it together is that ever-present radio. That, and the hand that holds it. The artist's hand, perhaps?

"The artist's hand": It's a familiar trope, a conceit of connoisseurship that joins the artwork to its maker, a vouchsafe of its authenticity, its historical importance, and, not incidentally, its monetary value. It's what makes a Rembrandt a Rembrandt; a Pollock a Pollock; a fake a fake. Berman, in the Verifax collages, inverts this reasoning; the artist's hand is little more than a cipher, an updating of the "transparent eye-ball" Ralph Waldo Emerson

*Berman admired the films of Jean Cocteau, and his Verifax collages recall Cocteau's 1949 film *Orpheus*, in which indecipherable messages are broadcast over a car radio.

famously described in "Nature": "I am nothing…the currents of the Universal Being circulate through me." But whereas Emerson sought the transcendent in untrammeled nature, Berman offers us a paradoxical Romanticism in which emanations of Spirit are conjured from the detritus of mass culture.

WHETHER ONE SPEAKS OF *SEMINA* OR THE VERIFAX WORKS, Berman's most sustained and best-known efforts were in the area of collage. Yet he is rightly recalled as one of the most—if not *the* most— influential figures in the assemblage movement that took shape in late fifties Los Angeles. (The *Artforum* editor John Coplans went so far as to claim that the entire "California assemblage movement stems from…Wallace Berman"—an overstatement, to be sure, but an understandable one.) Herms was probably the artist most indebted to Berman. As with Berman, there was a kind of redemption at work in Herms's art. Reclaiming the discarded and the dispossessed, Herms delivered everyday objects to an afterlife where their value as mere practical means to an end was replaced by more ambiguous, poetic purposes. But even Kienholz, hugely influential in his own right, owed something to Berman. Temperamentally, the two were almost polar opposites. If Berman was heir to Emerson, Kienholz channeled the spirit of Cotton Mather; he was a twentieth-century version of the Puritan Jeremiah inveighing against the moral turpitude that had descended on the New Jerusalem. Fixed within the hollow of *John Doe*'s chest, in place of a heart, Kienholz had placed a cross. Unlike Berman, whose *Cross* serves as a passage to erotic transcendence, Kienholz presents the emblem of Christian faith as a symbol of sterility. But it was only after Berman's ill-starred show at Ferus that Kienholz turned to his ambitious freestanding assemblages and, ultimately, his complex tableaux.

Beyond the circle of artists, poets, and others with whom he came into direct contact, Berman also had a lasting, if somewhat subterranean, influence on the broader culture of the coming decade,

as evidenced by the homage paid to him by artists in various fields. You can find him, for instance, among the onlookers who crowd the cover of the Beatles' *Sgt. Pepper's Lonely Hearts Club Band.* Similarly, Dennis Hopper cast Berman in a cameo in *Easy Rider*, as a hippie sowing seeds at a commune, a coy nod to the semina theme. Hopper ranked Berman alongside another of his close friends, the actor James Dean, as a figure of mythic proportions. "They're myths," Hopper said, "because they really were that talented and they really were that influential on the people around them."

The raid on the Berman show seems in hindsight not only a comedy of errors—the cops confused about where they were, and why; the Ferus gang unprepared to deal with the consequences of their actions or the emotional toll it would take on Berman—but also wholly unnecessary. Berman's art, like Ferus itself, dwelled on the margins of the art world, a world whose presence in 1950s Los Angeles was fairly marginal to begin with. But perhaps the police instinctively grasped something that the more commercially savvy gatekeepers of the art world missed: that embedded in even the most benign production of L.A.'s emerging assemblage movement was evidence of a gathering storm that threatened order, decency, and all that the postwar consumer's paradise held dear. The "cultural clock," as the art historian George Kubler wrote, "runs mainly on ruined fragments...from abandoned cities and buried villages." Berman's project was an archaeology of the present. Picking through the refuse heaps of postwar Los Angeles, culling the shards of its consumer culture, artists such as Berman, Kienholz, and Herms showed us a city transformed into instant ruins.

Reinventing the Wheel

VISITORS OFTEN ARRIVED UNANNOUNCED at the dilapidated wood-frame bungalow that was the Silver Lake studio of the sculptors John Mason and Peter Voulkos. Located in an area dubbed Mix-ville, after the movie cowboy Tom Mix, whose popular feature films had been shot in the surrounding hills and ravines, the place was a wreck, but the rent was cheap, and the landlord had given Mason and Voulkos more or less free rein to make it over as they saw fit. Voulkos, the most talked-about ceramic artist in the country, headed up the ceramics program at the Los Angeles Art Institute, where Mason had been among those who had fallen under his spell. The landlord even gave his blessing for them to build a six-foot-high kiln that would allow them to make work on a scale previously unimaginable. The only condition was that they obtain the necessary permits and pass a city inspection. When the equipment was installed, Voulkos made an ostentatious show of having someone in a suit and tie stand out front with a clipboard, a charade the land-lord never suspected.

Voulkos thrived on contact with others, and he was constantly inviting friends, artists, and almost anyone else to stop by. "If Peter was around, there was always a social scene," said Mason, who generally found it an unwelcome distraction. "You were either going to drink or have coffee or something, but you weren't going to work as long as the guest was there." But neither of them recognized the

unassuming young man who knocked on their door one night in early 1957. The stranger introduced himself as Walter Hopps, but that still didn't ring any bells. Hopps explained that he had recently opened a gallery and was hoping to interest Voulkos in a show. Voulkos had shown at the Felix Landau Gallery the previous year, and graciously declined Hopps's offer. Why leave one of the few prestigious modern art galleries in town to throw in your lot with an unknown? On the other hand, Voulkos countered, he *could* recommend a few other artists who would likely be more responsive to Hopps's entreaties, Mason among them. Hopps, noncommittal, slipped back out into the night.

Much as assemblage artists in the fifties had to overcome doubts about an art composed from industrial leftovers, artists working in clay faced resistance to a medium identified with "craft" and all that word implied. An unbridgeable gulf was presumed to exist between art, which sprang from the artist's personal vision and existed solely for aesthetic contemplation, and craft, for which utility trumped originality and form followed function. Craft served the body, art served the soul; one arose out of necessity, the other out of freedom. Now, in much the same spirit as the assemblagists, the small but dedicated group of ceramic sculptors that had formed around Voulkos in 1950s Los Angeles were daring to make art by turning useful objects into useless ones. Ken Price, one of those artists, said Voulkos was "the guy who essentially liberated the medium from the craft hierarchy that was controlling it up to that time." He was, in Price's words, "the hero of American ceramics."

VOULKOS ARRIVED IN LOS ANGELES in the late summer of 1954. The newly rechristened Los Angeles Art Institute, founded in 1918 as the Otis Art Institute—named for the owner of the *Los Angeles Times*, Harrison Gray Otis, whose ornate former mansion housed the school's classrooms and studios—had been given a significant face-lift after the Second World War, with a new building and a

more ambitious program, including graduate and undergraduate courses.* Guiding the institute on its more "professional" course was a new director, Millard Sheets, who, though still in his thirties, was already an eminence grise in L.A.'s small, tightly knit art world. A lifelong Southern Californian, raised in the horse country of Pomona some twenty-five miles east of the city, he had been a charter member of the California Watercolor Society. Beginning in the 1930s, he had built, virtually from scratch, a respectable art department at Pomona College and been put in charge of art exhibitions at the annual Los Angeles County Fair, a position he held for almost thirty years. Sheets had seen a few of Voulkos's pots and read the exultant reviews that had greeted larger displays of them around the country, so as he looked to put the finishing touches on the rejiggered Otis faculty, wondering who might pilot a first-rate ceramics program, he concluded that Voulkos was perfect.

It's easy to see why. The twenty-eight-year-old was the most talked-about potter in the country, an overnight sensation who, in 1950—only a year after throwing his first pot—was entering national juried exhibitions and taking home top honors. Home, in this case, was Bozeman, Montana, where Voulkos had been born to Greek immigrants whose marriage had been arranged before his mother's arrival in the United States. After serving in the Pacific, Voulkos returned home and entered Montana State College on the GI Bill. He more or less stumbled into studying art. "I had heard that artists didn't have to get up in the morning," he said later, apparently only half in jest (he had a well deserved reputation as night owl). His first love was painting; he enrolled in a ceramics class only to fulfill a graduation requirement. But the bond between artist and medium was almost instant. Voulkos all but lived in the ceramics

*The school was officially part of the Los Angeles County Museum of History, Science, and Art; after World War II, the trustees changed its name, in part to reflect its quasi-public status. It reverted to its original name in the 1960s, and even those who knew it in the fifties generally refer to it as Otis, which is how I will refer to it from here on out.

studio around the clock. Struck by his "intensity and focus," his bedazzled teacher observed: "What he did was always right." Even so, Voulkos's own mother was startled by the choice. "I thought you were going to be an artist," she remarked.

Despite his fast start, Voulkos still had plenty to learn about the medium. "I didn't realize at the time that you could buy a bag of clay, so I spent my weekends digging it up," he confessed. He discovered a source when he noticed the clay caked on the tires of the big rigs that pulled into a local truck stop. The drivers "would get stuck in it so they certainly remembered where it was." After finishing at Montana State, he spent a year at the California College of Arts and Crafts in Oakland. Back in Montana—Helena, this time—in 1952, his master's degree in hand, he and Rudy Autio, another recently minted potter, persuaded the owner of a local brickyard to help them build a kiln and workshop in exchange for their labor. When not manufacturing bricks, the two turned out "production ware": "We made little dishes and gift items" that, according to Autio, were "sold at gift stores all over the country." The demand for some of their items was so great they had their hands full trying to keep up.

A milestone in Voulkos's development came in the winter of 1952. Two internationally acclaimed potters—Bernard Leach of England and Shoji Hamada from Japan—had embarked on a U.S. tour, accompanied by the Japanese philosopher Soetsu Yanagi, and word of the young Montanan's prowess at the wheel convinced the trio to make a detour to Helena. Yanagi, sometimes called Japan's William Morris, was committed to reviving his country's vanishing craft traditions and had founded a museum of folk art and crafts. Hamada was the leading practitioner of the art that he, Yanagi, and Leach championed. Voulkos was especially impressed with Hamada's demonstration of the making of raku, a pottery associated with the ritual of the Japanese tea ceremony, which traces its origins to Zen Buddhism. Hamada showed him that chance was the artist's greatest ally, an idea not widely embraced in production ceramics, where individual pieces needed to be not just similar but interchangeable.

But the real turning point for Voulkos came the following summer. His growing national reputation had brought him to the attention of Black Mountain College, the experimentally inclined art school in North Carolina, and he was invited to teach a three-week summer course. At the end of the session, the poet and potter M. C. Richards invited Voulkos for a brief stay at the apartment she shared with her husband, the composer David Tudor, in New York. There Voulkos encountered all the major artistic developments of the day and befriended some of the artists, above all the painter Franz Kline. It was all a revelation for Voulkos. "I really got turned on to what the painters were doing," he recalled. "It was a special kind of time, a necessary kind of time…all the energies came together." He returned to Bozeman filled with new ideas. "He was like [Moses] having come down from the mountain," Autio said. "He was just glowing with that kind of inspiration…It seemed like he had just been born again." The exact nature of this rebirth would only become clear a few years later.

Mid-century Los Angeles was, geographically and otherwise, a long way from New York, but Voulkos knew that it had more to offer than a Montana brickyard. When Sheets called, the young potter jumped at the chance. The move was "the biggest thing that ever happened to me," he said. In L.A. "everything started falling into place. I began to go to all the shows, all the openings and galleries and museums—paintings shows and sculpture shows I had never been to before."

Voulkos had been brought in on such short notice that few students at Otis even knew that the school had a ceramics department, much less who was running it. The one exception, an important one, was Paul Soldner. From the start, theirs was an unusual student-teacher relationship. Soldner was older than Voulkos, who, in any case, "was more of a guru" than an instructor, said Soldner. Together, the two of them quite literally built the new department—the kiln, the wheels, the storage shelves, and just about everything else. Their isolation was short-lived. "Word got out that something good was

going on down in the basement at the Los Angeles Art Institute,"
Soldner recalled. "People began dropping in," he elaborated. "They
did not enroll. They just worked." Nor was it limited to the student
body at Otis. The Chouinard Art Institute, across MacArthur Park
from Otis, had a three-year-old ceramics program headed by Susan
Peterson, another rising star in the ceramics world. Talk about the
goings-on in Voulkos's basement studio circulated quickly among
Peterson's students and, little by little, they drifted over to where
Voulkos and Soldner had set up shop. Among the regulars were
two of Peterson's best students, Billy Al Bengston and Ken Price,
the closest of friends since they had met while surfing at Malibu
Beach in their mid-teens. Mason, a onetime Otis student who was
now Peterson's assistant, started showing up as well. "We were a
small group of very committed students," Price said. "Some people
thought they were pretty good before they got there, but when we
saw [Voulkos], he just blew our minds."

Voulkos's pedagogical style, if you can call it that, was loose.
One early student summarized the Voulkos method: "Here's the
clay, here's the wheel." Beyond that, added another, "you just went
forward and did your thing." One form of preparation Voulkos did
encourage was extracurricular. "The first thing we'd do," he remem-
bered, "is go off in three cars, driving around town, going to see
whatever there was to see in the galleries, drinking coffee and talk-
ing." "We were hungry for everything that was going on, and we
drank it in," Soldner elaborated. "Grades were not important. Only
working, hanging out together, drinking coffee, and night clubbing
in L.A. after midnight were important." Once they had their fill,
they would head back to the basement studio to work. The hands-
off approach succeeded largely because of Voulkos himself. "Pete
always had this magnetism about him," Autio maintained. "Even
as a student." As an instructor, he had grown into an unstoppable
force—"so vital and so exciting," in the view of Sheets. "Everyone
just loved him."

———

BY THE END OF HIS FIRST TERM AT OTIS, Voulkos was in high gear. Only then, at the beginning of the 1955 spring semester, did the experiences of the past few years—his first brush with Zen, the Black Mountain–New York interlude—start to catch up with him. Black Mountain was a vortex of creative energy in the mid-fifties, a laboratory for experimentalists such as the composer John Cage and the painter Robert Rauschenberg, both of whom encouraged the role of chance in their work. In New York, Voulkos immersed himself in the heady atmosphere of Abstract Expressionism and the apex of its influence. "New York completely opened up my eyes," he recalled. "I was just dumbfounded by all the energy." Kline, a frequent companion in those weeks, introduced Voulkos to Willem de Kooning and others at the Cedar Bar, the lions' den of what the critic Harold Rosenberg had crowned "action painting." These artists, Rosenberg said, worked in "a condition of open possibility" where the canvas was less a defined surface than "an arena in which to act," and what the painter put there "was not a picture but an event."

Voulkos never stopped thinking of himself as a painter, one whose canvas was the three-dimensional surface of a pot. Indeed, pot shapes were to a large extent given, variations on an ancient form. "You might spin out the same form as you would in production," Mason said of Voulkos's work in 1955 and 1956, "but you couldn't duplicate the painting. And you didn't know in advance what you would get." This was where the dictates of craft encountered the freedom of art, and Voulkos found it liberating. "I brush color on to violate the form," he said. "These things are exploding, jumping off. I wanted to pick up on that energy. That's different from decorating the surface, which enhances form, heightens the surface. I wanted to change the form." Yet while his painting assumed greater individuality and assertiveness, the classic vessel shapes of his pots had remained relatively constant. Then, suddenly, in early 1955, "his work began to evolve and change," Soldner said. It became clear that "he was headed towards sculpture."

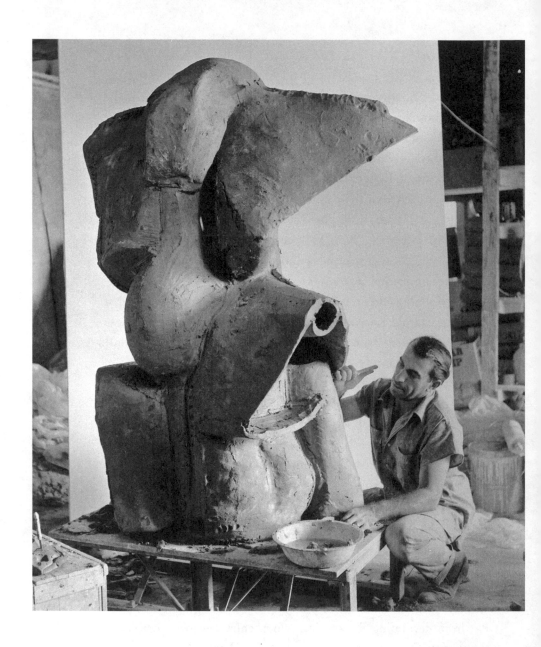

Peter Voulkos at work in the Glendale
Boulevard studio he shared with
John Mason, ca. 1959.

Sculpture had played a supporting role in early twentieth-century art—you can practically list the era's great innovators on one hand: Auguste Rodin, Constantin Brancusi, Jean Arp, Alexander Archipenko, Alberto Giacometti. With the change of scene from Europe to America and the rise of Abstract Expressionism, sculpture was pushed even further into the background. It is not by chance that one of the standard histories of the era is titled *The Triumph of American Painting*, or that the massive *American Art at Mid-Century* at the National Gallery, in 1978, included the work of only one sculptor. "The gesture on the canvas was a gesture of liberation," Rosenberg had proclaimed. But the "gestural" aspect of the new art didn't easily lend itself to carving stone or casting metal. Clay was different: a "fluid material," said Rudy Autio, "so like paint…that it was a logical extension" of action painting.

Voulkos made the connection. Working feverishly at the wheel, he molded the wet clay to unfamiliar forms he would then slash and scrape and pull apart and put together. He would "paddle it or drop it or hit it with a meat cleaver," Soldner said. The glazes, too, Mason added, often "looked a little nasty, actually, and rough." This was about as close as you could get to three-dimensional action painting. And Voulkos sometimes sounded like Rosenberg. "The minute you begin to feel you understand what you're doing," he said, "it loses that searching quality." But if you gave yourself over to the process, "your emotions take over and what happens just happens. Usually you don't know it happened until after it's done."

His flair for the dramatic made Voulkos a natural performer. To see him work, Soldner said, was "like watching a dancer." It drew a growing audience, mainly students from Otis and Chouinard but others as well. "In the beginning," Peterson recalled, "we were sitting there in the basement watching him throw these fantastic groups of cylinders, put them onto metal shelving units, and then in an hour or so he'd begin to collect the pieces." Stacking one upon another, he built them into ungainly towers two or three feet high, like a heap of broken Franklin stoves piled up in a wrecking

yard. Using his virtuoso skills at the wheel and his hack-and-stack method of construction, he would make, by Peterson's count, "four or five sculptures, every night." There were "no rules," Voulkos said. "Just concepts." He could violate form because he had dispensed with function. "We're not an age of potters like the Greeks," he reasoned. "The community doesn't need us." In the world of studio pottery, such a statement was tantamount to heresy.

LIKE THE ARTS AND CRAFTS MOVEMENT FROM WHICH IT SPRANG, the studio pottery movement of the mid-twentieth century was deeply imbued with an antimodernist ideology. Fueled by a "deep distrust of urban 'luxury' and the faith in the ennobling powers of hard work," writes the historian T. J. Jackson Lears, the Arts and Crafts movement surfaced in the nineteenth century as an expression of middle-class anxieties about industrialization; its primary concerns were not aesthetic but moral; its goal was "cultural regeneration," which lay in a revival of preindustrial, artisanal manufacturing. Unlike Romanticism, however, the Arts and Crafts movement's resistance to the routinization of work found sustenance not in the exaltation of the individual but in the reaffirmation of objective truth through ideal forms.

The failure of Arts and Crafts as a social movement had, by the early twentieth century, been tacitly acknowledged by devotees, who lowered their sights and preached a gospel of "improved standards of taste" and "the finer qualities of design and workmanship." But traces of the moral argument lingered even in the fifties: Leach, who had visited Voulkos in Helena, advocated something he called the "ethical pot," an extension of this idea; while Henry Varnum Poor, a sort of Renaissance man of American craft, excoriated "the unhealthy, too-long-indulged introspection, this absorption with ourselves." Toss out utilitarianism and you've tossed out the craft movement's reason for being. Voulkos didn't care. He hadn't rejected modernity. On the contrary, mass production, he saw, freed

him from the necessity of predetermined forms, whether teapots, tableware, or porcelain tchotchkes.

Craft-world traditionalists, who had swooned over Voulkos's work of the early fifties, now responded with alarm. This new direction seemed to them a betrayal of everything they believed in. "His philosophy was so upsetting to many people that they actually became hostile," Autio remembered. Letters in the main publications of the craft world attacked Voulkos's attitude; his pots were reviled as "chunks of stone, badly thrown, badly glazed and badly crafted." More important for Voulkos's immediate circumstance, the most vociferous critics included Sheets, the man who had hired him. Voulkos "rebelled against everything that was skillful," Sheets complained. "He just became a completely different kind of artist."

An unapologetic "regionalist" who, as he put it, "just loved to paint" his native ground, Sheets had an abiding interest in and strong opinions about ceramics. Contradictions between industrial and studio pottery had long since receded into history when, in the thirties, Sheets made a ceramist in the latter-day Arts and Crafts tradition his first hire at Scripps College. In Southern California, a number of factories were turning out "production" tableware sold throughout the country, and Sheets saw it as the responsibility of a ceramics program either to prepare students for industry jobs or to train studio potters who would produce decorative objects and architectural ornamentations. He wasn't looking for a revolution in ceramic art, just someone to teach the craft of pottery: "The respect for the medium, for the discipline, for what could be done in fine ceramics just went out the window. And it was tragic."

To make matters worse, in Sheets's view, Voulkos's unorthodox teaching methods struck him as disruptive and inappropriate. "The department," he felt certain, "was simply headed for the rocks." Alarmed by what he saw on visits to the basement studio—including at least one occasion when he found Mason "slapping clay all over the walls," according to Voulkos—Sheets would "call me into his office and holler, 'You can't do that. Clean up that studio.'"

John Mason at work on one of the large
ceramic wall pieces he created in the late
fifties and early sixties.

Venting his frustration over the situation, Sheets rejected all of the ceramic work submitted for the spring 1957 student show, except for a piece done by the one student who continued to make traditional pots. (It hadn't helped that Bengston chose to decorate a cup with the words "fuck you.") Railing against the alleged dilettantism and anticommercialism of Voulkos and his protégés, Sheets accused the group of sealing itself off in an "ivory tower." The sensible course, he insisted, was, in Soldner's summation, to "work for the industry, design for architects." When Voulkos's escalating battles with Sheets reached a boiling point in early 1957, Voulkos decided to abandon the studio he and Soldner had built at Otis and find work space elsewhere. Mason elected to join him and found the bungalow in Mixville. Sheets, unwilling to tolerate any more of Voulkos's errant ways, fired him the following year. Voulkos would continue to show regularly in Los Angeles in the years to come, but his presence in the L.A. art scene was effectively over after he moved north to teach at Berkeley in 1959.

VOULKOS WAS SURELY THE MOST IMPORTANT CERAMIC ARTIST of the postwar era—the one who legitimized clay as a medium for "art" rather than "craft." But while he drove the craft world to distraction, he remained in many ways its creature. His primary tool would always be the potter's wheel, his starting point the vessel form. Voulkos's influence on the L.A. art scene of the sixties had less to do with his gestural technique than with his unorthodox ideas and freewheeling attitude. His example liberated others from the strictures of the craft establishment and showed it was possible to go your own way. But it was Mason and Price who would have a more direct influence on future directions in L.A. art.

Not long after Hopps's visit to the Mixville studio in early 1957, Kienholz invited Mason and two other Voulkos veterans at Otis—Soldner and Jerry Rothman—to participate in a group show at Ferus. *Clay Forms*, which opened just weeks after Berman's arrest

temporarily closed the gallery, would be the first of several shows Mason would have at the gallery. "I didn't have to make proposals," Mason said. "I just had to make the work. And I was producing a lot of work at that time." When he felt he was ready, he would call up the gallery and "they would book me a slot." Kienholz turned the passageway leading from the sidewalk to the gallery into a changing installation of Mason's work that lasted until the gallery moved a year and a half later.

Mason's freestanding pieces of the period had a jagged, prehistoric quality and rose nearly six feet from the floor. He described some as "spear forms," but as a whole they evoked something even more primeval: measuring rods of geological time or the vertebrae of some beast otherwise missing from the fossil record. His wall reliefs were monochrome mosaics that he made in much the same way Pollock did his drip paintings, slapping the wet clay onto the floor. The Abstract Expressionist influence that was so strong in these early pieces gave way to simpler, more assertive geometric shapes of a sometimes monumental scale. This triumph of rationalism would impel Mason's work over the length of his career, leading him into ever more complex ideas expressed in deceptively simple forms. In its intellectual elegance, its ability to resolve elaborate puzzles with a kind of irrefutable logic that is Mason's alone, his work offers satisfactions similar to those to be found in a Bach fugue.

Price's work could hardly have been more different. With its boisterous colors and oozily erotic forms, it was concerned less with the contradictions between reason and nature than with the seductive sensuality of nature itself. All voluptuous curves and froggy bumps, Price's sculptures conjured those of Brancusi and Arp from half a century earlier. Closer to home, there were suggestions of John Altoon, in both the sly eroticism of forms and the surprising combinations of color. Mason's rationalist pursuit of form and Price's sensualist explorations of color, light, and surface would be characteristic of many L.A. artists of the sixties, particularly those who showed at Ferus.

Questions about art and craft would be critical ones for L.A. artists in that decade. "It should be obvious that art and craftsmanship are part of the same parcel," Mason said at the time of his Ferus debut. But then as now, there were partisans who thought otherwise, and opponents dug in on both sides of the question and refused to give up without a fight. The attacks from the craft world were met with no less conviction from many in the art world. At stake was more than a dispute about appropriate materials and methods. Ultimately it was about philosophical issues about the lofty position of art in modern society. Indeed, it's not immediately obvious why we *should* place so much higher a value on useless objects, such as paintings and sculpture, than on useful ones, such as teapots or tables. As late as the eighteenth century, painters and sculptors were still in many places simply another class of artisans, fulfilling the dictates of powerful patrons. Freed from the prerogatives of politics and religion, art made bold claims for itself, a promise of enlightenment and redemption through an act of imagination. Art's autonomy, and its insistence on the unique rather than the uniform, became an affirmation of our own individuality in the face of an impersonal marketplace, a momentary experience of freedom possible nowhere else in modern society. Craft, by contrast, returned us to the realm of necessity, where we spend our hours toiling in order to survive. These long-dormant issues were reawakened when Voulkos and others crossed the invisible line between art and craft.

"Prejudices about art and craft seemed to be deeply held," Price reflected. "After my student days were over I didn't want to be involved in that fight, so I just went about my business. As I saw it, the battle had already been won."

Wild West

BY THE TIME HE WAS EIGHTEEN, Edward Ruscha was sure of two things: He wanted to be an artist and he needed to get out of Oklahoma. Art school was the answer, and Ruscha knew that the most highly touted ones were in New York, maybe Chicago. But "the East," he thought, "that's just too old world for me." California was more like it; he had been there with his family as a kid and was taken with what he thought of as "that California style." Los Angeles was "the only place" to be, as far as Ruscha was concerned. So in the summer of 1956, he packed up his six-year-old Ford with the Smitty Mufflers and set out on Route 66, heading west.

In the mid-fifties, painters in Los Angeles were, like their counterparts in New York, searching for a way forward in the wake of Abstract Expressionism. Initially, few artists in either city doubted that the future of painting lay in abstraction of some kind, a presumption that would be seriously challenged only as the decade drew toward its close. Jasper Johns's paintings of targets and flags were shocking in their use of familiar symbols as "ready-made" images that both were and were not representational. (What, after all, is the difference between a flag and its image?) Ruscha would experience the shock firsthand in 1957, when he spied a reproduction of Johns's *Target with Four Faces* in a magazine.

But the present state of American painting was far from Ruscha's thoughts as he and his friend and fellow traveler Mason Williams

burned through countless quarts of oil, rumbling past the Indian reservations and trading posts, abandoned mining towns, and cheap motels that punctuated their crossing of the scorched desert regions that lay between Oklahoma and Los Angeles. Neither were the problems of Abstract Expressionism much on his mind as he and Williams took an apartment by Lafayette Park, a short walk from L.A.'s leading art schools. Ruscha had barely heard of Abstract Expressionism in 1956. His interests lay in graphic design and printing. So, having pored over the various schools' brochures, he decided to show his portfolio first at Art Center College of Art and Design, known for its emphasis on commercial art and industrial design. When Art Center turned him down, he tried his luck a few blocks away, at the Chouinard Art Institute. Compared to the businesslike atmosphere at Art Center, Ruscha said, Chouinard seemed like "the Bohemian school," a haven for hipsters, bristling with "beards and sandals and fine arts."

He was only half right. Chouinard was, when Ruscha showed up, the Los Angeles art school most vigorously engaged with Abstract Expressionism and the issues coming out of the current New York scene, as well as with developments locally among the artists who showed at Ferus and other new galleries. And over the next decade, some of L.A.'s most influential artists would pass through Chouinard. But all of that was something of a fluke. In fact, the school's primary emphasis was, like Art Center's, commercial, and in the 1950s, a substantial number of its students were veterans of the wars in the Pacific and Korea seeking professional training through the beneficence of the GI Bill. It "wasn't a fine arts school," Gerald Nordland, Chouinard's dean and director in the 1960s, made plain. "It taught drawing and painting, but they were as tools to be used by illustrators, fashion designers." Still, the role Chouinard played in shaping the emerging L.A. art scene was real enough.

———

AS MIGHT BE EXPECTED OF AN ART SCHOOL in Los Angeles, Chouinard had a history with the movie business, turning out set and costume designers, title and storyboard artists, scenery painters, and others. Edith Head, the doyenne of Hollywood wardrobe designers, was both a graduate and a sometime instructor. But by far the school's strongest and most enduring link, in or out of Hollywood, was to Walt Disney. Following the enormous success of his first Mickey Mouse cartoon, *Steamboat Willie*, in 1928, Disney "needed artists who could really draw and he needed people to be trained in a certain way," Marc Davis, a mainstay of the studio's animation department for some four decades, explained. Chouinard, with a strong emphasis on drawing fundamentals, had the faculty to do that training. For a time, Disney himself would shuttle his growing army of animators the four and a half miles from the studio, in the Silver Lake district, to their night classes at Chouinard, a block south of Westlake Park (now MacArthur Park). But with the onset of the Great Depression, the fledgling studio head found it difficult to cover the costs. "When I couldn't afford the school in the very early days," Disney reminisced many years later, "I made a deal with Mrs. Chouinard to take some of my boys…And she made a special little concession on it."

It was an indulgence Disney would not forget, and one he would eventually return in kind. The school was on the brink of financial ruin when he joined the board in 1955, even as he scrambled to launch his Anaheim theme park. Disney assigned one of his studio's senior executives the task of sorting out the school's accounts; it didn't take long to discover that the former bookkeeper had been draining the Chouinard coffers and lining her own. Teachers were owed back salary, and scholarships had been awarded with little attention to whether the funds were there to pay for them. Once the immediate crisis was resolved, Disney would continue to cover an operating deficit that Nordland estimated at "around $100,000" a year. The Disney people "were all of the hard-nosed accountant variety," recalled Mitchell Wilder, who was brought in to run the

place in 1958. "The school had been through some very serious times, and in order to set matters straight Walt Disney had been forced to use some very stern measures." Enthusiasm for those measures was less than unanimous, with opinion divided between—depending on your point of view—"traditionalists" and "modernizers," "idealists" and "pragmatists," or "creatives" and "suits." One side effect of the tumult, however, was a kind of benign neglect of the small fraction of the school devoted to "fine arts." When Ruscha discovered "bohemianism on the march" at Chouinard, it was there—above all in the painting department, which had hired a small complement of artists whose attitudes toward both art and teaching set them apart. "The school kind of lost control," said Ruscha's childhood friend Joe Goode, who started at Chouinard a few years after his fellow Oklahoman, "and the instructors kind of took over."

Much as Peter Voulkos had turned the neighboring Otis Art Institute upside down with his Abstract Expressionist approach to ceramics, the "renegade" instructors at Chouinard would shake up the way painting was taught there. And as with the Otis ceramists, those instructors and their students would quickly emerge as central characters in the unfolding drama of the Los Angeles art scene. The difference between Chouinard's old guard and the newcomers in the painting department was, said Goode, "like the difference between black and white." Like Ruscha, Goode had departed Oklahoma with vague expectations of a future in advertising or design. But when he got to Chouinard and saw "guys throwing paint around," Goode says, thoughts of an advertising career quickly faded. Ruscha emphasized that there was "no rivalry" or hostility between the two camps; it was more a matter of style, and of styles. The younger instructors were on top of current art-world developments and not so wedded as their colleagues to century-old teaching methods. (Donald Graham, whom Goode called "the godfather of the drawing department," and who had trained generations of Disney animators, demanded that his students learn the Old Masters' techniques for massing the human

form. "If it works in Rubens," Graham insisted, "it must work in Donald Duck.")

Emerson Woelffer, the first of the new breed, had worked with the Bauhaus veteran László Moholy-Nagy in Chicago and taught at Black Mountain College. Students revered him for what Goode called his "link to history," especially his personal acquaintance with Robert Motherwell, Clyfford Still, Franz Kline, and various European artists. Richards Ruben, one of L.A.'s few homegrown Abstract Expressionist painters, was the "intellectual" among the Chouinard faculty, a "deeply serious person," in Ruscha's estimation. Larry Bell, also a Chouinard student in those years, recalled Ruben as "extremely articulate, very philosophical, and a bit like a Zen kind of teacher." Artistically more of a traditionalist than either Woelffer or Ruben, Robert Chuey was nonetheless, in Bell's view, "a wonderfully loving man and a fucking great painter." Bell, who grew up in a "mundane, lower-middle-class tract home in the San Fernando Valley," treasured evenings at Chuey's Richard Neutra–designed house in the hills overlooking the city, where he and other students mingled with "these sort of beatnik type people, who were all incredibly civilized" and would "smoke pot, and talk about shit that I didn't know anything about."

"John Altoon was another one of the most important people in the school scene," Ruscha said. When not suffering from dangerous delusions, Altoon had a joie de vivre that was infectious. "He just walks into a room and kids would laugh," Ruscha noted. "Everybody knew all about Altoon and all his capers." It wasn't always clear whether those "capers" were lighthearted romps or bouts of madness. One student recalled Altoon walking in on the first day of life-class, telling the model to put her clothes back on, turning off the light, and announcing, "I want everybody to put away your drawing stuff. I want you to go home, I want you to call Hiroshima and I want you to talk to somebody who saw the bomb."

But the instructor who most affected these students was Robert Irwin. "He had a definite aura," said Ruscha, who saw Irwin as

"a Herculean Californian." As an instructor, Irwin "made his point very clear. Plus, he was a non-stop talker, just non-stop." Irwin had been a student at Chouinard himself only a few years earlier. And he did indeed embody the popular ideal of a Southern California youth—hot rods had competed with girls for his attention in high school, and drive-ins and sporting events were his natural habitat. He was always good at art, thanks in large measure to what he described with apparent disdain as his "magic wrist," an almost preternatural skill at drawing and painting, but he never thought much about it. A brief stint in postwar Germany as a U.S. Army private was followed by art school, along with various awards and inclusion in annuals at the Los Angeles County Museum and, in 1957, the year he joined Chouinard's faculty, the Whitney Museum. That was also the year he started to see his magic wrist as a handicap rather than a gift.

The crisis moment came on the occasion of Irwin's solo debut, at Felix Landau Gallery on La Cienega. The accolades he had garnered until then had come in response to watercolor, and then oil, portraits and landscapes in a bland, illustrational style. By the time of his Landau show, he had started to nudge his paintings toward abstraction, but without abandoning representation altogether. Looking around the gallery "one minute before the door opened," he had an unpleasant "epiphany." The paintings he had so proudly hung were, he now saw, "really bad." They were appealing—appealing enough to earn a show at one of the city's prestige galleries—but they were essentially a pastiche, well drawn and full of lively color but entirely lacking in conviction.

That this wasn't simply a case of opening-night jitters or self-doubt, Irwin says, was confirmed by a comment from Craig Kauffman. Widely considered the best of the city's up-and-coming young painters, Kauffman had made his own debut at Landau before joining Ferus, and while he and Irwin had been briefly introduced, they had until this evening exchanged no more than a few words. Now Kauffman stood before one of Irwin's bright confections, reflexively

rubbing his nose with thumb and forefinger, a habit of his at the time, and muttered in genuine disbelief, "you've got to be kidding." Irwin felt the sting: "I knew that he knew what I had just found out."

Although Kauffman and his buddies Billy Al Bengston and Ken Price were several years younger than Irwin, who was nearly thirty, Irwin was convinced "they knew something that I didn't," and he marked his introduction to them as the true beginning of his education. Over the next couple of years, Irwin would seek to expunge from his work elements he came to view as inessential—colors or gestures that may have pleased the eye but didn't serve the painting—subjecting his every move to unflinching self-criticism. At issue were not only the overwrought painterly excesses that had turned Abstract Expressionism from something vital to a tired visual cliché but also the implied psychologism of such efforts. Irwin searched for ways to rid his works of such emotional and compositional excesses. "Everything in a painting commands a certain amount of attention," he explained. "If it doesn't give you back more than it takes, then it's not necessary." His first move was to quite literally reduce his output, down to paintings of slightly less than one foot square. But he found the results were still "loaded with stuff that could be," as Irwin says, "Rorschached"—read for psychological meaning, or for any sort of meaning other than a kind of pure painting. More to the point, perhaps, he was displeased with how mannered and "superficial" these new paintings were because, as he admitted, "what I realized was that *I* was superficial."

Irwin applied the same principles in the classroom, refusing to play the knowing master or to cast his students as untutored apprentices. It wasn't that he questioned his students' need to acquire technical skills, to know their tools, their materials, and the history of their medium. To the contrary, he was nothing if not demanding on that score, "a taskmaster, the way he'd make you prepare," Ruscha remembered. "It made us kind of nervous about where do we put our first brushstroke." But all of that was preliminary. More important, Irwin insisted, "the one thing that is absolutely unique"

and would define you as a person and an artist for the rest of your life, was your "sensibility." Once you have grasped that, he added, "how you deal with it becomes your responsibility." He prodded his students to go their own ways, to discover their own talents and cultivate their own ideas about what it meant to be an artist. "Paint what you believe in," Goode said, summing up the most important lesson he learned from Irwin. "Don't worry about what other people think."

Irwin recalled an episode that drove home for him the risk of that advice, as well as the seriousness of a teacher's responsibilities. A night course in watercolors at Chouinard attracted, among a motley assortment of others, a number of women dealing with what we would now call midlife crises. "Their husbands were busy, their kids had all moved away," Irwin recalled; they were hoping that art might help them "redefine their lives." He was sympathetic and tried to provide encouragement, dispensing his usual advice about individual sensibility and responsibility. Some time later, having a beer at Barney's Beanery, he heard someone call out "Mr. Irwin"—one of the women from the night class, calling him to her table. "There are five Hell's Angels sitting at the table," Irwin recalled with a laugh. Turning to them, she proudly explained, "Guys, I want you to know that everything I am today, I owe to Mr. Irwin." The artist was nonplussed: "You think, 'What the fuck could I possibly have said?'"

The reaction of most students was less extreme, but Irwin prompted many to question their most basic assumptions. "I always thought of art as something you did," Goode explained, "never...as a way you see—until I met Irwin." Bell admitted having "no idea what he was talking about" when Irwin singled him out for praise in a watercolor class one night. But it was nearly the first time Bell could remember that "any teacher had paid any attention to me at all for what I had done," and it boosted his confidence at a moment when it was flagging. "I liked being around there," Bell said of Chouinard, "but I just didn't think I was going anyplace" until Irwin stepped in. Ruscha could have paid Irwin no higher compliment

when he declared that "the biggest thing that I learned in art school was that I had to unlearn everything I had learned before."

To appreciate how unorthodox Irwin's methods were, one only needed to look across town, to the campus of UCLA, where a more traditional approach to training artists was still enforced. The reigning spirit of the UCLA art department was Rico Lebrun. Like Millard Sheets, Lebrun was a revered "master" of the Los Angeles art world as it existed in the thirties, forties, and early fifties. "Millard Sheets and especially Rico Lebrun had a hammerlock on the situation," recalled James Elliott, the modern art curator at the nascent Los Angeles County Museum of Art. And at UCLA, "everybody worshipped Rico Lebrun," claimed Kauffman, who graduated from the department in 1956. "They really did." Lebrun didn't actually run the department. That responsibility fell to someone whose views on art were, if anything, more backward-looking than Lebrun's. America's struggle against communism, the department's chairman opined to *The New York Times*, left "little time to dissipate our spiritual resources in self-expression as an end in itself or escapism through trivial abstractions, or action painting, rubbish constructions, and other anti-art gestures."

A 1957 *Life* magazine photo-essay examined UCLA's commitment to studio arts, unusual in a major university in those days, and not without its critics. There was little danger that UCLA would become "a glorified trade school," the magazine explained. "Throughout the school is a realistic and earnest air, created partly by an excellent faculty which believes in first teaching fundamentals and partly by the hard-working students themselves." The teaching of art at UCLA, *Life* reassured its readers, was guided by "a strong feeling for the historical." That feeling for the historical was one of the most glaring differences between UCLA and Chouinard. "UCLA was an academy," said Charles Garabedian, a painting student there at the time. Students studied anatomy and learned by imitation; studio time was supplemented with required courses on the history of art, from the Egyptians to the early moderns. Above

all, Garabedian said, "what we were taught and what we looked at" were Cézanne, Picasso, and Matisse. "I stumbled through all that stuff," admitted Kauffman, who was, he laughed, "a half-baked Abstract Expressionist" at the time. Despite his 1953 Landau show, the UCLA faculty "just sort of tolerated me."

Grateful though he was for the intellectual and historical rigor of the UCLA program, Garabedian reckoned that it was, "in a funny way…detrimental to our artistic health." At Chouinard, he said, students "were thrown right into having to deal with contemporary life. They couldn't do some derivation of Cézanne or Picasso. They had to learn on the streets what was happening in New York." Maxwell Hendler, Garabedian's contemporary at UCLA, agreed, saying that fealty to the past "almost did me in." He and his friends "were so filled up with art historical ideas" that their work seemed mannered and self-conscious. The atmosphere at Chouinard was "scrappy" in comparison. "Chouinard," he concluded, "seemed real."

Students at Chouinard still had to take what Bell called "a basic beginners curriculum." Requirements included perspective drawing, figure drawing, painting, ceramics, and "general semantics," recalled Bell, who "had never even heard the word before [and had] no idea why they included it in the curriculum." But the classes seemed beside the point. Ruscha felt he "got more real inspiration from the students" than from most of the courses he took. Goode called the spirit of artistic invention at the school "contagious": "You see somebody come out of fucking nowhere, and you think, 'My god, where did he find that?' So you just felt, 'I gotta keep looking.'"

ART MAGAZINES WERE ONE WAY TO KEEP UP with what was going on in New York. It was in *Print* magazine that Ruscha first spotted the work of Jasper Johns, in 1957. And *ARTnews* could be found in the school library. But most important was the now largely forgotten *It Is*, an artists' magazine edited and published by the New York sculptor Philip Pavia. Pavia had also been the prime mover behind

the Artists' Club, a downtown Manhattan venue where artists and critics argued the pressing issue of the moment, and *It Is* was something of an extension of that. In addition to excellent reproductions, it included articles and commentaries by artists such as Ad Reinhardt and Clyfford Still. "Man, we just lived for that magazine to show up," Goode remembered. It was the closest he and his friends could get to a direct contact with the already mythic figures of the New York art world. The reproductions of works by Willem de Kooning, Philip Guston, and Jackson Pollock "just made you ache to go see one" in person. There was precious little chance for that in Los Angeles. No museum had any modern art collection to speak of, though if you were lucky you might catch a small loan show hidden behind the thicket of a natural history display at the County Museum downtown. That was Irwin's experience. "I saw my first Abstract Expressionist paintings walking through the dinosaurs," he said, laughing. The commercial galleries were a better bet, but not by much.

If the opportunities to see contemporary art in Los Angeles were limited in the late fifties and early sixties, for the artists just finding their footing there, finding somewhere to show it was even more so. "When we came out of school there were only one or two galleries, and nobody was selling anything," Goode recalled. "And certainly nobody was making a living out of it." And even Landau, who showed Kauffman, Irwin, and a few other up-and-coming local artists, had his limits. "He took risks up to a certain point," Kauffman said. But when it came to the most challenging new work, "he just didn't want to deal with it." For several years, Ferus was alone in its commitment to that work. Ruscha remembered "an electricity and vitality" to Ferus that was lacking elsewhere in the years he was at Chouinard.

For young men in a hurry to become "real" artists, even Chouinard felt frustratingly slow. "I just took advanced classes whether I was supposed to or not," Goode said. Ruscha stayed four years, but the others were out in a year or two. "I didn't feel that there was

anybody else that could teach me," explained Llyn Foulkes, who left after his second year. Having taken the top honors for painting and drawing, he "felt that I was so fucking great that I could quit then." Ruben urged Foulkes to take his work to Walter Hopps and Irving Blum at Ferus, where Ruben himself had shown a couple of times. "Irving told me do ten more of those [paintings] and I'll give you a show," Foulkes recalled. *An Introduction to the Paintings of Llyn Foulkes* opened at the gallery in the summer of 1961. Foulkes's works blurred the line between painting and assemblage, comparable in that respect to what Johns and Rauschenberg were doing in New York, but with the dark menace of West Coast assemblage artists like Kienholz. Allusions to violent death and destruction abound. One piece, consisting of a simple wooden desk chair placed in front of a blackboard, recorded an incident from Foulkes's time in war-ravaged Germany in the mid-fifties, when, as a soldier, he came upon a bombed-out school. The clearest indication of this source is a chalk-drawn swastika in the upper left-hand corner. The layers of black paint and collaged rags in *Geography Lesson* gave the impression of a work that had been charred beyond recognition. Another piece includes a partially burned newspaper headline peeking out from behind the black paint and the image of a man's head with the face obscured by paint, suggesting, in this instance, the "different explosion" alluded to in the headline.

Bell's departure from Chouinard was abrupt. As much as his self-confidence had been boosted by Irwin's praise, it was all but extinguished by an incident involving another instructor, Herbert Jepson, a leader of the old guard at Chouinard. In the beginning and intermediate drawing classes he taught, Jepson seldom talked about things like line or proportion. He spoke more mysteriously about inspiration and the artist's inner vision. Bell struggled to make heads or tails of Jepson's abstruse, spiritual-sounding references. The point, as Bell understood it, seemed to be that drawing "didn't come from the conscious desire to draw *something*...It came from the act of drawing," from its "spirit." And if that were

true, Bell reasoned, "then any drawing would qualify as a door to that spirit."

Bell ignored the models in the classroom and the pinned-up examples of other students' work; he concentrated instead on drawing something essential: squares. He would draw them over and over. "I was doing two, three hundred drawings a day when everybody else was noodling on the figures," he said. When Jepson finally noticed what the young man was up to, he expressed bafflement. Bell explained that he had found a "source of inspiration to follow," as Jepson instructed. Jepson encouraged Bell to discuss his ideas with "an aesthetic adviser" the school had recently hired. "I really liked the guy," Bell said. "I thought he was cool." But when Bell's roommate told him that the "adviser" was in fact a psychologist hired to "weed out the weirdos," Bell was devastated. "My whole fucking world collapsed, right then and there," Bell said. "I thought I was actually doing something important, I was finally getting the message." Instead he had been betrayed. "And that night I went and took all my shit out of the locker at school and never went back."

Bell may have been done with Chouinard, but he continued his education as an artist in situ, painting in his studio by day and carousing at Barney's Beanery, the favored haunt of local artists, at night. Barney's was a greasy spoon, a hangout popular with bikers and the teamsters from Bekins Moving and Storage next door. It drew a rowdy, macho crowd, and the Ferus gang fit right in. "Ed Kienholz kind of held court there every night," Kauffman said. Barney's was a far cry from the Cedar Bar. No one was starting drunken brawls over something Clem Greenberg had written in *Partisan Review*. "We'd talk about cars or pool games or girls or something like that," Kienholz insisted, but "never about art."

The Ferus group displayed an "insidious charm" that could be hard to resist, as the New York critic Max Kozloff testified. "Inbred," was how a neighboring gallery owner described them. Ferus, he said, was essentially their "clubhouse." Not even John Coplans, who

wrote about them in so many national magazines that he might as well have been their publicity agent, could deny their "aggressive and high-spirited arrogance." Whatever their public personae, however, they were serious about their art, and Bell found the atmosphere more conducive to learning than Jepson's drawing class.

Goode quit school not long after Bell, but for very different reasons. Having married and become a father in his second year at Chouinard, he was working three jobs to make ends meet and couldn't afford to continue as a student. Ruben suggested Goode introduce himself to Henry Hopkins. A former colleague of Hopps's in the UCLA continuing education courses that had whetted the appetite of so many young L.A. collectors, Hopkins had rounded up some backers to open the Huysman Gallery, opposite Ferus on La Cienega. Intrigued by Goode's portfolio of drawings, Hopkins asked to see more. He also wondered whether Goode knew of other promising young artists. Goode mentioned Ruscha, who was then traveling through Europe, as well as Bell, Ron Miyashiro, and Ed Bereal. "They were young, aggressive artists," Hopkins recalled, "and their whole ambition in life was to knock off...the artists across the street, to knock off Kenny Price and Ed Kienholz and Irwin. I liked that competitiveness."

The resulting show, in June 1961, was called *War Babies*, for reasons no one can remember—most of the artists were actually born before 1939. It caused a sensation, but less for the work on the gallery's walls than for the poster in the window. Designed by Goode, the poster gently mocked ethnic stereotypes. The four artists were seated at a table draped with an American flag. Bereal, who was black, held a watermelon; opposite him, Ron Miyashiro maneuvered chopsticks and a rice bowl. Between them were Bell—a "middle-class Jew from the San Fernando Valley," as he put it—taking a bite out of a bagel, and Goode, the onetime altar boy, settling down to a plate of fish. Its intent was lighthearted, but the irreverent use of the flag brought down the wrath of the John Birch Society, Hopkins said, and "all hell broke loose." The gallery's financial

"WAR BABIES"
(1937-1961)

Poster for *War Babies* at Huysman Gallery in 1961; from left to right: Ed Bereal, Larry Bell, Joe Goode, and Ron Miyashiro.

backers were unhappy with the ensuing firestorm, and the place was out of business by the end of the year.

For the artists, however, things were just getting started. The year 1962 would be the annus mirabilis for the Los Angeles art scene: the year Hopps would move from Ferus to the Pasadena Art Museum, and Blum's changes at Ferus would encourage a new aesthetic direction—one in which Irwin, Kauffman, and Bell would be central figures; the year that Ruscha and Goode would draw national attention for their participation in a history-making exhibition curated by Hopps; the year that Ferus would be joined by several new contemporary galleries along La Cienega, and Goode's work would make the cover of a new magazine called *Artforum*.

Walter Hopps, Hopps, Hopps

STARTING AN ART GALLERY IS ONE THING; running it is quite another. By 1962, Walter Hopps, who would turn thirty in May, had other ideas about how he wanted to spend his time. He was an educator and an agitator, not a businessman or a bureaucrat; chasing collectors and balancing the books would never have satisfied his restless spirit or his grand ideas. He had bought out Kienholz's interest in Ferus in 1958 (so much for the five-year partnership stipulated on their hot-dog-holder contract) and had the good fortune to meet Irving Blum not long after. With Blum as his partner, Hopps was able to focus on discovering new talent, teaching his courses at UCLA, and putting in time as a guest curator at the Pasadena Art Museum. And when, at the start of 1962, the museum's director Thomas Leavitt approached him with the offer of a full-time position, Hopps didn't hesitate. From his new perch at the museum, Hopps could build an audience for the art of the day in ways unimaginable to a commercial dealer. Or so he hoped.

THE PASADENA ART MUSEUM DATED TO 1924, but it was little more than a social club for the town's smart set until well into the fifties. Tucked cozily into the valley between downtown Los Angeles and the San Gabriel Mountains that rise to the northeast, Pasadena was a haven for the successful businessmen and lawyers who made the

daily twenty-minute drive from their large, well-appointed homes to their offices in the city, and for well-heeled Midwesterners who descended on their winter refuge as reliably as a flock of south-bound Canada geese at the end of each autumn. Few of the latter felt any great loyalty to the Pasadena museum. A prominent Cleveland family, for instance, would load their entire collection into a freight car in October and later ship it all back home once the ice floes on the Cuyahoga had thawed. The museum was "controlled by a small number of people who were moderately interested," at best, said John Leeper, who ran the place in the early fifties; the exhibition policy, insofar as one existed, was primarily a matter of "filling space": "Pasadena at that time was the only city in the United States that had two chapters of the American Garden Club, so an exhibition of flower material was a must." Other notable shows included "English sporting art" loaned by the Turf Club at the nearby Santa Anita racetrack, and the lace collection amassed by the museum's president. "Everybody from the upper echelon of Los Angeles came to that show," Leeper recalled. Openings tended to be sedate affairs at which somber men in dark suits exchanged greetings and women in evening wear whispered around a punch bowl at the center of the main room.

Beginning in the late forties, the museum occupied the faux-Chinese mansion that Grace Nicholson, a local merchant and self-styled Orientalist, had bequeathed to the city of Pasadena. But the signal event in the museum's transformation was the 1953 Galka Scheyer bequest, Walter Arensberg's lone success in placing a major collection in Southern California. Leeper understood the importance of the collection, but it took him three years and "a real fight" to persuade the socialites who were his employers that the Scheyer collection wasn't "too modern" for their museum. Leeper was scolded for "emphasizing...things that people don't want to see." Elizabeth Hanson, younger and more open than many to the idea of a serious collection in her town, admitted "we didn't...know much about the Galka Scheyer thing," but she enlisted a number

of "ladies in hats and gloves" who met weekly at the golf club and formed a museum support group, the Pasadena Art Alliance. With the Scheyer collection as its anchor, the Pasadena Art Museum over the next decade edged ever closer to defining itself as a museum of modern art. Leavitt's decision to hire Hopps as its first full-time curator all but guaranteed it. Few of the institution's board members knew anything about twentieth-century art, and several didn't much care one way or another what kind of art was shown as long as the operation was run smoothly and didn't break the bank. Hopps was fond of repeating the conversation he had with board chairman Harold Jurgensen, who owned a small chain of fancy grocery stores, when Jurgensen called Hopps into his office in the summer of 1963 to inform him that Leavitt was leaving. Would Hopps be prepared to serve as acting director? Hopps said he would. Good, said his new boss, but "let's get one thing straight. You don't know pissant about a balance sheet... [and] I don't know a Ming tea bowl from a Bangkok whorehouse."

One board member who did have a keen interest in modern art was Robert Rowan, whom Hopps called, not unfairly, "a kind of very well-to-do amateur and dandy," and who, when not busy managing the money he had inherited from his father's real estate investment business, snatched up works by the "Greenberg-certified" East Coast color field painters "by the square yard," as John Coplans deftly put it. Tall and wiry and endowed with a prominent beak, Rowan had a casual yet aristocratic bearing—his mother was titled nobility—and from certain angles he faintly resembled some rare species of egret in pinstripes, making him not only one of L.A.'s best-known collectors but also its most instantly recognizable. Rowan admired Hopps and had endorsed the idea of hiring him, although, as he recalled, "I did say that he was a bit eccentric, [that he found it] a little bit hard to, you know, remember to be at the museum, or where it was and how to get there."

Newly ensconced in his post, Hopps wasted no time, organizing a series of shows that helped enlarge the story of twentieth-century

art. His typical approach was to mix the work of audacious newcomers with that of modernism's acknowledged giants and unsung heroes. First up was a retrospective of the German Dadaist Kurt Schwitters, a show that local artists such as Ed Ruscha would recall long after as a turning point in their own self-conceptions. Opening in mid-June 1962, the Schwitters exhibition was paired with a show of California collage and assemblage artists. Hopps decided early on to adopt an unofficial policy of balancing East and West Coast artists, and he knew better than anyone the role that collage and assemblage played in the development of new art in both Northern and Southern California. Included in the show were examples of the Dada- and Surrealist-inspired works by not only the better-known California assemblage artists but a large contingent of more obscure figures as well.

Hopps's first real landmark show followed a couple of months later, sharing the stage with a solo exhibition of Llyn Foulkes that was organized by Leavitt. Hopps's show has been celebrated as the first museum exhibition devoted to Pop Art. But its curator chose a title that studiously avoided the debates about whether to call this work "Pop," "neo-Dada," or "New Realism," all of which had been trotted out by dealers and critics looking to cast the work in a particular light—and each of which made a certain amount of sense, depending on which artists and what work you counted as part of the movement. He chose instead a title at once both lyrical and banal: *New Painting of Common Objects*. He included five artists from the West Coast and three from the East. The California contingent was Joe Goode and Ed Ruscha; Robert Dowd and Phillip Hefferton, both from Detroit but then living in L.A.; and the Northern Californian Wayne Thiebaud. The New Yorkers were Andy Warhol, who had just had his solo debut at Ferus earlier in the summer; Roy Lichtenstein, whom Hopps had met on his travels to New York; and Jim Dine.

NEW PAINTING OF COMMON OBJECTS served notice that the Pasadena Art Museum and its young curator were important new forces in the contemporary art world, and it called attention to Ruscha and Goode as two of the most important new artists in Los Angeles. The works both artists showed remain among their best known and would contribute to their growing influence in years to come. And while their inclusion in the show alongside the likes of Lichtenstein and Warhol made perfect sense, even a brief examination affirms the wisdom of Hopps's decision to forgo the Pop Art label in favor of the more neutral-sounding reference to "common objects."

Unlike Lichtenstein, with his blowups of comic strips, or Warhol, with his soup cans, Ruscha didn't fill the canvas with the commercial image. The paintings were instead divided vertically, with words occupying one space and an image above or below it. The relationship between word and image was far from self-evident. In *Box Smashed Flat*, the image of a flattened Sun-Maid Raisin box in the upper half of the picture is accompanied by the word "Vicksburg" in the lower half, an early indication of the fascination with place-names—and with typefaces—that would continue throughout Ruscha's career. A similar incongruity teases the viewer in the other two paintings. In *Falling, But Frozen*, a drawing of an automobile tire sits just below dead center of the canvas, against a field of aquamarine; the word "Fisk" across the top of the canvas presumably refers to the tire manufacturer. But there is nothing to indicate the location of the tire in space, and without that, it is impossible to know whether the thing is falling or frozen.

The third picture, one of Ruscha's best known, depicted a Spam container that did, indeed, seem to be falling through the lower portion of the painting. Dominating the painting's top third, the word "Spam" appears in the same typeface and color as it is on the label below. The title, *Actual Size*, leads to nothing but questions. Does the picture of the tin of Spam match the dimensions of an actual tin? (Indeed it does: Ruscha was so concerned about getting things right he would measure simple objects such as ashtrays

before putting them in a painting.) But a more interesting question has to do with the word itself: Spam. What is *its* "actual" size? The one on the label, or the giant one looming overhead like some goofy Platonic ideal? What *is* the actual size of a word? Such questions may seem perverse, but they turn out to be perfectly apt in Ruscha's case. His reputation as an artist rests on conundrums of just this sort. "Actual size," a phrase familiar from advertising and packaging, promises that "what you see is what you get." That promise is challenged repeatedly in Ruscha's paintings, where what you see and what you get may be two very different things.

Goode showed three examples from a series he had started the previous year. Each canvas was just under six feet high and an inch or two less than that in width, and each was essentially monochrome, with subtle gradations of color density created by Goode's handling of the paint. In front of each canvas was a glass milk bottle painted the same color as the canvas; an outline or silhouette of the bottle's shape was repeated near the bottom of the canvas. These milk-bottle paintings, as they have become known, can throw you slightly off balance. They can surely be read as a gloss on the predicament of painting at the beginning of the sixties (the influence of Jasper Johns is apparent).

But the milk-bottle series also carries enormous emotional weight. Viewers have often concluded that Goode intended the paintings as some kind of joke, but nothing could have been further from the truth. He made them during what he would later call "the most miserable fucking time of my life." Struggling to make ends meet, Goode, who had recently married and become a father, was so busy working odd jobs all over town that he could find little time for his wife and daughter, and even less for his painting. He would squeeze in an hour or two when he could, committing to paper or canvas pictures of his car keys, sunglasses, and whatever else happened to be lying around his cramped studio. Returning home from work in the wee hours, he spotted the empty bottles his wife had left on the front steps to await the milkman's dawn delivery. One

of the paintings shown in Pasadena, *Happy Birthday*—made on his daughter's first birthday—is a shade of pink reminiscent of a little girl's party dress. Coplans got it right when he called Goode's milk bottles "the loneliest paintings imaginable."

Goode's *Happy Birthday* graced the cover of *Artforum* in November 1962, the magazine's first year. Coplans's review of the show appeared inside. But the milk-bottle paintings so haunted the editor, Philip Leider, that more than three years later he felt compelled to revisit them in a review-essay, "Joe Goode and the Common Object." He compared Goode's paintings to those of Robert Irwin and, less plausibly, Billy Al Bengston's work. But, Leider noted, there was "an unsettling quality" about Goode's paintings, a "moral overtone" and "compelling gravity" that set them apart from the "inscrutably noncommittal presentations" of so many L.A. artists.

Coplans, in his rave review of *Common Objects*, described the work as a commentary on the "trivialization of form and content" that had led modern painting to "the sense of crisis." This new art was a "direct response to life rather than to [theoretical] 'problems.'" The show was greeted with a good deal less enthusiasm by Jules Langsner in *Art International*, who seemed eager to like it: "something is going on worth notice, whatever judgment one finally renders," he wrote. But in contrast to Coplans, Langsner saw work that was driven purely by ideas, "excellent conversation pieces" that suffered from a "poverty of visual information." It's a judgment that was upheld by many critics and much of the public at the time.

Nonetheless, in museums and galleries on both coasts, and in the hinterlands too, Pop Art shows proliferated in the year after Hopps mounted *New Painting of Common Objects*. The greatest fanfare would be reserved for the Guggenheim Museum's *Six Painters and the Object* in March 1963, a show that included none of the West Coast artists seen in Pasadena. Reviews of the Guggenheim exhibition appeared not only in all of the predictable art magazines but in the national press as well. But the Californians wouldn't figure in the debates or benefit from the attention paid to artists showing at

the half-dozen or so New York dealers who were pushing the new style. Little surprise, then, that when L.A. artists finally did begin to draw some notice, they were erroneously dismissed as Johnny-come-latelies grabbing hold of the latest thing out of New York. For neither the first nor last time, New York critics wrote L.A. artists out of the story.

HOPPS'S GREATEST TRIUMPH — and the show that marked the Pasadena Art Museum indelibly on the map of modern art — was the 1963 Marcel Duchamp retrospective. Duchamp was not an unfamiliar name within the art world in the early sixties, but he wasn't recognized as the pivotal figure he is thought to be today. A 1959 monograph on the artist had been a major turning point, yet neither the Philadelphia Museum of Art, home to the Arensberg Collection since the mid-fifties, nor any of the several major institutions in New York, which had been Duchamp's home since the teens, had been moved to organize a major retrospective. It fell to Hopps to set the record right, and it was a responsibility he relished. Leavitt had initially suggested a Johns show for the fall 1963 slot, but Hopps countered with his Duchamp proposal. The young curator regarded it, along with the Schwitters exhibition and a Joseph Cornell show he planned to mount in 1966, as part of a "cycle" that would rebalance the art-historical scales.

Hopps had not communicated with Duchamp since their meeting at the Arensberg residence in Hollywood a decade and a half earlier, and Duchamp had long since disavowed his role as an artist, claiming that he devoted himself almost wholly now to chess. The extent to which he was bluffing would become apparent only upon his death five years after the Pasadena show. In any event, the allegedly former artist welcomed Hopps's query and agreed to his plan. "He remembered me as the boy who used to be so interested in his paintings," Hopps noted. "I suppose this may have helped me." Duchamp also agreed to design the exhibition's poster,

Marcel Duchamp (left) and Walter Hopps
at the opening of Duchamp's 1963
retrospective at the Pasadena Art Museum.

incorporating a work he had produced in the twenties by altering a wanted poster with photographs of himself in profile and full-face. Everything else he left to Hopps.

Hopps's layout for the show opened with a gallery devoted to photographs and ephemera—"nothing didactic," he explained, "but interesting divertissements, like a theater lobby." Visitors were then led through galleries that included early paintings and drawings as well as Duchamp's designs for chess sets, followed by works from the period that produced *Nude Descending a Staircase (No. 2)* and other Cubist-Futurist paintings. The final gallery housed the optical devices Duchamp had created. Without a doubt, however, the show's high point was the gallery devoted to the ready-mades and the most mysterious and enthralling of Duchamp's creations, *The Bride Stripped Bare by Her Bachelors, Even*, more commonly known as *The Large Glass*. (It was in fact a replica, borrowed from the Moderna Museet in Stockholm, the original in Philadelphia being too fragile to travel.) Duchamp got to town shortly before the opening and checked himself into the Green Hotel, a faded, half-forgotten ornament of old Pasadena that was but a short walk to the museum. He stopped in at the Nicholson mansion daily to consult on the show's installation and kibitz with the groundskeeper.

The installation of the show went smoothly for the most part, with one notable hitch. During a preview, Hopps said, a "bunch of Art Alliance women" were smiling their way through the galleries, "tongue-clucking about Marcel Duchamp," when they came upon Duchamp's notorious *Fountain*, the inverted pissoir that had apparently not lost its power to scandalize viewers more than forty years after its first appearance. One look "and they go nattering to Harold Jurgensen," Hopps recalled. The board president found Hopps and led him to the gallery. Pointing at the urinal, Jurgensen told Hopps, "I want to know your statement. Is that art? Yes or no." Yes, came the answer. "Fine," replied Jurgensen. "That settles it."

The *Los Angeles Times* society pages couldn't get enough of the "slight, soft-spoken French gentleman" who had once drawn a

Andy Warhol, Billy Al Bengston, and
Dennis Hopper at the Duchamp opening,
with Irving Blum in the background at left.

mustache on the Mona Lisa, "the mystery man of modern art" now in the city's midst. The show's opening was the event of the season, with a black tie dinner before the "once-in-a-lifetime exhibition" and another formal reception after. "Society and Art Worlds Converge," buzzed one *Times* headline. "They Came, They Saw—Duchamp Conquered," trumpeted another. Artists swarmed the galleries in rented tuxedos, but the newspaper was far more interested in international jet-setters who had come "cloud-hopping into Our Town" to sup with the San Marino swells. One "international authority," gushed the *Times* reporter, had an "unmistakable British appearance and accent." For all the excitement, however, once natives had been introduced to Duchamp, "most people there didn't know how to deal with him," the collector Donald Factor said with a laugh, remembering the after party at Jurgensen's home. "They sort of kept their distance and stared." The artists reconvened at the Green Hotel, soon joined by Hopps and Duchamp. Warhol, on his first West Coast trip, drank a bit too much pink champagne but discovered that "in California, in the cool night air, you even felt healthy when you puked—it was so different from New York." Goode, who was then living in Hopps's house, had everyone sign a tablecloth, Duchamp included, and presented it to his landlord in lieu of rent. Duchamp and his wife, accompanied by Hopps and half a dozen other friends, decamped for a weekend in Las Vegas. The famous photograph of Duchamp playing chess with a naked Eve Babitz in front of *The Large Glass* was taken at the museum a week later.

The *New Painting of Common Objects* show in 1962 had certified the ascent of Pop Art to the firmament of major art movements on both coasts. With the Duchamp retrospective a year later, Hopps illuminated the historical foundations of Pop by bringing the elusive Dadaist from the margins of twentieth-century art to its vital center. In the process, he had brought international recognition to his museum and made it the centerpiece of the L.A. art scene. "In all of L.A.," Hal Glicksman said, "that was the place to be." All that remained was to convince the locals.

The Other Side of Town

IN PASADENA, *Los Angeles* magazine teased in the 1960s, the three R's stood for "Rich, Reactionary, and Retired." That was an overstatement, of course—not everyone in the city was retired—but it contained more than a grain of truth. Founded late in the nineteenth century, Pasadena had by the beginning of the twentieth developed a social hierarchy that was to a remarkable extent still in place six decades later. At its peak was the Valley Hunt Club, where the local gentry donned full regalia for the annual fox hunt, although the wives generally preferred the club's more famous New Year's Day Tournament of Roses. The city's inhabitants prized above all, to borrow the historian Kevin Starr's felicitous phrase, "the emblematically genteel." Young ladies made their social debuts with great fanfare at the spring and fall cotillions, held at one or another of the city's grand hotels; blue-blazered young men proudly displayed the crest of the Polytechnic School. Pasadena's major cultural institutions, the historian Carey McWilliams contended, "could hardly be more carefully insulated from the rest of Los Angeles if they were surrounded by Chinese walls."

That insularity posed a singular challenge to the new staff of the Pasadena Art Museum. The coupon-clipping "old families" that filled the social register had the means but not the inclination to support an institution that embraced avant-garde art. They saw the museum primarily as another stop on the social circuit; they gave

enough to keep the doors open and were rewarded in turn with gala affairs where they could see and be seen by their peers. Thomas Leavitt recalled that during his tenure as the museum's director, its most ardent supporters sponsored an annual ball that "seemed to many members of the Art Alliance...to be the most important thing the museum did." The stated purpose of the event was to raise funds for the museum, but, Leavitt said, "they were so carried away by preparations for the ball that there wasn't much money left over."

Little wonder then that, as the Art Alliance cofounder Elizabeth Hanson attested, "there were a lot of people in Pasadena who really resented the museum, and who resented what was shown there, resented the direction, point of view." Leavitt agreed. "Some of the things we did weren't palatable for large numbers," he said. "We got into trouble a number of times." The California collage show Walter Hopps organized to accompany the Schwitters exhibition was a case in point. With their celebration of all manner of corporeal indulgence, it was perhaps inevitable that a percentage of the works in that show would grate. Outrage greeted a work that included, among the materials collaged, pubic hair, while the hypodermic needle that figured importantly in another was confiscated by the police. But those were trifles as compared with the American flag George Herms worked into one of his assemblages, which induced the ire of various patriot groups and was attacked by vandals who broke into the museum one night.

The most serious resistance to Hopps's ascendance, however, came not from such isolated episodes of violence; it came instead from the museum's very own network of volunteer groups. And his most formidable opponent was without a doubt Eudorah Moore, a cofounder with Hanson of the Art Alliance. Moore was prepared to wield every weapon at her disposal—and she had quite a few—in a battle to defend a strategic bit of personal turf: an annual extravaganza known as California Design. This was not, Hopps emphasized, a survey of the region's genuine luminaries, such as

Charles and Ray Eames or the émigrés Rudolph Schindler and Richard Neutra; it was "at best, a trade show," he said. "California Design…was always the bane of our existence," said Hal Glicksman, the preparator Hopps brought in as part of his effort to build a professional museum staff. "All this dreck would come into the museum from decorators, and Eudorah would take over the whole museum." Moore, Hopps said, "saw herself as a kind of populist and looked at vanguard art that obviously interested me as kind of elite and arcane." Hopps, Rowan, and even Harold Jurgensen were powerless to stop it. "The truth was," Rowan conceded, "at one time she literally did control the board with her friends."

It wasn't just the art that rankled; it was the people who came to see it, too. Right off the bat, Hopps said, the museum started to draw an unfamiliar crowd. The locals—especially the gracious ladies in pearls who volunteered their time to lead tour groups, manage the membership lists and rummage sales, and host openings and black-tie dinners—"suddenly [saw] themselves in the minority." Hanson was delighted by the "mobs of people from the other side of town" who showed up at the openings; Dennis Hopper and his wife, Hanson noted, were "among the avant-garde from the other side of town who slummed over."

THE OTHER SIDE OF TOWN. *Los Angeles* magazine explained to readers in the mid-sixties that "the other side of town" was, in the Pasadena lexicon, "the local expression for Beverly Hills, Bel-Air, Brentwood, and other newly arisen outposts of social presumption." Those neighborhoods—along with Westwood, Santa Monica, West Hollywood—are more generally labeled L.A.'s Westside, and in the postwar era they developed into a subregion as distinct, in its own way, as Pasadena. The Westside, the magazine enthused, was home to "the most affluently cosmopolitan citizenry" in L.A. And the cultural life of the area stood in stark contrast to that of Pasadena.

The restaurants and galleries along La Cienega, the rock-and-roll clubs on Sunset Strip, the movie houses clustered in Westwood Village, and the beaches in Santa Monica all contributed to the Westside's reputation for "the most exciting action" in town. But if all that wasn't inducement enough, the area could also lay claim to a "24-hour center of culture and entertainment" unrivaled in Southern California: the University of California, Los Angeles. The UCLA campus, *Life* magazine announced in 1957, "is fast becoming a cultural boom town." Even a decade later—*after* the opening of the city's new music center and art museum—*The New York Times* insisted that UCLA, with some four hundred events a year attended by three hundred thousand people, had been responsible for the "most impressive contribution" to L.A. cultural life since the war. Describing the musical offerings in the city, *High Fidelity* magazine noted that a concert of Igor Stravinsky's music performed by the Los Angeles Philharmonic at its downtown digs "ordinarily loses more audience than it gains," whereas "a Stravinsky program with a temporarily collected orchestra fifteen miles to the west at UCLA will pack the house." And "the majority of the audience" at a Stravinsky concert or any other cultural event, *Los Angeles* explained, "will not be the [university's] students but Westside residents…UCLA recognizes the fresh, vital outgoing nature of the surrounding community it serves."

The story was much the same for the visual arts. At a time when no other institution in Los Angeles would attempt such an ambitious show, UCLA celebrated Picasso's eightieth birthday in October 1961 with *Bonne Fête Monsieur Picasso*, an exhibition of some two hundred and fifty works drawn from Southern California collections and representing every phase of the artist's long career. No less impressive was a Matisse exhibition that opened the university's new gallery space a few years later. Even in the early sixties, of course, Picasso and Matisse were reasonably safe bets, but the fact that they were mounted in a university gallery, far from the city center and the machinations of the downtown establishment, says a lot

about the state of art museums and patronage in Southern California at the time. Modernism may have been marginalized by L.A.'s major cultural institutions, but it was alive and well on the city's Westside.

Shows on such a grand scale were possible only because of the small but high-powered network of patrons in the neighborhoods near the university. The principal volunteer support group, which functioned as an unofficial board of trustees for the UCLA gallery, included "people…who knew their way around the museum and collector world nationally," the gallery director Frederick Wight explained. And because collectors on the council owned works coveted by museums around the world, they also had more "borrowing power" than the gallery itself.* In general, serious collectors on the Westside focused on postwar American art. And here, too, UCLA was instrumental, along with Hopps and the courses he taught through the university's continuing education program.

Apart from UCLA, the city's leading public forum for discussion and debate about contemporary art in the late fifties and early sixties was another prominent Westside venue, the Westside Jewish Community Center. And that points to another defining fact about L.A.'s Westside: It was home to an overwhelming majority of the city's Jewish elite. (Hinting broadly at this basic truth of Southern California's social geography, *Los Angeles* magazine, in its stock-taking of the Westside's most enviable assets, reminded its readers that the Beverly Hills eatery "Nate 'n Al's [was] obviously the best delicatessen west of New York.") And with a few notable exceptions, the major Westside collectors were Jewish.

*This was especially true of Frances Brody, the council's president in the early sixties. Brody and her husband, Sidney, had built themselves a residence—a masterpiece of California mid-century modernism—to showcase the collection of major works by Matisse, Picasso, and other School of Paris figures they had started to acquire shortly after the war. When the Brodys' collection went on the block in 2010, it brought in record sums, including the highest price ever paid at auction for a work of art, for Picasso's *Nude Green Leaves and Bust*.

THE HISTORY OF MODERN ART AS AN ASPECT OF JEWISH ASSIMILATION
has yet to be written, but the important role of Jewish collectors in
the acceptance of modernism has not entirely escaped the attention
of historians. In Paris as well as in the German-speaking capitals
of late nineteenth-century Europe, financially successful, culturally
assimilated Jews—doctors and lawyers, professors and publishers,
bankers and industrialists—were "unusually receptive to innova-
tion," buying the most challenging new art of their time in num-
bers that far exceeded what could be expected by their presence in
the population as a whole. In the decades after German Jews were
granted full citizenship rights, the historian Amos Elon has written,
"when most non-Jewish art collectors preferred works of the Ital-
ian and Dutch Renaissance, Jewish patrons were interested in con-
temporary German works and even commissioned works by leading
Impressionists and Expressionists." Another scholar has estimated
that more than four out of five collectors of French modernist
paintings in turn-of-the-century Germany came from the ranks of
the "Jewish German *haute bourgeoisie*."

This Jewish affinity for modern art is too socially and psycho-
logically complex in origin to completely unravel here. But we can
identify some of the threads from which the fabric was woven. Col-
lecting art has always signaled social status, whether that of English
aristocrats, Florentine bankers, or Dutch merchants. As restrictions
against Jewish participation in society receded in the eighteenth and
nineteenth centuries, individuals of means sought the same symbols
of respectability as their gentile counterparts. But much art of the
past celebrated a social order that largely excluded and denigrated
Jews. Modernism offered an alternative, untainted by foul remnants
of the old regime. It boldly proclaimed its independence from a
bankrupt order, but it didn't preach revolution; it decried orthodoxy
yet sought respectability. And that was the heart of its appeal. It
was a way to stand out while also fitting in. Modernist ambivalence

about artistic tradition mirrored Jewish ambivalence about assimilation. Contemplating a modern painting, the newly respectable Jew saw his own reflection. "The restless age and the restless Jew," wrote the historian George Mosse, "incarnated a desperate modernity."

Modernity was not nearly so desperate in mid-twentieth-century Los Angeles. Still, the city was "marked by a definite if invisible separation of the Jewish and gentile worlds." Political and economic power resided primarily with the latter—or rather, with a small and deeply conservative elite from which Jews were largely absent. Dominated by a bloc of downtown businessman and their political allies, the California Republican Party of the fifties and the sixties was a highly influential voice for conservatism, not only in Los Angeles but in national politics as well. The bankers, oilmen, defense contractors, and newspaper publishers who talked business and politics over lunch at the California Club and the Jonathan Club downtown were the party's financial backers and kingmakers, locally and nationally. The downtown Los Angeles establishment mostly distanced itself from the extreme right-wing groups that were legion in Southern California in the fifties and early sixties. But the John Birch Society had made some inroads among prominent and powerful figures. And one downtown haberdasher, assailed by the Anti-Defamation League for sending anti-Semitic literature to his customers, was so far to the right that even the Birchers banished him. In the San Gabriel Valley, which includes Pasadena, avowed members of the society won the 1962 Republican primary in three congressional districts.

Until the late fifties, Jewish influence on the cultural life of Los Angeles rarely extended beyond "the gilded ghetto of the Westside," where political sentiments leaned far to the left of the downtown oligarchs and Pasadena blue bloods. Things began to change when Dorothy Chandler, the wife of the *Los Angeles Times* publisher, took charge of the campaign to build a new performing arts center downtown. "The old-money group really was insufficient to fund what she had in mind," said the collector Gifford Phillips, who moved

comfortably in both circles. "She made a real effort to bring some of the Westside people in." Mrs. Chandler's role has often been noted, and rightly so. But the drive to establish an art museum was also important. "The [old] county museum had a reputation of being somewhat anti-Semitic," Phillips said. "Whether it was deserved or not, I don't know." The senior curator James Elliott didn't have any doubts. There was, he asserted, "a very clear anti-Semitic situation" when he arrived in 1956. "Many pictures had been given to the museum by Jews who had moved to Southern California," and most languished in the basement storage areas. Elliott and his boss, Richard "Ric" Fargo Brown, helped change that.

A researcher formerly attached to New York's Frick Collection, Brown had been brought to Los Angeles in 1954 and charged with improving the county museum's art division. He quickly concluded that, while some very good things had been donated over the years, they were buried amid much more that was second-rate at best. After two years of sorting through the holdings and reviewing his division's priorities, Brown duly informed officials that "from the standpoint of both permanent collections and changing exhibitions, simple increase is no longer desirable...The available space for display and storage is full."

There were rumblings about the need for a separate art museum, but at first, that's all it was—talk. Until Brown met Norton Simon. Simon, who was Jewish, had taken a small orange-juice bottling operation and transformed it into the Hunts Food conglomerate, eventually branching out into everything from steel to publishing. He had started buying art only a few years earlier, but he was never one to do anything halfway, and collecting no doubt appealed to his acquisitive nature and his will to excel. Simon stunned Brown with an unsolicited offer: a million dollars toward the creation of an independent art museum. Brown and his museum were on their way.

Simon was brilliant and bursting with nervous energy, and with Brown's advice, he would become one of the shrewdest and most successful collectors of the later twentieth century. With his

collection as a foundation to build on, a new museum would have instant credibility. But he was also moody and mercurial, impatient with boardroom politics and disinclined to make polite conversation—not the sort of person to cajole supporters and reassure potential donors. Someone with those talents was needed. Brown turned to another self-made man, Edward W. Carter. A more conventional figure than Simon, Carter had built the largest chain of department stores in the western United States and was a civic booster in the classic mold, one who already served on the boards of high-profile organizations. "Mr. Establishment," *Los Angeles* magazine called him. But he was equally comfortable reaching out to the more liberal residents of the city's Westside. Even better, he was half Jewish, although no one seemed to know it. Carter named two chief fund-raisers: a Westside collector whose home was filled with modernist masterpieces, and a prominent Pasadena socialite married to a downtown banker. Elliott recalled an early fund-raiser, a $25,000-per-couple dinner, that was "the first time WASP powers from San Marino and Jewish powers from Beverly Hills sat down together." But breaking the ice wasn't easy. "Among Jews," Elliott observed, "there was real resentment toward the [existing] museum." Indeed, one Jewish Westsider assured him, "I'll never set foot in that goddam museum."

Nonetheless, when the new museum was officially launched in 1961, Elliott approached Phillips, hoping to groom a network of supporters. "He realized that there was a group of contemporary art collectors on the Westside that were totally disconnected from the museum," Phillips said, and "they were almost all Jewish." (Phillips was an exception. He was a Westside liberal, to be sure. But he was also a nephew of Duncan Phillips, the founder of the Phillips Collection in Washington, D.C.) With Elliott's encouragement, Phillips and a handful of others set up the Contemporary Art Council. Long before the county museum even had a department of modern art, the council filled the role, acquiring works, underwriting exhibitions, and organizing events.

Hopps felt that "it was the leadership pool on the Westside of the city that could make something happen" at the Pasadena museum too. After all, many of the Contemporary Art Council's members had first been introduced—to modern art and to one another—through Hopps and his living-room lectures. But the problem, as he saw it, "was the whole Jewish question and anti-Semitism. There were no Jews on the Pasadena board. And the state of old Pasadena and San Marino was rather closed…This became a real, apparent issue rather quickly." Indeed, before the Pasadena museum hired Hopps's boss, Leavitt, "there was some whisper-ing around the board about 'We mustn't have a Jewish director,'" Hanson acknowledged. Adding Jews to the board itself would be even trickier. "Even Rowan, who wasn't an anti-Semite, was not comfortable with having Westside Jews on the board," Hopps said. Hopps blamed Rowan's failure of nerve for the loss of a Barnett Newman show. "Rowan objected because there would be clergymen and parishioners and so on" who would take offense at Newman's Stations of the Cross series. "He all but said, 'A Jew like Barnett Newman putting up these blank, non-objective paintings'" would seem like an insult to some of the locals. As for "integrating" the board, Hopps said, "I proposed the idea without raising the Jew-ish issue first." Instead he asked, "How do we get people like Fred Weisman on the board?"

Fred Weisman and his wife, Marcia, were at the center of the group of collectors who had come together around Hopps and the classes he taught through the UCLA extension. They were not only extremely active as collectors; they had also become outspoken advo-cates for contemporary art and were especially supportive of the Los Angeles art scene. Fred would hire Ruscha and Goode to decorate his private jet; Marcia, who also happened to be Simon's sister, was always on the lookout for ways to advance the cause of L.A. artists through greater exposure. With Leavitt's support, Hopps succeeded in bringing both Fred Weisman and Donald Factor on the Pasadena Art Museum's board. ("I don't know whether the gentile fraternity

liked this couple of Jews—me and Freddie—but we were perfectly okay with that," Factor said.) But Hopps worried that the West-siders, whether Jews or Gentiles, "just couldn't be really convinced to be real players." They were already active in the Contemporary Art Council, after all, and had high hopes for the new county art museum. In the back of their minds, Hopps knew, the most enthu-siastic Westside collectors of contemporary art looked at Pasadena and wondered, "Can this museum, clear over in the old east side, really be it as our modern museum?"

Ferus Redux

"IRVING, WITH HIS FANCY AND SOPHISTICATED TASTE, was able to change the art scene," Ed Kienholz complained of Irving Blum. It was an extravagant charge, typical of Kienholz, and more a measure of his animus toward the man who replaced him as Hopps's partner in Ferus than of Blum's actual impact. That Blum transformed Ferus is beyond dispute. His influence was apparent almost from the moment he arrived in 1958. But even when he became Ferus's sole proprietor, after Hopps's departure for the Pasadena Art Museum four years later, Blum never wielded the sort of power Kienholz ascribed to him. The changes he made at Ferus were as much an effect as they were a cause, a response to the ways art and the art world in the early sixties were changing in Los Angeles and beyond.

Impeccably dressed and possessed of Cary Grant good looks, a regal bearing, and an infectious laugh, Blum moved easily among the monied classes whose patronage was a successful gallery's lifeblood. He was an entrepreneur, with a keen sense of the market and the recognition that business decisions were driven by financial realities, not emotional ties. Blum's first brush with the art world had come during his years as a salesman at Knoll, in New York, often working with corporate clients who would ask him to coordinate the art and furnishings on large building projects. He developed contacts among the galleries that could provide him with the

needed art—geometric and "post-painterly" abstraction were ideal, since they didn't demand much thought from the office workers and corporate titans who had to pass them every day. Blum was taken with the work he saw in New York's most up-to-date galleries, and he befriended several of the important dealers at the center of the new art. He arrived at Ferus in 1958 with a well-padded address book and an eye for what could sell.

Blum set out to build Ferus into a "national gallery," as he put it, rather than one saddled with the "stigma" of regionalism. "I didn't want to be considered a provincial gallery," he stated plainly. He decided, for starters, that the original building was simply "too primitive," that a "more sophisticated space" was needed. He found it just across the street, and by the end of 1958, the gallery had moved from the east side of La Cienega to the west. Gone was the funky, lived-in, artists' cooperative look of the original Ferus. The new gallery was clean and white and, in contrast with its predecessor—hidden, as it had been, behind an antique shop—the new address offered a large picture window and front door opening directly onto La Cienega's busy sidewalk.

Knowing that it would take time before the gallery could break even, much less turn a profit, Blum set out to find a financial backer, a silent partner who cared enough about contemporary art to underwrite such an iffy proposition—an untested gallery showing unknown artists in a uncertain market. Hopps jotted down names of likely prospects, starting with the obvious people, the handful of serious local collectors, people like Vincent Price and Gifford Phillips. But Price wasn't eager to reprise the role he had played once already with the ill-fated modern art institute in Beverly Hills; nothing persuaded him a remake would fare any better at the box office than the original. Phillips, for his part, was already committed to a well-intentioned, money-losing venture of his own, a Los Angeles–based, *Saturday Review*–style magazine called *Frontier*. Lower down on Hopps's list was Sayde Moss, a patron of contemporary music who had attended a few of the gallery's openings.

The recently widowed Moss welcomed the chance to throw herself into something new. "What sort of money are we talking about?" she asked when Blum approached her. "Give me a number." Somewhere in the range of $5,000 to $6,000 a year, he replied. Moss laughed. "Is that all?" Sure, she said, she would soak up the red ink so long as the gallery continued to hold her interest, though she couldn't predict how long that would be. In the event, six years would pass before Ferus worked its way into the black, but Moss never wavered. Blum would take her to lunch every so often and bring her up to date on the gallery's doings, she would express her satisfaction and make out a check, and the gallery's doors would remain open for another few months.

Not everyone would respond quite so warmly. Kienholz derided what he called "Irving's decorator taste" and, after Hopps's departure for Pasadena, severed all ties to the gallery he had cofounded. "When Irving took over Ferus," Kienholz groused, "it changed so radically...I would have nothing to do with it." It wasn't just Kienholz who objected. Gerald Nordland, the art critic for *Frontier*, felt that "Blum was more involved with glitz and flash than he was with content." The most contentious changes, not surprisingly, were those that cut closest to the quick and recast the gallery's reason for being. For Ferus to be commercially viable, Blum believed, it would have to reduce its list of nearly forty artists by more than half. "It was extremely hard," he said, "to confront some of those people and say, 'Look, you're no longer part of the situation.'" When Hopps, who had championed those artists' cause from the beginning, couldn't bear to give them the news, the job fell to Blum.

The changes weren't in the numbers alone. Ferus, as Blum was remaking it, would focus less on the sort of second-generation Abstract Expressionist painting coming out of San Francisco and still popular locally. Instead of Los Angeles–San Francisco, the new mix was essentially Los Angeles–New York. Blum's initial changes to the Ferus lineup were in evidence by the beginning of 1960, when the gallery unveiled *Fourteen New York Artists*—the first time New

Yorkers had appeared there—but the real turning point came in 1962. Two landmark shows that year illustrate the transformation: In March came Kienholz's installation *Roxys*, the last show the gallery's cofounder would have there, and the last to be shepherded by Hopps; July brought Andy Warhol's solo debut, with a suite of thirty-two Campbell's soup cans. Writing in the early years of the twenty-first century, the art dealer Richard Polsky declared it "probably the single most important gallery event of the last forty years."

THE KIENHOLZ AND WARHOL SHOWS could hardly have looked more different. Upon entering *Roxys* the visitor was transported to another time and place. The entire gallery, from the rugs on the floor to the kitschy needlepoint sampler on the wall, was filled with the decor of Kienholz's reimagined bordello. A calendar informs us that it is 1943, and a portrait of General Douglas MacArthur reminds us that World War II is raging. The war wasn't even a memory in the Warhol show: History had been erased; you had entered an eternal present marked by endless repetition, each day the same, the only variation being which flavor you would choose. Studying Warhol's paintings, the visitor would have searched in vain for symbolic meaning; none existed. The soup can paintings were not hung on the walls but placed on shelves lining the gallery, as if they were so much merchandise you might reach for in the canned goods aisle of your local A&P. We should not, however, let the obvious differences between the Kienholz and Warhol shows obscure their common theme: the relationship between art and commerce. Indeed, no two artists of the 1960s did more to remind the viewer of that relationship than Kienholz and Warhol.

Roxys was Kienholz's first fully realized tableau, a phantasmagoric whorehouse populated by misfits and charity cases. Kienholz described feeling "appalled" as a teenager by his visit to a brothel in Idaho, where he was not able to "perform" because the prostitutes turned out to be "a bunch of old women with sagging breasts that

Installation of Andy Warhol's Campbell's
soup can paintings at Ferus, 1962.

were supposed to turn you on." For Kienholz, the whore had come to symbolize not pleasure but decay and death. Entering *Roxys*, you are immediately cast in the role of an eager john, moving from room to room, surveying the goods. There are some half-dozen courtesans to consider, with names like "Five Dollar Billy," "Cockeyed Jenny," and "Fifi, a Fallen Angel." But if the gallery visitor is the john, Kienholz surely knew, then the artist was just another whore. Much has been written about images of prostitution in modern art, from Manet's *Olympia* to Picasso's *Desmoiselles d'Avignon*. Misogynistic fantasies—male domination, fears about women's sexuality, castration anxieties—have come in for thorough analysis. All of that is certainly relevant to *Roxys*. But Kienholz was highlighting a point that has received less attention: the male artist's *identification* with the prostitute; both are masters of artifice, purveyors of fantasies who are paid to dissemble. One offers her body for sale, the other his "genius." It's a deal that Kienholz was willing to make, but not, it seems, entirely without reservation.

Kienholz saw himself as a tradesman, available for hire and an honest day's work. He tooled around town in an aging pickup truck that boasted a hand-lettered sign reading "Ed Kienholz" and, in much larger lettering, "EXPERT." He could negotiate the marketplace as well as anyone and seemed to thrive on its contradictions. While he appreciated, for instance, the subsidy he received from Virginia Dwan, whose gallery he joined the year after *Roxys*, he didn't "feel as clean or as free" in taking it as he did living on actual sales alone. Yet for all that, Kienholz was also wary of the hazards the market brought. "If something actually sold" during the early days of Ferus, he later reflected, "that was maybe even a threat. I don't know. Maybe that was bad rather than good." The danger, as he saw it, was above all the temptation to pander to popular taste, and he was unsparing in his censure of artists and dealers he thought guilty of such commercial debasement. Among those who earned his scorn was Blum. An "art butcher," he called him.

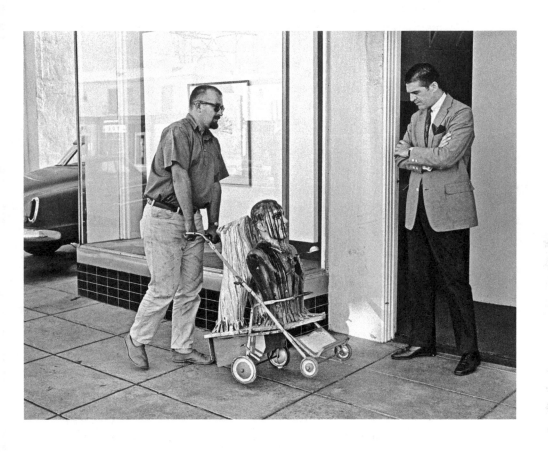

Ed Kienholz delivers *John Doe* to Irving
Blum at Ferus, 1962.

Warhol clearly had very different ideas about an artist's role and his relationship to the market. His early experiences in New York advertising had exposed him to the realities of corporate decision-making and marketing. He held few illusions about the artist's independence from the economic realities of postwar America, and he gave no indication that he felt sullied by those realities as Kienholz did. As he built up his Factory in New York over the course of the sixties, Warhol endorsed a conception of the artist as a corporate manager overseeing the mass production of upscale consumer goods. He was a captain of industry. So foreign was this idea to Kienholz that he mistook Warhol's soup cans as social satire, a critique of consumer society. Indeed, it took a while for many to see Pop Art as anything but a "put-on."

Response to the soup cans was tepid. "Public reaction," to the extent there was any, Blum said, "was either scandalous or indifferent." Across the street, the dealer David Stuart, enraged by the unabashed commercialism that violated his ideas about art, filled the picture window at the front of his gallery with a stack of Campbell's soup cans he had fetched from the supermarket and offered to the public as the "real thing." The editorial cartoonist for the *Los Angeles Times* weighed in with a drawing of a pair of beatnik types offering inane art-speak commentary as they ponder the Warhol soup can paintings arrayed before them on the walls of the "Farout Art Gallery." Among local artists, Blum reported "some were very hostile; others were intrigued."

Only six sold, all to the same few collectors who had become almost an extension of Ferus. "I thought it would be fun to have one of those," recalled Donald Factor, one of the original buyers. "So I chose my favorite soup, Tomato." The paltry sales turned out to be a mixed blessing for Blum, to say the least. Having guaranteed Warhol a thousand dollars for the show, he had brought in a mere fraction of that. But something told Blum the entire suite of thirty-two paintings should stay together. He wisely swallowed the $1,000 loss, paying Warhol a hundred dollars a month. "That's

when I had my falling out with Irving," Factor explained. "I got a call from Irving saying that Andy really wanted to try to keep the whole set together…What we didn't know was that Irving kept them all." More than thirty years later, Blum sold the complete set to the Museum of Modern Art for $15 million. Little wonder then that Hopps described handing his share in Ferus to Blum as a "generous gift."

The Warhol show was a harbinger. New York painters of the pop and minimal varieties would loom large in Ferus's future; the following twelve months brought shows by Josef Albers, Frank Stella, Roy Lichtenstein, and Warhol again; Ellsworth Kelly would have multiple shows there as well.

LONG BEFORE HE EVER CONTEMPLATED *ROXYS*, Kienholz, having divested himself of his financial interest in Ferus, saluted his friend and former business partner with a work mischievously titled *Walter Hopps, Hopps, Hopps*. The life-size assemblage portrayed the peripatetic Hopps peeling back his jacket lapel to reveal secreted works by Jackson Pollock and Willem de Kooning, much as another sort of dealer might offer drugs or stolen merchandise to the unsuspecting passerby. The idea of art as contraband appealed to Kienholz and animated the renegade spirit that watched over Ferus in its early days. Now, with Blum as the gallery's sole proprietor, that spirit was gone for good.

Art galleries, as we think of them today, didn't take off until well into the nineteenth century. Scholars studying the subject have distinguished between two types of art dealers: the "entrepreneurial," who made no bones about being anything other than a businessman, and the "ideological," who sought to promote a certain style or group of artists. The latter only came along quite late, around the time of the Impressionists, and even then, it seems fair to say that Paul Durand-Ruel, the major champion of Impressionist painters, was as much an entrepreneur as he was an advocate for the new art.

Edward Kienholz, *Walter Hopps,
Hopps, Hopps*, 1959 (assemblage,
87 x 42 x 21 in.). Kienholz's portrait
of his friend and former partner.

The story of Ferus—the dissonance between "the populist Ferus of Kienholz," as Hopps put it, and the "corporate" one of Blum—is an object lesson in the conflicts between the ideological and entrepreneurial attitudes toward the modern art gallery. Hopps himself was deeply torn. He had "a cosmic view of art," said Hal Glicksman, a belief that "art represented a higher aspiration of mankind." But he also knew that Blum's changes "meant that there could be a professional, remunerative career for those artists that were the core of that gallery." Indeed, the entrepreneurial Blum, like Durand-Ruel before him, did effectively champion a particular group of artists with a shared sensibility, just not the same group or sensibility that Hopps and Kienholz had originally envisioned.

The local artists that Hopps and Kienholz had brought together in the middle to late fifties had been central figures in the era's Beat-oriented bohemia, and they embodied its values; those who came later, the ones who formed the core of Blum's Ferus after 1962, were less enamored of bohemian ideals. Far from rejecting the consumer culture synonymous with L.A., as the assemblage artists had done, the new crop of L.A. artists seemed to epitomize it—even, in the view of critics, to celebrate it. They were Southern Californians to the bone. Billy Al Bengston raced motorcycles professionally, spending nearly as much time at the motocross track as he did in his studio. He posed with a pair of motorcycles for a *Life* magazine feature on California artist-athletes that also focused on Robert Irwin, who was pictured on the beach holding a surfboard. The poster for a Ken Price exhibition at Ferus featured the artist triumphantly riding a wave, standing tall, arms outstretched on his long board. Not to be outdone, Bengston had a photo of himself flying through the air on his dirt bike included on the poster for his show the following month.

These artists would emphasize a very different sort of art from the assemblage and Abstract Expressionism that were central to the early years. Ideas about the "creative spirit," of spontaneity as personal liberation, had yielded to their antithesis, a view of art-making

as a logical but laborious process of constant refinement; the work itself would become sparer and more deliberate than anything identified with the fifties bohemia. Even Blum's desire for a cleaner, "more sophisticated space" at Ferus was in synch with the changing sensibility. As Glicksman remarked, "it was the artists who really led that pure space thing," the artists who insisted on "white walls in their studios." The San Francisco–based artist Ron Nagle also noticed that among artists he knew in L.A.—and the Ferus group in particular—"there was an aesthetic about what your studio had to look like." Writing in *The New York Times*, Alan Solomon observed that "Irwin works in what may be the cleanest studio in the world. It would be inconceivable in New York." Kienholz recalled the "compulsively clean white space" of Craig Kauffman's studio. "A really clean space," Kauffman offered by way of explanation, was in his view a mark of "professionalism," which he believed increasingly distinguished L.A. artists from those in the Bay Area, where the bohemian influence remained strong. Such distinctions were more than simple quirks; they were indicative of the kinds of aesthetic choices artists in Los Angeles were making in the early to mid-sixties.

Those choices were on display in two other exhibitions in 1962. Larry Bell's solo debut featured paintings the twenty-two-year-old had completed in the months since he dropped out of Chouinard. The unrelieved mania for squares that had led to his leaving school now proved to be more productive than either he or his former drawing instructor would ever have guessed. At Ferus, he showed a series of acrylics on canvas that took on one of the most fundamental problems in painting: the illusion of volume, of three-dimensionality translated into the two dimensions of the picture plane. Using only two or three colors, he placed squares within squares, but off center and at oblique angles, as if he had erased an architect's orthogonal drawing and invited you to retrace it in your mind's eye. He experimented with irregularly shaped canvases that looked like he had clipped two opposing corners off at 45-degree angles; the squares now implied cubes. As Bell exulted in the Euclidian perfection of

the cube, his friend and former teacher Irwin was starting to feel constrained by right angles. In his second show at Ferus—a month after Bell's debut—Irwin presented a series of near monochrome paintings with four barely perceptible horizontal lines: two near the top of the canvas and two near the bottom. In their very simplicity, Irwin found his most complex challenge to date, but the approach, he said, enabled him to do "more and more with less and less."

Bell and Irwin would become the artists most prominently identified with Blum's Ferus. But their parallel efforts to discover a sort of zero degree of painting—to do "more and more with less and less"—typified a sentiment that was no less evident in the new courses being charted in those years by friends and stablemates such as Bengston, Kauffman, and Price. Indeed, this new art, which would come to define Ferus in the mid-sixties, would for better or for worse ultimately become synonymous with the city itself. It was the work critics had in mind when, increasingly, they referred to the "L.A. Look."

All That Is Solid

ON THE WAY BACK TO LOS ANGELES IN 1962 after a two-year stay in Europe, Craig Kauffman stopped in New York to visit galleries and see where American art had ventured during his time abroad. In the back room of the Martha Jackson Gallery, he saw recent work by his friends Billy Al Bengston and Ken Price. Bengston had a show at Jackson that spring, which the local critics savaged. The reviewer for *The New York Times* allowed that Bengston's work was "technically efficient and at times thoughtful" but ultimately deemed it "ineffective" and "inane." The write-up in *ARTnews* treated the artist's imagery with thorough disdain while ignoring his technical proficiency. Most damning was the vituperative review in *Arts*, which dismissed Bengston's work as "fun art" that had "scarcely enriched our culture." By comparison, the critic sniped, the other artist discussed in the review did "at least have some visible talent." For Kauffman, however, the work came as a revelation. "I knew just where it had come from," he remembered. "And it all looked kind of right." Here was a new way to make art in Los Angeles—an art *of* Los Angeles. "So I came back and started up very quickly."

Kauffman had lived in San Francisco briefly in the mid-fifties. In those days, the city had been seen, both there and in Los Angeles, as having the more mature, more sophisticated of the two cities' art scenes. Many artists there could boast of their firsthand acquaintance with Hans Hofmann, Mark Rothko, and Clyfford Still from

those artists' teaching days in San Francisco and Berkeley, a lineage that bestowed a seriousness not extended to the poor relations in L.A. But it wasn't long before Kauffman soured on the Bay Area's bohemian airs. "I sort of liked the beatnik scene," he allowed, "but I didn't like it all that much." It struck him as a "lonely, dismal movement," and the artists he knew seemed mired in a slough of overripe Abstract Expressionism, "splashing around" on canvases "with thick paint and muddy coloring." He wanted out of "all that mud stuff," he said. "I just wanted to do something very, very sparse."

The two Kauffman paintings included in the opening show at Ferus eschewed melodrama and "mud" but still had a "San Francisco flavor," as Kienholz put it. A year later, however, in his first one-man show at the gallery, Kauffman unveiled a group of paintings unlike anything seen on the West Coast. The only link between the new paintings and those that preceded them, Kienholz noted, was Kauffman's "ability to paint as though the light source were coming from the canvas." The newer canvases testified to a "funny combination of influences," Kauffman said. "Mondrian and Duchamp and Dada and biomorphism and Abstract Expressionism all at once." Despite the mix of influences, it worked. That's what Bengston meant when he called Kauffman "the first Southern California artist *ever* to paint an original painting."

As Bengston well knew, Kauffman was not the first painter of note in Los Angeles to dispense with the overwrought theatrics of late Abstract Expressionism. John McLaughlin's paintings, typically two or three muted colors juxtaposed in an ambiguous relationship of figure and ground, seemed as modest as their somewhat reclusive author. But the artist, then nearly sixty, made his intentions clear in the catalog for a 1956 show of his work at the Felix Landau Gallery: to employ "a neutral structure devoid of the...self-expressionistic." And McLaughlin wasn't alone, as evidenced by *Four Abstract Classicists*, an exhibition at the county museum that included McLaughlin and three other Southern Californians, and that introduced the term "hard-edge abstraction."

Even so, Bengston's enthusiasm for Kauffman's paintings was understandable. For one thing, they helped cure him of a "bad case of Northern California sensibility." Bengston had spent the 1955–56 academic year in the Bay Area, at Oakland's California College of Arts and Crafts, where he had hoped to combine his interest in ceramics with the painting instruction of Richard Diebenkorn. He found the school's ceramics program stodgy, however, nothing like the thrilling demonstration he had seen by Peter Voulkos, so he returned to L.A. and, along with Ken Price, enrolled in Voulkos's class at Otis. When Bengston concluded that, however much time and effort he put into it, he would never be Voulkos's equal as a ceramist, he turned full time to the halfhearted Abstract Expressionism he had picked up in San Francisco—what he would later dismiss as "a variation on finger painting." The Kauffman paintings at Ferus in 1958 offered a new direction. The grateful Bengston would return the favor a few years later. From their first meeting at Ferus in 1957 through their breakthrough works of 1962 and 1963, the two friends fed off each other's ideas and experiments with new materials and techniques. "In the very beginning," Robert Irwin judged, "Kauffman was probably the most talented," but Bengston quickly matured into "one of the greatest talents I've ever met."

There was a breezy insolence about Bengston, a bravado that friends could usually forgive but many others would not. Among the former, Ed Ruscha called Bengston "sort of a pied piper": "One moment he would be very serious, another moment he would be like a cartoon, a clown." The *Artforum* editor Philip Leider was less generous, finding Bengston "strangely adolescent." He could be "incredibly charming," Kauffman said, but couldn't resist "a quick, sarcastic remark about how you're dressed or something." If his cockiness did not always endear him to others, Bengston's compulsion to flout the rules seemed to serve his artistic purposes. In every painting class he had ever taken, his instructors affirmed the dos and don'ts of composition: "The one thing that everybody said you couldn't do was put [the image] in the center." It seemed an

odd prohibition to someone who had spent so much time in ceramics studios. "You don't throw very well if you get out of center," he noted dryly. "So I said, 'I'm gonna put that sucker in the center; if I'm gonna be bad, I'm gonna be completely bad.'" His compositions were not only centered; they were also symmetrical, his preferred motif being prefabricated emblems such as valentines and checkerboards, often enclosed in concentric squares or circles. He eventually settled on chevrons, or sergeant stripes, as the central image.

But Bengston's most important innovation wasn't so much *what* he painted as *how* he painted it. As a youngster in Southern California after the war, Bengston grew up riding the two-foot swells at Malibu and cruising the Coast Highway in chopped, cherry roadsters. Between races at the motocross track, he would clean the mud off his bike and repaint his tank, and he became intrigued by the automotive paints. "It wouldn't make it through the event if I was using oil paint," he said. He recalled his admiration for the paint job on a 1920s Rolls-Royce and the painstaking process behind its lustrous glow. "I knew it was painted with nitrocellulose lacquer, because that was the material that was available at the time, and it was thinned with banana oil, [which] slowed the drying process." The paint on the Rolls was applied with a brush and required many coats. "After each coat, they would sand it down and smooth it out and just keep going," Bengston explained. The result was "a depth and a quality that you just don't see from something that isn't done like that. And the car was probably forty years old." Why not, he wondered, paint pictures the same way?

He gave it a shot, applying acrylic lacquer with a brush, but quickly decided "there's gotta be a better way." Brushes, he concluded, were "about as stupid a way as possible to put paint down." The auto industry had long since abandoned brushes in favor of spraying the paint onto cars. If spray guns were good enough for the automobile industry, Bengston figured, they were good enough for him. To heighten the effect, he dispensed with canvas too, spraying the lacquer on Masonite instead, which allowed for a evenness he

likened to Pointillism. "Seurat knew that by activating those colors" with dots rather than brushstrokes, "he was allowing you to activate your eye in a different way." But where Seurat's technique gave his paintings a soft-focus quality, as if we were viewing the scene through a gauzy scrim, the high-gloss finish Bengston perfected gave his works a hard, adamantine quality that undergirds their symmetrical compositions and hot-rod colors. The result was a dizzying sensation, somewhere between the flashing lights of a pinball machine and Charles Demuth's hallucinatory painting from the 1920s, *The Figure 5 in Gold*.

Bengston's deep involvement with materials harkened back to his training in ceramics, and at the time he picked up the spray gun, he was sharing a Venice studio with Price. Clay remained Price's medium of choice, but there was a discernible kinship between the smooth, brilliantly colored, egg-shaped sculptures he embarked on beginning in 1962 and his studio mate's new paintings. Sculpture, everybody had seemed to know up until then, was governed by an unwritten rule that demanded "truth to material": metal should look like metal; stone, like stone. To apply color was taboo. Price would have none of that. "The beauty of color itself is enough reason to be interested in it," he insisted. His eggs and other works from the mid-sixties radiated with iridescent purples, candy-apple reds, and acid yellows. Other sculptors, Irwin observed, used color as "a kind of pastiche, on the surface." In Price's work, by contrast, color "magnified the form—it really enhanced the weight, the density, the physicality of it. You always had the feeling that if you broke one of those eggs in half, they'd be that color all the way through." At Bengston's suggestion, Price tried spraying automotive lacquer onto his work.

These early efforts by Bengston and Price were the cause of Kauffman's excitement when he saw them at the Martha Jackson Gallery. Back in Los Angeles, he threw himself into his work, testing various paints and surfaces to find a combination that would get him closer to that "clean" look he was after. He brushed paint onto

panes of glass, applying it on the back to produce a perfectly smooth surface and a "nice, neat line." But glass was heavy and unwieldy, and he wanted to work on a larger scale, so he turned to the comparatively lightweight Plexiglas. Then Bengston made a suggestion. "He said, 'Why don't you just spray that stuff on. It will go on better.' And it was true." But if there was a eureka moment for Kauffman, it came when he least expected it. At a doughnut shop across the street from his Venice Boulevard studio one day, Kauffman was brought up short by the drink dispensers behind the counter. "There were two big pop machines that bubbled and spewed stuff out." He had seen them a hundred times before—they were a familiar enough sight at diners around town—but now he really *looked*, and what he saw amazed him. One of the dispensers was a sphere, like a giant Sunkist orange, and it radiated a hue rarely found in nature; the other took the form of an oversize bunch of grapes, glowing an inky purple from the liquid within. "I thought, 'Jesus, that would be really great to have colors like that in my paintings.'"

The dispensers were, Kauffman knew, the products of vacuum forming, a process for modeling the plastics used in everything from consumer products to the automotive and aerospace industries. Postwar popular culture would not have looked the same without it. Vacuum-formed signs dotted the roadside and lit up the night sky: the glowing yellow clamshell that towered over the corner gas station; the golden arches that framed the familiar drive-in. Kauffman decided to make it his own. He located a fabricator near downtown Los Angeles and told them he was an advertising designer—he figured they wouldn't have wasted their time on an artist. But the charade wasn't necessary: "They were sort of curious about it too," he said. They could work him in between bigger jobs. He would design the forms, then take them down to the plant, where the crew would press the plastic over a mold.

The nicknames Kauffman adopted for his various series of the sixties give you a pretty good indication of their basic forms. There were "hockey sticks" and "washboards," "awnings" and "loops,"

"large bubbles" and "small bubbles," among others. Though an individual piece was vacuum formed from a single sheet of Plexiglas, the relationship between figure and ground was sustained by the simple, stylized shapes in relief and the contrasting colors, which were typically high-key and rarely strayed far from primary hues. That all changed with the large bubbles. Begun in 1968, those were formed by plastic sucked into a bathtub-shaped mold. Kauffman then painted the interior of each piece with "thirty or forty" coats of Murano paint, the sort that Price was using to such brilliant effect on some of his ceramic sculptures. He finished each with a layer of acrylic lacquer, which, he explained, "sort of eats into the surface" of Plexiglas, making the color appear indistinguishable from the form rather than as pigment applied on top of it. The final result was a strange, pearlescent object, like some oblong search craft sent from the future, emitting a glowing, inner light at a part of the color spectrum not ordinarily visible to the human eye. "I wanted it to kind of pulsate and be very vague about what it was," Kauffman said. He succeeded.

LARRY BELL TRAVELED A SIMILAR PATH during those same years. But whereas Kauffman had abandoned the idea of painting on glass to pursue the possibilities of color embedded in plastic, Bell, quite by accident, found a way to achieve a comparable shimmering surface effect on glass. He had a day job at a frame shop in 1962, and when business was slow, he would wander into the front of the store, grab one of the little maple shadow boxes the owner left in a $1 bin by the door, and retreat again to the workshop to toy with the thing. Using leftover scraps of glass, mirror, and other odds and ends that were lying around, he would crack the glass slightly and study the patterns of shadow on the back of the box. "I didn't think they were art," he said of the shadow boxes. "They were just something I was doing" to kill time. He was taken by surprise, therefore, when he set one of the boxes down on a table and noticed how it caught the

light. The line of a crack on the glass was redoubled by its shadow and redoubled again by the shadow's reflection in a mirror. "The proportions, the way the line went across—everything was just right." How, he wondered, "could anything be 'just right' so easy?" He tried at first to incorporate glass and mirrors into canvases not very different from those he had been working on, but the results seemed gimmicky and unresolved. "That's when I decided to start making the cubes themselves instead of making pictures of them," he said. "All of a sudden I became a sculptor."

His first effort was essentially a wooden box frame with glass sides, but the exercise proved more difficult, and more expensive, than he had anticipated. "If I was going to keep going with this kind of work, I had to figure an easier way." Through trial and error, he succeeded in streamlining and constructing a nearly all-glass cube, its six sides joined only by thin strips of brass. In the meantime, Bell learned about "front-surface mirroring," a process commonly used in the film industry to coat camera lenses. The mirroring is applied to the surface of the glass as vaporized metal, and it determines how much light, and what kind—ordinary spectrum or infrared, for instance—will pass through or be reflected off the glass. The tricky part is getting the vaporized metal onto the glass, a procedure that requires a vacuum chamber. Bell combed the Yellow Pages and found a supplier who not only had the sheets of mirrored glass Bell was looking for but was willing to answer the artist's many questions about working with it.

His earliest mirrored cubes were not much more than a foot per side; later ones were as much as triple that. They are dazzling at any size. Depending on the viewing angle, the glass may appear wholly transparent, completely opaque, or, more often, something in between. As you examine the cube, its actual volume comes in and out of view—now you see it now you don't—as does your own reflection. Color, too, varies with the play of light on the surface. Bell silk-screened geometric patterns—mainly ellipses, but checkerboards too—on some early cubes, but concluded that the

decoration was an unnecessary distraction. They rested "*on* the volume," he noted, "but they didn't have anything to do with it; they were pictures *of* something." He addressed himself instead to "the way the glass responded to various kinds of coatings."

The response to the cubes was near universal acclaim. Most of the Ferus gang was suitably impressed, the notable exception being Bengston, who explained to Bell that, if the process weren't so costly, he would have hit upon the same idea himself. Second only to the expense, the major drawback to the cubes was their extreme fragility. When Bell was invited to show them at Pace Gallery in New York, the entire lot was destroyed in transit. Bell flew to New York to produce another batch before the show opened. He ended up buying his own equipment and teaching himself the mirroring process, saving both time and money. Bell's mirrored cubes would become icons of mid-sixties art in Los Angeles.

AS IF TO UNDERSCORE THE RELATIONSHIP between changing West Coast aesthetics and the relative fortunes of the San Francisco and Los Angeles art scenes, three of the most prominent artists associated with the so-called L.A. Look—Tony DeLap, John McCracken, and Ron Davis—were in fact Bay Area transplants. DeLap's experience as an instructor at the San Francisco School of Fine Arts illustrates one reason for the southward migration. In the late fifties, DeLap, whose background in design and architecture had contributed to an aesthetic sensibility at a significant remove from Abstract Expressionism, taught a painting course several nights a week at the school, the local art establishment's jealously guarded seat of power, where the once radical ideas of Mark Rothko and Clyfford Still had hardened into dogma. When DeLap inquired about the possibility of a day job, a faculty friend shook his head. "They wouldn't have you around there in the daytime if hell froze over," he replied bluntly. When, in 1965, DeLap accepted an invitation to put together an art department at the new University of California campus in Irvine, in

Orange County, he immediately brought his friend and studio mate John McCracken on board as well.

Like Bengston, DeLap and McCracken were both attracted to the nitrocellulose lacquers that gave such a luster to their beloved sports cars. DeLap learned to prime a linen canvas with rabbit-skin glue, making it "drum tight," then spay on the lacquer, giving the piece a hard surface. "You could put on god knows how many coats, and there was a transparency to it." McCracken had already abandoned Abstract Expressionism when he met DeLap, and he had found his way to a hard-edged, urban-industrial painting style reminiscent of Fernand Léger or Stuart Davis. McCracken moved from canvas to lacquered-wood constructions, which he first exhibited in 1965 at the Nicholas Wilder Gallery in Los Angeles. Over the next couple of years, McCracken reduced his work to a few essential shapes—cubes, ziggurats, post-and-lintel structures—composed of fiberglass and plywood and painted one color. He wanted "to use color as if it were a material," he said. To "make a sculpture out of, say, 'red' or 'blue.'"

He eventually arrived at the simplest form imaginable, a wooden plank. About six to seven feet long, each plank was leaned casually against a wall, as if momentarily set aside while its owner attended to more serious business. Compared to other objects in a gallery, a plank seemed informal and out of place, impertinent even. ("Stand up straight when I'm looking at you!") For all the simplicity of the final product, however, making it was time-consuming, backbreaking work: hours upon hours spent laying down dozens of lacquer coatings, sanding each, and finally waxing and polishing it to a brilliant shine. "If I had some kind of extremely sophisticated machine that could make these things—you know, bam! bam!—and just make them physically perfect, then I would use it," he confessed. And while the finished work had an undeniable physical presence, it had a metaphysical one as well. For McCracken, the leaning plank was a "bridge" between sculpture (the floor) and painting (the wall)—and, more important, between an embodied reality and the flight of the

imagination into a world of its own. It was "almost a hallucination," as the artist himself put it: the "incarnation…of an idea."

DeLap and McCracken left painting behind and didn't look back. That wasn't true of Ron Davis, and, in that respect, he was the Bay Area transplant who most resembled Bengston and Kauffman. For, however much they may have pushed their work in the general direction of sculpture, all three artists would remain unapologetically committed to painting. Davis, for instance, was chasing new ways to convey pictorial illusion, using shape and structure to suggest depth and volume. When he set aside acrylics and canvas for more exotic combinations of tinted polyester resins on fiberglass, it was in the service of that illusion. The trapezoids, rhombuses, and other shaped paintings he began producing in 1966 grew out of his response to Frank Stella's V-shaped canvases, which Davis had seen at Ferus in 1965. The formal issues he addressed were those familiar to East Coast artists and critics, who responded enthusiastically to his work. Michael Fried, for instance, a passionate and persuasive advocate for Greenberg-style formalism, hailed the "untrammeled illusionism" of the 1966 paintings and pronounced them to be "among the most significant produced anywhere during the past few years."

FOR ALL THE HIGH-TECH AURA OF THEIR WORK, these artists were in many respects practicing some rather old-fashioned virtues. Technology for its own sake was never the point; their zeal was for the object—for making it look "right." "I didn't start out with the idea of an industrial aesthetic," Kauffman emphasized. What drove him was "a passion for a kind of color, a kind of light, a sensuous response to material." Price, too, attributed his experimentations to the search for "an organic fusion between the surface and the color." Technical advances might "suggest new conceptual possibilities," Price acknowledged, but it was usually the other way around: "the techniques [were] developed to make the work a certain way."

There is unmistakable irony here. Bengston and Price, whose works of the early sixties provided an important catalyst for Kauffman and others, had passed through Otis during the Voulkos era and credited their former teacher with opening ceramic art to new possibilities by "liberating" it from the strictures of craft. The tables were now turned, as Voulkos's onetime students reasserted craft's importance to making "fine" art. For Voulkos, the object was of no great importance; what truly mattered was the creative act, abandoning yourself to the moment, opening the door to chance. Now Bengston, Price, and the others were driven to produce flawless objects and would leave nothing to chance in that effort.

It has long since become a commonplace to suggest that the use of automobile paints, plastics, and resins was testimony to L.A. artists' unabashed affection for the Southern California "lifestyle," above all its youth culture of sleekly waxed surfboards and stream-lined, "kandy-kolored" cars, to borrow Tom Wolfe's spelling. That artists are influenced by their environments—social as well as phys-ical—can hardly be denied, and Los Angeles artists of the 1960s were no exception. But it is easy to overstate the case. Kauffman, for instance, took the investigation of plastics and new paints further than anyone in the Ferus group, yet his interest in youth culture was virtually nonexistent. Conversely, the outgoing and athletic Irwin, with whom Kauffman shared a studio and who argued passionately for hot rods as a legitimate form of *folk* art, showed little inclination to pursue that direction for himself. There was, in short, no confu-sion among these artists about what distinguished works of art from the proliferating artifacts of consumer culture. The new materials and technologies available to them simply made possible new solu-tions to problems as old as painting itself—solutions inconceivable before the mid-twentieth century, and unlikely almost anywhere outside Southern California.

Few of the artists ever fully embraced the notion of an L.A. Look. Indeed, like all such terms, its exact meaning can be elusive. Was it a matter of light and color? Of industrial materials and processes? Of

clean lines and hard surfaces? To varying degrees, it was all of the above. But if some artists resisted the term, they generally preferred it to the other popular rubric, "Finish Fetish," a phrase that connotes slavish devotion rather than conscious aesthetic choices. Indeed, the critic Max Kozloff detected in the "sublimated" and "narcissistic" art of Los Angeles a "hormonal excitement...transferred to an adoration for the appointments of the new sexual objects: motorcycles and racing cars."

THE BREAKTHROUGH PERIOD FOR THESE ARTISTS, roughly 1962 to 1968, was also the heroic age of minimalism in New York, and the parallels were immediately noted. "Minimalism" is, in its way, as slippery a term as "Pop"; the New York art world, as was its wont, engaged in verbal fisticuffs over what counted and what didn't, as well as what it all meant. And as with any respectable philosophical rumble, the weapon first wielded involved defining your terms: "ABC art," "specific objects," and "primary structures" were some of the most frequently tossed around monikers for what nearly everyone seemed to agree was a "new aesthetic" that led beyond familiar categories of painting and sculpture while incorporating elements of both. And though most of the belligerents in this battle traded punches over developments in New York, a few did look to what was happening out West. DeLap, McCracken, and Bell were included in the important 1966 show *Primary Structures* at the Jewish Museum in New York. And when the exhibition *A New Aesthetic* opened at the Washington Gallery of Modern Art a year later, four of the six artists presented—Bell, Davis, Kauffman, and McCracken—hailed from Los Angeles.

But if this was Minimalism, it was an erotically charged Minimalism. In contrast to much of the work to be found in New York galleries, which often seemed predicated on the notion that sensuous pleasure was to be resisted at all costs, the L.A. Look reveled in brilliant, lustrous color and sleek, seductive surfaces. And whereas the

New York version of Minimalism could sometimes seem intimidating—as though its own ambiguous status were an implicit challenge to the viewer—the West Coast work was distinctly nonthreatening, inviting even. New York Minimalism seemed to defeat the viewer's gaze; the L.A. variety rewarded it. But the debates that were so fierce in New York held little interest for the L.A. artists. "People out here found it convenient to move outside the role of what was traditionally called painting or sculpture," Kauffman explained. That's all there was to it: "It happened in a very unconscious way."

That nonchalance seemed to make New York critics nervous. Fried, for instance, could give his blessing to Davis's paintings because he could fit them into a conceptual framework alongside those of Stella, but the work of Bell, Irwin, and the others, Fried sniffed, counted for "nothing more than extraordinarily attractive objects." This was more than just an aesthetic shortcoming for Kozloff; it was the embrace of "a desperate prettiness, as if sensuous delight will compensate for the shapelessness of the human situation." Beware West Coast insouciance, Kozloff seemed to warn, it is the siren song: "For the Los Angeles artists, 'pretty' is as much a term of approval as in New York it is one of condemnation. The contrast illuminates how slight is the moral weight and polemical voltage given to works of art in the West as compared with the East." The heart of the problem, Kozloff wrote in *The Nation*, was that L.A. artists' work "refuses to be pried loose from the values of its local milieu, and even its physical climate." Presumably, the art to be seen in midtown Manhattan galleries had been successfully pried loose from the values of Wall Street and Madison Avenue, or perhaps the physical climate of New York ensured a seriousness of purpose. In any event, Kozloff was far from alone in his misgivings. Indeed, others dispensed with the niceties, voicing with undisguised contempt their distaste for "the endless plastic-glossy, Minimalist interior decorations" they attributed to Irwin, Bell, and other L.A. "makers of immaculate objects that portended a kind of mystical purity and, not incidentally, looked very expensive." "Fancy baubles

for the rich" churned out by "hip young drop-out types hanging out in Venice," was how another New York critic knowingly summarized the prevailing attitude among his compatriots. Clearly the new art coming out of Los Angeles lacked the existential angst that was de rigueur among New York intellectuals.

NEARLY HALF A CENTURY AFTER ITS MAKING, the L.A. Look remains as distinctly of its particular time and place as Impressionism is of Haussmann's Paris. The analogy is surprisingly apt. For though the artists in this chapter may not deserve equal billing with the Impressionists in the annals of modern art, the most interesting thing about both was their response to the life of cities in the midst of profound physical and social transformations. Los Angeles may have been "bound up with technology like no other city in history," as one observer put it in 1966, but Parisians of the later nineteenth century were no less in thrall to the technological marvels that defined their own modern metropolis: the feats of architecture and engineering enabled by reinforced concrete, the ironworks and paned glass that made modern cathedrals of railway stations and turned the shopping arcades into dream worlds.

Impressionism captured life in the city that Haussmann transformed in the 1850s and 1860s, when he leveled much of its historical core, carving broad boulevards through the center of town, creating new districts that helped redefine public and private, work and leisure. And if postwar Los Angeles heralded a new phase in consumer culture, it was along a path that started in mid-nineteenth-century Paris. Backdrop to a never-ending spectacle in which audience and performers were one and the same, the Paris streets directed eager shoppers to the new department stores, as remarkable for their own wondrous spaces and bright displays as for the wares on sale. The freeways and regional malls that made Los Angeles the prototypical city of American postwar culture were the boulevards and *grands magasins* writ large.

Kozloff objected that "an art which wallows in the luxuriance of such mechanistic techniques as enamel on Plexiglas, automobile lacquer sprays and engraved mirrors, effecting a sheer sensuous affirmation of these materials, may not produce a tragic sense of life, but it does give a distinctly chilling impression." Such distress was voiced by the academic artists and supporters in 1860s Paris who deplored the death of history painting. Quotidian scenes of the bourgeoisie at leisure were said to lack the gravity and moral courage of the great French painters of the past. The following decade brought war, revolution, and reaction in France, but the Impressionists and their followers elided the drama of history; they were making art for and about the new consumer class. You see it in their colors and their sense of light, in their brushwork and their ambiguous spaces. "If you look at *La Grande Jatte* from fifty feet away," Bengston insisted, "it'll look like a spray painting."

The Orgiastic Future

A TRIO OF COLONNADED, CLASSICALLY PROPORTIONED BOXES set back on a raised, sun-drenched plaza overlooking twenty acres of parkland and the Miracle Mile retail corridor of Wilshire Boulevard, the white-marble-clad Los Angeles County Museum of Art was, on its opening in March 1965, a radiant symbol of a city transformed. Reflecting pools surrounding the buildings were crowned by majestic fountains, one of which splashed a brightly colored Alexander Calder mobile, inciting it to dance to and fro. Visitors traversed the pools over a wide patio, then ascended a grand stairway to arrive at the largest art museum built in America since the end of the war. Coming only months after the inauguration of an equally ambitious downtown performing arts center, the museum represented, in the solemn and celebratory words of Edward Carter, the president of the museum's board, a "cultural coming of age" for Los Angeles. Long and mercilessly ridiculed by Easterners as a desert in more ways than one, L.A. could now point with pride to the kinds of cultural showcases befitting a sophisticated and increasingly cosmopolitan populace. "A Museum Worthy of a Metropolis," crowed the *Los Angeles Times*, the all but official voice of the city's establishment. "Civic progress is not measured in terms of population, business and industry alone." But, the editorialist gravely reminded readers, "the community will need to rise to the challenge of a separate art museum." Carter was confident that

Opening night of the Los Angeles
County Museum of Art, March 1965.

it would; L.A., he believed, was "uniquely ready to spend money on culture."

A stroll down La Cienega Boulevard, a mile west of the new museum, was enough to prove Carter right. The L.A. art world was still small by New York standards; when the art dealer Rolf Nelson arrived in 1962, "things were just starting to happen," but the pace, Nelson said, was already "hectic," and if you wanted a crash course in contemporary art, a jaunt through the city's new galleries was as good a place to start as any. La Cienega's most ardent devotees hoped the street could be to L.A.'s art scene what nearby Sunset Strip was fast becoming to its music scene. Spurred on by the throngs that turned out for the Monday-night art walks, another gallery seemed to open every other week along the half-mile stretch between Santa Monica Boulevard and Melrose Avenue. The street, said *Los Angeles Times* columnist Art Seidenbaum, was like "a miniature version of the Miracle Mile." He counted "more than two dozen pit stops" on the Monday night circuit: "Stroll along there some Monday evening," he advised, "and watch the enthusiasts criss-crossing the street to see, judge (often in loud voices) and sometimes buy the merchandise."

Seidenbaum marveled at "the range of humanity" making the rounds, including the "braided and bearded and bare-toed" as well as "those dressed for dignity." The uninitiated followed the convenient gallery guide published by the museum's Art Council and were often puzzled by what they saw; those in the know touted "the gospel according to *Artforum*," as Seidenbaum put it, holding forth on "plasticity" and "negative space." For artists and serious collectors, Ferus was still the most important stop, but by no means the only one stirring excitement. When Larry Bell asked the sculptor Lloyd Hamrol, fresh out of grad school at UCLA, "So, who you gonna go with?" the question struck Hamrol like a thunderbolt. It would have been all but inconceivable just a few years earlier. "All of a sudden," he realized, there were options, and "these young kids—we had the power to decide where we were going to go."

Among the first galleries to join Ferus on La Cienega was Nelson's. Nelson was a veteran of the New York gallery scene who was quick to take on some of the well-regarded young L.A. artists who didn't quite fit the Ferus mold. In his opening year, he gave assemblage artist George Herms his first major gallery show, provided a more comprehensive look at Joe Goode's milk-bottle series than seen in the *New Painting of Common Objects* show in Pasadena, and presented a striking show of new works by Goode's fellow Chouinard alumnus Llyn Foulkes. Nelson launched Hamrol's career with a show of painted wood-and-aluminum sculpture that walked a thin line between Minimalism and Pop and that of Judy Gerowitz, who also worked a Minimalist vein, fabricating unadorned columns of fiberglass and chess-piece-size forms of clear acrylic. In homage to Gerowitz's hometown accent, Nelson nicknamed her Judy Chicago.

David Stuart's gallery was a bit more staid than Nelson's. It had been Stuart, for one thing, who protested the Warhol soup cans at Ferus by stacking the real McCoy in his front window. Up the street was the Ceeje Gallery, which started life as an emporium catering to the interior design trade, until the owners, recent graduates of UCLA, concluded that the market for paintings outstripped the one for objets d'art. The artists they showed reflected both the strengths and weaknesses of the UCLA painting program, from which most of them had recently graduated. Their work was predominantly representational, an approach that seemed to many art-world insiders like a fool's errand in the early sixties, when the success of Pop Art suggested that representation was possible only between quotation marks. It was a dilemma acknowledged in the tongue-in-cheek title of a 1964 show at Ceeje: *Six Painters of the Rear Guard*.

If one gallery can be said to have rivaled, and often surpassed, Ferus as an incubator for adventuresome new West Coast art, it was Nicholas Wilder's, which opened for business one day after the new county art museum. "It was an exciting time," said Wilder, who had worked in a Palo Alto gallery after dropping out of Stanford Law. "You could go to L.A. with six thousand dollars—all I had

in my pocket that day—and open a gallery." Among the artists he showed were not only other Bay Area expatriates John McCracken and Ron Davis but also the very different sculptors Robert Graham and Bruce Nauman. Graham, whose early miniature dioramas dabbled in the soft-core eroticism of *Playboy*, would eventually become the premier figurative sculptor of his time, while Nauman would emerge as one of the most influential artists of the past fifty years.

Wilder's openness to divergent artistic temperaments set him apart. "He never thought that one artist's [ideas] should in any way embrace another's," Goode said. "That's what made him such a great dealer." Indeed, Wilder was the one dealer who inspired the kind of adulation and loyalty among artists that was otherwise reserved for Hopps. "There were artists who would do anything for Nick," recalled Patricia Faure, who worked for him before launching a gallery of her own. Visitors to the gallery were equally enthralled. "Nick would hold people spellbound in the gallery, just amazed at the things he said," added Faure. "He would gesture with his hands, and you felt the electricity, the intelligence leaping off his fingers. It was amazing."

AS SIGNIFICANT AS THE INCREASED EXPOSURE for local talent in the sixties was the influx of artists from points east. They came at first to show at the hot new galleries—at Ferus and Nelson and Wilder, among others. Indeed, Everett Ellin and Dwan—two of the city's most important venues for new art—were known primarily for the European and the East Coast artists they brought to town. The former presented retrospectives of Jasper Johns, the sculptor David Smith, and others, frequently in collaboration with major New York dealers. Dwan meanwhile provided a West Coast home to New Yorkers such as Mark di Suvero and Donald Judd as well as to the so-called "nouveaux realists" from France.

Artists from the East Coast had even greater incentive to make the cross-country trip after Ken Tyler founded his ambitious

printmaking atelier, Gemini G.E.L.* Los Angeles had become the center of a fine-art print revival beginning in 1960, when the artist June Wayne established her Tamarind Lithography Workshop. The workshop trained up-and-coming printers by pairing them with invited artists, and Tyler rose through the ranks at Tamarind to achieve the status of master printer. When he struck out on his own in 1965, he sought to expand the idea of what such a workshop could do. He made Gemini into a laboratory where no challenge appeared too daunting, from a Robert Rauschenberg photolithographic transfer to multiples of sculptures by Ed Kienholz and Claes Oldenburg. Although Gemini did invite Los Angeles artists to take advantage of the shop's expertise, the place was best known as a magnet for major New York artists, who couldn't find anything like it back home. Johns, Rauschenberg, and Frank Stella were among those who remained in residence at Gemini for weeks, or even months, depending on the complexity of their projects. Whether they had come to L.A. to work at Gemini or to show at one of the new galleries, many of the out-of-towners remained in the city long after; some even took up temporary residence in studios of their own. The New York–based sculptors John Chamberlain and Oldenburg both found studio space in the Venice area, only blocks from the work spaces of locals such as Billy Al Bengston, Robert Irwin, Larry Bell, and John Altoon. This intermingling "changed the whole Los Angeles scene, [making] it much more sophisticated and interesting," said John Coplans. As he saw it, "Los Angeles artists rubbing shoulders with all the major artists from the East," was comparable to the experience of "Léger and the Surrealist painters arriving in New York during World War II, [when] suddenly the American artists [were] seeing that these were human figures rather than gods."

For an artist such as Hamrol, the visitors' influence was incalculable. "I had more affinity for Mark di Suvero as a sculptor than

*The initials stood for Graphic Editions Limited.

I did for any of the people out here," he explained. He was also deeply affected by the work of Oldenburg, whose soft sculpture showed him a way to work on a grand scale without succumbing to the temptation of self-important monumentality. In 1963 Hamrol participated in a happening Oldenburg staged at a parking lot in Hollywood, an event that opened Hamrol's eyes to ideas about impermanence and participation in art, issues that would become paramount in his mind as he sought a middle ground "between transient events and...durable objects."

AMID THE COMMOTION, the *Los Angeles Times* art critic Henry Seldis could find little to cheer about. In heroic tales of modern art, critics have fulfilled their part of the bargain by being duly scandalized by every new development and prophesying a calamitous comeuppance for all involved. In this, Seldis was no different. "The biggest threat facing modern art," he warned in 1963, was the rampant "permissiveness toward everything new and different that we now encounter on America's booming art scene." He bemoaned the ascendency of abstract art, which had, in his estimate, overstayed its welcome. But he bristled more at what he saw springing up to take its place in the hippest new galleries. "If [a show] got reviewed at all," Faure noted, "it was just a mention, and probably a little bit snide." That's putting it mildly. Seldis credited Pop Art only with "complete banality and cheap sensationalism." Of Ed Ruscha's debut at Ferus, he sneered that, "if you have always wanted to own a billboard of your own, here is your chance. Curiously enough, I'd rather give my time and money to fighting the billboard lobby." An early work of Hamrol's was denounced as the latest in "neo-dada" and "anti-art" fads. But the lowest circle in Seldis's inferno seemed to be reserved for Kienholz, whom the critic rarely missed an opportunity to denounce. The assemblage artist was a leader of the "toy-smashing school." "Hatred No Spur to Greater Art" ran the headline of Seldis's review of Kienholz's first show at Dwan.

Despite Seldis's prominence as art critic for the city's most important newspaper, his was by no means the most influential critical voice helping to shape the L.A. art scene in the mid-sixties. That distinction belonged instead to *Artforum*. Started in San Francisco in 1962 by a printer's sales rep who intended it as a San Francisco gallery guide and promotional piece, the small-circulation monthly magazine was edited by two relative novices and newcomers to California who were eager to make a mark: John Coplans and Philip Leider. Frustrated in their efforts to stimulate a serious conversation about new art in the Bay Area, the two first met Hopps at a lecture he gave in Berkeley. After hearing him describe the activities in Los Angeles, they eagerly turned their attention to the scene emerging in the unruly city to the south, with its brash young artists and spate of new, risk-taking galleries. When they and the magazine's new publisher, Charles Cowles, decided to relocate from San Francisco to Los Angeles in 1965, they broadened the ranks of the Bay Area brain drain that worked to L.A.'s advantage. The importance of the decision can hardly be overstated. It confirmed what the magazine's most attentive readers might have already inferred: The center of gravity for West Coast art had shifted.

But the presence of *Artforum* in Los Angeles cut both ways. The magazine provided tremendous exposure to L.A. artists who might otherwise have been ignored, and it helped foster the growth of the local scene. It is surely no coincidence that the take-off period for national and international attention to L.A. was the period when *Artforum* was based there. The steady stream of articles, essays, and reviews the magazine ran over the next few years put the city's artists and their work front and center—or, more accurately, it put a select group of artists front and center. Editors Leider and Coplans were on a mission. Leider in particular was determined to promote the idea of an L.A. Look and, no less important, to decide what it should be. "Every month we had a Ferus guy on the cover and every month the stuff we were writing was on Ferus Gallery," Leider acknowledged. (When the

magazine moved to Los Angeles, it even set up shop upstairs from the gallery.)

Leider made no apologies for his single-minded focus on Ferus. As far as he was concerned, there was nothing else around worth writing about. "Basically, we set up a war room," he explained, "and we were going to proceed to elevate the artists, and ideas on art, that were important to us...No matter what else we did, the consistent thing we were going to do was that we were going to push people like Kenny Price, we were going to push people like Billy Al Bengston, we were going to push people like Bob Irwin." A strong point of view is what makes criticism worth reading, of course, and *Artforum* could be a bracing read. But Leider and Coplans had a vision not only of where art was going but also of where they thought it *should* go. They were "empire builders," as Hamrol put it, or at least they hoped to be.

A New York intellectual who, a decade earlier, would have seemed at home editing *Partisan Review*, Leider was a fish out of water in the Los Angeles art scene. And while *Artforum*'s self-conception was heterodox, Leider's ideas about art were steeped in formalist orthodoxy. "He was absolutely anti-Duchampian," Coplans said of his colleague. "And because he detested that wing of art he also began to detest, I think, some of the West Coast artists whose ideas were neither connected with Duchamp nor with Greenberg's ideas." In turn, artists in Los Angeles became "overtly hostile" to Leider, Coplans said. Goode remembered a phone call he received from Leider. "He asked me to describe to him how the color in Irwin's paintings influenced me. I told him they didn't influence me at all, and he got really pissed off." More often, the magazine simply chose to ignore artists who didn't fit its editors' agenda. "Usually, Leider would give me a subject," the critic Fidel Danieli explained. "Go write about the new Larry Bell or the Bengston Dentos." But when Danieli "submitted a list of about twenty" Southern California artists he wanted to write about, "Leider turned the whole list down."

Coplans, for his part, seemed to be everywhere, writing not just for *Artforum* but for half a dozen or more publications that, eager for coverage of the emerging L.A. art scene, would turn to him. Never at a loss for words, he gladly obliged, writing essentially the same story over and over. "I became a spokesman for the younger artists," he acknowledged. "I saw myself in a support situation for the unknown art, in the sense of a publicist." But he wasn't just reporting on what was happening in L.A., he was helping to make it happen. "He wanted to be sort of a West Coast Clement Greenberg," Hamrol commented, "and he wanted to make artists help him make his career, to be the living proof of his propositions and his advanced theories." Coplans, added a sometime colleague, "just couldn't be bothered with facts and information. That was for sissies." Goode and Hamrol both reported being lectured by him on the proper course for them as artists. "He really wanted to tell me what I should do with my life and my work," said Hamrol. "He was more than a little peeved that I should tell him where to stop." Coplans responded with an *Artforum* review of Hamrol's next show. "Three-quarters of the way through," Hamrol said, "he just pulled the rug out from under me. He basically said that I didn't know what I was doing."

Bullying of that sort wasn't unusual, even when it came to dealing with a close friend like Wilder. His shows of artists such as Ron Davis and John McCracken were received with lavish praise, but when he brought in artists who didn't fit the bill, the reaction turned ugly. "John Coplans and those people came to me," Wilder recounted, "and told me I couldn't be taken credibly as a dealer until I got rid of Bruce Nauman and Tom Holland and people like that, that they were a discredit; they weren't helping the scene; they weren't worthy artists." When Danieli told Leider he wanted to review Nauman's first show, he was refused; when he wrote it up anyway, the piece was rejected. Only when Nauman was picked up by the Leo Castelli Gallery in New York did Leider relent, putting the previously shunned artist on the magazine's cover. "I remember

how abusive I was when I went to see Nauman's first show in Nicky's gallery," a contrite Leider admitted decades later. "I was *infuriated* with him." But Goode thought the episode was typical Leider: "If you didn't agree with him, 'fuck you'—that was his attitude."

Writing in *The New York Times* about a joint exhibition of new work by Irwin and Price at the county art museum in 1966, Leider sounded a hopeful note about changes in the museum's support for local artists. Such shows, he observed, had historically been "lacklustre" affairs, guided more by a spirit of regional boosterism than by serious consideration of art-historical merit. But he went further, pointedly rejecting as equally provincial any claim that the museum should show support for a "broad variety of styles" among L.A. artists. To the extent that he was simply arguing against a return to the old museum's annual "open" exhibitions of the region's artists, his comment isn't especially controversial, but Leider seemed to be making a broader claim, advocating the "true path" to enlightenment. Leider's formalist intransigence was the flip side of Seldis's battered humanism—with Seldis pining for a departed "rational hierarchy of values," as he put it. Indeed, as far apart as they usually were in the verdicts they rendered on the latest developments in contemporary art, the two critics shared a fundamentally prescriptive approach to their calling.

WHATEVER THE VENUE, the reviews and articles made for stimulating debate. But neither high-minded criticism nor art-world polemics had as profound an effect on the Los Angeles public's enthusiasm for contemporary art as the new county art museum. Even before it took up residence in its elegant new home, the museum exercised a subterranean influence on local attitudes. "In the early days," the curator James Elliott explained, "a good deal of what [the director] Ric [Brown] and I did was introduce people who were potential collectors to the possibility of doing it well." They felt confident of success when "a lot of people who owned Rico Lebrun [paintings] sold

them and bought other things." Once the Wilshire Boulevard complex opened for business, Southern Californians poured through its portals in impressive numbers. Membership soared, from zero to thirty thousand in its first year; nearly five million visitors had passed through its galleries by the end of the next year, making it second only to New York's Metropolitan in attendance at American museums. Visitors crowded the galleries for large surveys widely heralded as landmarks: *The New York School* in 1965 and *American Sculpture of the Sixties* in 1967, both organized by the curator Maurice Tuchman, who had been hired away from New York's Guggenheim to boost the county museum's modern art department.

Tuchman was responsible for the 1966 Kienholz retrospective as well, a major turning point in the Los Angeles public's interest in contemporary art. Kienholz's impertinence toward moral pieties and their self-appointed enforcers almost brought down the curtain on that show before it even opened. Some of the county supervisors had been touring the galleries as Kienholz's show was being installed. They didn't like what they saw. The front-page headline of the *Los Angeles Times* for March 23, 1966, one week before the show was scheduled to open, announced: "Supervisors Urge Removal of Modern Exhibit at Museum." The furor arose over two works. The first was *Roxys*, the brothel Kienholz had previously installed at Ferus. The other was a more recent piece, *Back Seat Dodge, '38*. In it, an amorous couple grasp at each other, scratching the carnal itch in the rear seat of the eponymous blue sedan, while the radio plays a rollicking prewar swing tune. The car door is ajar, allowing us to catch the action. The female figure leans back on the seat cushion, her splayed legs barely touching the floor; in her right hand she still clutches a bottle of beer (more are scattered in and around the car). Her swain, a tangle of bent and twisted chicken wire, bears down on her, lifting her skirt and pushing forward between her legs. The county board had approved a letter to Edward Carter, the museum board president, that assailed the works as "revolting...and pornographic." The supervisors stopped just short of ordering that the

pieces be removed from the show, but the museum, barely a year old and partially dependent on county funds, nonetheless held its ground. Predictably, the county fathers' fulminations only piqued the public's curiosity and turned the exhibition into a succès de scandale before it had even opened; more than a thousand visitors were waiting for the museum doors to open on the show's first day. And Kienholz became a minor celebrity, his face familiar from his picture in the *Los Angeles Times*.

The museum also devoted several smaller shows to other Los Angeles artists—the Irwin and Price exhibition hailed by Leider was one, as were those presenting work by the ceramic sculptors Peter Voulkos and John Mason. For such artists, inclusion in a museum exhibition bestowed a legitimacy that a commercial gallery show alone couldn't guarantee, and that helped in cultivating a larger, better-informed public for the local art scene. If even a small fraction of museum visitors were inspired to look further, it meant increased traffic on La Cienega, more business for the galleries, and greater exposure for their artists. But the L.A. art scene at mid-decade was never the "hysteria" that dealer Felix Landau described, with "people…tearing wet canvases off gallery walls or fighting for still unsolidified plastic sculptures." Little business was actually transacted during the Monday-night festivities; the galleries were often so packed that you could barely see the art anyhow. The evenings were mostly a way of drawing the curious, with the hope that they would return.

Serious collectors were more deliberate in their buying habits. But their numbers were still small. "From the terrace of the Garden Room you could see the front door of every major gallery in Los Angeles," Cowles recalled of the daily lunch spot where he would gather with a rotating cast of dealers, curators, and critics. "So you could sit on that terrace and you could tell exactly who was going where and what they were doing." Moreover, the sums changing hands in the galleries were seldom great. Donald Factor generally spent "in the hundreds, not in the thousands" of dollars for

a painting, he said. "We were buying art because we loved it and wanted to support those artists," he said. "A lot of times I was buying pictures to help these guys pay their rent." And not all of the serious collectors were wealthy. Betty Asher managed to build one of the best collections in town, but did so on a budget. "I always paid for everything on time," Asher explained. "Whenever I had a little money, I'd walk down La Cienega and just give each [of the galleries] fifty dollars or seventy-five dollars or whatever I could spare at the time."

"TO HAVE LIVED IN L.A. DURING THE PAST YEAR OR TWO," the author Christopher Rand told readers of *The New Yorker* in 1966, "is to have weathered a barrage of publicity about High Culture. Hearing it, one would sometimes think that building a concert hall and a museum there were events of cosmic importance…No doubt this very belatedness, by making L.A. feel defensive, has had a lot to do with the excitement." It's a fair point. Los Angeles was playing catch-up, offering its citizenry the sort of "serious" cultural offerings that inhabitants of other American cities of its size—and, for that matter, many smaller ones—had long taken for granted. And as is so often the case, the boasting and the self-congratulatory tone in all of the speechifying and editorializing betrayed lingering self-doubts, a collective inferiority complex the city was perhaps working too hard to overcome, much the way a socially ambitious newcomer to a big city might stumble over himself as he attempts to conceal his embarrassing small-town roots. Carter must have winced, therefore, when *Time* headlined its coverage of the opening of the museum "Temple on the Tar Pits," a reminder of the building's precarious location over part of the La Brea Tar Pits and of the city's reputation as an amalgamation of theme parks and mindless diversions.

But if the openings of a new art museum and concert hall were not exactly world-historical events, the moment was nonetheless a turning point. Carter wasn't wrong about that. These new

institutions hinted at changes in the social and political character of Los Angeles. For the crowds who flocked to the new museum and filled the galleries up and down La Cienega, art seemed to matter in Los Angeles as never before. In the pages of *Artforum* and in Seldis's impassioned columns in the *Los Angeles Times*, there was a new sense of urgency, a sense that something important was at stake. Wherever you looked, said Gifford Phillips, "the whole atmosphere was charged with optimism." The New York critic Barbara Rose wrote: "Visiting the galleries along La Cienega, one begins to picture Europe as the Renaissance, New York as the avant-garde and L.A. as the 'orgiastic future.'"

Suburbia and the Sublime

"IT'S ALL FAÇADES HERE," Ed Ruscha once said. "That's what intrigues me about...Los Angeles—the façade-ness." He has described himself as a landscape painter, and it's true. But Ruscha's is also an art of façades, and the landscape he painted, especially in the 1960s, was that of L.A. and its many façades—its storefronts and apartment buildings, gas stations and restaurants, and, above all, its signs: Los Angeles is a city of signs, and Ruscha is its poet-painter laureate.

Interest in the Southern California landscape was not unique to Ruscha in the 1960s. It figured importantly as well in the work of Joe Goode and Vija Celmins, two painters whose initial focus on "common objects" gave way over the course of the decade to images of desert, sea, and sky. It was not an obvious choice. Though the landscape was the defining subject of American painting in the nineteenth century, it had, by the middle of the twentieth, largely faded from view. Yet Ruscha, Goode, and Celmins all discovered a way beyond the impasse of mid-century American painting by reclaiming the Western landscape. Such concerns were a long way from the alleged dictates of the L.A. Look, at least insofar as that label implied an art preoccupied with high-tech materials or a synthesis of color and form. Still, Ruscha, Goode, and Celmins had all studied with Robert Irwin, and even if their work didn't betray any stylistic influence, it is also true that their concerns were in many ways closer to those of Irwin and L.A.'s so-called Light and Space

artists than to those of the East Coast Pop artists to whom they were initially compared. Light was a constant theme in Ruscha's paintings, for instance, as space was in Celmins's; Goode, meanwhile, tested the limits of sight, of what could be seen and what could not.

However indirect or oblique their aesthetic kinship with other Los Angeles artists, the parallels among Ruscha, Goode, and Celmins are striking. Just as L.A.'s "façade-ness" was at the heart of Ruscha's work, the Southern California landscape we encounter in the work of Goode and Celmins is one of false fronts and obstructed views. What, if anything, lies beyond the façades? An answer, I think, can be found in the history of landscape painting and the American West—and the relationship between that landscape and the idea of the sublime.

THE SUBLIME—the frisson of exhilaration and terror that arises from the sense that one is in the presence of some overwhelming, even godlike power—found its purest artistic expression in Romanticism. In the early nineteenth century, poets such as William Wordsworth and painters such as Caspar David Friedrich and J. M. W. Turner immersed themselves in the natural sublime, mirroring in their art the experience of vertiginous mountain passes, the boundlessness of the sea, or the infinitude of stars in the night sky. Evocations of the sublime were likewise key to the popular success of many crowd-pleasing American landscape painters later in the century. The genre's heavyweight champion was Frederic Edwin Church, whose *Niagara* was a work of such sublimity that crowds would stand in line for hours for the chance to swoon before its majesty. Works such as *Niagara* were, for many observers, testament to the greatness not only of the artist but of America, symbols of the young nation's vaulting ambition and its promise of spiritual renewal. Sentiments of this sort stoked the zeal for westward expansion, the ideal of Manifest Destiny that demanded continental reach, and no

one did more to promote that ideal than Albert Bierstadt, whose paintings of the Sierra Nevada rivaled Church's in their grandeur.

Postwar American painting had a brief flirtation with what the art historian Robert Rosenblum, referring to painters such as Jackson Pollock and Mark Rothko, dubbed the "abstract sublime." By the late fifties, however, Duchampian irony was ripe for revival. And irony is the enemy of the sublime; it is a small, skeptical voice calling us back from the brink. We see it most clearly in Jasper Johns and the artists who followed in his wake, including Ruscha, whose work is thick with irony. But irony alone cannot account for the hold Ruscha's work has on the viewer's imagination. Amid the absurdities so abundant in his art, an air of mystery remains.

In a series of paintings begun shortly after the *New Painting of Common Objects* show, Ruscha hit upon a strategy he would build on in years to come. Emphatically horizontal canvases—what Ruscha himself once called his "Panavision format"—helped him push the conventions of architectural perspective to comic extremes. Ruscha regarded "the horizontal line and the landscape" as "almost one and the same," and these works illustrate the point. The first, *Large Trademark with Eight Spotlights*, depicted the Twentieth-Century Fox movie logo. Twice as long as it is high, the painting captures the absurd monumentality of the emblem. Against a black background, the towering logo occupies the left side of the picture; perspective lines extend from the logo's lettering to the lower right-hand corner, where they converge. Ruscha applied the same scheme—elongated horizontal format, black sky, perspective lines meeting at the lower right—in *Standard Station, Amarillo, Texas*. The picture is divided by a diagonal that constitutes the building's roofline and overhead sign, which simply reads "STANDARD." In both paintings, the overall effect is mock heroic, a ludicrous kind of triumphalist grandeur (looking at *Large Trademark*, you can almost hear the familiar Fox fanfare).

Ruscha tinkered slightly with the formula in what has become one of his most iconic images, the Hollywood sign, executed first

in a series of prints and reprised in two later paintings.* The sign sits proudly on its hilltop, its letters silhouetted against a glowing red-orange sunset. But it also looks a little lost, occupying but a small fraction of the real estate in the center foreground, where it is dwarfed by a sky that seems to go on forever. It is no match for the mythic Western landscape, the legacy of Bierstadt paintings and John Ford Westerns, yet its mere presence deflates the myth, reminds us that it's just a Hollywood production. As the last light fades, the sign serves as the closing credits for the American sublime.

Ruscha painted the Standard station in 1963, but it had already made an appearance in *Twentysix Gasoline Stations*, the first of his many small books. Ruscha's books have a very different feel from his paintings and prints; the mock heroic is replaced by the mystifyingly mundane. Each book comprises a series of photographs, artless snapshots, of exactly what its title promises: *Twentysix Gasoline Stations*, *Nine Swimming Pools*, *Thirtyfour Parking Lots*, among others. Some of the books—including, most famously, *Every Building on the Sunset Strip*, with its twenty-five-foot-long, multi-paneled accordion fold—deal specifically with the city's façade-ness.

Even the words in Ruscha's paintings serve as façades. They are as enigmatic as the photographs of swimming pools or apartment buildings in his books. They seem to have drifted into view, flotsam bobbing along the surface of contemporary culture: advertising slogans, announcements, non sequiturs, snatches of conversation. You can try to decipher them, but as Ruscha warns in the title of one painting, there's *No End to the Things Made Out of Human Talk*. "A lot of my ideas," he told one magazine, "come from the radio." He liked it best, he added, "when it's music overlapping talk, or talk over talk." In Ruscha's paintings, no matter how you try to fine-tune the dial, you keep getting static, the white noise of crossed signals.

*Ruscha has said that he relied on the Hollywood sign as a sort of smog barometer; if he could see the sign clearly from his studio on Western Avenue, he knew the air was breathable.

Edward Ruscha, *Every Building on the Sunset Strip*, 1966, edition of 1,000 (artist's book, 7 x 5⁵⁄₈ x 299½ in.)

Is it a clue, with some deeper meaning? Or just another one of the things made out of human talk?

Ruscha is identified with paintings of words, so much so that the fact that he titled one of his largest and most prominently placed works *Picture Without Words* is reason in itself to take note. The twenty-three-foot-high canvas (its extreme verticality is another exceptional aspect) was commissioned for the opening of the Getty Center in 1997. But it was the realization of ideas Ruscha first explored in the 1970s in a series of works on paper titled *Miracle*. In the Getty painting, a shaft of light pours through a high window and illuminates a rectangular section of floor. The symbolism is deliberately hokey, like something out of *Song of Bernadette* or a prison film where the killer finds redemption before his long walk to the gas chamber, but it would be a mistake to dismiss it out of hand. Ruscha has often pointed to the role of his childhood Catholicism and its continuing influence on him, despite his abandonment of the faith by the time he was an adult. He has described his mental universe as that of "a Catholic kid intersecting with the world of crass consumerism." *Picture Without Words* is not so much a declaration of faith as a declaration that, for Ruscha, words are opaque, another façade that obstructs our vision, and their absence here provides an opening of sorts for something unnameable: The light coming through the window, whatever its source, is not among the "things made out of human talk." This is about as close as Ruscha gets to an unambiguous acknowledgment of the sublime; absent words, only the B-movie cliché of the scene itself suggests the usual ironic counterpoint. It is Ruscha's genuine fascination with the sublime that prevents his work from being merely clever.

RUSCHA AND GOODE HAVE BEEN SO IDENTIFIED WITH EACH OTHER, their personal histories so intertwined, their friendship so close, that the very real differences between them—as individuals and as artists—have too often been neglected. It's an understandable

mistake. Their first contact dates to their Catholic childhoods in heavily Protestant Oklahoma City. By the time they reached high school, religious training was little more than a memory, and a passion for drawing and design had become their most obvious bond. But Goode is as "hot" as Ruscha is "cool"; his work is more emotionally up front than that of the reticent Ruscha, a master of indirection.

Goode has emphasized the importance of seeing in his work, in particular the ability to "see through" one thing to another—through the milk bottle to the canvas behind it, for instance. But in the work of the sixties, what you could see was often opaque—the façade of a house, to take that same instance. The real drama, it seemed, was on the other side, in what you could *not* see. Philip Leider, the editor for *Artforum*, rightly noted the feeling of "entrapment" those paintings induce. Much of Goode's early work, moreover, presented similarly disconcerting scenes from suburbia. Indeed, with each new series, Goode seemed to be leading the viewer through a procession of suburban interiors and exteriors, as though in search of something just beyond our grasp.

The milk-bottle paintings were followed by similarly sized and painted canvases that made the suburban setting explicit: At the center of each was a postcard-size drawing of one or another anonymous tract home. Next, Goode set aside paint and canvas briefly to construct a group of full-scale staircases that he showed at the Nicholas Wilder Gallery in 1966. By placing a three-dimensional staircase against the gallery's wall, Goode directed your vision to the place where a picture would normally hang, but instead the wall was blank. We have entered the house, penetrated its façade, only to run up against another. He followed with paintings of windows. As with the earlier houses, Goode positioned the image at the center of a larger canvas, this time against a background of pale blue sky and cottony white clouds. The window reveals only itself: frame, latch, and sometimes curtains. Through them, the summer sky has gone gray. And even the sky itself would prove to be a veil of illusion

when, in Goode's last series of the decade, he tore into the canvas to reveal another sky behind it.

Only when Goode left the suburban sprawl of Los Angeles did the picture clear. Living in the foothills of the Sierras, he encountered a world unobstructed by façades. But he was reminded, too, as he watched a fire consume much of the forest near his cabin, that nature wasn't always benevolent or predictable—that its destructive power was awesome and indifferent to human vanity. This reawakening of the sublime would fuel Goode's paintings over the coming decades, in multiple series depicting forest fires, tornadoes, waterfalls, and other emblems of nature's force. As Southern Californians are reminded to their never-ending regret, their comfortable suburban homes—the sorts of houses that Goode had painted in the early sixties—can be wiped away in the instant of a fire, a flood, an earthquake. Even in the artificial landscape of Los Angeles, Goode reminds us, the sublime is never as far away as we think.

CELMINS WAS AN APOSTLE OF THE "ANTI-SUBLIME": her late-1960s paintings and drawings of the Southern California landscape invoked the sublime only to reject it. "I...don't have that kind of romantic thing," she emphasized, "that Caspar Friedrich tendency to project loneliness and romance onto nature; to contrast nature's grandness with tiny, insignificant watchers." Instead, she compressed the vast spaces of the ocean, the desert, the night sky—quintessential markers of the sublime—containing them within a rectangle often no larger than a sheet of notebook paper. Forgoing the usual pictorial devices—horizon lines and vanishing point, foreground and background, changes of scale—Celmins presents us with precise renderings that manage at the same time to be completely abstract. The image itself became a façade, "an armature," as she put it, that allowed her to "explore a surface through drawing it." You're never seeing the thing itself, or even its representation, in Celmins's

work, her friend Doug Wheeler emphasized. "You're seeing a way of seeing."

The sense of loneliness that pervades Goode's milk-bottle paintings comes through no less powerfully in works Celmins painted a year or two later—paintings that, like Goode's, isolated common objects from the artist's studio against a nearly monochrome ground. Celmins had been a displaced person practically from the moment she was born in Latvia in 1938. Her family was uprooted by the outbreak of war and spent the next decade constantly on the move, searching for safety amid the fighting and later trying to scrape by in occupied Germany before an international relief agency sponsored their relocation to the United States, where they settled in Indiana. "It wasn't until I was ten years old and living in the United States that I realized living in fear wasn't normal," she explained. After graduating from art school in her hometown of Indianapolis, Celmins traveled cross-country to continue her studies at UCLA. It was the first time she had been separated from her family by such a distance for more than a few weeks. "When I finally left my family and moved to Los Angeles to go to graduate school, I spent years working out my longing for my lost childhood."

Celmins arrived in Los Angeles at the end of the summer in 1962, just weeks before the opening of the *Common Objects* show. But it was indicative of how "out of it" she felt in this strange city that she didn't learn of the show's existence until after it had closed. At UCLA, however, Celmins encountered Irwin, an instructor whose ideas would have a lasting effect, even when the two artists disagreed, which was most of the time. Her aesthetic restlessness and penchant for self-criticism made Celmins a fitting match for Irwin. The latter's teaching methods hadn't changed much since his time at Chouinard where, he said, he had been "fired for being too successful." (Encouraging students to reject traditional instruction, it turned out, was not a strategy to win the undying gratitude of the school's administration.) His interactions with Celmins were, if anything, even more hands-off. "I'd present her with a question,"

he explained. "And she would put that question up in the air, and she'd break it down in all of its parts, examine each one of them, then shoot them all down." Celmins was characteristically more laconic in her assessment: "We would meet in his office and argue about painting."

Celmins found a studio on Venice Boulevard, a ten-minute walk from the ocean, which would remain her address for thirteen years. Not yet the bastion of million-dollar homes, upscale restaurants, and trendy shops it has become in the decades since, Venice was "a wonderful, lonely place," Celmins recalled nostalgically. "Almost all the buildings were empty," and the neighborhood's desolate, "wind-swept" streets suited her temperament. "I would go down…and walk along the ocean and brood." When not brooding by the ocean, she was in her studio, stripping her work of anything deemed inessential.

Celmins achieved her pictorial asceticism only after a painstaking process of elimination, trying on one style after another, rejecting it, and moving on to the next. "I probably went through five lifetimes of different sorts of painting," she said. The results were pictures filled with color and dramatic gesture that somehow left her unsatisfied. "I could make something that looked really nice but it was meaningless," she said. "So I quit." She all but drained her canvases of color, reducing almost everything to shades of gray. Her unadorned renderings of an electric fan, a space heater, or a desk lamp were somber, even severe, more evocative of the humble domestic scenes in seventeenth-century Dutch interiors, making the orange-glowing coils of the heater and a hot plate all the more intense against the shades of mud and slate.

Little escaped her obdurate eye. "I would go through my studio every six months…and take another load to the dump." One of Celmins's closest friends during their years together at UCLA recalled her removing finished canvases from their stretchers so she could reuse the wooden bars. The paintings, she figured, may have been beyond redemption, but that was no reason to waste perfectly good stretchers. Another close friend remembered visiting Celmins

and hearing a lot of rushing around before she opened her studio door to him. Once inside, he understood: She had been covering all of her works in progress with bedsheets. Irwin once remarked: "Vija has perfect taste; she doesn't like anything."

She started to take her camera on her evening walks along Venice Beach and amassed a large cache of photographs of the ocean—not clichéd, picture-postcard scenes but tightly framed shots of the surface of the water, the repetitive patterns of the waves seen from above. During this same period, Celmins made frequent trips to the desert regions east of Los Angeles and farther afield to areas such as Death Valley, often alone but occasionally with Wheeler and another close friend with a Venice studio, James Turrell. Wheeler and Turrell were both pilots, and Celmins would join them in their small planes, soaring above some of the more remote regions of the Mojave. "We all loved the desert," Celmins said. "We loved flying, we loved space, we loved light." She photographed the desert floor, framing anonymous patches of it much the way she did the ocean waves. She also incorporated distant galaxies in the night sky and some of the lunar landscapes that had been transmitted from the Apollo moon shots of the late sixties into her standard repertoire of images.

Setting aside her oil paint and canvas, Celmins instead worked with pencil and paper. By preparing the paper with an acrylic ground, she had extraordinary control over the hundreds of concise graphite marks she set down in slowly constructing the image, a process she has likened to bricklaying. Celmins conveyed depth solely through the variations of light and dark, achieving the "all-over" quality of space associated with Jackson Pollock's drip painting in works that, in every other respect, could hardly have been more different. A more apposite comparison, however, would be to Irwin and his line paintings.

Like Irwin, Celmins reduced picture-making to the essentials of light, space, and line. But in contrast to Irwin, who sought to create a painting that "doesn't begin and end at an edge" of canvas,

Celmins imposed boundaries to hold the image in check. Irwin was trying to split the atom, as it were, to reduce painting to the point of near invisibility in order to release the energy within, to achieve an escape velocity that would free him from the gravitational pull of the canvas. Celmins had no interest in such an escape. On the contrary, she said, she was "only interested in controlling the space in front of me."

IN HIS SMALL BUT INFLUENTIAL 1960 BOOK, *The Image of the City*, the urban planner Kevin Lynch investigated the "legibility" of American cities—how the people who lived and worked in a particular city formed a mental image of their urban environment. In Los Angeles, Lynch concluded, they simply couldn't: The city was too "hard to envision or conceptualize as a whole"; it was, for all intents and purposes, *illegible*.

The illegibility of Los Angeles was to a great extent a function of its sprawling, de-centered geography. But not of that alone. What was missing from L.A. was not just a real, physical center but, more important, a symbolic center, a touchstone where the city's past could speak to its present. It has often been noted that L.A.'s greatest architectural treasures are private residences, largely hidden from view, rather than public buildings. It is the latter that imbue a place with collective meaning, that serve as monuments to recall us to our history. Instead of monuments, mid-century Los Angeles was, as Ruscha never ceased to remind us, a city defined by signs, a repeating loop of signifiers that seemed to lead only to one another.

If the city was illegible, the Western landscape blazed with the unnameable; it teamed with significance, at once mythic and historic—of the frontier spirit and a continental empire, of providential favor and self-realization, of an immanent presence beyond the reach of human talk—a surfeit of meaning characteristic of the sublime. In taking that landscape as their subject, Ruscha, Goode, and Celmins each had to reconcile the contradictions between the mythology

and the dull sublunary reality of postwar Los Angeles, a task they approached with varying degrees of skepticism. "You can't just go up and read it," Celmins said of her own work. "You have to stand back and find your relationship to [it]." That was true of the Southern California landscape as well. For artists such as Ruscha, Goode, and Celmins, the challenge was to find a place to stand—a place situated, however precariously, between suburbia and the sublime.

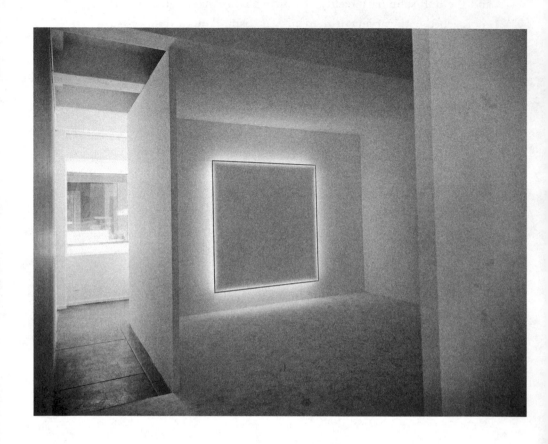

Doug Wheeler exhibition at the
Pasadena Art Museum, 1968.

Seeing and Nothingness

STUMBLING UPON ONE OF DOUG WHEELER'S "ENCASEMENTS" for the first time, you half suspect that this is what it would have felt like to be one of the lunar archaeologists in Stanley Kubrick's *2001: A Space Odyssey*, gazing in wonder at the mysterious black monolith. At the very least, the experience recalls your own first glimpse of the ultimate minimalist sculpture early in the film: With the gallery lights dimmed, you are enveloped once again in the darkness of the theater; before you is a form cloaked in shadow, its rectangular shape defined by the intense light that emanates from an unseen source behind it. The parallel seems all the more striking when you realize that Kubrick's masterpiece arrived in theaters at almost the exact moment Wheeler's pieces were making their own public debut at the Pasadena Art Museum in the spring of 1968—a moment when lunar expeditions were becoming a reality and faith in science and technology to unlock the secrets of the universe was widespread.

Wheeler's was the last of three consecutive one-artist exhibitions at the Pasadena museum that had commenced the previous fall with an installation by James Turrell and continued through the winter with a display of new works from Robert Irwin. Using different means, each artist had transformed the galleries into ambiguous spaces in which spectral objects of pure light confounded ordinary sensory experiences. Turrell employed a high-intensity light projector to cast precisely defined beams of white or colored light onto

gallery walls and into corners. To a viewer standing a few feet away, the resulting image appeared to be a three-dimensional object: a cube of light floating in a corner or a cutaway opening onto a brilliantly lit corridor. For his part, Irwin produced a series of convex aluminum discs—each about five feet in diameter and illuminated by four strategically placed spotlights—that seemed to hover in some indefinable space between the viewer and the wall.

Here was an art that pushed the technological sophistication and minimalist aesthetic of the L.A. Look to new heights. The so-called Finish Fetish art, with its embrace of industrial materials and processes, had signaled a move away from spontaneity to craftsmanship, from the artist's experience to the solid object. The new art of Light and Space took this attitude of deliberation and painstaking labor a step further, in pursuit of an immaterial object of perception. All that was solid now melted into air.

IN THE SUMMER OF 1968, just weeks after the close of Wheeler's show in Pasadena, Irwin was approached by Maurice Tuchman of the county art museum with an idea he had been turning over in his head for some time. What would happen, Tuchman wondered, if you could bring the technological resources of Southern California industry to bear on contemporary art? Or, to put it another way, if the creative imaginations of artists could harness the powerful new technologies that were rapidly transforming the world? He envisioned an ambitious, ongoing project in which the museum would bring together contemporary artists and corporations to explore the possibilities. He gave the program the working title Art and Technology, which was soon shortened to A&T.

The idea was not entirely without precedent. In 1966, around the time Tuchman began formulating his proposal, Robert Rauschenberg and a Bell Labs engineer named Billy Klüver organized Nine Evenings, a series of performances that brought together the talents of several artists and engineers in New York, and the following year

they launched an organization known as Experiments in Art and Technology. The novelty in Tuchman's proposal lay in his suggestion that the museum play the role of matchmaker, pairing artists with private corporations that could provide resources beyond the scope of the artists themselves. The trustees were less than enthusiastic about the idea when Tuchman brought it to them, but they gave him the go-ahead to approach artists and companies informally and see where it might lead. By the time he approached Irwin, Tuchman had signed up twenty corporations willing to take on an artist in residence and commit to financing any projects that might result. The specifics for the projects would be worked out by the individual artists and corporations; the results would be presented in an exhibition Tuchman planned for 1970.

Involving Irwin in the project seemed an obvious choice to Tuchman. He knew the artist well, having organized a 1966 exhibition of Irwin's paintings—slightly bowed canvases covered with colored dots of almost microscopic proportions—paintings in which, as Irwin put it, "there was nothing to look at per se" but that somehow activated "a field of energy." Those canvases, in turn, had led Irwin to the question he attempted to answer with the floating discs seen in Pasadena: "How do I paint a painting that doesn't begin and end at an edge?" Irwin's intellectual probing and his systematic method, characteristic of both his art and his success as a teacher, also made him an ideal candidate for an experiment such as A&T.

To Tuchman's surprise, Irwin hesitated; he was eager to collaborate with scientists and engineers, but he expressed misgivings about the museum's role: Would its plans for an exhibition, especially one that was only two years away, automatically predetermine the nature of the collaborations and favor certain kinds of outcomes? Tuchman assured him that it wouldn't, and Irwin eventually came around, but not before Tuchman had agreed to a further request. Irwin wished to involve a second artist in this collaborative effort, James Turrell. Turrell had developed an interest in art while growing up in Pasadena, but it had been more an avocation than a calling. As an

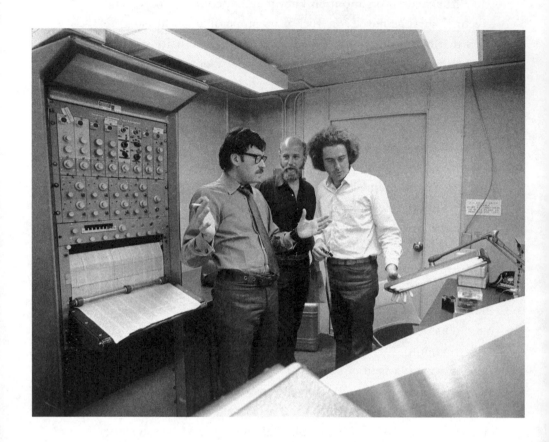

Maurice Tuchman with Robert Irwin and
James Turrell at the Garrett Corporation,
during research for the artists' contribution
to LACMA's Art and Technology project.

undergrad at Pomona College in the early sixties, his emphasis was on mathematics and perceptual psychology. Only toward the end of his time there did he reverse the equation, making those technically exacting fields the ground on which to build his ideas about art. For graduate school he chose that hotbed of minimalism, the University of California, Irvine, where he met Irwin.

The first lunar landing was less than a year away when Irwin and Turrell got started, and the kinds of issues that piqued their interest included several raised by space flight. What happens to perception under extreme conditions, they wondered. How do you keep your bearings straight in weightless conditions? The Caltech physicist Richard Feynman acted as an informal consultant to the artists early on, before they had settled on a corporate partner, helping them formulate the sorts of questions they might put to candidates. Their search led them to the Garrett Corporation, a company engaged in just the sort of research the artists wanted to undertake. Indeed, Ed Wortz, an experimental psychologist and the head of the Garrett's life sciences division, dealt with precisely the kinds of issues Irwin and Turrell wanted to explore.

The team conducted a series of experiments in perception, most notably involving varieties of sensory deprivation. They subjected student volunteers, as well as themselves, to isolation in anechoic chambers, spaces designed to absorb sound waves, not only blocking sounds from outside the room but muffling those generated inside the chamber too. Under such conditions of total silence, you begin to hear your own bio-systems at work—your lungs filling with air, blood coursing through your veins—a fact that intrigued the artists. They likewise investigated Ganz fields, visual fields (including "total peripheral vision") in which there is no color variation and, as Wortz explained, "no objects you can take hold of with your eye." (The term is an Anglicization of the German *Ganzfeld*, or "total field.") The result, said Wortz, is that "light appears to have substance in the Ganz field." At one point, the group proposed that their contribution to the exhibition be a room (or a sequence of

rooms) in the museum that would combine the conditions of Ganz fields and anechoic chambers.

Wheeler, too, had begun to explore the possibilities of the Ganz field phenomenon. In the two years following his Pasadena show, he undertook a series of increasingly complex, ambitious, large-scale installations at galleries and museums in the United States and Europe. Setting aside discrete objects such as the Plexiglas boxes he had used for the encasements, he created entire rooms occupied by nothing but light and shadow, while experimenting with various kinds of light sources—natural and artificial, neon and argon gas-filled tubes—and room configurations. For an installation at Ace Gallery in L.A., he placed the light source between a temporary wall he constructed and the gallery's permanent one and imperceptibly modified the ceiling and floor so that they tapered slightly toward the resulting wall of light, into which harder edges and surfaces dissolved. He expanded on the idea at the Tate Gallery in London, one of several venues where he shared billing with Irwin during this period. There, Wheeler concocted a vast scallop-shaped space, a Ganz field environment of pale lavender light in which the visitor seemed to vanish, as if stepping into a world of immateriality.

IN A CLIMATE WHERE ARTISTS WERE DOUBLING AS RESEARCH SCIENTISTS, studios served as live-in laboratories and exhibition halls for projects that would have been impossible in more traditional spaces. Larry Bell and Irwin, for instance, opened their studios—across the street from each other along the Venice boardwalk—for a 1970 symposium on habitability organized by Wortz. Wortz had convened a gathering of researchers in social science, ecological systems, architecture and urban design, biotechnology, psychology, and medicine to explore how "in the midst of plenty, with few material needs, we find our society dissatisfied, unfulfilled, and in need." The meetings took place mainly in Irwin's studio, in a space designed by Frank Gehry. (Gehry, a close friend to several artists, was already well on

his way to becoming the all but official architect of the L.A. art scene, responsible for studios, galleries, and exhibition installations.) But it was Bell's studio that truly tested the limits of habitability.

Bell constructed two rooms in his studio. One, designed to provide a shadowless environment, consisted of fake walls with high windows; what appeared to be daylight pouring in through the windows was in fact artificial, coming from a hidden source. The effect was especially disconcerting if you entered from the street at night. Even more unsettling, the walls of the room were not at perfect right angles to the floor and ceiling, making it seem as though the whole room was leaning. "It was not subtle. The walls were 5 degrees off," Bell said. Still, "it was amazing how many people did not notice it for a long time." The second room, painted black and lit only by a single bulb, anticipated Bell's contribution to the Tate Gallery show with Irwin and Wheeler a few months later. Wortz's wife, Melinda, recalled that the blackened room "was so unpleasant that people didn't meet there at all, but reassembled on the beach instead."

Light and Space environments were a natural progression for Bell following the success of his cubes. Indeed, the difference between the earlier cubes and the works he first made in 1968 — eight-foot-high, freestanding glass panels, connected to one another at right angles — was primarily one of scale, but was significant nonetheless. As a viewer, your relationship to a cube was never in doubt: You were *here*; the box was *there*. The glass walls, however, swallowed you whole. You might still catch a glimpse of yourself as you moved between them, but your reflection vanished a moment later, as if into an impenetrable fog, leaving you behind. It was as if you were inside one of the cubes, looking out. Such ideas were implicit in Bell's work from the start. It was not an accident that he titled a painting from 1962–63 *Larry Bell's House* and one of his first cubes *LB's House 2*. "Some of those early paintings," he said, "were direct translations...of the volume of the skylight in my studio."

Turrell's work space was a five- or ten-minute walk from the Venice boardwalk, in the Mendota, a brick, two-story former hotel

he had converted into his studio. To work on the early light projections he showed in Pasadena, he blacked out the windows and, for good measure, installed new walls in front of them, ensuring no ambient light would seep in. After the Pasadena show, however, he decided to reopen some of the windows and selectively expose the studio's interior spaces to intermittent light from the world outside—both natural and artificial, direct and reflected.

The hotel stood on the northeast corner of an intersection, so south- and west-facing windows opened onto the brilliant Southern California sunlight in the daytime; at night, streetlamps and traffic lights, combined with the headlights and taillights of passing cars and trucks, illuminated a constantly changing magic lantern show that danced across the studio's walls. Interior doorways could be opened or closed to allow combinations of light to pass through from one room to another. Turrell invited friends and others to experience the rooms, establishing a formal sequence with set durations. The *Mendota Stoppages*, as he called it, was at once an environment and a performance that involved both chance and a predetermined arrangement, as if the composer John Cage were to design a light show. Indeed, Turrell highlighted the musical dimension of the work in a set of drawings he titled *Music for the Mendota*.

WITH BUBBLING POOLS OF MUD, flashing strobes, and Claes Oldenburg's giant rotating ice bag, Tuchman's *Art and Technology* exhibition was a popular success. But in many respects, the four-year project was an expensive bust, in which neither art nor technology was particularly well served: necessity wasn't the mother of invention; technical solutions were offered for questions no one was asking. With few exceptions, the eighteen works seen at the county museum felt more like novelties than meaningful works of art. Touring the galleries was delightful fun, but in much the same way as visiting a World's Fair, where corporations such as General

Motors and IBM once thrilled audiences with their world-of-tomorrow pavilions.*

As a cultural artifact, however, the Art and Technology program holds more than passing interest. Its history revealed much about popular attitudes toward technology in the late sixties and early seventies. Technological utopianism has a long and distinguished history in American intellectual life, dating to the colonial era. By the mid-1960s, the advent of a technological Eden seemed to be upon us, especially in California, where research centers for rocket science and computer engineering did not seem out of place amid fertile valleys and citrus groves. New prophets, such as Marshall McLuhan and Buckminster Fuller, preached the virtues of life in the "global village" that was the inevitable destiny of "spaceship earth." The Art and Technology program offered grist for the New Age mill.

The collaboration between Wortz and the two artists yielded no tangible results that could be included in an exhibition. Turrell, moreover, abruptly withdrew his participation after a year, with little explanation. Measured by a different standard, however—Tuchman's stated goal of a dialogue between art and technology—their project was arguably A&T's most enduring success. Compared to the projects that *did* end up in the museum show, most of which were one-offs that had little to do with the rest of an artist's work, the knowledge gained by Irwin and Turrell would prove instrumental in their development for years to come. Whatever the philosophical motives and scientific methods employed by Irwin and Turrell, their research was leading them into a region where science and mysticism seemed to meet, opening unexpected vistas onto processes of perception and cognition, throwing into question the subjective "I" and its relationship with the world of objects.

There was, as we have seen, a rich history of such investigations in the region, some of it dubious-sounding but much else that was

*Indeed, the exhibition had a trial run of sorts at the 1970 Expo in Osaka, Japan.

compelling: Aldous Huxley's mescaline writings and Oscar Janiger's LSD studies spring to mind. And Turrell, in his notes on the anechoic-chamber experiments, referred directly and indirectly to that work. "Dealing with states of consciousness," he wrote, "is like a drug experience." He also jotted down the famous quote from William Blake about the "doors of perception" that had provided the title of Huxley's famous book: "If the doors of perception were cleansed, everything would appear to man as it is, infinite." Irwin resisted in vain tendencies to read spiritual significance into his art. The impulse among viewers to search for higher meaning in an art of such mystery and illumination was simply too great, and the larger cultural context—the fascination with altered states of consciousness that was so prevalent in the late sixties and early seventies—was inescapable. After all, even Hilton Kramer of *The New York Times*, not one given to mystic effusions, had described a presentation of Irwin's dot paintings at the Pace Gallery in 1966 as "Nirvana, in the form of four paintings."

The work of Irwin, Turrell, and Wheeler recalled a group of nineteenth-century American landscape painters whose light-filled canvases gave Emersonian transcendentalism visible form. With its bucolic scenes of rolling hills and placid shorelines, Luminism differed significantly from the powerful and popular panoramas of Church and Bierstadt. In contrast to the sublime of grandeur associated with the panoramas, a "sublime of repose" informed the quieter, contemplative canvases that exemplify Luminism. The former were full of sound and fury; the latter, silence and calm. The middle decades of the twentieth century witnessed a similar contrast between the sublime of Abstract Expressionism and that of the Light and Space artists working in L.A. The art historian Barbara Novak's comments about the glassy, still surfaces of lakes and ponds in Luminist pictures—that they offered "a refuge bathing and restoring the spirit...marrying sky and ground by bringing the balm of light down to the earth"—could be applied more generally to the devices explored by the L.A. group.

If technology and consumerism seemed to produce a world of routinization and alienation from nature, the powers harnessed by twentieth-century technologies nonetheless also provided new metaphors for the Emersonian oversoul, none more basic than the electric light itself. "The currents of Universal Being circulate through me," Emerson wrote. The oversoul, from which flowed our individual souls, he explained, was "not a faculty, but a light... From within or from behind, a light shines through us upon things and makes us aware that we are nothing, but the light is all." In the Ganz field and other light environments, distinctions between subject and object start to break down; we enter into the work of art and the work of art enters into us, flows through us. As Novak says of Luminist painting, "the spectator is brought into a wordless dialogue with nature, which quickly becomes a monologue of transcendental unity." The Light and Space art of late sixties Los Angeles bore witness to a transcendentalism for the electronic age.

AS THE EVOCATION OF EMERSON WOULD SUGGEST, we have come full circle to themes encountered in the work of Wallace Berman. It's a surprising turn in several respects. The art of Light and Space certainly looked nothing like Berman's aesthetic of assemblage and collage. On the contrary, the proximate visual source of this new work can be located easily enough in the luminescent, minimalist objects of the Finish Fetish crowd. Turrell's light projections and Wheeler's walls of beatific light were in line with the efforts of artists such as Ken Price and, especially, John McCracken (who was Turrell's instructor at UC Irvine) to create an art that embodied pure color; the essential difference was in the nature of the resultant objects: material in one case, immaterial in the other. And both groups were driven by a fascination with the possibilities afforded by the latest advances in science and technology. All of that would seem a world away from Berman's art, steeped as it was in Symbolist poetry and orphic mysteries. But Berman's interest in mystical

traditions such as Kabbalism was always tempered by a nod to rationalism, as the repeated grids of the Verifax collages remind us, just as Turrell's scientific rationalism underlay his speculations about the affinities between hallucinogenic drugs and an art of regeneration.

More surprising, perhaps, than such parallels with Berman, is the profound influence of Ed Kienholz on Wheeler. Heading back out into the street after experiencing the installation of *Roxys* at Ferus in 1962, Wheeler found that everything looked "bleached," less vivid to him than the invented world he had inhabited for an hour or so. Recapturing that same sort of intensity, that sense of being drawn into a world that is realer than real, would become one of his primary motivations as an artist.

The deepest kinship between the Light and Space movement and contemporaneous trends within L.A. was with such artists as Celmins, Goode, and Ruscha and the ways they responded to the distinctive light and wide-open spaces of Southern California. "We relate to our landscape the same way," Wheeler said, referring to his close friend Celmins. But "how she dealt with that in her work is quite different from me." That difference had to do with their respective attitudes toward the sublime. If Celmins was, at the very least, ambivalent about its allure, Wheeler showed no such hesitations, even when confronted by the narrow confines of urban reality: "No matter where I am—in a crowded street, somewhere in a city—there's a chunk of sky there that has that indefinite, dimensionless quality, [and] you're seeing a sliver of it." Or you could be, if you're attentive. "There's this whole bit of world that so many people just don't see," Wheeler added. Celmins condensed nature's plenitude into the confines of her dense drawings and paintings; Wheeler sought moments in which the confines of daily life unexpectedly gave way to the infinite beyond.

Bell was, like Goode, someone with a foot in both camps. The mazelike arrangements of his high, vapor-coated walls, with their ambiguous mirroring effects, seemed to close in on you at one moment, only to open up a realm of boundless space and infinite

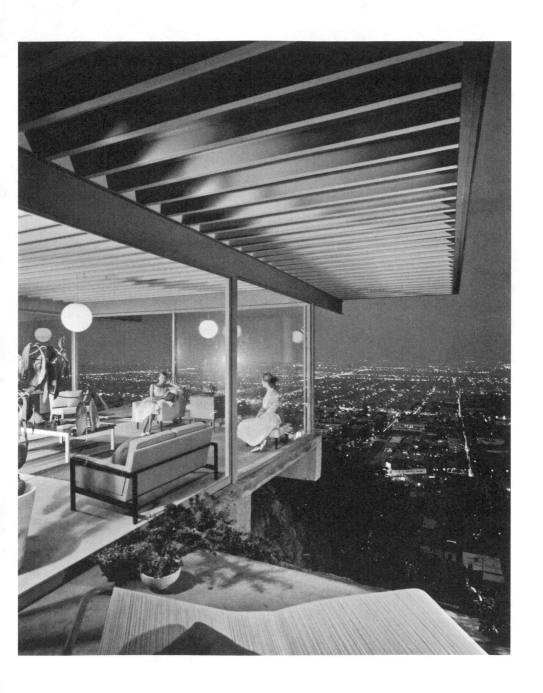

Julius Shulman, Case Study House #21.

reflection at another. In this, they resembled Goode's paintings of windows and skies, in which he placed his "torn sky" paintings behind Plexiglas so that as you looked *through* the sky to whatever lay beyond, you also caught your own reflection looking back. Similarly, one of Bell's fondest memories of his student years was standing in the studio of his instructor Robert Chuey's Richard Neutra–designed hillside home, an "all-glass room looking out over Hollywood" at night. The iconic photograph by Julius Schulman of an all-glass living room high on a hilltop, overlooking the vast sea of lights that is nighttime Los Angeles, gives a sense of what entranced Bell. At such moments, the city itself loses its "façade-ness" and serves as a vehicle for the experience that the historian David Nye dubbed the "electrical sublime": "The electrical sublime eliminated familiar spacial relationships," he writes. "In the night city, there were no shadows, no depth, no laws of perspective, and no orderly relations between objects. The urban landscape no longer seemed physically solid…The night city was a wonder that urged the viewer to merge the scintillating landscape into the self."

For the viewer gazing out at the flickering lights that seemed to stretch into infinity, the sprawl that made Los Angeles illegible by day transformed it into an emissary of the unnameable at night.

After the Gold Rush

AS FAST AS EVERYTHING HAD COME TOGETHER for the Los Angeles art scene—artists and collectors, galleries and museums, and a magazine that provided exposure and thoughtful criticism—it just as quickly seemed to fall disastrously apart. By 1967, the museums were mired in boardroom politics, several of the most important galleries had closed, the magazine had flown the coop, and even some of the artists were starting to pack up and move out.

Despite the appearance of abruptness, the problems were not new. The changes to the region in the postwar era had been profound, but the village attitude built into Southern California's sprawling, fragmented geography was still a powerful counterforce. In older American cities of the East, the monied elite had established cultural institutions in the late nineteenth century; over time, involvement in those institutions not only conferred social status but also inculcated a sense of duty to past and future generations, a form of noblesse oblige practiced by the new aristocracy of industrialists. To serve on the board of a great museum or symphony orchestra was to assume a responsibility to the larger community. Civic life was an expression of civic identity. But such a culture had not entirely taken hold in Los Angeles by the mid-sixties, and civic identity wasn't possible where there was no *civitas* to begin with. Los Angeles was, as one study of the city summed up, a "fragmented metropolis" and, to borrow the title of

another, a "reluctant metropolis." There was little noblesse and even less oblige.

The repercussions of that deficit were evident almost immediately at the new county art museum. Richard Brown, the director who had guided the project from conception to fruition over the course of a decade, was gone a mere six months after the gala opening, forced out by trustees who jealously guarded their power and prestige. A fundamental problem was the dual nature of the organization, conceived as a public institution but controlled by private interests. Edward Carter, the board president, was a consummate deal-maker, and the deal he struck with the county was shrewd: The county would provide the land and the expenses of operating the physical plant; wealthy donors would be financially responsible for everything from staff salaries to programming.

To lure major donors, Carter coaxed, cajoled, and promised. And at the very outset of the project, he made a promise that would have grave consequences. In securing a pledge of $2 million from Howard Ahmanson, the chairman of Home Savings, Carter agreed that the new museum would be known as the Ahmanson Gallery of Fine Arts. This understandably infuriated Norton Simon, whose pledge of $1 million had started the ball rolling, and who staunchly opposed naming a public institution for a private patron. Even if you set aside the propriety of such an act, he argued, you were courting disaster by discouraging future donors. Indeed, as if to prove Simon's point, one early donor withdrew his promised gift of Old Master paintings, a collection shaped in no small part by Brown's predecessor with the future museum in mind. Simon immediately reduced his pledge to $100,000, and the future of his collection, assumed by many to be destined for the new museum, was suddenly in doubt. Brown stepped in with a Solomonic solution: instead of one building, erect three; the largest could bear Ahmanson's name, while the institution as a whole could be the more publicly spirited sounding Los Angeles County Museum of Art (commonly known by its acronym, LACMA). The idea had the added attraction of

providing two more structures crying out for some generous bene-
factors' names over the doors. All agreed.

The question now became: Who would design this cathedral
of culture and symbol of civic virtue? An architect of international
stature was undoubtedly called for. Brown offered up a list compris-
ing several distinguished designers of the day: Philip Johnson, Eero
Saarinen, I. M. Pei, Richard Neutra, and half a dozen or so others.
Brown himself lobbied for the great German modernist Ludwig
Mies van der Rohe. Carter leaned toward Saarinen. Finalists were
flown in and paraded before the board. A month of deliberations
delivered a unanimous decision: the Los Angeles County Museum
of Art would be designed by Mies van der Rohe. There was just one
hitch: The unanimous decision wasn't quite unanimous. It had been
made without Ahmanson, and though the billionaire banker had
agreed to the compromise on the museum's name, another condi-
tion he had extracted from Carter—veto power over the choice of
an architect—was still in force. Ahmanson had participated in the
vetting process, relying on advice from Millard Sheets, the man who
had fired Peter Voulkos from Otis, but he had given no hint that
he would stand in anyone's way. Not long after he was informed of
the other board members' selection, however, a new list suddenly
appeared. At its top was a name no one else had considered a seri-
ous contender until then, William Pereira, a local architect prized
by large developers for his no-nonsense institutional style—a staple
of college campuses, television studios, and airports. Instead of a
modernist landmark along the lines of Mies van der Rohe's 1968
Neue Nationalgalerie in Berlin, or a valedictory magnum opus from
the Viennese-born Neutra, who had made Los Angeles his home
for nearly four decades (he died in 1970), the new museum build-
ings would prove to be an uninspired amalgam of "temple of cul-
ture" clichés wedded to the banal familiarity of a suburban shopping
mall in which the Ahmanson gallery was the "anchor store." (A fit-
ting choice for Carter, whose fortune was tied to just such regional
malls, and Ahmanson, whose lumpish savings and loan buildings

around Los Angeles had been designed not by an architect but by Sheets.)

Critics held their fire at first. They overlooked the buildings' obvious shortcomings, praising instead the patios, the parklike setting, and the view of the hills. That soon changed. In the *Saturday Review*, the widely respected Katharine Kuh condemned the "heavy-handed architecture" and declared the overall effect "singularly oppressive." Others followed, and opinion soon hardened against both the museum's bland exteriors and its poorly organized, unevenly lit interiors. In 1967 Hilton Kramer, reviewing *American Sculpture of the Sixties* in *The New York Times*, called the museum an "already antique monster of a building" and a "monument to bad taste." The locals didn't like it any better. The dealer Paul Kantor labeled it "the ugliest building in Los Angeles" and complained that "there's no way of making any sense out of anything…because those galleries are so bad you can't even see what's in [them]." Referring to the adjacent La Brea Tar Pits, the collector Marcia Weisman recalled an out-of-town friend consoling her: "Don't worry, honey, when it sinks into the pits, you [can] fill it in and build the right kind of museum."

The buildings were the least of Brown's problems in the summer of 1965. Powerful men who expected their employees to do as they were told, the trustees were not much inclined to listen to the museum's director or professional staff about institutional policies. Ahmanson reportedly demanded that his own collection be prominently displayed, but curators were less than enthusiastic and questioned the accuracy of several attributions. As *Newsweek* reported, "One trustee even ordered the museum's interior temperature, carefully set to preserve the art, to be changed for his personal comfort." Tensions came to a head when the trustees informed Brown that, in short, he would be demoted. The reason for this, Carter alleged, was Brown's "demonstrated inability to deal adequately with the administrative problems of a major art museum," a surprising charge against the man who had steered this very same art museum

from idea to reality. Other trustees complained about Brown's "bad decorum" and, in a stunning display of psychological projection, described him as "petulant and insecure." Carter claimed that staff morale was low and Brown's incompetence was to blame. But the staff made it clear that they backed Brown.

The local art community was in an uproar. A Save the Museum committee sprang into being, drawing a crowd of some five hundred concerned citizens to a meeting at the Westside Jewish Community Cultural Center, where they demanded changes in the size and structure of the board and in its relationship to the professional staff. The board, they insisted, should be expanded to allow for representation of a broader cross-section of the community. An editorial in *Artforum* denounced the trustees as "self-seeking individuals making a crude spectacle of themselves in an attempt to slice the museum pie according to their own untrained wishes." Collectors announced that their collections would never end up at the museum.

The outrage wasn't limited to the art crowd. Angry letters poured into the *Los Angeles Times*, many pointing out that the museum was a tax-supported institution and challenging the right of a private, self-perpetuating board to act in ways that seemed to put self-interest before the public good. "It is imperative," protested one, "that we, as taxpayers, initiate sufficient pressures to effect basic changes" in the museum's management as a public trust. "The feeling grows that the vast promise offered by the new museum," another wrote, "is being threatened by the actions and desires of a few men whose right to their positions of power is highly questionable."

Carter and his fellow trustees were caught off guard by the depth of the public's hostility toward them. But they were particularly stunned by the *Times*'s own editorial siding with Brown: "It was Brown who conceived the idea of the new facility," the paper noted, "and who served as a catalyst in the extraordinary effort that led to its construction." An administrator should answer to the director, not to the board, and "board members must not circumvent the director's authority in administrative or creative fields."

Carter fumed at the audacity of the paper's editorial writers in daring to question the board's judgment. "It may be somewhat presumptuous of your staff to lecture this quite sophisticated group of corporate managers on...what represents the ideal future administrative arrangement within our organization." The effrontery came as a surprise because the *Times* had been such a strong supporter of the museum, Carter responded, either missing the essential point or deliberately confusing the issue.

Declaring himself "deeply disturbed" by the board's actions, the senior curator James Elliott soon announced his resignation. The board went through the motions of conducting a search for a new director before promoting Brown's self-effacing former deputy. "They had to get a weak director," charged the always outspoken Marcia Weisman. "Someone that was going to follow orders from the big boys." Gifford Phillips, who served on numerous museum boards over the years, contrasted the LACMA board to others he had known. The trustees "didn't have any real respect for the institution as such," he said. "They were much more interested in dominating and throwing their weight around than they were in serving the institution." Brown's dismissal shadowed everything the museum did for years. Kantor spoke for many when he complained that "the county museum has no active program for anything, except bullshit."

IN LIGHT OF LACMA'S SORRY BEGINNINGS, the Pasadena Art Museum's fall from grace presents a dismal case of déjà vu. In their broad outlines, the two stories have much in common: an architectural fiasco accompanied by growing hostility between the director and the board. But the fascination, like the devil, is in the details.

Talk of a new building to house the Pasadena museum had commenced the moment it first occupied the Nicholson mansion. The museum had a dollar-a-year lease option on a seven-and-a-half acre rolling hillside site in Carmelita Park, its home before the

Nicholson residence, but that arrangement was set to expire if the museum didn't build on the site soon. When Walter Hopps became the director, he persuaded the board president Harold Jurgensen to abandon grandiose plans for a "cultural center" that would house spaces large and small for performing art along with the museum's galleries. When it came time to hire an architect, however, Jurgensen was less open to suggestions, and he awarded the job to a local firm of little note. The museum staff submitted briefs on the demands of displaying and storing contemporary art, much of which the architects ignored. "Everybody hated [the design] from the word 'go' because it just didn't fulfill any functional requirements," said the preparator Hal Glicksman. And Hopps, Glicksman added, seemed to withdraw into a state of "catatonic shock."

As with Brown's trials and tribulations at the county museum, Hopps's greatest problems with his board had less to do with architecture than with politics, institutional and otherwise. The only influential board member from Pasadena who was truly committed to contemporary art was Robert Rowan, and he would prove to be an overcautious and ineffectual leader. In any event, the board itself was weak. The real energy at the museum was generated by the volunteer Art Alliance, for whom, as Hopps's predecessor, Thomas Leavitt, explained, "the quality of the parties was more important than the quality of the exhibitions." Board meetings were often rambling affairs, dwelling on minutiae while important decisions were deferred; the upkeep of the vines in the patio merited as much interest as a growing deficit in the education department's budget. There was talk of an Oriental wing for the new building, a proposal that made little sense in the context of the institution's modern focus but that would help secure a sizable contribution from one potential donor.

Rowan's approach to fund-raising left much to be desired. He informed his colleagues on one occasion that he had "received three $100 memberships from corporations just by remembering to ask his business friends, and he suggested all board members remember

to do the same." Despite rosy projections, the financial burden would only grow heavier as plans for the new building went forward undeterred. Fund-raising goals were not being met, and the museum would need to borrow half a million dollars. "Even though [Donald] Factor and [Fred] Weisman were on that board, they were still Jews and they were from the Westside of the city," Hopps said. "They were outsiders on that board, so no one was looking to them for major money." Eventually construction costs and operating expenses would bleed the Pasadena Art Museum dry. "They were completely incapable of raising money," John Coplans said of the trustees. "It was a social misdemeanor in their eyes."

At the heart of the Pasadena museum's problems was the unresolved tension that it had unwittingly acquired when it accepted the Galka Scheyer collection in the early 1950s: Could the place satisfy the demands of a culturally conservative local constituency while cultivating a national presence as the region's museum of modern art? The board seemed to hope that if it just ignored this basic conflict, it would eventually go away—the new building would solve everything. But the debate that erupted in 1965 over whether to demand Hopps's resignation demonstrated that the problem had only grown more acute. His most vocal defenders were the newly appointed representatives from the Westside, who argued that the real issue was "the policies of this museum"—more specifically "the kind of art it has, will exhibit and acquire." The museum, they insisted, needed "to serve the whole area, not just Pasadena." Years later, after Hopps was long gone and the ribbon cutting for the new building approached, museum supporters threw an Eastside-Westside Party. The theme was " 'Altogether Now' for the Pasadena Art Museum." It would be too little, too late.

LOCAL GALLERIES WERE NOT IMMUNE to many of the same ailments that beset the city's museums. Primary among those afflictions was a shortsightedness common to local collectors, often accompanied by

a stubborn refusal to loosen the grip on their purse strings. "Nobody wants to pay for anything here," was Kantor's blunt assessment. An aggrieved Rolf Nelson took it more personally. "You're basically turning yourself inside out and becoming desperately poor to help artists sell their work," he asserted. "And not getting any help from the local art scene." Contemporary art collecting in Los Angeles had entered its awkward adolescence, mimicking the outward signs of a mature market but not quite confident in its own judgments. Timid collectors waited for a "buy" signal from New York before committing to a new artist. Nelson made an effort to promote the underappreciated New York painter Alfred Jensen. "People thought I was insane," he said. Irving Blum noted that hometown sales of Larry Bell's work were modest at best before the artist's 1965 show in New York. Only afterward did local buyers show serious interest.

When they did buy, Los Angeles collectors often tried to sidestep the local dealers, in some cases purchasing work directly from artists and making frequent shopping trips to New York to buy work that was already available to them on La Cienega. To some extent this was just another sign of insecurity, the need to look to some recognized authority for approval. To buy a work at Leo Castelli or Sidney Janis was to buy with a certain confidence that your choice had already been validated by the people who mattered. But it was also a hardnosed business calculation: Buy a Frank Stella from Leo today and maybe he'll sell you a Jasper Johns tomorrow. Unfortunately for L.A. dealers, the traffic was one-way: Out-of-town collectors weren't landing at LAX, checkbooks at the ready, and making a mad dash for La Cienega. They were only dimly aware of the L.A. scene, if at all, and they figured the best of the work would find its way to New York soon enough. "Los Angeles isn't quite sophisticated, cosmopolitan, and convenient enough to attract them at the moment," one dealer said at the time. "If you have a gallery in Los Angeles you are forced to sell only to local collectors, who are a very restricted group." Finding that "love pays no bills," three out of

the four most important galleries for new art—Nelson, Ferus, and Dwan—closed for good at the end of the 1966–67 season. (Dwan remained open in New York.)

The *Los Angeles Times*'s junior art critic, William Wilson, dismissed the talk of collapse that was by the fall of 1967 becoming common among "the supersensitive denizens of the art world." But mounting evidence that the L.A. art bubble had burst convinced Philip Leider that the future of *Artforum*, if it had one, lay in New York. The high hopes for the L.A. scene, which had inspired the magazine's move from the Bay Area in 1965, seemed misplaced by 1967, when Leider and Charles Cowles moved the publication's business and editorial offices east. "I...don't propose to simply abandon the scene," Leider wrote to the New York artist and critic Sidney Tillim, "though, economically, the scene has very definitely abandoned us." Leider's bitterness over what he regarded as L.A.'s misplaced hostility toward *Artforum* was palpable. "At this point the West Coast owes us far more than we owe it." Harsh words, but if we substitute *need* for *owe*, then it was almost certainly true. For all its faults, *Artforum* had been instrumental in putting L.A. artists on the map; without the magazine's serious, sustained coverage, those artists would find themselves isolated once again. "What remains to be seen," Coplans wrote, "is whether the cultural climate of Los Angeles...can ever foster a sustained vitality."

Perhaps the greatest loss was that of Hopps, who headed east for what he expected to be a temporary exile. But he ended up staying, and the Hopps era of the L.A. art world was over. For more than a decade, he had been its indispensable man. He saw what others missed—in art and in the possibilities for building an important art scene where none existed. "He was always finding artists under rocks," Irwin said. "People nobody knew about." And for all the chaos that seemed to trail him everywhere, Hopps had a kind of genius for making things happen. From the Merry-go-round Show to Ferus and the historic exhibitions at the Pasadena Art

Museum, he had brought artists before an audience that hadn't realized how ready it was for what he had to show them. He was "like a mad orchestrator in the wings," the artist Terry Allen said. "Like the Wizard of Oz." "Who else can you think of who was at that same level?" asked Nelson, who answered his own question: "There was no one."

"There oughta be a law against sunny Southern California"*

NOWHERE WERE THE CONTRADICTIONS ROILING AMERICAN SOCIETY in the late 1960s more pronounced than in Southern California. The region, always a mecca for dreamers, became a favored destination for a new western migration, bringing seekers of a paradise unimaginable to their predecessors. Loosed from their middle-American moorings, thousands of young people drifted to L.A., where they blended in with the usual crush of runaways and wannabes. Along Sunset, from the Aquarius Theater to the Whisky-a-Go-Go, some four miles west, the sidewalks were a crowded bazaar of panhandlers, prostitutes, undercover narcs, and sightseers who had come to gawk. Barefoot kids sold the *Los Angeles Free Press* on corners. The voice of L.A.'s underground, the *Free Press* brought news of police raids, student strikes, Black Panther communiqués, the Peace and Freedom Party convention, and a sizable dose of conspiracy theorizing that, all things considered, didn't seem so far-fetched. "Who Wanted Kennedy Dead?" asked a headline in June 1968, the week after the late president's brother Robert was shot by Sirhan Sirhan in the Ambassador Hotel. A front-page story that same month explained, helpfully, "how to tell if your phone is bugged." The revolution was at hand, or maybe it was the apocalypse. No matter: Nixon rode the backlash all the way to the White House that fall.

*Terry Allen, *Juarez*.

And all of that was only a prologue to the paranoia of 1969. "That summer of the moonwalk," the novelist Robert Stone wrote in his memoirs, "the estrangement of Los Angeles from itself continued." The astronauts returned to earth in late July; lunacy itself followed a fortnight later, descending on Cielo Drive, in Benedict Canyon. From the first reports of the murders to the arrest of Charles Manson and his "family" at the beginning of December was more than enough time to sow suspicion all around. "It was," as Stone put it, "saturnalia time in Hollywood."

Like a seismograph recording rumblings deep within the culture, art in late sixties Los Angeles provided a stress test of the national psyche. The alleged dominion of the L.A. Look had always been a half-truth, but never more than now, as sixties hope and optimism morphed into seventies despair. To be sure, there were plenty of artists who continued to make the sort of exquisite objects that New York critics loved to hate. But a powerful countercurrent also gathered momentum. At issue was not just the ethereal "dematerialization" of the art object undertaken by the Light and Space movement but a more contentious *anti*-materialism, with the art object cast as the fall guy for the failed promise of an affluent society. When an artist such as Michael Asher dismantled a gallery's walls, exposing the back-room office and eliminating the symbolic barrier between art and commerce, he didn't simply remove the object from the equation; he cast doubt on the entire enterprise of art.

ROUSED FROM ITS SLUMBER, the Romantic demiurge rekindled the spirit of bohemia. Assemblage, with its emphasis on outcasts and obsolescence, returned to the fore, along with the related strategies of collage and montage. Notable in this regard was the growing importance of photography. The major assemblage artists of the fifties and early sixties had made use of photographs; Ed Kienholz integrated them into his works on occasion, and, more significantly, Wallace Berman, in *Semina* and his later Verifax collages, developed an entire

aesthetic out of the ingenious manipulation and juxtaposition of photographic images. Berman's friend and neighbor Robert Heinecken pushed that line of investigation to a breaking point of sorts, where considerations of the photographic *image* gave way to questions about the photograph as *object*—one that, like any other object in the assemblage universe, could be taken apart and reassembled.

Heinecken had established the photography program at UCLA in 1962, though he eschewed the label "photographer," since taking pictures had little to do with making his art. In works that sometimes recall Berman's collages, Heinecken dissected magazine advertising, news photos of the Vietnam War, hard- and soft-core porn, and other found elements that he recombined and rephotographed. In *Child Guidance Toys*, he photographed a department store ad in a newspaper, then dissected and reconstructed the image into a disturbing evocation of violence and national trauma, as a well-scrubbed boy peers through the scope of his rifle at a toy JFK in his rocking chair. But just as important as the image was the way it was displayed; rather than a print, Heinecken produced a black-and-white transparency, which he hung adjacent to a small spotlight a few inches from the wall. You didn't look *at* the photograph; you either looked *through* it—thus mimicking the child in the ad—or you viewed its projection on the wall. In either case, the previously simple act of looking at a photograph had been made complicated, and photography's reliability as a witness to the real was called into doubt.

Heinecken found other ways to physically disrupt the photograph as well. Affixing the image to solid objects, such as a stack of wooden blocks or puzzle pieces, he would then reorient the blocks or shuffle the pieces, breaking the image into half-recognized fragments. It was "cubist" photography (using actual cubes). Heinecken had attracted a community of like-minded students and faculty to UCLA, and many of those within his circle further expanded the sculptural possibilities of photography. So did several artists outside the Heinecken circle. In 1970, when the Museum of Modern Art

mounted *Photography into Sculpture*, an exhibition examining the formal innovations of the decade that had just ended, more than half of the works in the show were by artists based in L.A.—and half of *those* had been Heinecken's students.

Assemblage also served as a point of departure for more elaborate forays into installation, environments, and performance. Allen Ruppersberg, for example, was, much like the assemblage artists, part scavenger and part urban archaeologist. He sifted through the city's ruins in "a search for the soul of Los Angeles," as he put it. That search took him to historic neighborhoods that had been sacrificed to urban renewal as well as to alleyways behind Hollywood studios, where he would forage through Dumpsters for discarded strands of film footage he could weave into a movie assemblage. But Ruppersberg's most famous creations—*Al's Café* in 1969 and *Al's Grand Hotel* two years later—were environments on a scale that exceeded in size and scope even the grandest of Kienholz's tableaux. In *Roxys*, Kienholz slyly pointed to the parallel between the viewer and a whorehouse john; it was a parable of art as transaction. In contrast, Ruppersberg, in *Al's Café* and *Al's Grand Hotel*, built functioning businesses in which art became an actual transaction between the viewer and the artist. Fare at the café included a menu of found objects, from pinecones and twigs to eight-by-ten glossies of Hollywood starlets, as well as cold beer. Likewise, the seven guest rooms at the hotel, each a riotous installation in its own right, were occupied every night. Both places also functioned as convenient watering holes for artists who were otherwise scattered far and wide around L.A. (The café was eventually closed by the authorities, who informed Ruppersberg that in art, as in life, you couldn't serve alcohol without a license.)

By its very nature, of course, assemblage calls attention to things society would just as soon forget. That was one reason it became such an effective instrument in the hands of several African American artists, most of whom lived and worked outside the orbit of the La Cienega gallery scene—the L.A. art world being no more

Allen Ruppersberg, *Al's Grand Hotel*
(details), 1971. Ruppersberg checking
in a guest; one of the guest rooms;
Terry Allen performing on opening night.

integrated than the city itself.* And in August 1965, as white Los Angeles basked in the glory of its new art museum, the predominantly African American neighborhood of Watts erupted in a week of violence that left some three dozen people dead and set the stage for the nationwide racial strife that would mark the rest of the decade. In its wake, a dozen or so artists all too accustomed to their isolation came together to form the Black Artists Association. They developed their own support system, showing in their own galleries, exchanging ideas about art, politics, and their role in the evolving consciousness of black nationalism. "It was difficult to separate your work from that innermost feeling you had as a participant in protest of some sort," the artist John Outterbridge observed.

There were practical reasons to work in assemblage: Materials were abundant, and the prices were right. Watts was littered with wreckage; artists could walk the neighborhood's streets, collecting the elements through which they would memorialize the event and the conditions that made it inevitable. But beyond the physical detritus, Outterbridge explained, "even the trauma within the community" became part of "the debris that artists manipulate[d] and that manipulate[d] the sensibility of artists."

David Hammons, the most strikingly original talent to rise from this community, integrated found objects with a process that was at once both a performance and an ingenious twist on printmaking. Covering his own body with grease or fat, he would roll on large sheets of paper, leaving an impression he would then coat with ink or paint, revealing his profile in almost photographic detail. If the essence of action painting was an artist's immersion in the object, then Hammons's "body prints" have to be regarded as a form of action painting, one in which the final image is concrete rather than abstract. But Hammons's most profound gift was his ability to pose

*There were exceptions: Ed Bereal, for one, had been part of the 1962 *War Babies* show at the Huysman Gallery, instigated by his Chouinard classmate Joe Goode; another Chouinard alumnus and assemblage-maker, Daniel LaRue Johnson, had a solo exhibition at Rolf Nelson's gallery two years later.

difficult questions about identity and its discontents, as he assumed multiple roles in his body prints: a beggar wrapped in an American flag, a rabbi, the ace of spades, and, most memorably, the bound-and-gagged Black Panther leader Bobby Seale, silenced by the court during the infamous 1969 Chicago Eight trial.

THE SOCIAL AND POLITICAL UPHEAVALS OF THE DAY often found their most eloquent expression in unexpected places. Few artists have generated a body of work quite so perplexing or so relentlessly personal as Bruce Nauman, for instance, yet none captured more completely the paranoia of the age of Nixon. In his 1970 *Corridor Installation (Nick Wilder Installation)*, Nauman used closed-circuit video and three long, barely passable hallways to produce an electronic hall of mirrors. As you walk down the thirty-foot corridor toward a video monitor, you see your own image there, but only from behind, as if you were looking at someone else. Moreover, because you are caught between the monitor and the camera, the closer you get to the former, the farther away you seem to be from your own image. In contrast to the widespread techno-utopianism of the moment, and particularly the popular notion that the new medium of video heralded an era of participatory democracy, Nauman exposed the darker aspects of the technology and its potential for greater personal alienation and social control.

Violence, experienced as primarily psychological in Nauman's vaguely sinister rooms and corridors, was given a real, corporeal presence in the various performances that earned Chris Burden instant notoriety in the early seventies as an enfant terrible of the art world. Burden represented the most extreme instance of an artist abandoning the clean minimalism of the L.A. Look in favor of a much darker, edgier approach to art. When he entered the graduate program at the University of California, Irvine in 1969, Burden was making large monochrome cubes; by the time he finished there two years later, he had abandoned such rationalist pursuits. In the course

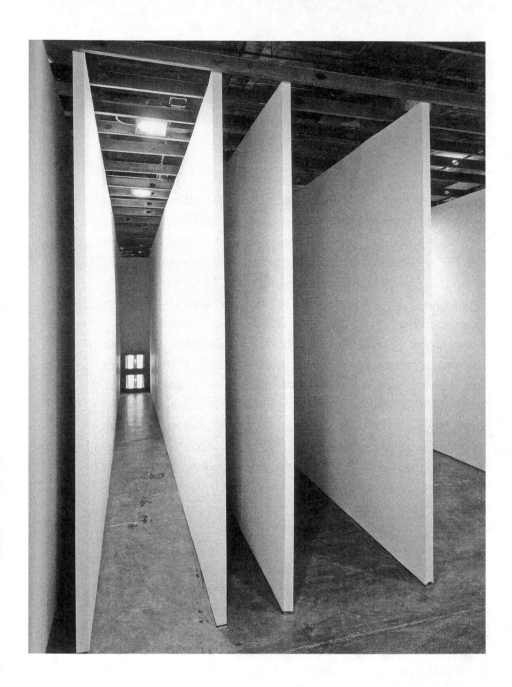

Bruce Nauman, *Corridor Installation (Nick Wilder Installation)*, 1970 (wallboard, video cameras, monitors, videotape; dimensions variable, 132 x 480 x 360 in. overall as installed at the Nicholas Wilder Gallery)

of 1971 alone, he crawled through broken glass, risked electrocution, invited gallery visitors to stick him with pins, and had himself crucified on a Volkswagen Beetle. In *Shoot*, he stood before a gallery wall as a friend put a .22-caliber bullet through his arm from fifteen feet.

Skeptics—and they were legion—dismissed Burden's death-defying feats as sideshow stunts, sensationalism rather than serious art. But Burden wasn't providing cheap thrills for a paying public; most of those early efforts were performed before a small audience of friends and fellow artists. He documented his performances with photographs, and post-performance he would display "relics," such as the nails from his VW crucifixion. Indeed, Burden's performances evince some of the same morbid fascination to be found in shrines to various Christian saints. He reminds us of just how much the history of Western art commemorates acts of ritual violence.

Opposition to the war in Vietnam had spread within the art community since 1965, when many local artists contributed to an Artists' Tower for Peace, erected on an empty lot at the uppermost end of La Cienega, where it intersects Sunset.* But deeper reflection on the war's meaning emerged from a work of art that made no obvious reference to the conflict, Terry Allen's *Juarez*, from 1970. The work was a breakthrough for Allen, the first in which he brought together his talents as a writer and musician with his increasingly surreal drawings and growing interest in theater. The "drawings" in this instance were in fact mixed media—pencil, watercolor, pastel, and enamel, as well as collage—framed in Plexiglas boxes and teeming with bizarre scenes of cowboy boots, cheap motels, and maps of the American Southwest. A radio played country and western and, as you made your way through the gallery, a narrative slowly unfolded. It was, as the Texas-tinged voice on the radio explained, a "simple

*One indicator of the changing national mood was the art world's reception of the *Art and Technology* show when it opened at the county art museum in 1971. Many of the corporations that participated in the A&T program also turned out to be significant contributors to the war effort, and in *Artforum*, Max Kozloff lambasted the program as "a rogue's gallery of the violence industries."

story": two young couples, strangers to one another, drive from Los Angeles to Colorado; fates collide, one couple dies at the hands of the other; the survivors flee south to Juarez.

Behind this sordid and seemingly inconsequential tale lie forces of myth and history. Among the dead is Sailor, "a Texas boy just returned from duty with the Navy in the Pacific." His assassin is Jabo, a Juarez-born pachuco haunted by visions of the Conquest, as though he were the reincarnation of an Aztec warrior, dreaming of the golden age before the Europeans arrived. Allen didn't explain the exact nature of Sailor's duty in the Pacific, but it would have been impossible in the late 1960s to have avoided thoughts of Vietnam. Sailor may have joined the navy to see the world, but in doing so he had assumed the conquistador's mantle, riding west across the waves in the name of empire. He is sacrificed to pay for the original sin of the Conquest.

WITH FEW EXCEPTIONS — the most obvious being Nauman, an international phenomenon almost from the start — these artists and their work enjoyed little of the fanfare that had greeted those who had preceded them by just a few years. Galleries quickly came and went in the late sixties and early seventies, and even the handful with staying power couldn't keep pace with the growing ranks of artists. Missing, too, was the critical attention that might have piqued the curiosity of the larger art world. In any event, there was no real market for the art emerging from late sixties Los Angeles — appropriately, perhaps, since so much of the work seemed to pride itself on its defiance of the market. A subtler but no less significant change was taking place within the local art schools. The cluster of schools that had been neighbors in the mid-city district had dissipated. The Otis Art Institute remained, but the Art Center College of Art and Design had relocated to Pasadena. Most troubling was the fate of Chouinard. The small school that had played such a large role in producing L.A.'s artists of the sixties shut its doors in 1969.

The museums offered little consolation. Complaints about the county art museum's tepid support for local artists were standard fare at Los Angeles art-world gatherings. The curator Maurice Tuchman had gone on record decrying the board's disregard for contemporary art. But things were not much more encouraging at the once reliable Pasadena Art Museum. When the institution's new building opened in 1969, the inaugural exhibition, organized by a New York curator, was a twenty-five-year survey of painting in New York, not exactly a vote of confidence in the local talent. A small companion show—*West Coast, 1945–1969*—was pulled together at the last minute, but it felt like the afterthought it was. Pasadena did offer both Ruppersberg and Allen their solo museum debuts, and smaller museums around Southern California presented group shows of emerging artists. But by 1969, even that circumspect tribune of traditional standards, the *Los Angeles Times* critic Henry Seldis, citing the widespread discontent, campaigned in his column for a semiautonomous contemporary art institute. *Art in America* wasn't so far off when it titled a 1972 survey of the L.A. art scene "All Quiet on the Western Front."

Magic Kingdom

PULLING UP TO THE CALIFORNIA INSTITUTE OF THE ARTS on opening day, instructor John Baldessari was struck by a telltale sign on the line of cars in the parking lot. "I would say ninety percent of the plates were New York and New Jersey," said the California native. At that moment, he "realize[d] that this was going to be a sort of total import of New York culture in California."

Walt Disney hoped that the school, his final creation, would also be his greatest legacy. "This is the thing I'm going to be remembered for," said the man who had given the world Mickey Mouse and the theme parks that bear his name. Having delivered Chouinard from near extinction in the late fifties, Disney turned his attention to a dream of something far grander, a Disneyland-scale "City of the Arts" in which Chouinard would exist alongside other schools, theaters, restaurants, shops, and even model homes. Mrs. Chouinard, advancing in years, the future of her school in doubt, embraced her old friend and supporter's plan to ensure its survival. The first step toward realizing Disney's scheme was the merger of Chouinard with the equally precarious Los Angeles Conservatory of Music, laying the foundation for a larger interdisciplinary school to be known as the California Institute of the Arts. In addition to art and music, there would be schools of design, theater and dance, and film and television. Disney first floated the idea in 1961, and the new arrangement was made official three years later, but neither he

nor Mrs. Chouinard would live to see the final result. The city of the arts was still in the planning stages when its benefactor died in 1966, leaving nearly half his estate to the new school. Mrs. Chouinard died three years later.

Disney had considered several locations for his city of the arts and initially had his heart set on a swath of undeveloped property situated above the Cahuenga Pass, about midway between two of the most recognizable landmarks in Los Angeles: the Hollywood Bowl and the Hollywood sign. When that proved impractical, the school's trustees looked farther afield and eventually settled on a sixty-acre hilltop site some thirty miles north of L.A. in the planned city of Valencia. Robert Corrigan, the school's first president, likened the creative atmosphere at CalArts to that of Paris or Greenwich Village in decades past. All that was missing, he apparently failed to notice, was a city.

Installed in 1967, a year after Disney's death, Corrigan had been the dean of the School of the Arts at New York University. He saw the new institute as an opportunity to establish the kinds of far-reaching, interdisciplinary programs he had hoped to build at NYU, where his ideas were met by resistance from administrators and existing departments. "There is such an Establishment power structure in the East that it is difficult to do something as innovative as this," he explained at the time. "The future of the arts is here," Corrigan declaimed with confidence. Liberated from "the cynicism that surround[ed] the arts" in New York, "the artistic axis [was] really shifting from a New York–European axis one to a West Coast axis." And what better way to break the stranglehold of the East Coast "Establishment power structure" and free untapped West Coast energies than to fire all the West Coast faculty and replace them with a new and improved East Coast establishment?

"The various deans were mostly out of New York," said Baldessari, "and they got teachers that they knew, mostly from New York, and the teachers brought their graduate students." Corrigan hired Herbert Blau, from the Lincoln Center Repertory Theater, to be his

number two as well as the dean of the school of theater and dance. Corrigan and Blau envisioned CalArts as a radical rejection of the status quo. They handed responsibility for the design school over to a psychologist of the "human potential" variety. To run the school of critical studies, they brought in the sociologist Maurice Stein, a coauthor of *Blueprint for Counter-Education*, a book—or, rather, a "non-book," as he preferred—that expounded on the need to "counter-educate" students in "a counter university." CalArts would counter-educate students by giving them more or less free rein to do as they pleased. There would be no fixed timetable, no curriculum, and no official records other than those kept by the students themselves. The only requirement was to follow your bliss.

Corrigan and Blau entrusted the school of art to Paul Brach, a transplanted New Yorker who had spent two years as the chairman of the art department at the University of California, San Diego. The cigar-smoking Brach saw himself as "the commander of his troops," said Lloyd Hamrol, one of the few local artists hired in the early days. Among Brach's first decisions was to fire nearly the entire Chouinard faculty, all of whom had believed that they would continue in their posts. Corrigan and his team justified the firings by explaining that the veterans were set in their ways and could not be counted on to make the transition to the bold new CalArts approach. "You can't play guessing games about the potentiality of any given person," was Blau's defense. Like his colleagues, Brach invoked the avant-garde's vaguely defined project of merging art and politics, and vowed to use his new position to help find "a meaningful, coherent alternative...to making luxury goods for the rich." The politics of the early twentieth-century avant-gardes had led many adherents into the arms of communism and fascism; Brach and his allies were now determined to launch their revolution from a Disney-financed academy in the planned community of Valencia.

But the art world's answer to Tomorrowland was plagued from the start with problems of all sorts. Vandalism and theft were rampant; fund-raising ground to a halt. Discontent was widespread

among students and faculty. The *Los Angeles Times* reported that "the greatest single source of complaints from students was they weren't getting enough direction," a claim supported by insiders. "There were...a number of students who wanted, and ended up demanding, more traditional classes," said Nancy Chunn, a Chouinard graduate who worked in the admissions office at CalArts. If the students were somewhat unhappy, the Disney-controlled board of trustees was beside itself. At one point the Disney faction tried to unload the school on one or another local university. Caltech and the University of Southern California were both approached, and both declined the honor. It came as a relief to almost all involved, therefore, when both Corrigan and Blau were ousted by the summer of 1972. They were replaced by an interim president, a corporate executive and Disney in-law with no background in the arts. The talk turned from dislodging the Establishment to budget cuts and "productivity."

CalArts' heavy hand alienated the locals. "The entire L.A. art community," Chunn said, "was aggressively anti-CalArts because of the way their colleagues were being treated. They were all marginalized." Tom Wudl, who attended Chouinard in the late sixties but received his degree from CalArts, made no secret of where his loyalties lay, likening CalArts to "an ill wind" that blew away "the tiny pueblo called Chouinard." And even Jack Goldstein, an artist who would become nearly synonymous with CalArts in the late seventies, acknowledged that, "in the early days of the merger, fine arts students usually said they went to Chouinard."

WHATEVER ANIMOSITY CALARTS EXPERIENCED in some corners of the Los Angeles art community, the school overcame many of its early missteps and built a reputation that, at the time, rested mainly on two programs: Post-Studio Art, the creation of Baldessari; and the Feminist Art Program, headed by Judy Chicago. The two instructors could have hardly been more different in temperament or artistic agendas, but the paths that led them to CalArts shared

common themes. In 1970, shortly before joining the faculty, both artists had publicly performed what might be called rituals of self-invention. And in both cases, they defined their new selves in opposition to the Los Angeles art scene of the 1960s. The "anxiety of influence" that fueled both artists' rise to prominence attested to a changing climate in the L.A. art world.

Baldessari's reinvention involved burning all of the work he had made before 1966. Indeed, rather than simply burn it, he had the work "cremated" and the ashes preserved in an urn. He then published a sworn affidavit announcing the action in his local newspaper and commissioned a bronze plaque memorializing it with the "birth" and "death" dates of his former artistic self. The cremation took place in July 1970. Four months later, an announcement posted outside a gallery showing her new work informed the world that "*Judy Gerowitz* hereby divests herself of all names imposed on her through male social domination and freely chooses the name *Judy Chicago*."

Brach knew Baldessari from San Diego and invited him to teach painting at CalArts, but Baldessari had lost interest in the medium. He wanted instead "to teach students who don't paint or do sculpture or any other activity done by hand," he explained. Instead he ordered film and video equipment and encouraged his students to use them as they saw fit. To "transcend the local art situation," he concluded, the Post-Studio Art program would have to hire faculty "pretty much...only from New York." The Los Angeles art scene, Baldessari explained, "was very provincial," and he would make it his mission to dethrone the "stupid" Finish Fetish and "bring in an alternative aesthetic to L.A." Baldessari's first commercial gallery show in Los Angeles, in 1968, had taken its title, *Pure Beauty*, from one of the word paintings included in the show. Like its companions, the painting lampooned a notion identified with the L.A. Look. He displayed the same irony toward the local emphasis on craft in *Quality Material*, a tongue-in-cheek list of the key ingredients in making a "perfect painting," and took direct aim at *Artforum* in *This Is Not to Be Looked At*, in which the words were accompanied

PURE BEAUTY

John Baldessari, *Pure Beauty*, 1968
(acrylic on canvas, 45³/₈ x 43³/₈ in.)

by a reproduction of the magazine featuring a shaped Frank Stella canvas on its cover.* But despite his protestations, Baldessari's conceptual bent was, as we have seen, not without precedent in 1960s Los Angeles. A distinctly Duchampian element was evident among L.A. artists throughout the fifties and sixties. You see it in assemblage, in the books and word paintings of Ed Ruscha, in the early series of Joe Goode, and even in the mechanical eroticism of Craig Kauffman, a quintessential artist of the L.A. Look. Moreover, Baldessari himself had been included in group shows alongside several of the younger L.A. conceptualists.

Baldessari's rejection of the Los Angeles art scene applied not only to the faculty he invited to CalArts. It figured prominently in his advice to students as well. "Nothing is going to happen in L.A.!" he insisted, recommending that serious would-be artists head to New York. Many who took that advice to heart were, in fact, rewarded with successful careers in the high-flying New York art world of the 1980s.

UNLIKE BALDESSARI'S SYMBOLIC AUTO-DA-FÉ, Gerowitz's reinvention as Judy Chicago had more to do with politics than aesthetics. Nothing about the work in her new persona's "debut" constituted a radical break with her own past or that of the L.A. art scene more generally. Since graduating from UCLA and landing her first show at Rolf Nelson in 1965, her work had progressed along familiar lines. Following the lead of artists like Billy Al Bengston and Kauffman, she learned automobile painting at a trade school and sprayed lacquers on vacuum-formed Plexiglas or sheets of acrylic, and her minimalist forms enjoyed a measure of critical success both locally and nationally, appearing in such landmark shows as *American Sculpture of the Sixties* and *Primary Structures*. But she felt excluded from the

*The irony is hard to ignore: The ideologically revamped *Artforum*, now based in New York and driven by heavy doses of theory, would in the 1970s become, as the critic Barbara Rose put it, the "bible" of CalArts.

group of artists whose work she admired, the notoriously macho Ferus crowd, and saw that they refused to take women artists seriously. In this, she was far from alone. An artist such as the painter Mary Corse, for instance, whose early experiments with Plexiglas light boxes should have earned her a place among the pioneers of Light and Space, was surely justified in her suspicion that "the girl thing," as she put it, counted as a strike against her when John Coplans declined an invitation to visit her studio. Women artists came up against such barriers repeatedly. "All we wanted to do was be included with the guys," the painter Karen Carson recalled. But in L.A.'s "star-struck, male-dominated art culture," she explained, "you had to be a girlfriend."

Chicago's self-baptism coincided with her founding of the Feminist Art Program at the California State University campus in Fresno. And it was then that her thinking about art in general began to change. Ordinarily, she noted, art students "were supposed to concern themselves with…formal issues that had little to do with their actual day-to-day experience." The Feminist Art Program would be different; it would emphasize art as feminist consciousness-raising rather than as the "male-oriented" mastery of particular media or genres. Students were encouraged to "deal with the sensation or experience of being physically invaded by a man or men," Chicago explained. "There was no media restriction. They were free to paint, draw, write, make a film, or do a performance."

Brach saw the program as a perfect fit for CalArts, as did his wife, the painter Miriam Schapiro. Schapiro and Chicago joined forces, and within a year, the Feminist Art Program had moved to CalArts. But the program's leaders were disappointed to discover that many women who attended art school did so because they wanted to learn how to make art as most people understood that term, not as a form of consciousness-raising or political protest. Nor were they much interested in being anyone's acolytes. "Many students did not want to be in the Feminist Art Program with Mimi Schapiro and Judy Chicago because they were so dogmatic," Chunn

said. "For some, those two were really frightening. It was especially difficult for many of the female students who were neither embraced by the Feminist group nor found a home with the Post-Studio people, which was so male dominated."

This was true outside of CalArts as well, in the larger Los Angeles art scene. Carson participated in a "consciousness-raising group," with Chicago. "It was hell," she said. "Feminism as sort of an armed boot camp." Alexis Smith, and other women artists she knew, "wanted to be taken seriously" and given the same opportunities that male artists seemed to take for granted: gallery representation, inclusion in museum shows, reviews. As far as Smith was concerned, that was the all-important role for feminism in the art world. But "the necessity of making art about it was not what this was about. We were going to make whatever art we were going to make." Chicago rejected that view. "Some women argued their right to make any kind of art they wished," she wrote in her autobiography. Artists who "ignore their situation as women" are making "a self-defeating choice." But younger artists such as Smith, Carson, Margaret Nielsen, Carole Caroompas, and others weren't ignoring their situation as women; they were responding with sharpened wits and work that balanced anger and frustration with irony and a strong sense of the absurd. Carson conceived a series of wall pieces with sections of felt that unzipped and flopped toward the floor, as a droll commentary on the assertive posturing she saw in the "New York, hard-ass, minimalist guys." She was pleased with the results. The pieces, she said, "could have been taken as a feminist statement or just minimalist art—they worked in both realms." But Chicago seemed to dismiss it for just that reason.

For all their criticisms of Chicago's heavy hand, however, women artists in Los Angeles credited her outspokenness and relentless efforts toward the cause, the most important being the Woman's Building, which she cofounded in 1973. Occupying the two-story concrete bunker of a structure that had been built for Chouinard in the 1930s, the Woman's Building complemented studio classes

with printing workshops, lectures on feminism, galleries, and a bookstore, and was instrumental in raising the profile of women artists in Los Angeles. But Chicago's claim on art history ultimately rests on *The Dinner Party*, an ambitious undertaking that was every bit as provocative, and divisive, as the artist herself—and one that highlights her ambivalent relationship with the L.A. art scene. A collaboration involving ceramists, textile workers, lace-makers, and designers, among others, the work consisted of three long tables arranged in a triangle, each comprising thirteen place settings for women from throughout history, some of whom were already celebrated writers and artists but many others whose efforts had faded into obscurity. The settings and the tablecloths were made by hand, thus incorporating into the work crafts historically identified with women and treated as handmaidens to the heroic, male-dominated realms of painting and sculpture. Each plate, based on drawings by Chicago, was an elaborately rendered vulva.

Conceived in 1974 and completed five years later, *The Dinner Party* emerged as a flash point of critical differences from the moment it was unveiled at San Francisco's modern art museum. A touchstone of feminist history and empowerment for some, it was reviled as demeaning and exploitive by others. Critics, including feminists, have blasted it as simplistic and banal, reducing women's identities to sexual anatomy, and many have accused Chicago of taking advantage of the goodwill and idealism of the dozens of "assistants" who contributed their time and labor to the elaborate tableau. Of greater interest to us here, however, is the extent to which *The Dinner Party* expressed the anxiety of influence that drove the artist—specifically, the influence of those swaggering male artists who were the self-anointed heroes of the L.A. art scene. *The Dinner Party* encapsulated the major artistic developments in Los Angeles over the previous decade and a half. The issue of craft and the alleged Finish Fetish had been central for artists in L.A. The symmetry of Chicago's imagery echoed that of Bengston's sergeant stripes and chevrons, much as her earlier training in auto-body painting recalled

his mastery of nitrocellulose lacquers. Likewise, the sexually explicit plates are usefully understood in the context of Ken Price's eroticized ceramic sculptures. But above all, *The Dinner Party* can be seen as a feminist answer to *Roxys*. However sympathetic Kienholz may have been toward the pathetic creatures that populated his infernal whorehouse, *Roxys* exudes male fears about female sexuality: the prostitutes are hideous, moldering untouchables; their sexual organs, emblems of putrefaction. *The Dinner Party* is Chicago's riposte to Kienholz's allegory of feminine corruption.

THE FEMINIST AGITPROP OF CHICAGO stood in sharp contrast to the conceptualism championed by Baldessari, but both developments were, at least in part, responses to the artists' impatience with the L.A. art scene as it existed at the start of the 1970s. And while their discontent sprang from disparate sources, it was in keeping with a general anxiety that had begun to surface among artists in Los Angeles following the collapse of the La Cienega gallery scene and the departure of *Artforum*. Growing ambivalence about the L.A. Look flourished in a climate of self-doubt, along with concerns about "provincialism" and L.A.'s standing as second fiddle to New York. The "second city" label, a token of esteem when proffered by East Coast critics in the mid-sixties, sounded with each passing year more like a backhanded compliment at best, a synonym for "second rate." Even "L.A. artist" started to sound like a loaded term, a qualifier that signaled lowered expectations. In any case, acclaim by the New York art world remained the sine qua non of success for artists in Los Angeles. CalArts just seemed to make it official.

Still the importance of the change should not be understated: The students who had emerged from Chouinard at the end of the fifties and beginning of the sixties all but defined the city's distinctive art scene for close to a decade; now Chouinard was gone, replaced by an institution that showed little interest in the fate of art in Los Angeles.

Location, Location, Location

"A RAY OF HOPE FOR CONTEMPORARY ART SCENE IN L.A.," promised a *Los Angeles Times* headline in the late spring of 1974. It was welcome news. By the mid-seventies, the diminished gallery scene along La Cienega, the departure of *Artforum*, and the disillusionment with the county art museum had all taken a toll. But the cruelest cut had been delivered by the Pasadena Art Museum.

Faced with a widening budget gap and no easy answers, Robert Rowan, the board president, floated one desperate idea after another. Perhaps, he ventured, the county art museum would be interested in a merger, making the Pasadena institution the modern branch. But the county museum had enough problems of its own and wasn't eager to take on anyone else's. Rowan turned next to the Museum of Modern Art in New York. Wouldn't its board like to have a truly national presence? There was a building in Los Angeles ready and waiting. But MoMA, too, respectfully declined. At the beginning of 1974, with disaster looming, the Pasadena museum's executive committee approved the sale of artwork—as much as $200,000 worth, including, if necessary, its greatest prize, the Galka Scheyer collection—in order to keep the museum afloat for another six months, a decision that was met with howls of protest. William Agee, the museum's final director, called the Scheyer collection "the very heart of the Museum" and announced that he "simply cannot be a party to this action."

Norton Simon was the Pasadena Art Museum's last best hope. Although he was a founder of the county art museum, and most observers had assumed his superlative collection would end up on Wilshire Boulevard, his prickly personality and take-no-prisoners style meant that nothing was ever a certainty. His early disenchantment with Edward Carter, Howard Ahmanson, and others on the county museum's board had only grown over the years. At the same time, Simon was in the habit of making repeated, often unrealistic demands, using his collection as leverage. In 1971 he quit the board and actively courted other suitors for his collection. Then, in the spring of 1974, the Pasadena board came to him, hat in hand.

Simon spelled out the conditions for his support, which were quickly agreed to. They included, among other things, the resignation of nearly all of the museum's existing board aside from Rowan and Gifford Phillips. Simon never hid his intention to turn the museum into a home for his extraordinary collection, overwhelmingly consisting of Old Master and nineteenth-century paintings, though the agreement with the Pasadena board stipulated he would devote a quarter of the museum's exhibition space to the old museum's permanent collection for five years. Since the permanent collection included the Galka Scheyer bequest of prewar paintings, he wasn't obligated to display much in the way of contemporary art; in fact, Rowan and the others vainly sought a court injunction to prevent Simon from selling off works from the contemporary collection. Among the works he deaccessioned were some that had been donated by local artists and collectors, but his actions weren't all that different from those taken by the old board in a desperate attempt to keep the museum afloat. The real difference was in the symbolism. It was clear to all that an era had ended, and the Pasadena Art Museum continued to exist in name only. In a couple of years, that would change too, and the sign out front would read "Norton Simon Museum." A sense of failure and frustration gripped the local art community.

The "ray of hope" reported by the *Los Angeles Times* was the founding of an artist-run "alternative space," the Los Angeles Institute of Contemporary Art (LAICA). The institute was the brainchild of Robert Smith, who had previously run small nonprofit galleries around greater Los Angeles. Following a series of gatherings Smith convened in artists' studios and collectors' homes around town, he enlisted a dedicated few to launch a sort of *Kunsthalle* for Southern California art, focused almost exclusively on exhibitions and unencumbered by buildings, permanent collections, and board members with outsize egos and hidden agendas. Smith declined the director's prerogative to set the course; he would act solely as an administrator, and there would be no permanent curators. All decisions would be made democratically.

Smith had envisioned a small storefront in an unfashionable neighborhood, where rents would be affordable. But Marcia Weisman, who summoned Smith to her home when she learned of his proposal, had grander ideas. A decade earlier, the aluminum manufacturer Alcoa had joined with a local developer to purchase a hundred and eighty acres of land, formerly the back lot of Twentieth-Century Fox studios. There, wedged into a corner that joined portions of Beverly Hills and Westwood, they built Century City, a new business district of high-rise office and apartment buildings, hotels, restaurants, and retail space—an instant downtown for L.A.'s Westside. Weisman saw an opportunity. A tenant such as LAICA could burnish the new district's upscale image, while the expected foot traffic—some sixty thousand people worked in Century City, and several thousand more lived there—would bring people into the galleries. Weisman made a few phone calls, and a deal was struck: LAICA would lease 6,500 square feet for a dollar in year one. The plan succeeded for a time, generating large crowds and genuine excitement.

The good times didn't last. The idealism that first inspired LAICA soon foundered. From the outset, some artists had worried that the focus on local artists had an aura of provincialism, while

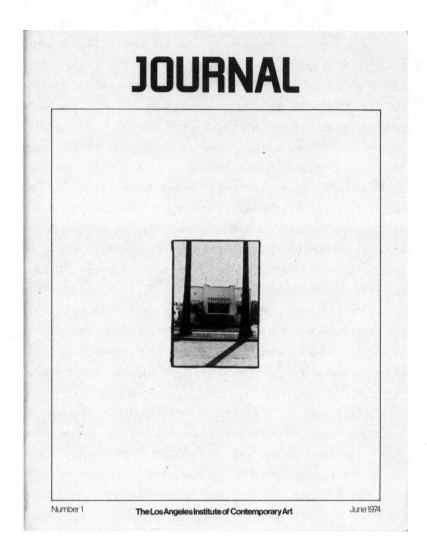

JOURNAL

Number 1 **The Los Angeles Institute of Contemporary Art** June 1974

LAICA Journal no. 1, June 1974,
featuring a photograph by Judy Fiskin.

others regarded the eventual decision to introduce new artists from New York and Europe as a "betrayal." The critic Fidel Danieli, who served as the first editor of the *LAICA Journal*, was firmly in the latter camp. Under his direction the journal would focus exclusively on Los Angeles and its artists. "If it's from New York," he insisted, "let the New York magazines take care of it." To make his case, and to counter what he regarded as the just-so story of Los Angeles art popularized by *Artforum*, Danieli chose as the journal's first cover image a minuscule black-and-white photograph of a quintessentially Southern California stucco bungalow framed by two towering palm trees, taken by a then relatively unknown female artist, Judy Fiskin. It was about as far as you could get from the Ferus guys and their big, brilliantly colored plastic objects. "Forget the L.A. Look," Fiskin's photograph seemed to say. "Just look at L.A.!"

The question of regionalism was only one of the problems dividing LAICA. The idea of a nonhierarchical institution with a democratic decision-making process was a noble idea, but one that was easier proposed than put into practice. Organizing exhibitions turned out to be harder than it looked: Committee meetings devolved into debates about process, and the results were a mixed bag at best. One of the artists involved compared the "vitriolic assemblies of [LAICA's] membership" to "scenes out of the French Revolution." Another so objected to the haphazard installation of one show that he removed his paintings from the gallery. Smith could see that the institution was heading off course. LAICA was supposed to be about exhibiting art he said, "not about *how* to have exhibition committees." When the *Los Angeles Times* followed up on its original story a couple of years later, the sobering headline read, "Hope, Reality Clash at Art Institute."

MARCIA WEISMAN WAS NOTHING if not persistent. When LAICA proved not to be the answer, she looked elsewhere. Frustrated by the situation in L.A., she joined the board of San Francisco's modern

art museum. But throughout the mid- to late seventies, she contin-
ued to agitate for a permanent home for modern art in Los Angeles.
In conversations with her brother, Norton Simon, she floated the
possibility of building a modern and contemporary museum next
to his in Pasadena. Her husband, Fred, who had not given up on
the county art museum, tried to negotiate (and fund) the museum's
purchase of an eight-story office tower nearby to serve as a "semi-
autonomous" modern and contemporary museum. When those
negotiations came to naught, the Weismans developed plans to erect
a building to house their collection in Venice, only to be rebuffed
by the state's Coastal Commission, which oversaw zoning issues
affecting the beach areas. So when, at a political fund-raiser in the
spring of 1979, Mayor Tom Bradley cheerfully asked "What's new?,"
Weisman skipped the pleasantries and seized the moment. "What's
new is what isn't new," she replied. Five years after the demise of the
Pasadena Art Museum, she protested, there was still no permanent
home for modern art in the city. Without one, she argued, the city
remained a hick town. And as things stood now, Los Angeles was
in jeopardy of losing important collections, including her own, to
more accommodating cities, such as San Francisco and New York.

Bradley's election to the mayor's office in 1973 represented a
sea change in the social and political life of Los Angeles. A former
police lieutenant, he had been the first African American elected
to the city council a decade before his ascent to the mayor's office.
Raised in South Central, his rise to power had run through the
Westside, first during his years as a star athlete at UCLA in the
late thirties and later as an LAPD community relations officer and
liberal political activist. Bradley's success in the Democratic Party
hinged not on the powerful state party machine but on a reform-
minded wing that was home to a large number of Jewish Westside
liberals, and it was a coalition of blacks and Jews that allowed him
to claim city hall.

Initially opposed by the downtown business establishment, the
new mayor was a pragmatist "with a keen understanding of who

really runs Los Angeles," as one veteran city hall watcher phrased it. L.A. hadn't seen its first real skyscrapers until the mid-sixties, when downtown interests went on a building spree, adding millions of square feet of office space. "We want to make Los Angeles look like a city," said Councilman Gilbert Lindsay, whose district happened to include downtown. "We need a skyline." But such enthusiasm for downtown redevelopment was far from unanimous elsewhere in the city, and the strategy's success was by no means guaranteed. Many of the new buildings stood half empty when Bradley arrived in the mayor's office. He succeeded nonetheless in pushing through an agenda that included substantial new investment in a downtown that had seemed doomed to irrelevance.

Two weeks after his dinner chat with Weisman, Bradley received a visit from his friend William Norris, a Democratic Party insider. Norris was a major player in city politics, but he had no reputation as an advocate for contemporary art. The mayor was curious, then, when Norris petitioned him to appoint a committee to study the feasibility of a new museum. A publicly financed museum was out of the question. But if Bradley's unofficial endorsement could help get the drive for a *private* institution off the ground, it presented little risk and potentially enormous gain—for the city and for his most loyal backers. Bradley responded to Norris with a question of his own: "Do you know Marcia Weisman?"

A week after first sitting down to discuss the idea with Bradley and Norris, Weisman arrived at the mayor's office holding commitments from half a dozen of the city's most important and well-heeled collectors, who pledged a collective $6 million of art from their collections. She also produced letters and telegrams from more than three dozen artists, dealers, and other supporters. The mayor's support for the project helped open the door to a historic site for it: Bunker Hill. The development plans for this downtown area had dragged on for close to twenty years, slowed by legal and political opposition as well as the sheer scale of the project, one of the largest urban renewal projects in the nation. Slated for mixed use, the

plan was to create just the sort of genuine neighborhood street life glaringly absent from the canyon of new skyscrapers that had risen several blocks to the south: low- and middle-income housing, complemented by restaurants, shops, and other amenities of urban life.

The Community Redevelopment Agency, the quasi-governmental body charged with remaking downtown through private development, instantly saw that including an art museum in the plans would go a long way toward making the area more inviting. And planners saw a way to deliver a building at virtually no cost to either the city or the museum's supporters. The agency required developers to set aside 1.5 percent of a project's budget for art, which typically translated into the forgettable sculpture and murals that grace many office-building lobbies and plazas. But on a $500 million deal like the one anticipated for the unsold remainder of Bunker Hill, the projected $7.5 million pot could easily underwrite the construction costs of a museum.

The new museum would be the jewel in the crown of a new Los Angeles—a city that "looks like a city," as Councilman Lindsay had put it, with a towering skyline and a cosmopolitan culture. Provincialism, real or imagined, was the common enemy for all involved. "We don't want another provincial museum of modern art," Eli Broad, the founding chair of the new museum's board, made clear. "We are going to shoot for primacy in art since the Second World War." The bold talk was infectious: Another founding trustee boasted that the board's appointment of the Pompidou Center's Pontus Hultén as the L.A. museum's first director "immediately puts us in the international art ballgame."

The choice of Bunker Hill brought the geography of arts patronage in Los Angeles full circle. It was the site of the Music Center, where Dorothy Chandler, the wife of the *Times* publisher and doyenne of L.A. society, had triumphed in her efforts two decades earlier to bring the Jewish Westside into the city's social and cultural establishment. Now the modern art museum that Weisman had pursued so doggedly would rise just down the street from the Music

Center.* But instead of the old-line WASP establishment reaching out to "the other side of town," it was now the liberal Jews on the Westside who were in a position to extend an open hand to potential supporters in Pasadena, including former board members of the Pasadena Art Museum, who would become founding trustees of the new museum as well. The balance of power had clearly shifted.

THE NEW MUSEUM WOULD FULFILL A DREAM that had commenced in the 1940s, when Walter Arensberg sought a permanent Los Angeles home for his collection and a handful of Hollywood entertainers hoped to make their Modern Institute of Art that home. Those doomed efforts were just a little ahead of their time. It would take another decade for the city to have any kind of art museum at all, much less one devoted to modern art (which would have to wait longer still). During the fifties and sixties, it was Arensberg's protégé, Walter Hopps, who did more than anyone in Los Angeles to make that day possible. He rounded up the artists, provided them with a showcase—first at Ferus and then in Pasadena—and taught a generation of collectors to see. He couldn't know, as he set up his projector and showed slides for an hour or two in the Weismans' living room, that the evening's hosts would make the museum a reality more than a quarter of a century later.

The resounding success of the new museum—the $10 million goal for an endowment was exceeded in just over a year—along with its building designed by the Japanese architect Arata Isozaki, not

*It wasn't just Chandler, of course; Weisman could also now claim to be on equal footing with her brother, Norton Simon, whose million-dollar pledge had set in motion the campaign for the county art museum in the 1950s. And the fact that Simon was Weisman's brother gave many in the L.A. art scene hope that the trove of contemporary art languishing in storage at his museum—much of it donated to the Pasadena Art Museum by local collectors and artists—might again see the light of day. But Simon would demonstrate, not for the first or last time, that he cared naught about goodwill or public opinion.

only established contemporary art as a centerpiece of cultural life in Los Angeles; it also quickly cemented L.A.'s status as a force in the international art world. Neither Southern California provincialism nor New York parochialism stood in its path. But what, exactly, was gained? And what, to ask a pointed question, may have been lost? As illustrated by the history of Chouinard and CalArts, the more Los Angeles became integrated into the larger art world, the more of what had made the local scene distinctive began to fade. This was inevitable and, in a sense, necessary if L.A. artists hoped to escape the "regional" label that diminished their accomplishments and relegated them to runner-up status in the contest for recognition. But a strong case could also be made in defense of such "regionalism," a case in which the particularities of place are celebrated rather than disparaged.

It's not so simple, of course. Art and the art world were changing profoundly during the decades when L.A. art came into its own. Part of the change was hinted at in the decision, about a year after the new museum's conception, to change its name. What had started out as the Los Angeles Museum of Modern Art was rechristened the Museum of Contemporary Art. Trading "modern" for the more up-to-the-minute sounding "contemporary" was in part an acknowledgment of the institution's emphasis on art created since the Second World War rather than on the longer history of modernism. But such a distinction at least implicitly raised a question much on many peoples' minds at that moment: Was the history of modern art now over? Had we entered a new and radically different period, one that could only be described as "postmodern"? Talk of "postmodernism" and "postmodernity" had gained currency throughout the course of the 1970s, even if the exact meanings of these terms were often vague and self-contradictory. It is doubtful, at best, that such matters weighed heavily on the heads of those who made the decision to change the museum's name, but the fact was that doubts about modernism were becoming endemic to the art world.

Moreover, the new museum signaled a new stage in more than just the L.A. art scene; contemporary art was going global, and over the course of the eighties and nineties, new museums went up in cities large and small that hoped to revitalize aging neighborhoods and draw both upscale locals and cultural tourists. The formula seldom varied: A world-famous architect would be called upon to deliver a "signature building" that, far more than the art it housed, was the main reason to add a city to your itinerary. The most celebrated of these was the Frank Gehry–designed branch of the Guggenheim Museum in the relatively remote city of Bilbao, in Spain's Basque region, but there were dozens of less spectacular examples. For the truly committed (and seriously rich), there is also now the expanding universe of art fairs and biennials. Only the locations change; the art and the crowds remain essentially the same. This may be the ultimate, self-defeating irony of art-world globalization: The more you see of contemporary art in one place the less you need to see it in another.

Today's globe-girding art world, where staggering sums chase brand-name artists and newly minted billionaires find their ways onto the boards of museums half a world away, differs not only in size but in kind from the do-it-yourself world of Hopps and his gang of artist friends, where you built a gallery out of stolen scrap and hoped for the best. The L.A. art scene of the sixties was small by anyone's standards, and that smallness is part of its present appeal. It recalls a time in the not-so-distant past when art seemed to matter in ways that seem impossible today. "It was an enthusiast's scene," the much-admired sixties dealer Nicholas Wilder observed, reflecting on the small circle of artists and collectors who came together around Hopps. "They had an agenda," he added. "The agenda was to make an art scene." Against all odds, they did just that.

Wallace Berman, untitled, ca. 1964–76
(Verifax collage, 47 x 49 in.)

George Herms, *The Librarian*, 1960
(assemblage: wood box, papers,
books, loving cup, and painted stool,
57 x 63 x 21 in.)

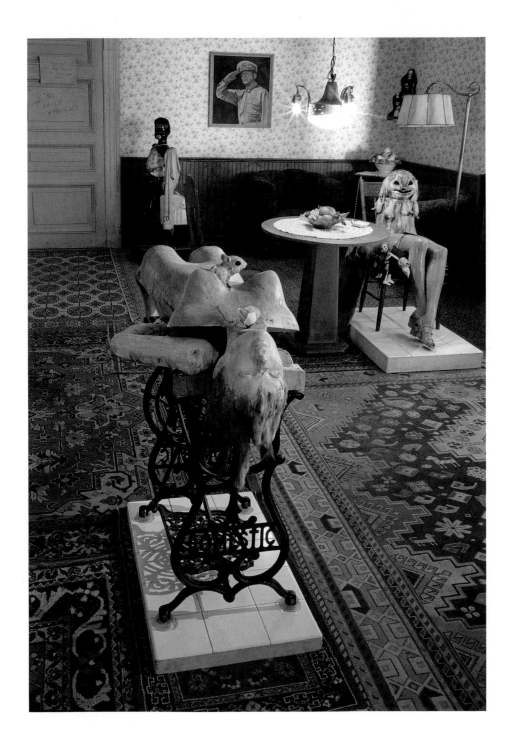

Edward Kienholz, *Roxys* (detail), 1960–61
(mixed media, dimensions variable)

Ken Price, *L. Blue*, 1961 (ceramic
painted with lacquer and acrylic, on
wood base, 6 x 9 x 5 in.)

Edward Ruscha, *Hollywood*, 1968
(screenprint on paper, 17½ x 44⁷⁄₁₆ in.)

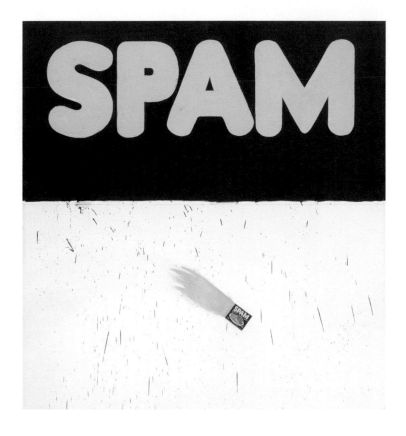

Edward Ruscha, *Actual Size*, 1962
(oil on canvas, 72 x 67 in.)

Joe Goode, *One Year Old*, 1961
(oil on canvas with painted milk bottle,
67 x 67 x 6 in.)

Joe Goode, *Torn Cloud Painting*, 1975
(oil on canvas, 60 x 60 in.)

Vija Celmins, untitled *(Big Sea #1)*, 1969
(graphite on acrylic ground on paper,
34⅛ x 45¼ in.)

Billy Al Bengston, *Busby*, 1963
(oil, polymer, nitrocellulose lacquer
on masonite, 80 x 60 in.)

Craig Kauffman, untitled, 1969
(sprayed acrylic lacquer on vacuum-
formed plexiglas, 22 x 50 x 16 in.)

Larry Bell, untitled, 1965 (metal vapor
on glass, 15 x 15 x 15 in.)

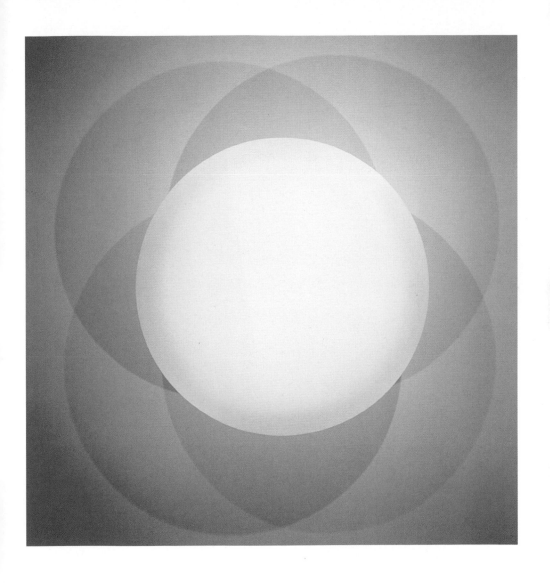

Robert Irwin, untitled, 1968 (synthetic
polymer paint on metal disc, 60 in. diam.)

John McCracken, *Firewalker*, 1969
(polyester resin and fiberglass on plywood,
96 x 14 x 1 ½ in.)

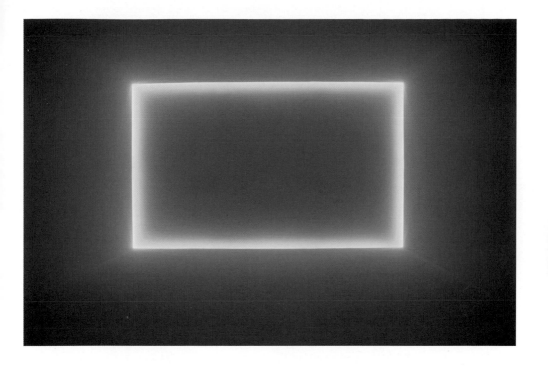

Doug Wheeler, *Eindhoven Environmental Light Installation*, 1969 (steel, coved plaster walls, acrylic paint, nylon scrim; and daylight neon light, 144 x 192 in.)

Lloyd Hamrol, *5 x 9*, 1966/2010
(Formica over plywood, dimensions
variable)

Robert Heinecken, *Fractured Figure
Sections*, 1967 (gelatin silver prints on
wood blocks, 8¼ x 3 x 3 in.)

Judy Chicago, *The Dinner Party*, 1974–79 (porcelain and textiles, 576 x 576 in.). Detail: Emily Dickinson place setting (54 x 33½ in.)

ACKNOWLEDGMENTS

THIS BOOK HAS BEEN, as they used to say about movie extravaganzas, years in the making. I began working on it in earnest around 2001, but its inspiration and some early false starts go back a good deal further.

My first encounter with the Los Angeles art scene of the 1960s came in the waning months of that decade, at an event that was as much an end to an era as it was a beginning of an education. In late 1969, I visited the Pasadena Art Museum, which had recently reopened to much fanfare in its new building. I had been living in Los Angeles for only a year and a half and knew nothing of the museum's storied history, the landmark shows it had presented in its peculiar-looking former home. In its new digs, the museum's inaugural exhibition was *Painting in New York, 1944–1969*. Though I was no older than Walter Hopps had been at the time of his first visit to the Arensbergs' residence, I had seen the inside of enough museums in cities like New York and Chicago to have at least a passing familiarity with the kinds of canvases hanging on the gallery's walls. But there was a small companion show as well: *West Coast, 1945–1969*. Crammed into a couple of galleries, it felt like an afterthought, and for good reason—it really *was*. Some of the work seemed interesting enough, but lacking any context for it, I left the museum with no real sense of what these artists were up to. Taken together, the overall effect of the two shows was to reinforce

a neophyte visitor's assumption that important art was made in New York.

A more substantial introduction to the art of Los Angeles came, oddly enough, not in Los Angeles but in Chicago. There, in the first week of 1972, during a visit to the city's new Museum of Contemporary Art, I was confronted by some three dozen mixed-media drawings by an artist I had never heard of, Terry Allen. His *Juarez* series of multimedia drawings-cum-assemblages were like nothing I had seen. Framed in Plexiglas boxes, they teemed with bizarre scenes and sprouted all manner of objects. There was a story that you followed from one piece to another while a gently Texas-twanged voice intermittently spoke and sang the sorry tale of two hapless couples traveling through the American Southwest. Strangers to one another, they meet in Cortez, Colorado, which leads to a denouement of senseless killings in a seedy motel. The survivors hightail it to Juarez, one step ahead of the law.

I continued from one ripe tableau to the next, lingering before each, seduced by the extravagance, soaking up the lurid details. Apart from the guilty pleasures the work elicited, I hardly knew what to make of it; nothing I had seen before quite prepared me. Allen's phantasmagoria displayed utter indifference to the formalist doctrine that was then so prevalent. In the sixties and early seventies, one needn't have read Clement Greenberg to absorb the lessons of formalism; its influence was everywhere, from popular magazines to museum wall panels. It hadn't dawned on me that there might be other ways of looking at things. But now, faced with Allen's riotous installation, vulgar as it was in every sense—representational, narrative, pulpy, bordering on obscene—I could only wonder: What *is* all this? Is it even *allowed?*

Back in Los Angeles the following summer, I joined a friend who was helping a coworker move. They had summer jobs as extras in a TV show called *Room 222*. When not pretending to be a high-school student, Margaret Nielsen—the person who was changing addresses that day—was an artist, and her new place was an

ACKNOWLEDGMENTS

industrial loft on the southern edge of downtown. After a few hours of dragging furniture, boxes, a stove, and a refrigerator up the narrow staircase to her upper-story space, I asked the diminutive twenty-four-year-old with Rapunzel-length hair about her art. She pulled out a portfolio and showed me some drawings. Rendered in stippled pen-and-ink on paper, they were by turns hilarious, sinister, and absurd: a pig with a garter belt and silk stocking lay impassively between two potted palms; a cactus grew out of a picture postcard; women's legs stuck out from under various pieces of furniture. With their sly invocation of popular illustration and wicked sense of humor, they reminded me of the work I had seen in Chicago. Had she, I asked, ever heard of an artist named Terry Allen?

Had she ever! Allen, it turned out, had graduated from the Chouinard Institute of Art around the time Nielsen was starting there, and he continued on as an instructor while she was enrolled. Since the late fifties, I also learned, many of the most respected artists in L.A. had passed through Chouinard, either as students or as teachers—or both. I was dimly aware of some of them: Robert Irwin, Larry Bell, Ed Ruscha, and Joe Goode, for example. Hadn't they been in that show in Pasadena? Through Nielsen, I soon became friendly with the assemblage artist George Herms. Together, Herms and I crisscrossed Southern California to catch some of the jazz greats who were still around: Charles Mingus at the Coconut Grove, Dexter Gordon at the Lighthouse, Art Blakey at the Parisian Room, and Thelonious Monk at Shelly's Manne-Hole. Between sets, Herms would regale me with accounts of other artists whose names were new to me: Wallace Berman and Edward Kienholz, the yin and yang of the Los Angeles assemblage movement; John Altoon, one of the most compelling painters the city had produced. And from both Herms and Nielsen, I heard wondrous tales of Walter Hopps.

As the seventies were drawing to a close, I found myself at dinner in Paris with Nielsen and Hopps. Nielsen was an artist in residence at the Pompidou Center; Hopps, who was the curator at

the National Collection of Fine Art in Washington, D.C., was on the committee that had selected her for the three-month sojourn. Hopps was a legendary talker, but he was also an attentive listener. I told him of my enthusiasm for various artists in Los Angeles, and of my interest in chronicling the history of the city's art scene. Someone needed to tell this story, we agreed.

It would be another few years before I would speak to Hopps again. To my surprise he remembered me and the details of our conversation. Around the same time, I met Lyn Kienholz and Henry Hopkins. Like Hopps, they encouraged me to pursue my idea to write a book about L.A. art in the sixties. Kienholz, Hopkins, and I discussed various possibilities. It was through Kienholz that I would eventually meet Ed Kienholz, in Berlin. It was also thanks to Lyn's endorsement that, in the summer of 1986, I wound up writing a two-part article about the history of the L.A. art scene for *California* magazine, timed to the opening of the Museum of Contemporary Art and the new contemporary art building at the Los Angeles County Museum of Art. Some of the interviews I conducted for those articles remain in my files, and I revisited some of them in writing this book.

In 1991, I was granted a three-month sabbatical from my job at the J. Paul Getty Trust, during which I researched and wrote some of what, much revised, appears as portions of the first four chapters of this book. A few years later, I found my way to Lars Nittve, at the time the director of the Louisiana Museum of Art, outside of Copenhagen, Denmark, who was organizing an exhibition on L.A. art. Opening in 1996, *Sunshine and Noir*, as the show was titled, would be the first of several major exhibitions over the next decade and a half devoted to reexamining the history of art in Los Angeles — some focusing on particular artists or movements, others broader in scope. Much new scholarship was produced as a result of these shows, and the public is, on the whole, better informed about the subject than it was when I wandered through the Pasadena museum in 1969 or dined with Hopps a decade later.

Inevitably, my thinking about this book has changed over the years. My goal has not been to present a comprehensive survey of L.A. art and artists during the period I examine. I have sought instead to tell a story that will, I hope, shed light on many of the successes and failures the L.A. art scene met with in the sixties. Telling one story necessarily means not telling another. I have, often reluctantly, sacrificed breadth for the sake of depth, passing over interesting developments and fascinating artists in order to focus on themes and characters that emerged as central for me.

I have benefited from conversations with friends and colleagues throughout the years. Among those who have been especially helpful are, in addition to the aforementioned, Tosh Berman, Tom Frick, Jocelyn Gibbs, Glenn Goldman, Lee Kaplan, Annette Leddy, Frank Lloyd, and Joe and Amita Molloy. One of my profound regrets is that neither Glenn nor Joe—the former a bookseller, the latter a book designer—lived long enough to see this book a reality.

One benefit of having worked as an editor is having other editors as friends. Two in particular deserve mention here: Sylvia Tidwell and Dorothy Wall, who both helped whip early drafts of some chapters into shape. Patricia Albers, Dedi Felman, and Laura Ferguson also offered valuable comments on the manuscript.

I owe a debt of thanks to all of the artists, dealers, collectors, and others who generously made time to speak with me in person or over the phone, and to answer desperate e-mails. They were mostly fascinating, frequently entertaining, and without exception patient. No one ever complained about what must at times have struck them as rudimentary questions, whatever they might have been quietly thinking.

Sandra Leonard Starr's work on the 1988 exhibition *Lost and Found in California: Four Decades of Assemblage Art*, mounted simultaneously at three Los Angeles–area galleries, surely must make her the leading authority on the subject. I have relied heavily on the oral history interviews she conducted for that ambitious show, an invaluable resource for future scholarship. Caroline Huber Hopps

was always prompt and thorough in replying to my queries about some of the more elusive the facts of her late husband's life.

Mary Dean and Susan Amorde, in Ed Ruscha's studio, toiled to accommodate my many requests, as did Kristina Simonsen, Joe Gold, Romy Colonius, and Lois Rodin in the studios of Joe Goode, Robert Irwin, Ken Price, and Larry Bell, respectively. Hopps's longtime assistant, Alberta Mayo, was a valuable resource at various stages. Lauren Knighton of the David Zwirner Gallery was indefatigable and unfailingly cheerful in her ready response to my every query.

My agent and friend Laurie Fox encouraged me to write this book and loyally stuck with it against all odds. I was fortunate to find in Judith Gurewich of Other Press a publisher who was an intellectual kindred spirit, enthusiastic about the project and prepared to take a chance on making it a reality. I hope her commitment will prove to have been farsighted rather than foolhardy. Marjorie DeWitt has been a sympathetic and judicious editor and a pleasure to work with throughout. I count myself lucky to have benefitted from Julie Fry's thoughtful design and Yvonne E. Cárdenas's seemingly effortless management at every stage of the book's production.

Marilyn Anderson lived with this book night and day more or less from beginning to end, and it is to her that this book is dedicated, with love and gratitude.

In citing oral history interviews and other research material from archives, the following abbreviations have been used:

AAA/SI: Archives of American Art, Smithsonian Institution, Washington, DC

YRL/UCLA: Center for Oral History Research, Young Research Library, University of California, Los Angeles

INTRODUCTION

2 *"every available inch"* Jules Langsner, "The Arensberg Riches of Cubism," *ARTnews* (November 1949).

2 *"The whole house"* "From the Great Arensberg Collection," *Vogue* (February 1, 1945), 130.

2 *"necessary sometimes to stoop"* Langsner, "The Arensberg Riches of Cubism."

3 *"I was blown away"* Hopps interview with author, September 1986.

3 *"I thought of myself"* Hopps quoted in Art Seidenbaum, "A Young Turk in Old Pasadena," *Los Angeles Times*, May 25, 1964: D1.

4 *"the whole scene in America"* Coplans in Amy Newman, ed., *Challenging Art: Artforum 1962–1974* (New York: Soho Press, 2000), 131.

4 *"Monday night on La Cienega"* *Time* (July 26, 1963).

4 *"San Francisco may be"* Hilton Kramer, "Los Angeles, Now the 'In' Art Scene," *The New York Times*, June 1, 1971.

4 *"taken as a group"* Philip Leider, "The Cool School," *Artforum* II, no. 12 (Summer 1964): 47.

5 *"Some of us thought"* Gehry interview in Kristine McKenna, *Ferus Gallery: A Place to Begin* (Göttingen: Steidl Verlag, 2004), 236.

5 *"the intellectual godfather"* Hopper to Kristine McKenna in *The Cool School*, directed by Morgan Neville (Tremolo Productions, 2008).

7 *"That there is such a thing"* Peter Schjeldahl, "L.A. Art: Interesting—But Painful," *The New York Times*, May 21, 1972.

9 *"People in New York"* Irwin quoted in Barbara Isenberg, *State of the Arts: California Artists Talk About Their Work* (New York: William Morrow, 2000), 354.

10 the *"Sterilized"* and the *"Sweaty"* Max Kozloff, "West Coast Art: Vital Pathology," *The Nation* (August 24, 1964): 76.

CHAPTER ONE

13 *"Famous Art Collection"* Los Angeles Examiner, January 5, 1924, from Ferdinand Perret research material on California art and artists, 1769–1942, Roll 3867, AAA/SI.

14 *"They wanted homes"* Carey McWilliams, *Southern California: An Island in the Land* (Santa Barbara, CA: Peregrine Smith, 1973), 159.

14 *"shall be, not one great whole"* G. Gordon Whitnall, the director of the city planning agency, 1923; cited in Robert Fogelson, *The Fragmented Metropolis: Los Angeles, 1850–1930* (Cambridge, MA: Harvard University Press, 1967), 135.

15 *"the manners, culture"* Morrow Mayo, *Los Angeles* (New York: Knopf, 1933), 327.

15 *"congested, impoverished, filthy"* Fogelson, *The Fragmented Metropolis*, 145.

15 *"the most priggish community"* McWilliams, *Southern California*, 157.

15 *"There wasn't any modern art"* Feitelson oral history, interviewed by Fidel Danieli, March 2 and October 19, 1974, YRL/UCLA.

16 *"in Los Angeles, we treat modern art"* Elizabeth Bingham in *Saturday Night*, May 17, 1924; cited in Victoria Dailey, "Naturally Modern," in Victoria Dailey, Natalie Shivers, and Michael Dawson, *L.A.'s Early Moderns: Art, Architecture, Photography* (Los Angeles: Balcony Press, 2003), 36.

16 *"everything but a unicorn's head"* Brown quoted in Drew Cochran, "Ric the Lion-Hearted," *Los Angeles* 7, no. 5 (June 1964): 46.

16 *"What Art Means"* "The Art News," April 5, 1924, from Ferdinand Perret research material on California art and artists, 1769–1942, Roll 3867, AAA/SI.

16 *"Has anybody noticed"* The California Art Club Bulletin, March 1, 1923, ibid.

17 *"a clubhouse in Italian Renaissance style"* Artland Newsletter I, no. 1, 1926, ibid.

18 *"Let our work affect you"* Macdonald-Wright foreword to the catalog of the 1923 exhibition sponsored by the Group of Independent Artists, ibid.

18 *"Such feeble flutterings"* Artland Newsletter I, no. 2 (1926), ibid.

18 *"degenerate"* and *"un-American"* Arthur Millier, "Los Angeles Events," *Art Digest* 21, no. 18 (July 1, 1947): 6, and "Reaction and Censorship in Los Angeles," *Art Digest* 16, no. 4 (November 15, 1951): 9; cited in Susan Ehrlich, "Five L.A. Pioneer Modernists," (PhD diss., University of Southern California, 1985), 4.

18 *"a morbid mental epidemic"* "Art War Breaks Out," *Los Angeles Times*, May 26, 1933.

18 *"the few artists that were serious"* Feitelson oral history, YRL/UCLA.

19 *"isolated" and "lonely"* Wood oral history, interviewed by Paul Karlstrom, August 26, 1976, AAA/SI.

19 *"the most perfect vacuum"* "Light in Los Angeles," *Time* (September 11, 1939).

19 *"The county museum was"* Price oral history, interviewed by Paul Karlstrom, August 6–14, 1992, AAA/SI.

20 *"determined to try and get"* Ibid.

20 *"Mr. Arensberg was excited"* Ibid.

CHAPTER TWO

25 *"at least some of the elements"* "The California Way of Life," *Life* 19, no. 17 (October 22, 1945): 105.

25 *"unprecedented opportunities"* "California," *Look* 26, [issue number unknown] (September 25, 1962).

26 *"terrible shapelessness"* Dwight Macdonald cited in Richard Pells, *The Liberal Mind in a Conservative Age* (New York: Harper & Row, 1985), 189.

26 *"The essence of the new postwar"* Norman Mailer, "Superman Comes to the Supermarket," *Esquire* (November 1960).

26 *"a moral intensity"* Thomas Bender, *New York Intellect* (New York: Knopf, 1987), 230.

27 *"the borders of bourgeois"* Jerrold Seigel, *Bohemian Paris* (New York: Viking, 1986), 11.

28 *"you were still forty-five minutes"* Herms in Sandra Leonard Starr, *Lost and Found in California: Four Decades of Assemblage Art* (Santa Monica, CA: James Corcoran Gallery, 1988), 85.

28 *"a loose group"* Hopps interview with author, September 1986.

28 *"in the shadows"* Walter Hopps, "L.A. c. 1949: Dark Night-Jazz," in Eduardo Lipschutz-Villa, ed., *Support the Revolution: Wallace Berman* (Amsterdam: Institute of Contemporary Art, 1992), 11.

29 *"the lost, the seekers"* Lawrence Lipton, *The Holy Barbarians* (New York: Julian Messner, 1959), 18.

30 *Family life in Venice* "Squaresville U.S.A. vs. Beatsville," *Life* (September 21, 1959): 33.

32 *"get bombed and listen"* Herms in Starr, *Lost and Found in California*, 85.

33 *"It was really alive"* Shirley Berman, ibid., 77.

34 *"We were [searching]"* McClure in Uri Hertz, "Michael McClure on Wallace Berman: Interview," *Third Rail* 10 (1988), 4.

34 *"very widely passed around"* Alexander in Starr, *Lost and Found in California*, 78.

34 *"Word of the Beverly Hills shrink"* Jay Stevens, *Storming Heaven: LSD and the American Dream* (New York: Harper & Row, 1987), 61.

34　"we all tried acid" Alexander in Starr, *Lost and Found in California*, 78.

34　"We had the illusion" Hopps interview with author, September 1986.

35　"New art" Hopps in Calvin Tomkins, "A Touch for the Now," *The New Yorker* (July 29, 1991): 38.

35　"If you poked the paint" Kauffman oral history, interviewed by Michael Auping, May 21 and 15, 1976, and January 24 and February 7, 1977, transcript, YRL/UCLA, 18.

35　"We clamored for space" Ibid., 17.

35　"There was no Mason-Dixon line" Herms in Starr, *Lost and Found in California*, 84.

35　"We were kind of nervy" Kauffman oral history, YRL/UCLA.

36　"He just sort of appeared" DeFeo oral history, interviewed by Paul Karlstrom, June 3, 1975–January 23, 1976, AAA/SI.

36　"We wanted to get art" Hopps interview with author, September 1986.

CHAPTER THREE

38　"I'm an artist" Kienholz interview with author, September 1986. Unless otherwise stated, all Kienholz quotes in this chapter are from this source.

38　"The strangest looking bird" Alexander in Sandra Leonard Starr, *Lost and Found in California: Four Decades of Assemblage Art* (Santa Monica, CA: James Corcoran Gallery, 1988), 76.

38　"ruddy-faced, round-faced" June Wayne oral history, interviewed by Kathryn Smith, 1976, transcript, YRL/UCLA, 229.

39　"abstract paintings" Kantor oral history, interviewed by George Goodwin, July 12, 19, and 29 and August 2, 1976, transcript, YRL/UCLA, 144.

39　"thought that was going to be" Kauffman oral history, interviewed by Michael Auping, May 21 and 15, 1976, and January 24 and February 7, 1977, transcript, YRL/UCLA, 187.

40　"you couldn't exist" Kantor oral history YRL/UCLA, 154.

40　"Felix would say" Kauffman oral history, YRL/UCLA, 185.

41　"Walter's gang" Ibid., 21.

41　"any damn fool knows" Quoted in Jules Langsner, "Art News from Los Angeles," *ARTnews* (December 1951): 52.

42　targeted by the Birch Society Elliott interview with author, September 1986.

42　"looked straight and professional" Brittin in Starr, *Lost and Found in California*, 89.

42　"He was very, very sharp" Alexander in ibid., 82.

42　"all tits-and-ass curves" Hopps interview with author, September 1986.

43　"We will be partners" Ibid.

43　"We keep our own books" Ibid.

43　"He [was] always lurking" Kauffman oral history, YRL/UCLA, 199.

44　"His habitat was the studio" Kienholz in *John Altoon* (Santa Clara, CA: De Saisset Museum, University of Santa Clara, 1980).

44 *"had the most guts"* Burkhardt oral history, interviewed by Paul Karlstrom, November 25, 1974, AAA/SI.

44 *"If you could take one artist"* Ruscha oral history, interviewed by Paul Karlstrom, October 29, 1980–October 2, 1981, AAA/SI; see also Paul Karlstrom, "Interview with Edward Ruscha in His Western Avenue Studio," in Ed Ruscha, *Leave Any Information at the Signal: Writings, Interviews, Bits, Pages,* edited by Alexandra Schwartz (Cambridge, MA: Massachusetts Institute of Technology, 2002), 175.

44 *"the features of an Indian chief"* Kienholz in *John Altoon.*

44 *"probably the most charismatic"* Blum oral history, interviewed by Lawrence Weschler, August 1, 1978, transcript, YRL/UCLA, 75.

45 *"dearly loved, defiant"* Blum in Craig Krull, ed., *Photographing the L.A. Art Scene 1955–1975* (Santa Monica, CA: Smart Art Press, 1996), 5.

45 *"He was passionate"* Wexler in *John Altoon.*

45 *"probably, the most remarkable"* Blum oral history, YRL/UCLA.

45 *"At times in Mallorca"* Robert Creeley, *A Daybook* (New York: Scribner, 1972), n.p.

46 *"between twenty and thirty"* Hassell Smith in *John Altoon.*

46 *"page after page"* Benay oral history, interviewed by Paul Karlstrom, November 30, 2000, AAA/SI.

47 *American manhood under siege* On the changing image of manhood, see Michael Kimmel, *Manhood in America* (New York: The Free Press, 1996), 240.

48 *"Out of the non-objective ashes"* Gerald Nordland, "Innovation," *Frontier* (May 1957).

49 *"For me, the Ferus gallery"* Donald Factor interview with author, January 17, 2011. All Donald Factor quotes in this chapter are from this source.

49 *"walked in and walked out"* Asher oral history, interviewed by Thomas Garver, June 30 and July 7, 1980, AAA/SI.

49 *"A small group of us"* Betty Factor interview with author, August 1986.

49 *"that whole first generation"* Blum in Amy Newman, ed., *Challenging Art: Artforum 1962–1974* (New York: Soho Press, 2000), 32.

CHAPTER FOUR

51 *"What's this, an art show?"* Hopps in *Wallace Berman Retrospective* (Los Angeles: Otis Art Institute Gallery, with Fellows of Contemporary Art, 1978), 9.

52 *"He didn't care"* Shirley Berman in Sandra Leonard Starr, *Lost and Found in California: Four Decades of Assemblage Art* (Santa Monica, CA: James Corcoran Gallery, 1988), 90.

52 *"Why interview me?"* Berman in Grace Glueck, "Art Notes: From Face to Shining Face," *The New York Times,* September 29, 1968.

52 *"He went through"* Alexander in Starr, *Lost and Found in California,* 57.

52 *"Give me a hustler"* Kienholz interview with author, September 1986.

53 *"a stunning presence"* Hopps in Eduardo Lipschutz-Villa, ed., *Support the Revolution: Wallace Berman* (Amsterdam: Institute of Contemporary Art, 1992), 11.

53 *"Wallace opened a very different"* Hopps in *Wallace Berman Retrospective*, 9.

53 *"a shack on stilts"* Shirley Berman in Starr, *Lost and Found in California*, 73.

53 *"a place where art"* Herms, ibid., 85.

53 *"You'd listen to some music"* Brittin, ibid., 74.

54 *"That little house"* Alexander, ibid., 74.

54 *"From the first"* Robert Duncan, "The Fashioning Spirit," in *Wallace Berman Retrospective*, 19–20.

58 *"The magician becomes"* Cited in P. Adams Sitney, *Visionary Film: The American Avant-Garde* (New York: Oxford University Press, 1974), 106.

59 *"were really kids"* Brittin in Starr, *Lost and Found in California*, 93.

64 *"I am nothing"* Ralph Waldo Emerson, "Nature," in *Essays and Lectures* (New York: Library of America, 1983), 10.

64 *"California assemblage movement"* John Coplans, "Art Is Love Is God," *Artforum* II, no. 9 (March 1964): 27.

65 *"They're myths"* Hopper cited in Colin Gardner, "The Influence of Wallace Berman on the Visual Arts," in Lipschutz-Villa, *Support the Revolution*, 79.

65 *"cultural clock"* George Kubler, *The Shape of Time: Remarks on the History of Things* (New Haven, CT: Yale University Press, 1962), 14.

CHAPTER FIVE

67 *"If Peter was around"* Mason interview with author, December 18, 2011.

68 *"the guy who essentially"* Ken Price, "Objects to Live With: Ken Price at Chinati," *Chinati Foundation Newsletter* 10 (2005): 51.

69 *"I had heard that artists"* Voulkos quoted in Rose Slivka, "The Artist and His Work: Risk and Revelation," in Rose Slivka and Karen Tsujimoto, *The Art of Peter Voulkos* (Oakland, CA: Oakland Museum of Art, 1995), 34.

70 *"What he did was always"* Frances Senska, ibid., 35.

70 *"I thought you were going"* Slivka, ibid., 36.

70 *"I didn't realize"* Voulkos, ibid., 35.

70 *"We made little dishes"* Autio oral history, interviewed by LaMar Harrington, October 10, 1983–January 28, 1984, AAA/SI.

71 *"I really got turned on"* Voulkos quoted in Elaine Levin, *The History of American Ceramics* (New York: Harry Abrams, 1988), 201.

71 *"He was like [Moses]"* Autio oral history, AAA/SI.

71 *"the biggest thing"* Voulkos in Levin, *The History of American Ceramics*.

71 *"was more of a guru"* Soldner oral history, interviewed by Mija Riedel, April 27 and 28, 2003, AAA/SI.

72 *"We were a small group"* Price, "Objects to Live With," 23.

72 *"Here's the clay"* Henry Takemoto, in "Peter Voulkos and the Otis Group," part three of *Revolutions of the Wheel,* a five-part documentary series, Queens Row productions, Los Angeles.

72 *"you just went forward"* Malcolm MacLean, ibid.

72 *"The first thing we'd do"* Voulkos quoted in Slivka, "The Artist and His Work," 40.

72 *"We were hungry"* Soldner in ibid., 39

72 *"Pete always had"* Autio oral history, AAA/SI.

72 *"so vital and so exciting"* Sheets oral history, AAA/SI.

73 *"New York completely opened"* Voulkos in Levin, *The History of American Ceramics.*

73 *"a condition of open possibility"* Harold Rosenberg, "The American Action Painters," *ARTnews* (December 1952): 22; reprinted in Ellen G. Landau, ed., *Reading Abstract Expressionism: Content and Critique* (New Haven, CT: Yale University Press, 2005).

73 *"You might spin out the same form"* Mason quoted in Slivka, "The Artist and His Work," 41.

73 *"I brush color on to violate the form"* Voulkos quoted in ibid., 49

73 *"his work began to evolve"* Soldner oral history, AAA/SI.

75 *"The gesture on the canvas"* Rosenberg, "The American Action Painters," 22.

75 *"fluid material"* Autio oral history, AAA/SI.

75 *"paddle it or drop it"* Soldner oral history, AAA/SI.

75 *"looked a little nasty"* Mason oral history, AAA/SI.

75 *"The minute you begin"* Voulkos cited in Conrad Brown, "Peter Voulkos: Southern California's Top Potter," *Craft Horizons* 16, no. 5 (September 1956): 12.

75 *"like watching a dancer"* Soldner oral history, AAA/SI.

75 *"In the beginning"* Peterson oral history, interviewed by Paul Smith, March 1, 2004, AAA/SI.

76 *"no rules"* Voulkos in Slivka, "The Artist and His Work," 47.

76 *"deep distrust of urban 'luxury' "* T. J. Jackson Lears, *No Place of Grace: Antimodernism and the Transformation of American Culture, 1880–1920* (New York: Pantheon, 1981), 61.

76 *"improved standards of taste"* Ibid., 77.

76 *"the unhealthy, too-long-indulged"* Henry Varnum Poor, *Craft Horizons* (November 1951); cited in *Ken Price* (Houston, TX: The Menil Collection, 1992).

77 *"His philosophy was so upsetting"* Autio oral history, AAA/SI.

77 *"chunks of stone"* Letter, *Ceramics Monthly* (1957); cited in Garth Clark, "Otis and Berkeley: Crucibles of the American Clay Revolution," in *Color and Fire: Defining Moments in Studio Ceramics, 1950–2000* (Los Angeles: Los Angeles County Museum of Art, 2000), 139.

77 *"rebelled against everything"* Sheets oral history, interviewed by George

Goodwin, November 17 and 30 and December 4, 10, and 13, 1976; January 1, 6, 13, and 16, 1977; and video sessions February 5, 6, and 9, 1977, YRL/UCLA.

77 *"just loved to paint"* Sheets oral history, interviewed by Paul Karlstrom, October 1986–July 1988, AAA/SI.

77 *"The respect for the medium"* Sheets oral history, YRL/UCLA.

77 *"The department"* Ibid.

77 *"slapping clay all over"* Voulkos in Levin, *The History of American Ceramics.*

79 *"ivory tower"* Soldner oral history, YRL/UCLA.

81 *"It should be obvious"* Mason cited in J. Bennet Olson, "Soldner-Mason-Rothman," *Craft Horizons* (September–October 1957): 41.

81 *"Prejudices about art"* Price e-mail to author, October 15, 2011.

CHAPTER SIX

83 *"the East"* Ed Ruscha, *Leave Any Information at the Signal: Writings, Interviews, Bits, Pages,* edited by Alexandra Schwartz (Cambridge, MA: Massachusetts Institute of Technology, 2002), 105.

84 *"the Bohemian school"* Ibid.

84 *"wasn't a fine arts school"* Nordland oral history, interviewed by Susan Larsen, May 25–26, 2004, AAA/SI.

85 *"needed artists who could"* Marc Davis cited in Robert Perine, *Chouinard: An Art Vision Betrayed* (Encinitas, CA: Artra Publishing, 1985), 155.

85 *"When I couldn't afford"* Disney cited in Perine, ibid., 25. The story of Disney driving the staff to Chouinard is recounted in Neil Gabler, *Walt Disney: The Triumph of the American Imagination* (New York: Knopf, 2006), 174.

85 *"around $100,000"* Nordland oral history, AAA/SI.

85 *"were all of the hard-nosed"* Wilder cited in Perine, *Chouinard.*

86 *"The school kind of lost"* Goode oral history, interviewed by Paul Karlstrom, January 5, 1999–April 12, 2001, AAA/SI.

86 *"like the difference between"* Ibid.

87 *"If it works in Rubens"* Graham cited in Gabler, *Walt Disney,* 230.

87 *"extremely articulate"* Bell interview with author, February 12, 2010. Unless otherwise stated, all Bell quotes in this chapter are from author interview.

87 *"John Altoon was another"* Ruscha, *Leave Any Information at the Signal,* 115.

87 *"I want everybody"* Norton Wisdom oral history, interviewed by Paul Karlstrom, April 27, 2000, AAA/SI.

87 *"He had a definite aura"* Ruscha, *Leave Any Information at the Signal,* 108.

88 *"magic wrist"* Irwin interview with author, April 24, 2010. Unless otherwise stated, all Irwin quotes in this chapter are from author interview.

89 *"a taskmaster"* Ruscha oral history, interviewed by Paul Karlstrom, October 29, 1980–October 2, 1981, AAA/SI.

90 *"Paint what you believe in"* Goode interview with author, October 17, 2010.

Unless otherwise stated, all Goode quotes in this chapter are from author interview.

91 *"the biggest thing that I learned"* Ruscha oral history, AAA/SI.

91 *"Millard Sheets and especially Rico Lebrun"* Elliott interview with author, September 1986.

91 *"everybody worshipped Rico Lebrun"* Kauffman oral history, interviewed by Michael Auping, May 21 and 15, 1976, and January 24 and February 7, 1977, transcript, YRL/UCLA, 15.

91 *"little time to dissipate"* Lester Longman, "Letter on a Dilemma," letter to the art editor, *The New York Times*, April 30, 1961.

91 *"a glorified trade school"* "Art Rides High at a Great University," *Life* 42, no. 20 (May 20, 1957): 92.

91 *"UCLA was an academy"* Garabedian interview with author, July 16, 2010.

92 *"I stumbled through"* Kauffman oral history, YRL/UCLA, 16.

92 *"in a funny way"* Garabedian interview with author, July 16, 2010.

92 *"almost did me in"* Hendler interview with author, September 29, 2010.

92 *"got more real inspiration"* Ruscha interview with author, April 21, 2010.

93 *"He took risks"* Kauffman oral history, YRL/UCLA, 187.

93 *"I didn't feel that there was"* Foulkes oral history, interviewed by Paul Karlstrom, June 25, 1997 and December 2, 1998, AAA/SI.

95 *"Ed Kienholz kind of held court"* Kauffman oral history, YRL/UCLA.

95 *"We'd talk about cars"* Kienholz oral history, interviewed by Lawrence Weschler, 1977, YRL/UCLA.

95 *"insidious charm"* Max Kozloff, "West Coast Art: Vital Pathology," *The Nation* (August 24, 1964): 76.

95 *"Inbred"* Everett Ellin oral history, interviewed by Liza Kirwin, April 27–28, 2004, AAA/SI.

96 *"aggressive and high-spirited"* John Coplans, "Circle of Styles on the West Coast," *Art in America* 52, no. 3 (June 1964): 40.

96 *"They were young, aggressive artists"* Hopkins oral history, interviewed by Wesley Chamberlin, October 24–December 17, 1980, AAA/SI.

96 *"all hell broke loose"* Hopkins oral history, AAA/SI.

CHAPTER SEVEN

100 *"controlled by a small number of people"* John and Blanche Leeper oral history, interviewed by Joanne Ratner, May 9–10, 1988, transcript, YRL/UCLA, 22.

100 *"we didn't…know much"* Hanson oral history, interviewed by Joanne Ratner, April 20 and May 18, 1988, transcript, YRL/UCLA, 13.

101 *"let's get one thing straight"* Hopps oral history, interviewed by Joanne Ratner, October 11, 1987, transcript, YRL/UCLA, 40.

101 *"Greenberg-certified"* John Coplans, "Pasadena's Collapse and the Simon Takeover: Diary of a Disaster," *Artforum* 13 (February 1975); reprinted in

Provocations: Writings by John Coplans (London: London Projects, 1996), 180.

101 *"I did say that he was"* Rowan oral history, interviewed by George Goodwin, 1983, transcript, YRL/UCLA, 94.

104 *"the most miserable"* Goode oral history, interviewed by Paul Karlstrom, January 5, 1999–April 12, 2001, AAA/SI.

105 *"the loneliest paintings"* John Coplans, "The New Painting of Common Objects," *Artforum* I, no. 12 (November 1962): 26.

105 *"an unsettling quality"* Philip Leider, "Joe Goode and the Common Object," *Artforum* IV, no. 7 (March 1966).

105 *"trivialization of form"* Coplans, "The New Painting of Common Objects," 26.

105 *"something is going on"* Jules Langsner, "Los Angeles Letter," *Art International* 6, no. 3 (April 1962); reprinted in Steven Henry Madoff, ed., *Pop Art: A Critical History* (Berkeley: University of California Press, 1997), 33.

106 *"He remembered me"* Hopps quoted in Murray Schumach, "Pasadena to See Art of Duchamp," *The New York Times*, August 13, 1963.

108 *"nothing didactic"* Hopps quoted in Calvin Tomkins, *Duchamp: A Biography* (New York: Henry Holt and Company, 1996), 421.

108 *"bunch of Art Alliance women"* Hopps oral history, YRL/UCLA.

108 *"slight soft-spoken French gentleman"* Christy Fox, "Society and Art Worlds Converge," *Los Angeles Times*, October 9, 1963.

110 *"cloud-hopping into Our Town"* Mary Matthew, "They Came, They Saw—Duchamp Conquered," *Los Angeles Times*, October 9, 1963.

110 *"international authority"* Fox, "Society and Art Worlds Converge."

110 *"most people there"* Donald Factor interview with author, January 17, 2011.

110 *"in California, in the cool"* Andy Warhol and Pat Hackett, *Popism: The Warhol Sixties* (New York: Harcourt Brace, 1980), 43.

110 *"In all of L.A."* Glicksman oral history, YRL/UCLA.

CHAPTER EIGHT

111 *"Rich, Reactionary, and Retired"* Ray Duncan, "Pasadena, the Old Order Changeth," *Los Angeles* (December 1963), 39.

111 *"the emblematically genteel"* Kevin Starr, *Inventing the Dream: California Through the Progressive Era* (New York: Oxford University Press, 1985), 102.

111 *"could hardly be"* Carey McWilliams, *Southern California: An Island in the Land* (Santa Barbara, CA: Peregrine Smith, 1973), 327.

112 *"seemed to many members"* Leavitt oral history, interviewed by Joanne Ratner, 1990, transcript, YRL/UCLA, 17.

112 *"there were a lot of people"* Hanson oral history, interviewed by Joanne Ratner, April 20 and May 18, 1988, transcript, YRL/UCLA, 17.

112 *"Some of the things"* Leavitt oral history, YRL/UCLA.

113 *"at best, a trade show"* Hopps oral history, interviewed by Joanne Ratner, October 11, 1987, transcript, YRL/UCLA, 29.

113 *"always the bane"* Glicksman oral history, interviewed by Joanne Ratner, 1988, YRL/UCLA.

113 *"saw herself as a kind"* Hopps oral history, YRL/UCLA.

113 *"The truth was"* Rowan oral history, interviewed by George Goodwin, 1983, transcript, YRL/UCLA, 101.

113 *"suddenly [saw] themselves"* Hopps oral history, YRL/UCLA, 51.

113 *"mobs of people"* Hanson oral history, YRL/UCLA.

113 *"the other side of town"* Duncan, "Pasadena, the Old Order Changeth," 37.

113 *"the most affluently cosmopolitan"* Robert Carson, "Upper Los Angeles," *Los Angeles* (January 1966): 56.

114 *"the most exciting action"* Ibid.

114 *"is fast becoming"* "Art Rides High at a Great University," *Life* (May 20, 1957).

114 *"most impressive contribution"* Howard Taubman, "Culture Way Out West," *The New York Times*, November 8, 1966, 36.

114 *"ordinarily loses more audience"* *High Fidelity* cited in Wes Marx and Gil Thomas, "The Westside Story," *Los Angeles* (February 1962): 19.

114 *"the majority of the audience"* Ibid., 19.

115 *"people…who knew their way around"* Wight oral history, interviewed by Bernard Galm, 1982, transcript, YRL/UCLA, 186.

115 *"Nate 'n Al's"* Carson, "Upper Los Angeles," 56.

116 *"unusually receptive to innovation"* Amos Elon, *The Pity of It All: A History of the Jews in Germany, 1743–1933* (New York: Metropolitan Books, 2002), 263.

116 *"Jewish German* haute bourgeoisie" Vera Grodzinksi, "Collecting Against the Grain," *The Jewish Quarterly* (Summer 2006).

117 *"The restless age"* George Mosse, *Rassismus* (Frankfurt: 1978) 108; cited in Elon, *The Pity of It All*, 359.

117 *"marked by a definite"* Quoted in Robert Sheer, "Line Drawn Between Two Worlds," the second in the three-part series "The Jews of Los Angeles," *Los Angeles Times*, January 30, 1978.

117 *"the gilded ghetto"* Ibid.

117 *"The old-money group"* Phillips interview with author, March 30, 2010. Unless otherwise stated, all Phillips quotes in this chapter are from author interview.

118 *"a very clear anti-Semitic situation"* Elliott interview with author, September 1986. All Elliott quotes in this chapter are from author interview.

118 *"from the standpoint"* Richard Brown, *Outline of Statistics Concerning Art Museum Program*, Annual Report to L.A. County Supervisors, 1956.

120 *"it was the leadership pool"* Hopps oral history, YRL/UCLA.

120 *"there was some whispering"* Hanson oral history, YRL/UCLA.

120 *"Even Rowan, who wasn't"* Hopps oral history, YRL/UCLA.

120 *"I don't know whether"* Donald Factor interview with author, January 17, 2011.

121 *"just couldn't be really convinced"* Hopps oral history, YRL/UCLA.

CHAPTER NINE

123 *"Irving, with his fancy"* Kienholz interview with author. Unless otherwise stated, all additional Kienholz quotes in this chapter are from author interview.

124 *"I didn't want to be considered"* Blum oral history AAA/SI, interviewed by Paul Cummings, May 31–June 23, 1977, AAA/SI.

125 *"What sort of money"* Ibid.

125 *"Blum was more involved"* Nordland oral history, interviewed by Susan Larsen, May 25–26, 2004, AAΛ/SI.

125 *"It was extremely hard"* Blum oral history, AAA/SI.

126 *"probably the single most important"* Richard Polsky, *I Bought Andy Warhol* (New York: Abrams, 2003), 91.

126 *"a bunch of old women"* Kienholz oral history, interviewed by Lawrence Weschler, 1977, YRL/UCLA.

128 *"feel as clean or as free"* Ibid.

130 *"Public reaction"* Blum oral history, AAA/SI.

130 *"I thought it would be fun"* Donald Factor interview with author, January 17, 2011.

131 *"generous gift"* Hopps interview with author, September 1986.

131 *Scholars studying the subject* On "entrepreneurial" versus "ideological" art dealers, see Robert Jensen, *Marketing Modernism in Fin-de-Siècle Europe* (Princeton, NJ: Princeton University Press, 1994).

133 *"the populist Ferus"* Hopps interview with author, September 1986.

133 *"a cosmic view of art"* Glicksman oral history, interviewed by Joanne Ratner, 1988, YRL/UCLA.

133 *"meant that there could be"* Hopps quoted in Calvin Tomkins, "A Touch for the Now," *The New Yorker* (July 29, 1991).

134 *"it was the artists"* Glicksman oral history, YRL/UCLA.

134 *"there was an aesthetic"* Ron Nagle in *The Dilexi Years: 1958–1970* (Oakland, CA: Oakland Museum, 1984), 42.

134 *"Irwin works in"* Alan Solomon, "Making Like Competition in L.A.," *The New York Times*, July 11, 1965.

134 *"compulsively clean white space"* Kienholz in *Craig Kauffman* (Hope, ID: Faith and Charity in Hope Gallery, 1983).

134 *"A really clean space"* Kauffman in *The Dilexi Years*, 43.

135 *"more and more"* Irwin interview with author, April 24, 2010.

137 *"technically efficient"* Brian O'Doherty, "John Hultberg's War Between Sky and Earth," *The New York Times*, May 9, 1962.

137 *"fun art"* Vivian Raynor, "Fun Art," *Arts* (September 1962): 50.

137 *"I knew just where"* Kauffman oral history, interviewed by Michael Auping, May 21 and 15, 1976, and January 24 and February 7, 1977, transcript, YRL/UCLA, 28.

138 *"I sort of liked the beatnik scene"* Ibid., 25.

138 *"ability to paint as though"* Edward Kienholz in *Craig Kauffman* (Hope, ID: Faith and Charity in Hope Gallery, 1983).

138 *"funny combination of influences"* Kauffman oral history, YRL/UCLA.

138 *"the first Southern California"* Billy Al Bengston, "Late Fifties at the Ferus: A Participant Refuses to Take the Show Lying Down," *Artforum* VII, no. 5 (January 1969): 35.

138 *"a neutral structure"* McLaughlin's statement cited in Peter Plagens, "The Soft Touch of Hard Edge," *LAICA Journal* (April–May 1975): 17.

139 *"bad case of Northern California"* Bengston, "Late Fifties at the Ferus."

139 *"a variation on finger painting"* Bengston interview with author, September 20, 2010. Unless otherwise stated, all Bengston quotes in this chapter are from author interview.

139 *"In the very beginning"* Irwin interview with author, April 24, 2010.

139 *"sort of a pied piper"* Ruscha interview with author, April 21, 2010.

139 *"strangely adolescent"* Leider in Amy Newman, ed., *Challenging Art: Artforum 1962–1974* (New York: Soho Press, 2000).

139 *"incredibly charming"* Kauffman oral history, YRL/UCLA, 198.

140 *"It wouldn't make it"* Ibid.

140 *"there's gotta be"* Ibid.

141 *"The beauty of color"* Price e-mail to author, October 15, 2010.

141 *"a kind of pastiche"* Irwin interview with author, April 24, 2010.

142 *"He said, 'Why don't you'"* Kauffman oral history, YRL/UCLA, 34.

142 *"There were two big"* Ibid., 35.

142 *"They were sort of curious"* Ibid., 48.

143 *"sort of eats into"* Ibid., 223.

143 *"I didn't think they were art"* Bell interview with author, February 12, 2010. Unless otherwise stated, all Bell quotes in this chapter are from author interview.

145 *"They wouldn't have you"* DeLap interview with author, January 18, 2011.

146 *"You could put on god knows"* Ibid.

146 *"to use color"* John McCracken quoted in Frances Colpitt, "Between Two Worlds," *Art in America* 76, no. 4 (April 1988): 88

146 *"If I had some kind"* Ibid.

147 *"untrammeled illusionism"* Michael Fried, "Ron Davis," *Artforum* (April 1967): 37.

147 *"I didn't start out"* Kauffman in *A New Aesthetic,* edited by Barbara Rose (Washington, DC: Washington Gallery of Modern Art, with Garamond-Pridemark Press, 1967), 51.

147 *"an organic fusion"* Price to Vija Celmins, in *Ken Price* (catalog to *Ken Price: Sculpture and Drawings 1962–2006* exhibition at the Matthew Marks Gallery) (Göttingen, Germany: Steidl, 2007), 7.

147 *"the techniques [were] developed"* Price e-mail to author, October 15, 2010.

149 *"hormonal excitement"* Max Kozloff, "West Coast Art: Vital Pathology," *The Nation* (August 24, 1964).

150 *"People out here"* Kauffman interview with Frederick Wight in *Transparency, Reflection, Light, Space: Four Artists* (Los Angeles: UCLA Art Gallery, 1971), 108.

150 *"nothing more than extraordinarily"* Fried, "Ron Davis."

150 *"a desperate prettiness"* Kozloff, "West Coast Art: Vital Pathology."

150 *"the endless plastic-glossy"* Peter Schjeldahl, "L.A. Art: Interesting—but Painful," *The New York Times,* May 21, 1972.

150 *"Fancy baubles"* Joseph Masheck, "New York," *Artforum* 9 (January 1971): 72–73.

151 *"bound up with technology"* Christopher Rand, *Los Angeles: The Ultimate City* (New York: Oxford University Press, 1967), 32.

152 *"an art which wallows"* Kozloff, "West Coast Art: Vital Pathology."

CHAPTER ELEVEN

153 *"cultural coming of age"* Carter quoted in Henry Seldis, "County Museum of Art Dedication Rites Held," *Los Angeles Times,* March 31, 1965: 3.

153 *"Civic progress is not measured"* "A Museum Worthy of a Metropolis," *Los Angeles Times,* January 6, 1961.

155 *"uniquely ready to spend money"* "Brightness in the Air," *Time* (December 18, 1964).

155 *"things were just starting"* Nelson interview with author, July 22, 2010.

155 *"a miniature version"* Art Seidenbaum, "Bulls and Bears in Art Market," *Los Angeles Times,* January 27, 1963.

155 *"Stroll along there"* Art Seidenbaum, "A Look at Bomb Craters After Cultural Explosion," *Los Angeles Times,* April 12, 1968.

155 *"the range of humanity"* Art Seidenbaum, "Art: Is It Trick or Treat?" *Los Angeles Times,* March 17, 1963.

155 *"the gospel according to Artforum"* Art Seidenbaum, "La Cienega Blvd. Learns How to Please All the Palettes," *Los Angeles Times,* March 6, 1966.

155 *"So, who you gonna go with?"* Hamrol interview with author, July 14, 2010. Unless otherwise stated, all Hamrol quotes in this chapter are from author interview.

156 *"It was an exciting time"* Wilder oral history, interviewed by Ruth Bowman, July 18, 1988, AAA/SI.

157 *"He never thought"* Goode interview with author, February 17, 2010. Unless otherwise stated, all Goode quotes in this chapter are from author interview.

157 *"There were artists"* Mitchell Syrop and Michael McCurry, "Interview with Patricia Faure," C3i *Striking Distance*, strikingdistance.com/c3inov/faure .html.

158 *"changed the whole Los Angeles"* Coplans interview with author, August 1986.

159 *"The biggest threat"* Henry Seldis, "The Biggest Threat Facing Modern Art," *Los Angeles Times*, February 10, 1963.

159 *"If [a show] got reviewed"* Syrop and McCurry, "Interview with Patricia Faure."

159 *"complete banality"* Henry Seldis, "'New Realism' Comes in Humor, Cynicism," *Los Angeles Times*, December 2, 1962.

159 *"if you have always wanted"* Henry Seldis, "Billboards and the 'Pop' Art Complex; Sign of Times?" *Los Angeles Times*, May 31, 1963.

159 *"toy-smashing school"* Henry Seldis, "Hatred No Spur to Greater Art," *Los Angeles Times*, June 21, 1963.

160 *"Every month we had"* Leider in Amy Newman, ed., *Challenging Art: Artforum 1962–1974* (New York: Soho Press, 2000), 118.

161 *"Basically, we set up"* Ibid., 116.

161 *"He was absolutely anti-Duchampian"* Coplans oral history, interviewed by Paul Cummings, April 4, 1975–August 4, 1977, AAA/SI.

161 *"Usually, Leider would give me"* Danieli oral history, interviewed by Robert Pincus, 1986, YRL/UCLA.

162 *"I became a spokesman"* Coplans oral history, AAA/SI.

162 *"just couldn't be bothered"* Hal Glicksman oral history, interviewed by Joanne Ratner, 1988, YRL/UCLA.

162 *"John Coplans and those people"* Wilder oral history, AAA/SI.

162 *"I remember how abusive"* Leider in Newman, *Challenging Art*, 308.

163 *"lack-lustre" affairs* Philip Leider, "The Best of the Lack-Lustre," *The New York Times*, August 7, 1966.

163 *"In the early days"* Elliott interview with author, September 1986. All Elliott quotes in this chapter are from author interview.

164 *"revolting…and pornographic"* Letter from Supervisor Warren Dorn to Edward Carter, March 17, 1966, cited in Robert L. Pincus, *On a Scale That Competes With the World: The Art of Edward and Nancy Reddin Kienholz*, (Berkeley: University of California Press, 1990), 33.

165 *"people…tearing wet canvases"* Felix Landau quoted in Art Seidenbaum, "A Look at Bomb Craters."

165 *"From the terrace"* Cowles in Newman, *Challenging Art*, 130.

165 *"in the hundreds"* Donald Factor interview with author, January 17, 2011.

166 *"I always paid"* Asher oral history, interviewed by Thomas Garver, June 30 and July 7, 1980, AAA/SI.

166 *"To have lived in L.A."* Christopher Rand, *Los Angeles: The Ultimate City* (New York: Oxford University Press, 1967), 161.

NOTES

167 *"the whole atmosphere"* Phillips oral history, interviewed by George Goodwin, June 14 and December 14, 17, 1979, transcript, YRL/UCLA, 115.

167 *"Visiting the galleries"* Barbara Rose, "Los Angeles: Second City," *Art in America* (January 1966): 115.

CHAPTER TWELVE

169 *"It's all façades here"* Ruscha in *L.A. Suggested by the Art of Edward Ruscha*, video produced and directed by Gary Conklin; quoted in Ed Ruscha, *Leave Any Information at the Signal: Writings, Interviews, Bits, Pages*, edited by Alexandra Schwartz (Cambridge, MA: Massachusetts Institute of Technology, 2002), 223–224.

171 *"Panavision format"* Bernard Blistène, "Conversation with Ed Ruscha," in ibid., 307.

172 *"A lot of my ideas"* Ruscha in "Hollywood Decks the Halls: Ruscha," *Elle Décor* (December 1995–January 1996); reprinted in ibid., 341.

174 *"a Catholic kid intersecting"* Ruscha interview with author, April 21, 2010.

176 *"I...don't have that"* Celmins interviewed by Chuck Close, *Vija Celmins*, edited by William S. Bartman (Los Angeles: A.R.T. Press, 1992), 38.

176 *"an armature"* Ibid., 45.

177 *"You're seeing a way"* Wheeler interview with author, March 29, 2010.

177 *"It wasn't until"* Close, *Vija Celmins*, 20.

177 *"When I finally left"* Ibid., 23.

177 *"fired for being too successful"* Irwin interview with author, April 24, 2010.

178 *"We would meet in his office"* Celmins interview with author, February 25, 2010.

178 *"a wonderful, lonely place"* Ibid.

178 *"I probably went through"* Close, *Vija Celmins*, 12.

178 *"I would go through"* Ibid., 46.

179 *"Vija has perfect taste"* Tony Berlant quoting Irwin in interview with author, October 28, 2010.

180 *"only interested in controlling"* Close, *Vija Celmins*, 29.

180 *"hard to envision or conceptualize"* Kevin Lynch, *The Image of the City* (Cambridge, MA: Massachusetts Institute of Technology, 1960), 40.

181 *"You can't just go up"* Celmins quoted in Susan Larsen, "Vija Celmins," in *Vija Celmins: A Survey Exhibition* (Newport Beach, CA: Newport Harbor Art Museum, with Fellows of Contemporary Art, 1979), 28.

CHAPTER THIRTEEN

185 *"there was nothing to look at"* Irwin interview with author, April 24, 2010.

187 *"no objects you can take hold of"* Wortz quoted by Jane Livingston in *Art & Technology: A Report on the Art & Technology Program of the Los Angeles County Museum of Art, 1967–1971* (New York: Viking Press, 1971), 136.

188 *"in the midst of plenty"* Wortz, introduction to the First International Symposium on Habitability (1970), Robert Irwin papers, Getty Research Institute.

189 *"It was not subtle"* Bell e-mail to author, June 15, 2011.

189 *"was so unpleasant"* Melinda Wortz, "Larry Bell: An Overview," in Thierry Raspail, ed., *Larry Bell: Works from New Mexico* (Lyon: Musée d'Art Contemporain, 1989), 64. Cited in Peter Frank, "Larry Bell: Understand the Percept," in *Zones of Experience: The Art of Larry Bell* (Albuquerque, NM: The Albuquerque Museum, 1997), 43.

189 *"Some of those early paintings"* Bell interview with author, February 12, 2010.

192 *"Dealing with states of consciousness"* Turrell quoted by Jane Livingston in *Art & Technology*, 132.

192 *"Nirvana, in the form"* Hilton Kramer, "Richard Smith Takes a Robust Term," *The New York Times*, November 19, 1966.

192 *"a refuge bathing"* Barbara Novak, *Nature and Culture: American Landscape and Painting, 1825–1875* (New York: Oxford University Press, 1980), 40.

193 *"The currents of Universal Being"* Ralph Waldo Emerson, "Nature," in *Essays and Lectures* (New York: Library of America, 1983), 10.

193 *"not a faculty"* Ralph Waldo Emerson, "The Over-Soul," in *Essays: First and Second Series* (New York: Library of America, 1991), 156–57.

193 *"the spectator is brought"* Novak, *Nature and Culture*, 29.

194 *"We relate to our landscape"* Wheeler interview with author, March 29, 2010.

196 *"electrical sublime"* David E. Nye, *American Technological Sublime* (Cambridge, MA: Massachusetts Institute of Technology, 1994), 196–97.

CHAPTER FOURTEEN

197 *Los Angeles was* See Robert M. Fogelson, *The Fragmented Metropolis: Los Angeles, 1850–1930* (Cambridge, MA: Harvard University Press, 1967), and William Fulton, *The Reluctant Metropolis: The Politics of Urban Growth in Los Angeles* (Point Arena, CA: Solano Press, 1997).

199 *At its top was a name* See John Dreyfuss, "How to Pick a Winner," *Los Angeles Times*, August 17, 1979.

200 *"heavy-handed architecture"* Katharine Kuh, "Los Angeles: Salute to a New Museum," *Saturday Review* (April 3, 1965): 29.

200 *"already antique monster"* Hilton Kramer, "Nostalgia for the Future," *The New York Times*, May 7, 1967.

200 *"the ugliest building"* Kantor oral history, Kantor oral history, interviewed by George Goodwin, 1976, YRL/UCLA.

200 *"Don't worry, honey"* Marcia Weisman oral history, interviewed by George Goodwin, 1982, YRL/UCLA.

200 *"One trustee even ordered"* "Drawing the Line in L.A.," *Newsweek* (November 22, 1965): 98.

201 *"self-seeking individuals"* Philip Leider, "Comment," *Artforum* 4 no. 4 (December 1965): 2.

201 *"It is imperative"* Letter to the editor, *Los Angeles Times*, November 13, 1965.

201 *"The feeling grows"* Letter to the editor, *Los Angeles Times*, November 20, 1965.

201 *"It was Brown"* "Management of the Art Museum," editorial, *Los Angeles Times*, November 10, 1965.

202 *"It may be somewhat"* Edward Carter, letter to the editor, *Los Angeles Times*, November 13, 1965.

202 *"They had to get a weak director"* Weisman oral history, YRL/UCLA, 222.

202 *"didn't have any real respect"* Phillips interview with author, March 30, 2010.

202 *"the county museum has"* Kantor oral history, YRL/UCLA.

203 *"Everybody hated [the design]"* Glicksman oral history, interviewed by Joanne Ratner, 1988, YRL/UCLA.

203 *"the quality of the parties"* Leavitt oral history, interviewed by Joanne Ratner, 1990, transcript, YRL/UCLA, 13.

203 *"received three $100 memberships"* Martha Padve papers, 1965–1988, Library Special Collections, YRL/UCLA.

204 *"Even though [Donald] Factor"* Hopps oral history, interviewed by Joanne Ratner, 1985, transcript, YRL/UCLA, 70.

204 *"They were completely incapable"* Coplans oral history, interviewed by Paul Cummings, April 4, 1975–August 4, 1977, AAA/SI.

204 *"the policies of this museum"* Letter from Frederick Weisman to Pasadena Art Museum board of trustees, October 12, 1966. Martha Padve papers, YRL/UCLA.

204 *"to serve the whole area, not just Pasadena."* Williams Janss quoted in minutes from board of trustees meeting, October 12, 1966. Ibid.

204 *"Altogether Now'"* Ibid.

205 *"Nobody wants to pay"* Kantor oral history, YRL/UCLA.

205 *"You're basically turning yourself"* Nelson interview with author, July 22, 2010.

205 *"Los Angeles isn't quite"* Glenys Roberts, "The Schizophrenic Art Market," *Los Angeles* 12, no. 9 (September 1967).

206 *"the supersensitive denizens"* William Wilson, "The Explosion That Never Went Boom," *Saturday Review* (September 23,1967).

206 *"I...don't propose"* Leider to Tillim, August 2, 1966, cited in Amy Newman, ed., *Challenging Art: Artforum 1962–1974* (New York: Soho Press, 2000), 500.

206 *"What remains to be seen"* John Coplans, "Art Bloom," *Vogue* (November 1967).

206 *"He was always finding artists"* Irwin interview with author, April 24, 2010.

207 *"like a mad orchestrator"* Allen interview with author, March 5, 2011.

210 *"That summer of the moonwalk"* Robert Stone, *Prime Green: Remembering the Sixties* (New York: Ecco, 2007).

212 *"a search for the soul"* Ruppersberg interview with author, January 27, 2011.

214 *"It was difficult to separate"* Outterbridge oral history, interviewed by Richard Candida Smith, 1989–90, YRL/UCLA.

221 *"I would say ninety percent"* Baldessari oral history, interviewed by Christopher Knight, April 4–5, 1992, AAA/SI.

221 *"This is the thing"* Neil Gabler, *Walt Disney: The Triumph of the American Imagination,* (New York: Knopf, 2006), 592.

221 *"City of the Arts"* Ibid., 573 passim.

222 *"There is such an Establishment"* Corrigan quoted in Steven V. Roberts, "Coast Arts School on Unorthodox Path," *New York Times* (December 3, 1970).

222 *"The future of the arts"* Corrigan quoted in John Weisman, "CalArts Aiming for Magic Kingdom of Creative Education," *Los Angeles Times,* October 4, 1970.

222 *"The various deans"* Baldessari oral history, AAA/SI.

223 *"counter-educate"* students Cited in James Real, "CalArts: When You Wish Upon a School," *Los Angeles Times Magazine,* February 27, 1972.

223 *"the commander of his troops"* Hamrol interview with author, July 14, 2010.

223 *"You can't play guessing games"* John Dreyfuss, "Ouster Fought by Art School Faculty," *Los Angeles Times,* November 15, 1969.

223 *"a meaningful, coherent alternative"* Brach oral history, interviewed by Barry Schwartz, ca. 1971, AAA/SI.

224 *"the greatest single source"* Mike Goodman, "New Direction Applied to Trouble-Plagued CalArts," *Los Angeles Times,* October 5, 1972.

224 *"There were . . . a number"* Chunn quoted in Richard Hertz, ed., *Jack Goldstein and the CalArts Mafia* (Ojai, CA: Minneola Press, 2003), 79.

224 *"The entire L.A. art community"* Ibid., 74.

224 *"an ill wind"* Wudl interview with author, August 28, 2010.

224 *"in the early days"* Goldstein in Hertz, *Jack Goldstein and the CalArts Mafia,* 67.

225 *"to teach students who don't paint"* Baldessari oral history, AAA/SI.

225 *"bring in an alternative"* Baldessari in Hertz, *Jack Goldstein and the CalArts Mafia,* 60.

227 *"Nothing is going to happen"* Ibid.

228 *"the girl thing"* Corse interview with author, May 6, 2011.

228 *"All we wanted to do"* Carson interview with author, December 9, 2010. All Carson quotes in this chapter are from author interview.

228 *"were supposed to concern themselves"* Judy Chicago, *Through the Flower: My Struggle as a Woman Artist* (New York: Anchor, 1975), 79.

229 *"Many students did not"* Chunn in Hertz, *Jack Goldstein and the CalArts Mafia*, 80.

229 *"wanted to be taken seriously"* Smith interview with author, November 23, 2010.

229 *"Some women argued"* Chicago, *Through the Flower*, 100.

CHAPTER SEVENTEEN

233 *"A Ray of Hope"* Henry Seldis, "A Ray of Hope for Contemporary Art Scene in L.A.," *Los Angeles Times*, May 26, 1974.

233 *"the very heart of the Museum"* Agee in the Martha Padve papers, 1965–1988, Library Special Collections, YRL/UCLA.

234 *Simon spelled out* For a thorough account of Simon's machinations, see Suzanne Muchnic, *Odd Man In: Norton Simon and the Pursuit of Culture* (Berkeley: University of California Press, 1998).

235 *The institute was the brainchild* Robert Smith, "Evolution of the Institute," *LAICA Journal* 1 (June 1974).

237 *"betrayal"* Harden oral history, interviewed by Karen Anne Mason, September 23 and 25, 1992, YRL/UCLA.

237 *"If it's from New York"* Danieli oral history, interviewed by Robert Pincus, 1984, YRL/UCLA.

237 *"vitriolic assemblies"* Walter Gabrielson, "LAICA: Only Game in Town," *Art in America* (June 1974): 43.

237 *"not about how to have"* Smith oral history, interviewed by Robert Pincus, 1984, YRL/UCLA.

238 *"What's new is what isn't new"* Weisman interview with author, September 1986.

238 *"with a keen understanding"* Bill Boyarsky, "Bradley Record: Pluses, Minuses," *Los Angeles Times*, October 9, 1980.

239 *"We want to make Los Angeles"* Lindsay quoted in Pamela G. Hollie, "Downtown Los Angeles Getting New Focus," *The New York Times*, April 11, 1980.

239 *"Do you know Marcia"* Norris interview with author, September 1986.

240 *"We don't want another"* Broad quoted in William Wilson, "Downtown Museum Has the Big 'M,'" *Los Angeles Times*, April 2, 1980.

240 *"immediately puts us"* Leon Banks in Barbara Isenberg, "Launching a Contemporary Art Museum," *Los Angeles Times*, September 7, 1980.

242 *"postmodernism" and "postmodernity"* For a thorough discussion of the early usage of "postmodern" and its appendages, see Perry Anderson, *The Origins of Postmodernity* (London: Verso, 1998).

242 *"It was an enthusiast's scene"* Wilder oral history, interviewed by Ruth Bowman, July 18, 1988, AAA/SI.

BIBLIOGRAPHY

AUTHOR INTERVIEWS

1986: Shirley Berman, Tosh Berman, Irving Blum, Betye Burton, James Byrnes, John Coplans, James Demetrion, James Elliott, Betty Factor, Merle Glick, Hal Glicksman, George Herms, Walter Hopps, Henry Hopkins, Edward Kienholz, Thomas Leavitt, William Norris, Robert Rowan, Frederick Weisman, Marcia Weisman, Billy Wilder

2006–2011: Terry Allen, Larry Bell, Billy Al Bengston, Tony Berlant, Ellie Blankfort, Chris Burden, Karen Carson, Vija Celmins, Dagny Corcoran, Mary Corse, Tony DeLap, Donald Factor, Monte Factor, Judy Fiskin, Llyn Foulkes, Charles Garabedian, Joe Goode, Scott Greiger, Lloyd Hamrol, Maxwell Hendler, Dennis Hopper, Robert Irwin, Joni Gordon, Peter Lodato, John Mason, Jean Milant, Rolf Nelson, Gifford and Joann Phillips, Allen Ruppersberg, Edward Ruscha, Manny Silverman, Alexis Smith, Jacqueline Anhalt Stuart, DeWain Valentine, Doug Wheeler, Tom Wudl

ORAL HISTORIES AND ARCHIVES

Archives of American Art, Smithsonian Institution, Washington, DC: Betty M. Asher, Rudy Autio, John Baldessari, Susan Benay, Irving Blum, Paul Henry Brach, Hans Burkhardt, Bruce Conner, John Coplans, Jay DeFeo, Everett Ellin, Llyn Foulkes, Joe Goode, Wally Hedrick, Henry Hopkins, Larry Jordan, Gerald Nordland, Susan Peterson, Vincent Price, Edward Ruscha, Millard Sheets, Paul Soldner, Nicholas Wilder, Norton Wisdom, Beatrice Wood

Ferdinand Perret research material on California art and artists, 1769–1942, Roll 3867

University of California, Los Angeles: Irving Blum, Lois Boardman, Frances Lasker Brody, Hans Burkhardt, Elizabeth Burton, James Byrnes, Judy Chicago,

Fidel Danieli, Alonzo Davis, Kenneth Donahue, Connor Everts, Lorser Feitelson, Cecil Ferguson, Beatrice Gersh, Harold Glicksman, Elizabeth Hansom, Marvin Harden, Henry Hopkins, Walter Hopps, Robert Irwin, Suzanne Jackson, Paul Kantor, Craig Kauffman, Edward Kienholz, Felix Landau, Thomas Leavitt, John and Blanche Leeper, Samella Lewis, Lee Mullican, Gerald Nordland, John Outterbridge, Martha Bertonneau Padve, Noah Purifoy, John Riddle, Robert Rowan, Betye Saar, Millard Sheets, Robert Smith, Paul Soldner, Peter Voulkos, June Wayne, Marcia Weisman, Frederick Wight, Emerson Woelffer

Martha Padve papers, Special Collections

The Getty Research Institute, Los Angeles, California
 Betty Asher papers, 1960–1999
 Robert Irwin papers, 1940-2011
 Rolf Nelson gallery records, 1953–1973
 Barbara Rose papers, 1940–1993

BOOKS AND ARTICLES

Abstract Expressionist Ceramics. Irvine, CA: University of California, Irvine, 1966.

Adcock, Craig. *James Turrell: The Art of Light and Space.* Berkeley: University of California Press, 1990.

Alberro, Alexander, and Blake Stimson, eds. *Conceptual Art: A Critical Anthology.* Cambridge, MA: Massachusetts Institute of Technology Press, 2000.

Allen Ruppersberg: Books, Inc. Limoge: FRAC Limousin, 1999.

Allen Ruppersberg: One of Many—Origins and Variations. Düsseldorf: Kunsthalle, 2006.

Allen Ruppersberg: The Secret of Life and Death, Volume 1, 1969–1984. Los Angeles: Museum of Contemporary Art, 1985.

American Light: The Luminist Movement, 1850–1875. Washington, DC: National Gallery of Art, 1980.

American Sculpture of the Sixties. Los Angeles: Los Angeles County Museum of Art, 1967.

Anderson, Perry. *The Origins of Postmodernity.* London: Verso, 1998.

Antin, David. "Art and the Corporations." *ARTnews* (September 1971).

Art in Los Angeles: Seventeen Artists in the Sixties. Los Angeles: Los Angeles County Museum of Art, 1981.

The Art of California: Selected Works from the Collection of the Oakland Museum. Chronicle Books, 1984.

"Art Rides High at a Great University." *Life* 42, no. 20 (May 20, 1957).

Baker, Elizabeth. "Los Angeles, 1971." *ARTnews* (May 1971).

Banham, Rayner. *Los Angeles: The Architecture of Four Ecologies.* Berkeley: University of California Press, second edition, 2000.

Bart, Peter. "Curator of Los Angeles Museum Resigns in Aftermath of Dispute." *The New York Times*, March 4, 1966.

Bauman, William S., ed. *Vija Celmins*. Los Angeles: A.R.T. Press, 1992.

Bätschmann, Oskar. *The Artist in the Modern World: A Conflict Between Market and Self-Expression*. New Haven, CT: Yale University Press, 1997.

Becker, Bill. "Rightist Mailings Stir Coast Clash." *The New York Times*, February 9, 1964.

Becker, Howard S. *Art Worlds*. Berkeley: University of California Press, 1982.

Behner, Victoria Turkel. "Identity, Status, and Power: The Architecture of Contemporary Art Exhibition in Los Angeles." PhD diss., University of Michigan, 2003.

Belgrad, Daniel. *The Culture of Spontaneity*. Chicago: University of Chicago Press, 1999.

Bender, Thomas. *New York Intellect*. New York: Knopf, 1987.

Bengston, Billy Al. "Late Fifties at the Ferus: A Participant Refuses to Take the Show Lying Down." *Artforum* VII, no. 5 (January 1969).

Billy Al Bengston. Los Angeles: Los Angeles County Museum of Art, 1968.

Boyarsky, Bill. "Bradley Record: Pluses, Minuses." *Los Angeles Times*, October 9, 1980.

"Brightness in the Air." *Time* (December 18, 1964).

Brown, Conrad. "Peter Voulkos: Southern California's Top Potter." *Craft Horizons* 16, no. 5 (September 1956).

Brown, Milton W. *The Story of the Armory Show*. New York: Abbeville, 1988.

Brown, Richard. *Outline of Statistics Concerning Art Museum Program*. Report to L.A. County Supervisors, 1957.

Burnham, Jack. "Corporate Art." *Artforum* (October 1971).

Butterfield, Jan. *The Art of Light and Space*. New York: Abbeville, 1993.

California: The State of the Landscape, 1872–1981. Newport Beach, CA: Newport Harbor Art Museum, 1981.

"The California Way of Life." *Life* 19, no. 17 (October 22, 1945).

"The Call of California." *Life* (October 19, 1962).

Canaday, John. "Art: New Coast Museum." *The New York Times*, March 29, 1965.

Carson, Robert. "Upper Los Angeles." *Los Angeles* (January 1966).

Carter, Edward. Letter to the editor. *Los Angeles Times*, November 13, 1965.

Caughy, John and LaRee, eds. *Los Angeles: Biography of a City*. Berkeley: University of California Press, 1977.

Chicago, Judy. *Through the Flower: My Struggle as a Woman Artist*. New York: Anchor, 1975.

Clark, T. J. *Farewell to an Idea*. New Haven, CT: Yale University Press, 1999.

———. *The Painting of Modern Life: Paris in the Art of Manet and His Followers*. Princeton, NJ: Princeton University Press, 1984.

Cochran, Drew. "Ric the Lion-Hearted." *Los Angeles* 7, no. 5 (June 1964).

Coffin, Patricia. "California Is Bustin' Out All Over." *Look* (September 29, 1959).

Color and Fire: Defining Moments in Studio Ceramics, 1950–2000. Los Angeles: Los Angeles County Museum of Art, 2000.

Coplans, John. "Abstract Expressionist Ceramics." *Artforum* 3, no. 34 43 (November 1966).

———. "Art Bloom." *Vogue* (November 1967).

———. "Art Is Love Is God." *Artforum* II, no. 9 (March 1964).

———. "Circle of Styles on the West Coast." *Art in America* 52, no. 3 (June 1964).

———. "Lloyd Hamrol's 'Multiples.'" *Artforum* 4, 50–51 (December 1966).

———. "The New Painting of Common Objects." *Artforum* I, no. 12 (November 1962).

———. "Pasadena's Collapse and the Simon Takeover: Diary of a Disaster." *Artforum* 13 (February 1975). Reprinted in *Provocations: Writings by John Coplans*. London: London Projects, 1996.

———. "Pop Art USA." *Art in America* (October 1963).

———. "The Sculpture of Kenneth Price." *Art International* (March 20, 1964).

Craig Kauffman. Hope, ID: Faith and Charity in Hope Gallery, 1983.

Craig Kauffman: A Comprehensive Survey 1957–1980. Los Angeles: La Jolla Museum of Contemporary Art, with Fellows of Contemporary Art, 1981.

Crane, Diane. *The Triumph of the Avant-Garde: The New York Art World, 1940–1985*. Chicago: University of Chicago, 1987.

Creeley, Robert. *A Daybook*. New York: Scribner, 1972.

Crow, Thomas. *The Rise of the Sixties*. New York: Abrams, 1996.

Dailey, Victoria, Natalie Shivers, and Michael Dawson. *L.A.'s Early Moderns: Art, Architecture, Photography*. Los Angeles: Balcony Press, 2003.

Davis, Mike. *City of Quartz: Excavating the Future in Los Angeles*. New York: Verso, 1990.

Didion, Joan, *Slouching Towards Bethlehem*. New York: Farrar, Straus and Giroux, 1968.

———. *The White Album*. New York: Simon & Schuster, 1979.

Donahue, Kenneth. "What the Art Museum Offers the Public." *Los Angeles Times*, March 28, 1965.

"Drawing the Line in L.A." *Newsweek* (November 22, 1965).

Dreyfuss, John. "Bunker Hill Project Massive, Uninspiring." *Los Angeles Times*, August 11, 1980.

———. "How to Pick a Winner." *Los Angeles Times*, August 17, 1979.

———. "Ouster Fought by Art School Faculty." *Los Angeles Times*, November 15, 1969.

Duncan, Ray. "Pasadena, the Old Order Changeth," *Los Angeles*, December 1963.

Edward Kienholz. Los Angeles: Los Angeles County Museum of Art, 1966.

Edward Kienholz, 1954–1962. Houston: Menil Collection, 1996.

Edward Ruscha. Rotterdam: Museum Boymans-van Beunigen, 1990.

Edward Ruscha: Editions, 1959–1999. Two volumes. Edited by Siri Engberg. Minneapolis, MN: Walker Art Center, 1999.

Edward Ruscha: Romance with Liquids: Paintings 1966–1969. New York: Gagosian Gallery, with Rizzoli International Publications, 1993.

Ehrlich, Susan. "Five L.A. Pioneer Modernists." PhD diss., University of Southern California, 1985.

Eleven Los Angeles Artists. London: Hayward Gallery, 1971.

Elon, Amos. *The Pity of It All: A History of the Jews in Germany, 1743–1933*. New York: Metropolitan Books, 2002.

Emerson, Ralph Waldo. *Essays and Lectures*. New York: Library of America, 1983.

Fifteen Los Angeles Artists. Pasadena, CA: Pasadena Art Museum, 1972.

Findlay, John M. *Magic Lands: Western Cityscapes and American Culture After 1940*. Berkeley: University of California Press, 1992.

Finish Fetish: L.A.'s Cool School. Edited by Frances Colpitt. Los Angeles: Fisher Gallery, University of Southern California, 1991.

Fogelson, Robert M. *The Fragmented Metropolis: Los Angeles, 1850–1930*. Cambridge, MA: Harvard University Press, 1967.

Forty Years of California Assemblage. Los Angeles: Wight Gallery, University of California, Los Angeles, 1989.

Four Los Angeles Sculptors. Chicago: Museum of Contemporary Art, 1973.

Fox, Christy. "Society and Art Worlds Converge." *Los Angeles Times*, October 9, 1963.

Francastle, Pierre. *Art & Technology in the Nineteenth and Twentieth Centuries*. New York: Zone Books, 2000.

Fried, Michael. "Ron Davis." *Artforum* (April 1967).

Fulton, William. *The Reluctant Metropolis: The Politics of Urban Growth in Los Angeles*. Point Arena, CA: Solano Press, 1997.

Gabler, Neil. *An Empire of Their Own: How the Jews Invented Hollywood*. New York: Crown, 1988.

———. *Walt Disney: The Triumph of the American Imagination*. New York: Knopf, 2006.

Gabrielson, Walter. "LAICA: Only Game in Town." *Art in America* (June 1974).

Gardner, Paul. "Pasadena Museum: Cutbacks and Hopes." *The New York Times*, August 13, 1971.

George Herms: The Secret Archives. Los Angeles: Los Angeles Municipal Art Gallery, 1992.

Glueck, Grace. "Art Notes: From Face to Shining Face." *The New York Times*, September 29, 1968.

———. "Judge Restrains Auction of Simon Museum Art." *The New York Times*, May 17, 1980.

———. "Los Angeles Regains Vigor as an Art Center." *The New York Times*, May 29, 1969.

———. "Million in Norton Simon Funds to Aid Pasadena Art Museum." *The New York Times*, October 22, 1974.

———. "The Simon Museum—'The Fief of a Private Acquisitor.' " *The New York Times*, February 24, 1980.

———. "Simon Sale of Art Is Challenged." *The New York Times*, May 9, 1980.

Goff, Tom. "Art Museum Upheaval Stirs Up Supervisors." *Los Angeles Times*, November 9, 1965.

Goldin, Amy. "Art and Technology in a Social Vacuum." *Art in America* 60, no. 2 (March–April 1972).

Goldstein, Malcolm. *Landscape with Figures: A History of Art Dealing in the United States*. New York: Oxford University Press, 2000.

Goodman, Mike. "New Direction Applied to Trouble-Plagued CalArts." *Los Angeles Times*, October 5, 1972.

Gottlieb, Robert, and Irene Wolt. *Thinking Big: The Story of the Los Angeles Times, Its Publishers, and Their Influence on Southern California*. New York: Putnam, 1977.

Grodzinksi, Vera. "Collecting Against the Grain." *The Jewish Quarterly* (Summer 2006).

"Group Sets Rally to Discuss Art Museum." *Los Angeles Times*, November 26, 1965.

Herbert, Ray. "$500 Million Bunker Hill Project Plan Centers on Museum." *Los Angeles Times*, August 16, 1979.

Heroic Stance: The Sculpture of John McCracken, 1965–1986. New York: P.S. 1, with Newport Harbor Art Museum, 1987.

Hertz, Neil. *The End of the Line*. New York: Columbia, 1985.

Hertz, Richard, ed. *Jack Goldstein and the CalArts Mafia*. Ojai, CA: Minneola Press, 2003.

Hertz, Uri. "Michael McClure on Wallace Berman: Interview." *Third Rail* 10 (1988).

Hill, Gladwin. "Coast Metropolis One-Third Vacant." *The New York Times*, June 30, 1963.

———. "Renewal Project Spurred on Coast." *The New York Times*, April 7, 1963.

———. "Three in Birch Society Win in California." *The New York Times*, June 7, 1962.

Hise, Greg. *Magnetic Los Angeles: Planning the Twentieth-Century Metropolis*. Baltimore, MD: The Johns Hopkins University Press, 1997.

Hobbs, Stuart D. *The End of the American Avant-Garde*. New York: New York University Press, 1997.

Hollie, Pamela G. "Downtown Los Angeles Getting New Focus." *The New York Times*, April 11, 1980.

Hurwitz, Daniel. *Bohemian Los Angeles and the Making of Modern Politics*. Berkeley: University of California Press, 2007.

I Don't Want No Retrospective: The Works of Edward Ruscha. San Francisco: San Francisco Museum of Art, 1982.

Isenberg, Barbara. "Bradley Panel Seeks Site for Art Museum." *Los Angeles Times*, June 9, 1979.

———. "In Quest of L.A. Home for Modern Art." *Los Angeles Times*, June 11, 1979.

———. "Launching a Contemporary Art Museum." *Los Angeles Times*, September 7, 1980.

————. *State of the Arts: California Artists Talk About Their Work.* New York: William Morrow, 2000.

James Turrell. Tallahassee, FL: Florida State University Gallery and Museum, 1989.

Jensen, Robert. *Marketing Modernism in Fin-de-Siècle Europe.* Princeton, NJ: Princeton University Press, 1994.

Joe Goode, Edward Ruscha. Newport Beach, CA: Fine Arts Patrons of Newport Harbor, 1968.

Joe Goode: Waterfall Paintings. Santa Monica, CA: James Corcoran Gallery, 1990.

John Altoon. San Francisco: San Francisco Museum of Art, 1967.

John Altoon. Santa Clara, CA: De Saisset Museum, University of Santa Clara, 1980.

John Altoon. San Diego, CA: Museum of Contemporary Art San Diego, 1997.

John Altoon: An Exhibition of Paintings, Drawings, and Prints. Sacramento, CA: Crocker Art Gallery, 1974.

John Altoon: Drawings and Prints. New York: Whitney Museum of American Art, 1971.

John Altoon: 25 Paintings 1957–1969. Pasadena, CA: Baxter Art Gallery, California Institute of Technology, 1984.

John Altoon: Works on Paper. Chicago: Arts Club of Chicago, 1984.

John McLaughlin: Western Modernism, Eastern Thought. Laguna Beach, CA: Laguna Art Museum, 1996.

Jordan, David P. *Transforming Paris: The Life and Labors of Baron Haussmann.* New York: Free Press, 1995.

Juarez Series: Terry Allen. Houston: Contemporary Arts Museum, 1975.

Karlstrom, Paul, ed. *On the Edge of America: California Modernist Art, 1900–1950.* Berkeley: University of California Press, 1996.

Ken Price. Houston, TX: The Menil Collection, 1992.

Ken Price: Sculpture and Drawings, 1962–2006. New York: Matthew Marks Gallery, 2006.

Kienholz: A Retrospective. New York: Whitney Museum of American Art, 1996.

Kimmel, Michael. *Manhood in America.* New York: The Free Press, 1996.

Klein, Norman M. *The History of Forgetting: Los Angeles and the Erasure of Memory.* New York: Verso, 1997.

Klein, Norman M., and Martin J. Schiesl, eds. *Twentieth-Century L.A.: Power, Promotion, and Social Conflict.* Claremont, CA: Regina, 1990.

Knud Merrild, 1894–1954. Los Angeles: Los Angeles County Museum of Art, 1965.

Kozloff, Max. "The Multimillion Dollar Boondoggle. *Artforum* (October 1971).

————. "Under the Corporate Wing." *Art in America* (July–August 1971).

————. "West Coast Art: Vital Pathology." *The Nation* (August 24, 1964).

Kramer, Hilton. "Los Angeles, Now the 'In' Art Scene." *The New York Times*, June 1, 1971.

———. "Nostalgia for the Future." *The New York Times*, May 7, 1967.

———. "Richard Smith Takes a Robust Term." *The New York Times*, November 19, 1966.

Kraynak, Janet, ed. *Please Pay Attention Please: Bruce Nauman's Words*. Cambridge, MA: Massachusetts Institute of Technology Press, 2003.

Krull, Craig, ed. *Photographing the L.A. Art Scene 1955–1975*. Santa Monica, CA: Smart Art Press, 1996.

Kubler, George. *The Shape of Time: Remarks on the History of Things*. New Haven, CT: Yale University Press, 1962.

Kuh, Katharine. "Los Angeles: Salute to a New Museum." *Saturday Review* (April 3, 1965).

Langsner, Jules. "The Arensberg Riches of Cubism." *ARTnews* (November 1949).

———. "Art News from Los Angeles." *ARTnews* (December 1951).

———. "Los Angeles Letter." *Art International* 6, no. 3 (April 1962). Reprinted in Steven Henry Madoff, ed. *Pop Art: A Critical History*. Berkeley: University of California Press, 1997.

L.A. Pop in the Sixties. Newport Beach, CA: Newport Harbor Art Museum, 1989.

Larry Bell, Robert Irwin, Doug Wheeler. London: Tate Gallery, 1970.

Larry Bell: The Sixties. Santa Fe, NM: Museum of Fine Art, Museum of New Mexico, 1982.

The Last Time I Saw Ferus. Newport Beach, CA: Newport Harbor Art Museum, 1976.

Lee Mullican: An Abundant Harvest of Sun. Los Angeles: Los Angeles County Museum of Art, 2005.

Leider, Philip. "The Best of the Lack-Lustre." *The New York Times*, August 7, 1966.

———. "The Cool School." *Artforum* II, no. 12 (Summer 1964).

———. "Joe Goode and the Common Object." *Artforum* IV, no. 7 (March 1966).

———. "Los Angeles and the Kienholz Affair." *The New York Times*, April 3, 1966.

Leighton, Patrician. *Re-Ordering the Universe: Picasso and Anarchism*. Princeton, NJ: Princeton University Press, 1989.

Lindsay, Robert. "Los Angeles, in a Building Boom, Debates Urban Revival." *The New York Times*, December 5, 1975.

Lippard, Lucy. *Six Years: The Dematerialization of the Art Object from 1966 to 1972*. Berkeley: University of California Press, 1973.

Lipschutz-Villa, Eduardo, ed. *Support the Revolution: Wallace Berman*. Amsterdam: Institute of Contemporary Art, 1992.

Lipton, Lawrence. *The Holy Barbarians*. New York: Julian Messner, 1959.

Livingston, Jane. "Two Generations in Los Angeles." *Art in America* (January–February 1969).

Llyn Foulkes. Newport Beach, CA: Newport Harbor Art Museum, 1974.

Llyn Foulkes: The Sixties. New York: Kent Gallery, 1987.

Longman, Lester. "Letter on a Dilemma," letter to the art editor. *The New York Times*, April 30, 1961.

Los Angeles in the Seventies. Fort Worth, TX: Fort Worth Museum of Art, 1977.

Los Angeles 1955–1985. Paris: Centre Pompidou, 2006.

"The Los Angeles Scene Today," *Artforum* II, no. 12 (Summer 1964).

Lynch, Kevin. *The Image of the City*. Cambridge, MA: Massachusetts Institute of Technology Press, 1960.

Maddow, Ben. *Edward Weston: His Life*. New York: Aperture, 1973.

Mailer, Norman. "Superman Comes to the Supermarket." *Esquire* (November 1960).

Mainardi, Patricia. *Art and Politics of the Second Empire*. New Haven, CT: Yale University Press, 1987.

"Management of the Art Museum," editorial. *Los Angeles Times*, November 10, 1965.

Mann, Bert. "Norton Simon Museum Takeover Approved." *Los Angeles Times*, April 27, 1974.

———. "Pasadena Officials Back County Takeover of City's Art Museum." *Los Angeles Times*, June 7, 1972.

Man Ray 1966. Los Angeles: Los Angeles County Museum of Art, 1966.

Marshall, Richard D. *Ed Ruscha*. London: Phaidon, 2003.

Marx, Wes, and Gil Thomas. "The Westside Story." *Los Angeles* (February 1962).

Masheck, Joseph. "New York." *Artforum* 9 (January 1971).

Matthew, Mary. "They Came, They Saw—Duchamp Conquered." *Los Angeles Times*, October 9, 1963.

May, Elaine Tyler. *Homeward Bound: American Families During the Cold War*. New York: Basic Books, 1988.

May, Kirsee Granat. *Golden State, Golden Youth: The California Image in Popular Culture, 1955–1966*. Chapel Hill, NC: University of North Carolina, 2002.

May, Lary, ed. *Recasting America: Culture and Politics in the Age of Cold War*. Chicago: University of Chicago Press, 1989.

Maynard, John Arthur. *Venice West*. New Brunswick, NJ: Rutgers University Press, 1991.

McCracken, John. "New Talent USA," *Art in America* 54, no. 4 (July–August 1966).

McDougal, Denis. *Privileged Son: Otis Chandler and the Rise and Fall of the Los Angeles Times Dynasty*. Cambridge, MA: Perseus, 2001.

McKenna, Kristine. *The Ferus Gallery: A Place to Begin*. Göttingen: Steidl Verlag, 2004.

McWilliams, Carey. *Southern California: An Island in the Land*. Santa Barbara, CA: Peregrine Smith, 1973.

Meyer, James, ed. *Minimalism*. London: Phaidon, 2000.

A Minimal Future?: Art as Object, 1958–1968. Edited by Ann Goldstein and Lisa Gabrielle Mark. Los Angeles: Museum of Contemporary Art, 2004.

"Monday Night on La Cienega." *Time* (July 26, 1963).

Muchnic, Suzanne. *Odd Man In: Norton Simon and the Pursuit of Culture*. Berkeley: University of California Press, 1998.

———. "Simon Museum Sells More Art." *Los Angeles Times*, July 4, 1980.

"A Museum Worthy of a Metropolis." *Los Angeles Times*, January 6, 1961.

Myth of the West. Seattle, WA: Henry Art Gallery, University of Washington, with Rizzoli, 1990.

Nadeau, Remi. *Los Angeles: From Mission to Modern City*. New York: Longman, 1960.

The Natural Paradise: Painting and Sculpture in America, 1800–1950. New York: Museum of Modern Art, 1976.

A New Aesthetic. Edited by Barbara Rose. Washington, DC: Washington Gallery of Modern Art, with Garamond-Pridemark Press, 1967.

Newman, Amy, ed. *Challenging Art: Artforum 1962–1974*. New York: Soho Press, 2000.

Nin, Anaïs. *The Diary of Anaïs Nin, Volume Five 1947–1955*. New York: Harcourt Brace Jovanovich, 1966.

———. *The Diary of Anaïs Nin, Volume Six 1955–1966*. New York: Harcourt Brace Jovanovich, 1966.

19 Sixties: A Cultural Awakening Re-evaluated, 1965–1975. Edited by Lizzetta LeFalle-Collins and Cecil Fergerson. Los Angeles: California Afro-American Museum Foundation, 1989.

Noble, David. *The Religion of Technology*. New York: Knopf, 1997.

"A Noble Contribution to the World of Art." *Los Angeles Times* editorial, March 28, 1965.

Nordland, Gerald. "Innovation." *Frontier* (May 1957).

Novak, Barbara. *Nature and Culture: American Landscape and Painting, 1825–1875*. New York: Oxford University Press, 1980.

Nye, David E. *American Technological Sublime*. Cambridge, MA: Massachusetts Institute of Technology, 1994.

O'Doherty, Brian. "John Hultberg's War Between Sky and Earth." *The New York Times*, May 9, 1962.

Painting and Sculpture in California: The Modern Era. San Francisco: San Francisco Museum of Art, 1976.

Paul Soldner: A Retrospective. Claremont, CA: Lang Gallery, Scripps College, 1991.

Pells, Richard. *The Liberal Mind in a Conservative Age*. New York: Harper & Row, 1985.

Perine, Robert. *Chouinard: An Art Vision Betrayed*. Encinitas, CA: Artra Publishing, 1985.

Perl, Jed. *New Art City: Manhattan at Mid-Century*. New York: Knopf, 2005.

"Peter Voulkos Exhibits New Stoneware at Felix Landau Gallery in Los Angeles." *Craft Horizons* (May 1956).

Peter Voulkos: Sculpture. Los Angeles: Los Angeles County Museum of Art, 1965.

Peter Voulkos: Sculpture, Painting, Ceramics, Felix Landau Gallery, May 4 – May 23, 1959. Los Angeles: The Gallery, 1959.

Phenomenal: California Light, Space, Surface. San Diego: Museum of Contemporary Art, 2011.

Pincus, Robert. *On a Scale That Competes with the World: The Art of Edward and Nancy Reddin Kienholz.* Berkeley: University of California Press, 1990.

"Place in the Sun." *Time* (August 30, 1968).

Plagens, Peter. *Sunshine Muse.* Berkeley: University of California Press, 1974.

———. "The Soft Touch of Hard Edge." *LAICA Journal* (April–May 1975).

Pollock, Duncan. "All Quite on the Western Front." *Art in America* 61, no. 2 (March-April 1973).

Polsky, Richard. *I Bought Andy Warhol.* New York: Abrams, 2003.

Pop Art: U.S./U.K. Connections. Houston: Menil Collection, 2001.

Price, Ken. "Objects to Live With: Ken Price at Chinati." *Chinati Foundation Newsletter* 10 (2005).

The Prints of Vija Celmins. New York: Metropolitan Museum of Art, 2002.

The Prometheus Archives: A Retrospective of the Works of George Herms. Los Angeles: Los Angeles Municipal Art Gallery, 1979.

Proof: Los Angeles Art and the Photograph, 1960–1980. Laguna Beach, CA: Laguna Art Museum, 1992.

"Proposed Center Will Focus on Culture." *Los Angeles Times,* October 17, 1963.

Radical Past: Contemporary Art and Music in Pasadena, 1960–1974. Pasadena, CA: Armory Center for the Arts, 1999.

Rand, Christopher. *Los Angeles: The Ultimate City.* New York: Oxford University Press, 1967.

Raynor, Vivian. "Fun Art." *Arts* (September 1962).

Real, James. "CalArts: When You Wish Upon a School." *Los Angeles Times Magazine,* February 27, 1972.

Report on the Art and Technology Program of the Los Angeles County Museum of Art, 1967–1971. Los Angeles: Los Angeles County Museum of Art, 1971.

Revolution in Clay: The Marer Collection of Contemporary Ceramics. Claremont, CA: Ruth Chandler Williamson Gallery, Scripps College, 1994.

Robert Heinecken, Photographist. Chicago: Museum of Contemporary Art, 1999.

Robert Irwin. Los Angeles: Museum of Contemporary Art, 1993.

Robert Irwin. San Diego: Museum of Contemporary Art, 2007.

Roberts, Glenys. "The Schizophrenic Art Market." *Los Angeles* 12, no. 9 (September 1967).

Roberts, Steven V., "Coast Arts School on Unorthodox Path," *New York Times,* December 3, 1970

Rockwell, John. "CalArts Mood Hopeful Despite President's Exit." *Los Angeles Times,* May 10 1972.

Rose, Barbara. "California Surrealism: Irvine's Golden Years, When Marcel Was Still Da Champ." *The Journal of Art* (November 1991).

———. "Los Angeles: Second City." *Art in America* (January 1966).

Rosenberg, Harold, "The American Action Painters." *ARTnews* (December 1952). Reprinted in Ellen G. Landau, ed. *Reading Abstract Expressionism: Content and Critique*. New Haven, CT: Yale University Press, 2005.

Rosenblum, Robert. *Modern Painting and the Northern Romantic Tradition*. New York: Harper & Row, 1975.

Rotman, Brian. *Signifying Nothing: The Semiotics of Zero*. New York: St. Martins Press, 1987.

Ruscha, Ed. *Leave Any Information at the Signal: Writings, Interviews, Bits, Pages*. Edited by Alexandra Schwartz. Cambridge, MA: Massachusetts Institute of Technology, 2002.

Schjeldahl, Peter. "L.A. Art: Interesting—but Painful." *The New York Times*, May 21, 1972.

Schorske, Carl E. *Fin-de-Siècle Vienna: Politics and Culture*. New York: Knopf, 1980.

Schumach, Murray. "Pasadena to See Art of Duchamp." *The New York Times*, August 13, 1963.

Schwartz, Alexandra. *Ed Ruscha's Los Angeles*. Cambridge, MA: Massachusetts Institute of Technology, 2010.

Seidenbaum, Art. "Art: Is It Trick or Treat?" *Los Angeles Times*, March 17, 1963.

———. "Bulls and Bears in Art Market." *Los Angeles Times*, January 27, 1963.

———. "La Cienega Blvd. Learns How to Please All the Palettes." *Los Angeles Times*, March 6, 1966.

———. "A Look at Bomb Craters After Cultural Explosion." *Los Angeles Times*, April 12, 1968.

———. "A Young Turk in Old Pasadena." *Los Angeles Times*, May 25, 1964.

Seigel, Jerrold. *Bohemian Paris*. New York: Viking, 1986.

Seldis, Henry, "After Four Years, Goals Undefined." *Los Angeles Times*, March 5, 1969.

———. "The Biggest Threat Facing Modern Art." *Los Angeles Times*, February 10, 1963.

———. "Billboards and the 'Pop' Art Complex; Sign of Times?" *Los Angeles Times*, May 31, 1963.

———. "Choices That Will Determine Future Stature." *Los Angeles Times*, March 9, 1969.

———. "Consensus on the Role of Moderns." *Los Angeles Times*, March 7, 1969.

———. "Contemporary Works Need a Permanent Home." *Los Angeles Times*, June 15, 1969.

———. "County Museum of Art Dedication Rites Held." *Los Angeles Times*, March 31, 1965.

———. "Dr. Brown Quits Art Museum Post." *Los Angeles Times*, November 7, 1965.

———. "Group Urges Changes for Art Museum." *Los Angeles Times*, November 30, 1965.

———. "Hatred No Spur to Greater Art." *Los Angeles Times*, June 21, 1963.

———. "Leadership Roles Need Clarification." *Los Angeles Times*, March 6, 1969.

———. "New Museum to Bring Growing Art Center." *Los Angeles Times*, November 9, 1961.

———. "Newness and Nowness in Pasadena." *Los Angeles Times*, July 6, 1969.

———. "'New Realism' Comes in Humor, Cynicism." *Los Angeles Times*, December 2, 1962.

———. "Pasadena Museum: From Jet-Set Debut to Partial Shutdown." *Los Angeles Times*, July 18, 1971.

———. "Pasadena's Lopsided West Coast Survey." *Los Angeles Times*, November 30, 1969.

———. "Pasadena's New Now Art Museum." *Los Angeles Times*, November 16, 1969.

———. "A Ray of Hope for Contemporary Art Scene in L.A." *Los Angeles Times*, May 26, 1974.

Selz, Peter. *Art of Engagement: Visual Politics in California and Beyond*. Berkeley: University of California Press, 2006.

———. *Beyond the Mainstream*. Cambridge, MA: Cambridge University Press, 1997.

Semina Culture: Wallace Berman and His Circle. Santa Monica, CA: Santa Monica Museum of Art, 2005.

Sennett, Richard, ed. *Classic Essays on the Culture of Cities*. Englewood Cliffs, NJ: Prentice Hall, 1969.

Sexual Politics: Judy Chicago's Dinner Party in Feminist Art History. Edited by Amelia Jones and Laura Cottingham. Los Angeles: UCLA at the Armand Hammer Art Museum and Cultural Center, 1996.

Sharp, Willoughby. "New Directions in Southern California Sculpture." *Arts Magazine* (Summer 1970).

Sharpe, William, and Leonard Wallock, eds. *Vision of the Modern City*. Baltimore, MD: The Johns Hopkins University Press, 1987.

Sheer, Robert. "Line Drawn Between Two Worlds," the second in the three-part series "The Jews of Los Angeles." *Los Angeles Times*, January 30, 1978.

Silberman, Robert. "Ken Price in Retrospect." *American Craft* (August–September 1992).

Simon, Joan. "An Interview with Ken Price." *Art in America* (May 1980).

Sitney, P. Adams. *Visionary Film: The American Avant-Garde*. New York: Oxford University Press, 1974.

Slivka, Rose, and Karen Tsujimoto. *The Art of Peter Voulkos*. Oakland, CA: Oakland Museum of Art, 1995.

Smith, Bob. "Evolution of the Institute." *LAICA Journal* 1 (June 1974).

Smith, Richard Candida. *Utopia and Dissent: Art, Poetry, and Politics in California*. Berkeley: University of California Press, 1995.

Solnit, Rebecca. *River of Shadows: Eadweard Muybridge and the Technological Wild West.* New York: Penguin, 2004.

———. *Secret Exhibition: Six California Artists in the Cold War Era.* San Francisco: City Lights, 1990.

Solomon, Alan. "Making Like Competition in L.A." *The New York Times,* July 11, 1965.

Southern California: Attitudes 1972. Pasadena, CA: Pasadena Art Museum, 1972.

"Squaresville U.S.A. vs. Beatsville." *Life* (September 21, 1959).

Starr, Kevin. *Americans and the California Dream.* New York: Oxford University Press, 1986.

———. *The Dream Endures: California Enters the 1940s.* New York: Oxford University Press, 2002.

———. *Embattled Dreams: California in War and Peace, 1940–1950.* New York: Oxford University Press, 2003.

———. *Golden Dreams: California in an Age of Abundance, 1950–1963.* New York: Oxford University Press, 2009.

———. *Inventing the Dream: California Through the Progressive Era.* New York: Oxford University Press, 1985.

———. *Material Dreams: California Through the 1920s.* New York: Oxford University Press, 1991.

Starr, Sandra Leonard. *Lost and Found in California: Four Decades of Assemblage Art.* Los Santa Monica, CA: James Corcoran Gallery, 1988.

Stone, Robert. *Prime Green: Remembering the Sixties.* New York: Ecco, 2007.

Sullivan, Dan. "CalArts Hassle: They Should Have Seen It Coming." *Los Angeles Times,* October 31, 1971.

Sunshine and Noir: Art in LA 1960–1997. Copenhagen: Louisiana Museum of Modern Art, 1997.

Surrealism Is Alive and Well in the West. Pasadena, CA: Baxter Art Gallery, California Institute of Technology, 1972.

Syrop, Mitchell, and Michael McCurry. "Interview with Patricia Faure." *C3i Striking Distance.* Available at strikingdistance.com/c3inov/faure.html.

Taubman, Howard. "Culture Way Out West." *The New York Times,* November 8, 1966.

"Temple on the Tar Pits." *Time* (April 2, 1965).

Ten from Los Angeles. Seattle, WA: Seattle Art Museum, 1966.

Terry Allen: Mixed-Media Drawings. Chicago: Museum of Contemporary Art, 1971.

Tomkins, Calvin. *Duchamp: A Biography.* New York: Henry Holt and Company, 1996.

———. "A Touch for the Now." *The New Yorker* (July 29, 1991).

Transparency, Reflection, Light, Space: Four Artists. Los Angeles: UCLA Art Gallery, 1971.

Turning the Tide: Early Los Angeles Modernists. Santa Barbara, CA: Santa Barbara Museum of Art, 1990.

Ulin, David, ed., *Writing Los Angeles: A Literary Anthology*. New York: Library of America, 2002.

"Unveiling a New Masterpiece," editorial. *Los Angeles Times*, March 31, 1965.

Vija Celmins. Newport Beach, CA: Newport Harbor Art Museum, 1979.

Vija Celmins. Philadelphia: Institute of Contemporary Art, University of Pennsylvania, 1993.

Wallace Berman Retrospective. Los Angeles: Otis Art Institute Gallery, with Fellows of Contemporary Art, 1978.

Warhol, Andy, and Pat Hackett. *Popism: The Warhol Sixties*. New York: Harcourt Brace, 1980.

Weiskel, Thomas. *Romantic Sublime: Studies in the Psychology of Transcendence*. Baltimore, MD: The Johns Hopkins University Press, 1976.

Weisman, John. "CalArts Aiming for Magic Kingdom of Creative Education." *Los Angeles Times*, October 4, 1970.

Wernick, Robert. "Wars of the Instant Medicis." *Life* 61, no. 18 (October 28, 1966).

Weschler, Lawrence. *Seeing Is Learning to Forget the Name of the Thing One Sees*. Berkeley: University of California Press, 1982.

West Coast: 1945–1969. Pasadena, CA: Pasadena Art Museum, 1969.

White, Harrison C. and Cynthia A. *Canvases and Careers: Institutional Change in the French Painting World*. Chicago: University of Chicago Press, 1965.

Wilson, William. "Aspects of Modernity in Orange County Shows." *Los Angeles Times*, October 27, 1968.

———. "Bruce Nauman's Unsettling Art Given a Masterful Touch." *Los Angeles Times*, March 23, 1970.

———. "Downtown Museum Has the Big 'M.'" *Los Angeles Times*, April 2, 1980.

———. "The Explosion That Never Went Boom." *Saturday Review* (September 23, 1967).

———. "Patrons of Pop." *Los Angeles Times Magazine*, December 7, 1969.

———. "Two Shows Give Southlander Broad Look at What's New." *Los Angeles Times*, June 13, 1971.

Winer, Helen. "How Los Angeles Looks Today." *Studio International* (October 1971).

Wright, Robert. "Los Angeles Looks Eastward for Plan to Revive Decaying Midtown." *The New York Times*, August 26, 1970.

Zones of Experience: The Art of Larry Bell. Albuquerque, NM: The Albuquerque Museum, 1997.

PHOTO CREDITS

PAGE X: Philadelphia Museum of Art, Arensberg Archives.

PAGE 31: Allan Grant/The LIFE Picture Collection/Getty Images.

PAGES 55, 60, AND 61: Photographs by Charles Brittin; Charles Brittin Archive, Getty Research Institute. Used with permission.

PAGE 57: Courtesy of the Cameron Parsons Foundation.

PAGE 74: Courtesy of Peggy Voulkos and the Voulkos & Co. Catalogue Project.

PAGE 78: Photograph by Robert Bucknam, courtesy of John Mason.

PAGE 97: © Jerry McMillan. Courtesy of Jerry McMillan and Craig Krull Gallery, Santa Monica, California.

PAGES 107 AND 109: © Julian Wasser. Courtesy of Julian Wasser and Craig Krull Gallery, Santa Monica, California.

PAGE 127: Photograph by Seymour Rosen, © SPACES—Saving and Preserving Arts and Cultural Environments.

PAGE 129: © Marvin Silver. Courtesy of Marvin Silver and Craig Krull Gallery, Santa Monica, California.

PAGE 132: The Menil Collection, Houston, Gift of Lannan Foundation. Photo: Paul Hester. © Nancy Reddin Kienholz.

PAGE 154: Los Angeles Times Photographic Archive, Young Research Library Special Collections. © Regents of the University of California.

PAGE 173: © Ed Ruscha. Courtesy of the artist and Gagosian Gallery.

PAGE 182: Photograph by Frank J. Thomas, courtesy of the Frank J. Thomas Archives. © 2014 Doug Wheeler; courtesy David Zwirner, New York/London.

PAGE 186: © Malcolm Lubliner. Courtesy of Malcolm Lubliner and Craig Krull Gallery, Santa Monica, California.

PAGE 195: © J. Paul Getty Trust. Used with permission. Julius Shulman Photography Archive, the Getty Research Institute.

PAGE 213: Courtesy of Allen Ruppersberg.

PAGE 216: Friedrich Christian Flick Collection. Photo courtesy Sperone West-water, New York. © 2014 Bruce Nauman/Artists Rights Society (ARS), New York.

PAGE 226: Courtesy of John Baldessari.

COLOR INSERT

BERMAN, Verifax collage: Courtesy of the Estate of Wallace Berman and the Kohn Gallery.

HERMS, *The Librarian*: Norton Simon Museum, Gift of Molly Barnes. © George Herms.

KIENHOLZ, *Roxys*: © Nancy Reddin Kienholz. Photo by Cathy Carver; courtesy of David Zwirner, New York/London.

PRICE, *L. Blue*: Fredric Nilsen.

RUSCHA, *Hollywood* and *Actual Size*: © Ed Ruscha. Courtesy of the artist and Gagosian Gallery.

GOODE, *One Year Old*: Chris Bliss Photography. Orange County Museum of Art.

GOODE, *Torn Cloud Painting*: Portland Art Museum, Portland, Oregon. Museum Purchase: Funds provided by the Contemporary Art Council.

CELMINS, untitled *(Big Sea #1)*: © Vija Celmins. Courtesy McKee Gallery, New York. Private collection.

BENGSTON, *Busby*: © Billy Al Bengston.

KAUFFMAN, untitled bubble: Museum of Contemporary Art, Los Angeles. Gift of Irving Blum. © Craig Kauffman Estate.

BELL, untitled cube: Courtesy Larry Bell.

IRWIN, untitled disc: Norton Simon Museum, Gift of Mr. and Mrs. Eugene Schwartz. © 2014 Robert Irwin/Artist Rights Society (ARS), New York.

McCRACKEN, *Firewalker*: The Museum of Contemporary Art, Los Angeles. Gift of Janet and Martin S. Blinder.

WHEELER, *Eindhoven Environmental Light Installation*: Hirshhorn Museum and Sculpture Garden, Washington, D.C., Panza Collection. © 2014 Doug Wheeler; courtesy David Zwirner, New York/London.

HAMROL, *5 x 9*: Photograph Matthew Brandt. Courtesy of the artist and Tomwork, Los Angeles.

HEINECKEN, *Fractured Figure Sections*: Museum of Modern Art, New York. The Photography Council Fund and Committee on Photography Fund. © 2014 The Robert Heinecken Trust. Courtesy of Cherry & Martin Gallery, Los Angeles.

CHICAGO, *The Dinner Party*: © 2014 Judy Chicago/Artists Rights Society (ARS), New York.

INDEX

INDEX

light
 artists' experiments with,
 187–188, 190
 in Pasadena Art Museum exhibits,
 183–184
 in transcendentalism, 192–193
Light and Space movement, 9,
 169–170, 179, 184, 189, 192–194,
 210, 228
Lindsay, Gilbert, 239–240
Lipton, Lawrence, 29
loneliness, in paintings, 177–178
Los Angeles. *See also* Westside
 Artforum editors moving to, 160–161
 artists leaving, 62, 79
 artists moving to, 71, 145
 bohemian venues in, 28–30, 32–33
 boosterism of, 13–14, 16
 bound up with technology, 151
 compared to NY, 15
 compared to Paris, 151–152
 compared to Pasadena, 111
 cultural coming-of-age in,
 153–155, 166–167
 culture of, 26, 114, 117–118, 151,
 197, 240
 decentralization as goal of,
 14–15, 180
 development of downtown,
 14, 239–240
 effects of Bradley's election
 as mayor of, 238–239
 effects of decentralization in,
 197–198
 facade-ness of, 169–170, 172, 196
 growth of, 4, 13–17, 22–23,
 25–26, 239
 hierarchies in, 113, 117–118
 as illegible, 180, 196
 jazz thriving in, 34
 middle class in, 4, 15–16
 natural beauty around, 22–23
 postwar affluence of, 4

 real estate development in, 13–15
 as symbol of mass culture and
 alienation, 26, 133
 village feeling of, 14–15
Los Angeles Art Institute.
 See Otis Art Institute
Los Angeles Conservatory of Music,
 merged into CalArts, 221
Los Angeles County Fair, art exhibits
 at, 69
Los Angeles County Museum of Art
 (LACMA), 166
 architect for, 199–200
 Art and Technology project of,
 184–188, 190–191, 217n
 attendance at and membership of,
 164, 167
 Brown forced out by trustees of,
 198, 200–201
 buildings for, 198–200, 238
 complaints about trustees of,
 200–202
 contemporary art at, 163, 238
 Kienholz retrospective at, 164–165
 local artists and, 163, 219
 opening of, 153, *154*
 problems of, 198, 233
 Simon and, 234, 241n
Los Angeles County Museum of
 History, Science, and Art, 69n
 art in, 16, 19, 41, 138
 attitudes at, 19, 118
Los Angeles Institute of Contem-
 porary Art (LAICA), 235–237
*Los Angeles Institute of Contemporary
 Art Journal, 236, 237*
Los Angeles Museum of Modern
 Art, becoming Museum
 of Contemporary Art, 242
LSD, effects on creativity, 34
Lubistch, Ernst, 20
Luminism, 192–193
Lynch, Kevin, 180